Ex dono Paul Johnson
MMVI

OXFORD–WARBURG STUDIES

General Editors

DENYS HAY *and* J. B. TRAPP

OXFORD–WARBURG STUDIES

═══

*Giotto and the Orators: Humanist Observers of Painting in Italy
and the Discovery of Pictorial Composition*
By MICHAEL BAXANDALL. 1971

The Figurae of Joachim of Fiore
By MARJORIE REEVES and BEATRICE HIRSCH-REICH. 1972

*Joseph Scaliger: A Study in the History of Classical Scholarship, I.
Textual Criticism and Exegesis*
By ANTHONY GRAFTON. 1983

Latin Poetry and the Classical Tradition
Essays in Medieval and Renaissance Literature
edited by PETER GODMAN and OSWYN MURRAY. 1990

Prophetic Rome in the High Renaissance Period
Essays edited by MARJORIE REEVES. 1992

*Joseph Scaliger: A Study in the
History of Classical Scholarship, II.
Historical Chronology*
By ANTHONY GRAFTON. 1993

The Elect Nation: The Savonarolan Movement in Florence 1494–1545
By LORENZO POLIZZOTTO. 1994

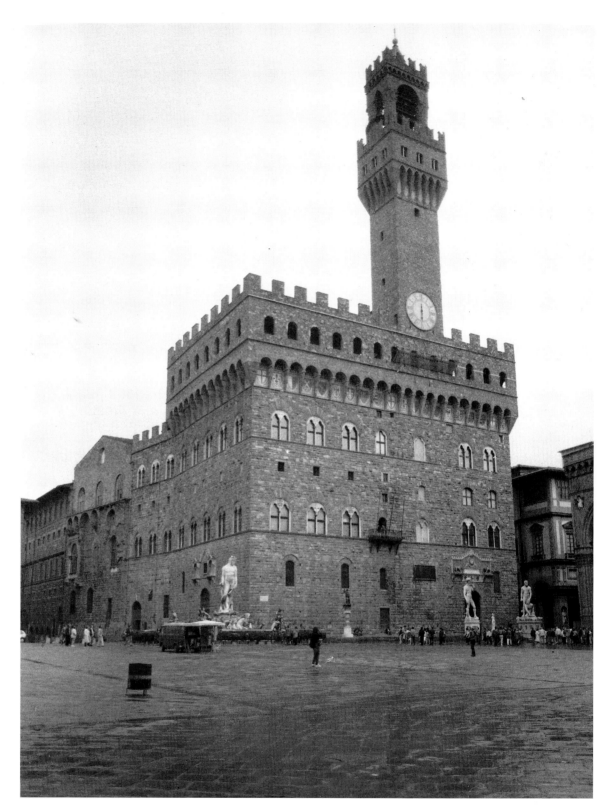

Frontispiece: Palazzo Vecchio

THE
PALAZZO VECCHIO
1298–1532

GOVERNMENT, ARCHITECTURE, AND
IMAGERY IN THE CIVIC PALACE OF THE
FLORENTINE REPUBLIC

NICOLAI RUBINSTEIN

CLARENDON PRESS · OXFORD
1995

Oxford University Press, Walton Street, Oxford OX2 6DP

Oxford New York
Athens Auckland Bangkok Bombay
Calcutta Cape Town Dar es Salaam Delhi
Florence Hong Kong Istanbul Karachi
Kuala Lumpur Madras Madrid Melbourne
Mexico City Nairobi Paris Singapore
Taipei Tokyo Toronto
and associated companies in
Berlin Ibadan

Oxford is a trade mark of Oxford University Press

Published in the United States
by Oxford University Press Inc., New York

British Library Cataloguing in Publication Data
Data available

Library of Congress Cataloging in Publication Data
Rubinstein, Nicolai.
The Palazzo Vecchio, 1298–1532: government, architecture, and
imagery in the civic palace of the Florentine Republic/Nicolai
Rubinstein.
(Oxford-Warburg studies)
Includes bibliographical references and index.
1. Palazzo Vecchio (Florence, Italy) 2. Florence (Italy)—
Buildings, structures, etc. I. Title. II. Series.
DG759.3.P34R83 1995
945'.51—dc20 94–38018
ISBN 0–19–920602–3

1 3 5 7 9 10 8 6 4 2

Typeset by Best-set Typesetter Ltd., Hong Kong
Printed in Great Britain
on acid-free paper by
Butler and Tanner Ltd
Frome and London.

To Ruth

PREFACE

The idea for this book grew out of my study of the government of Florence under the Medici, published in 1966. The records of meetings in the palace of the Signoria, the Palazzo Vecchio, of magistracies, committees, and councils often refer to the rooms in which the meetings were held; and what I began as a random collection of notes on the use to which the palace was put during the fifteenth century, turned into a systematic enquiry embracing the entire period from the building of the palace to the abolition of the republican constitution in 1532. During the long gestation of this book, which much of the time has gone on side by side with work on other subjects, I have incurred so many debts that it would be impossible for me to acknowledge them all individually. I have endeavoured to express, in the notes, my thanks for specific indications of source materials, but the obligations I have incurred to friends and colleagues for help of diverse nature cannot even distantly be repaid by these acknowledgements.

From the very beginning of my interest in the evolution of the palace, the architects in charge of the fabric, first Piero Micheli and then Ugo Muccini, have generously helped me with their expert knowledge of its structure and have made it possible for me to view those of its rooms which are not accessible to the public. The staff of the Florentine State Archives has rendered me the continuous assistance which is so invaluable to research on Florentine history. Without the library of the Warburg Institute this book would not have been written; my friends at the Warburg Institute have been endlessly and patiently helpful in discussing with me scholarly and technical problems of many kinds.

For help with the illustrations I am greatly indebted to the Kunsthistorisches Institut in Florence, which undertook a photographic campaign in the Palazzo Vecchio on my behalf, and to the curator of its photographic collection, Irene Hueck, to the Musei Comunali of Florence and their director, Fiorenza Scalia, and to Paul Davies, who kindly took a number of photographs for me. I should also like to thank all the friends who offered me their help and advice in the preparation of the illustrative material; special thanks are due to Ian Jones of the photographic studio of the Warburg Institute.

Among the many friends who over the years have contributed to this book, I owe particular gratitude to Caroline Elam for her generosity in sharing with me the results of her own researches, for her incisive comments, and for encouraging me in persisting with a project which involved my venturing into the field of architectural history. I should also especially like to thank for their help Maria Monica Donato, Michael Hirst, Kate Lowe, and Diane Zervas.

For the completion of this book, my warmest thanks must go to Joe Trapp, whose unfailingly critical reading of the text in consecutive versions and whose indefatigable help with editorial problems went far beyond the normal duties of an editor. I am grateful to Shayne Mitchell for compiling the index and for helping me with proof-reading. I should also like to express my

appreciation of the kind and meticulous asistance I have received from Anne Ashby and Enid Barker of the Oxford University Press. My wife has contributed to this study in more ways than I can tell. This book, which has accompanied our life in London and Florence during so many years, is dedicated to her.

N.R.

Warburg Institute, London
June 1994

CONTENTS

List of Illustrations xi
Photographic Credits xiii
Ground Plans xiv

INTRODUCTION I

1. THE EVOLUTION OF THE PALACE AS SEAT OF
 THE GOVERNMENT OF FLORENCE 5

 The Building of the Palace 5
 Fortification 13
 Internal Disposition 18
 Building Operations 24
 The Palace as Administrative Centre in the Fifteenth Century 35
 Republican Reform 40
 Piero Soderini Gonfalonier of Justice for Life 43

2. THE INTERIOR DECORATION OF THE PALACE 47

3. THE PIAZZA DELLA SIGNORIA 79

 EPILOGUE 95

APPENDICES

 I. The *Camere* of the Priors and the Gonfalonier of Justice 97
 II. *Fra le camere* 101
 III. The Sala dei Gigli 102
 IV. The Chapel and the Audience Chamber of the Signoria 104
 V. The Sala dei Grandi and the Chancery of the *Riformagioni* 107
 VI. The Secretum 109
 VII. The Tribunes of the Signoria 111
 VIII. The Location of the Tribune of the Signoria in the Sala dei Cinquecento 114
 IX. The Sala degli Otto 116
 X. The Operai del Palazzo 118

Abbreviations and Archival Sources 123
Bibliography 124
Index 139

LIST OF ILLUSTRATIONS

Unless otherwise indicated, all references to rooms and other locations are to the Palazzo Vecchio. They are given their current names. For contemporary equivalents, see legends of the ground plans and index.

Frontispiece: Palazzo Vecchio

1. Florence, Bargello
2. Pietro del Massaio, Plan of Florence (1469). Ptolemy, *Cosmographia*, Biblioteca Apostolica Vaticana, Cod. Vat. lat. 5699, fo. 126ᵛ
3. North façade
4. Domenico Ghirlandaio, *Confirmation of the Franciscan Rule by Honorius III*. Florence, S. Trinita. Detail.
5. Orcagna, attr., *Expulsion of the Duke of Athens from Florence* (detached fresco now in the Palace)
6. Camera dell'Arme
7. Cortile della Dogana
8. Courtyard
9. Sala dei Dugento
10. Room on the mezzanine
11. Ground plan of the ground floor (*c*.1775). Prague, State Archives, Family Archive of the Habsburgs in Tuscany
12. Ballatoio
13. Sala dei Cinquecento
14. Anon., *Sala del Maggior Consiglio*, Venice, Doge's Palace, sixteenth-century engraving
15. South façade, detail
16. North façade
17. Chapel, Mariano da Pescia, *Virgin and Child with Sts Elizabeth and John the Baptist*
18. Newel post on the mezzanine (photo of 1931)
19. Spiral stairs in west wall
20. Mezzanine, fourteenth-century ceiling
21. Hercules seal of Florence, cut by Domenico di Polo, 1532. Florence, Palazzo Pitti, Museo degli Argenti
22. Donatello, marble *David*. Florence, Museo del Bargello
23. Verrocchio, *David*. Florence, Museo del Bargello
24. Filippo Lippi, *Vision of St Bernard*. London, National Gallery

25. Giovanni del Ponte, attr., *Annunciation*

26. Verrocchio, Candlestick. Amsterdam, Rijksmuseum

27. Sala dei Gigli, ceiling, detail

28. Udienza, ceiling, detail

29. Sala dei Gigli, marble doorway

30. Sala dei Gigli, marble doorway, detail

31. Udienza, marble doorway

32. Giuliano da Maiano and Francione [Francesco di Giovanni], *Dante* and *Petrarch*, inlaid panels. Sala dei Gigli, marble doorway

33. Domenico Ghirlandaio, *St Zenobius and Famous Romans*. Sala dei Gigli

34. Giuliano da Maiano, *St Zenobius with Sts Eugenius and Crescentius*, inlaid panel. Duomo, Sacrestia delle Messe

35. Domenico Ghirlandaio, *Famous Romans*, left side

36. Domenico Ghirlandaio, *Famous Romans*, right side

37. Filippino Lippi, *Virgin and Saints*. Florence, Galleria degli Uffizi

38. Donatello, bronze *David*. Florence, Museo del Bargello

39. Donatello, *Judith and Holofernes*. Piazza della Signoria (now in the Sala dei Gigli)

40. Anon., *Burning of Savonarola*. Florence, Museo di San Marco

41. Filippo Lippi, *Virgin Adoring the Child*. Berlin, Staatliche Museen, Preussischer Kulturbesitz, Gemäldegalerie

42. Fra Bartolomeo, *Virgin and Saints*. Florence, Museo di San Marco

43. Leonardo da Vinci, *Battle of Anghiari: The Fight for the Standard*, engraving by Lorenzo Zacchia after Leonardo. Vienna, Albertina

44. Michelangelo Buonarroti, *Battle of Cascina: The Bathers*, grisaille by Bastiano da Sangallo, attr., after Michelangelo. Holkham Hall

45. Sala dei Dugento, marble doorway

46. Sala dei Dugento, marble doorway, frieze

47. Sala dei Dugento, marble doorway, base, detail of Fig. 45

48. Sala dei Dugento, second marble doorway

49. Giorgio Vasari, *Antonio Giacomini Addressing a Council Meeting*. Sala dei Cinquecento

50. Davide Ghirlandaio, *Sts Peter and Paul*. Florence, Palazzo Pitti, Galleria Palatina

51. Chapel, Ridolfo Ghirlandaio, *Annunciation*

52. Stefano Bonsignori, Map of Florence (1584), detail

53. Bernardo Bellotto, *Piazza della Signoria*. Budapest, Museum of Fine Arts

54. Andrea Scacciati, *Piazza della Signoria*, engraving

55. Florence, Loggia dei Lanzi

56. Florence, Mercanzia

57. Giovanni Stradano, *Gifts from Leo X Presented to the Signoria*. Sala di Leone X

58. Francesco Granacci, attr., *Portrait of Man in Armour*. London, National Gallery

59. Master of the Hamilton Xenophon, attr., *Tribune of the Signoria on the Ringhiera*. Leonardo Bruni, *Historia fiorentina*, trans. Donato Acciaiuoli. BNF, MS Banco rari, 53 (1480), fo. 1r

60. Master of the Hamilton Xenophon, attr., *Tribune of the Signoria in the Palace*. Leonardo Bruni, *Historia fiorentina*, trans. Donato Acciaiuoli. BNF, MS Banco rari, 53 (1480), fo. 1r

61. Sala degli Otto, ceiling

GROUND PLANS

I. Ground floor xvi

II. First floor xvi

III. Mezzanine xvii

IV. Second floor xvii

scale 1:300

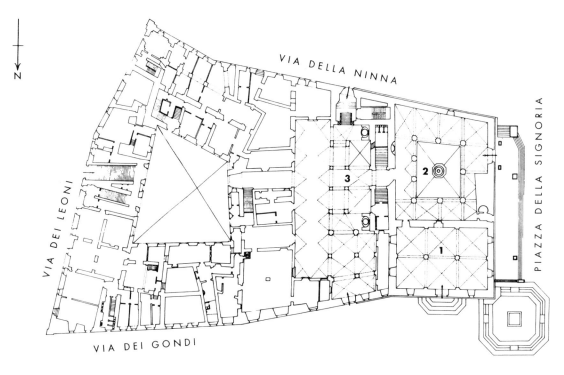

I. GROUND FLOOR

Contemporary names are enclosed in curved, when conjectural in square, brackets. Otherwise names conform to current usage.

1. Camera dell'Arme
2. Courtyard
3. Cortile della Dogana
 (Cortile del Capitano)

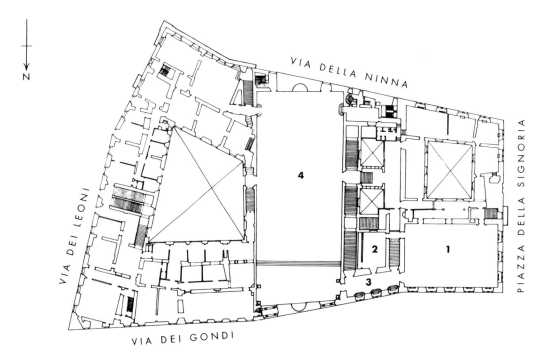

II. FIRST FLOOR

Contemporary names are enclosed in curved, when conjectural in square, brackets. Otherwise names conform to current usage.

1. Sala dei Dugento
 (Sala del Consiglio)
2. Sala degli Otto
3. (*Andito*)
4. Sala dei Cinquecento
 (Sala del Consiglio,
 Sala Grande del
 Consiglio)

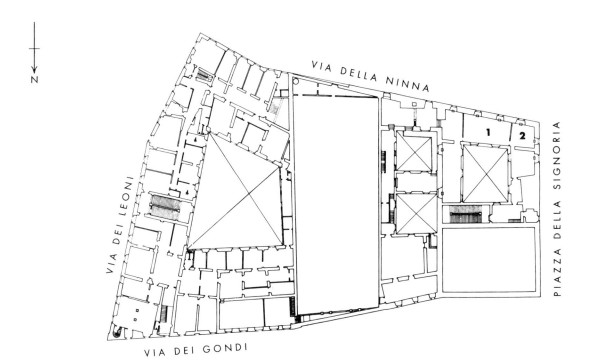

scale 1:300

III. MEZZANINE FLOOR

Contemporary names are enclosed in curved, when conjectural in square, brackets. Otherwise names conform to current usage.

1. (Sala dei Dieci; 1481–Sala dei Settanta)
2. (Udienza dei Dieci)

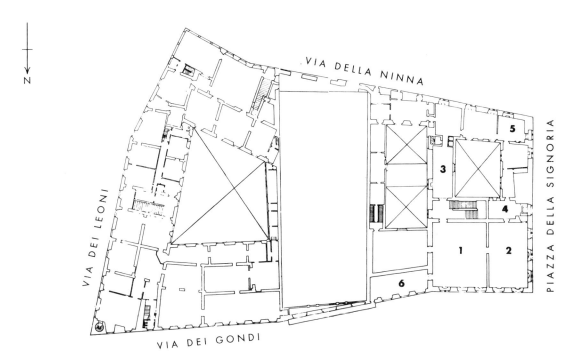

IV. SECOND FLOOR

Contemporary names are enclosed in curved, when conjectural in square, brackets. Otherwise names conform to current usage.

1. Sala dei Gigli (Sala dei Signori, sala grande di sopra)
2. Udienza (Udienza dei Signori)
3. Saletta

4. Chapel (1511–)
5. Sala di Penelope (Camera de Gonfaloniere di Giustizia)
6. (1511–Cancelleria delle lettere)

INTRODUCTION

The last years of the thirteenth century in Florence were marked by unprecedented activity in public building. This was to a large extent due to the spectacular growth of the city's population which by the turn of the century may have reached nearly 100,000. Another major reason was the far-reaching changes in the government and administration of the city-republic. These changes, which began with the establishment, from 1282, of the Priorate of the Guilds as the supreme executive office, culminated in the Ordinances of Justice of 1293, by which the magnate nobility was excluded from government. By giving the merchant guilds a predominant role in the new popular regime, the constitutional reforms privileged the wealthiest and most enterprising section of the population; they also held out, after the feuds and factions of the preceding decades, the promise of domestic peace and political stability.

It was hardly a coincidence that the great public building projects of the end of the century were initiated soon after the establishment of the Priorate—the third circuit of town walls was planned by 1284, although its foundation stone was laid only in 1299, the construction of the mendicant churches of S. Maria Novella and S. Croce was begun in 1283 and 1295 respectively. The foundation stone of the new cathedral of S. Reparata was laid in 1296. The building of the palace which was to serve as the residence of the Priors was debated by the city's councils from 1285, and begun in 1299. The chronicler Giovanni Villani, who was a member of the works committee for the new town walls, later attributed the decision to build a third circle of walls to the growth of the Florentine population as well as to the peace and prosperity the city was enjoying at that time. Likewise, the building of the new cathedral was decided, he writes, because the existing church 'was very primitive and small in comparison with such a city'. The need of space to accommodate larger numbers might also account for the building of the two great mendicant churches, but hardly for that of the new civic palace.

The palace of the Signoria, that is, of the Priors and the Gonfalonier of Justice, is the subject of this book. The palace was intended to house, during their period of office, the members of the government, together with their small household staff and their armed guard. Centuries later, after Cosimo I had transferred his residence from it to the Pitti Palace across the river, it became known as the Palazzo Vecchio. When it was first built, it must by far have exceeded day-to-day requirements.

Its huge size, enhanced a few years later by its soaring tower, was no doubt due in the first place to the need to be able to defend the new popular regime from attack, at a time when the stability of that regime was threatened by renewed civil strife. It could also be seen as an expression of the self-confidence and the patriotic pride of the new ruling class. At the time of

its construction, a visit to Rome in the jubilee year 1300 had inspired Villani, as he wrote later, to compose his Florentine chronicle, since that visit had brought it home to him that his city, 'the daughter and creation of Rome, was rising and had great things in store for her, while Rome was declining'.

During the two centuries and more which followed on the building of the palace, the expanding administration of the republic, the growth of her diplomatic relations, and changes in the way her government was conducted, led to the creation of new magistracies and committees. These required office space or meeting places in the palace. Hence the available space gradually contracted, so that by the mid-fifteenth century the palace was practically bursting at the seams. The history of the palace of the Signoria as affected by these developments is the first of the principal themes of this book. Political events and institutional changes in Florence thus help explain the architectural evolution of the palace, and this evolution in its turn provides evidence for political and constitutional history. The same applies to the second theme, the decoration of the palace. Much of its iconography reflects dominant trends in contemporary political thought. The third and final chapter is devoted to the Piazza of the Signoria, whose evolution was completed by the end of the fourteenth century and was closely linked to that of the palace. Hence, in its turn, it is intimately connected with political history. After the city's capitulation to the imperial army in 1530, it was on the piazza that a popular assembly confirmed the demise of the last republican regime. Ten years later, duke Cosimo I took up residence in the palace. With this there began a new epoch in its history; Vasari and his successors transformed it into a vastly expanded and richly decorated ducal residence. It is therefore fitting that the final date of this study should be the abolition in 1532 of the government of the Priors and the Gonfalonier of Justice, for whom the palace had been constructed two and a half centuries previously.

There are considerable difficulties facing the historian who seeks to reconstruct the architecture and the decoration of the medieval palace. Some are the result of its sixteenth-century conversion into a ducal residence. Others derive from the alterations that were made more than three centuries later when it became, for a few years from 1865, the seat of the chamber of deputies and of the foreign ministry of the new Italian kingdom. Some rooms had already disappeared or been converted to new uses before 1540, when furnishings and mural decoration had also been destroyed. Much more of the same occurred in the 1860s. The problem is compounded by the virtual absence of contemporary descriptions of the interior of the early palace and of its decoration. Some help is forthcoming from inventories of objects kept in its rooms, which provide valuable though necessarily limited information on their distribution and use. There are also incidental references in histories of Florence and in family memoirs. Similar information is also provided, on a larger scale, by the records of magistracies and of committees, which often indicate where their meetings were held. Copies of epigrams for figurative decoration in contemporary or near-contemporary manuscripts furnish evidence of lost paintings. For the building and decorative operations in the palace during the one and a half centuries following its construction, legislation by the councils and the deliberations of the Signoria and the Colleges are our chief source. After 1470, the proceedings of the works committee of the palace, the Operai del Palazzo, are recorded in their extant registers.

The fragmentary nature of much of the evidence for the history of the palace under the republic necessarily sets limits to attempts to 'reconstruct' its appearance before the conversions to which it was later subjected. On the other hand, the very diversity of that evidence can be of help in such a 'reconstruction'; while legislative and administrative records allow us to trace, often in considerable detail, the evolution of the palace. This evolution raises time and again the question of who was ultimately responsible for commissioning works of art or initiating building campaigns. In contrast to the palaces of princes and of private citizens, where the patron was identical with the owner, a public palace such as the Palazzo Vecchio was the property of the commune, and the citizens who resided in it did so only during their short terms of office. Substantial decisions regarding the palace would normally be passed by the councils, but their execution would be left to the Signoria and its two Colleges or to the Operai of the palace. Since the Priors and the Gonfalonier of Justice were in office for two months only, the members of the two Colleges for four and three months respectively, the execution of building and decorative projects depended to a large extent on the way in which the Operai, who were in office for longer periods, carried out the decisions of the Signoria. Their close involvement with work in progress and their longer terms of office were liable to encourage independent action, which the Signoria in its turn would seek to restrain by insisting that no major projects should be initiated without its prior approval, an approval which could be linked to the obligation to display plans of such projects in the palace.

From 1479 onwards, the Operai were elected for one year; in 1487 their term of office was extended to five years. One of the five Operai elected in that year was Lorenzo de' Medici, another his brother-in-law Bernardo Rucellai, a third a close confidant. Lorenzo had previously been a member of the works committee. Even when he was not one of the Operai, moreover, he may well have influenced its decisions. Much the same may have been true of his grandfather Cosimo and of his father. It is tempting to detect in the renovation campaigns that began shortly before the middle of the century the hand of the Medici. When in 1444 it was decided to renovate the council hall, Cosimo was one of the three Operai who were put in charge; in 1454, Piero was elected one of the three who were to supervise the restoration of the courtyard. An evaluation of the role of the Medici in the evolution of the palace during the second half of the century must, however, take into account the nature of their ascendancy in the government of the republic.

It is sometimes taken for granted that since Lorenzo was the virtual ruler of Florence, the changes that took place in the palace after 1469, when he succeeded his father as head of the regime, were ultimately due to him. But Lorenzo was not the Signore of Florence. Throughout his life he insisted on respecting the institutional structure of the republic, eroded though that progressively was by the extension of Medicean controls. The question of Lorenzo's intervention in the palace has, like his urban policy, to be seen in this context. In particular, the extent to which he influenced the building and decorative projects that were carried out after 1469 in the Sala dei Gigli, must therefore remain a matter of speculation as long as conclusive documentary evidence is lacking. It is, nevertheless, highly probable that he had a significant share in their formulation.

The question of individual patronage in the Palazzo Vecchio under the republic does not arise only in the case of the Medici. The decorative campaign in the new hall of the Great Council was initiated after Piero Soderini had been elected Gonfalonier of Justice for life in 1502. It is generally assumed that the commissioning first of Leonardo and then of Michelangelo to fresco the hall was due to him, although as before, artists would be commissioned either by the Operai or by the entire Signoria. As the only permanent member of the Signoria, and as such permanently resident in the palace, Piero Soderini must have had a far greater influence on the decorative programme of the hall than his colleagues who were in office for two months only. Although it is difficult to assess the exact extent of his influence on the changes that took place during the ten years of his Gonfaloniership, Soderini's constitutional position as head of the government for life was bound to have made it easier for him to act as 'patron of the arts' in the palace than it had been for Lorenzo de' Medici.

Other questions remain which can be answered only tentatively, if at all. New finds will no doubt add or revise details, and fill out the picture we have been trying to draw of the development of the Palazzo della Signoria under the republic. Even so, it is hoped that this book, by combining different historical disciplines, will help the reader to see this development, with its manifold interrelations of architecture, art, and politics, of administrative requirements and of personal aspirations, as an integral part of the history of Florence during the 230 years from the foundation of the palace to the fall of the last republican regime.

1

THE EVOLUTION OF THE PALACE AS SEAT OF THE GOVERNMENT OF FLORENCE

THE BUILDING OF THE PALACE

On 30 December 1298, the councils of the Captain of the People of Florence ordered the Priors, the Priori delle Arti, to choose the location for the new residence which was to be built for them, and voted the money required for this purpose.[1] As early as March 1302, the Priors and the Gonfalonier of Justice are recorded as residing 'in the new palace', 'in pallatio novo'.[2]

The decision to build the palace forms part of the political history of the city-republic after 1280. In that year, the papal legate Cardinal Latino tried to put an end to the family feuds and the factions which were dividing Florence by making peace between the Guelfs and the Ghibellines. His work of pacification soon proved a failure. The new magistracy of Fourteen, in which both factions were represented, had to rely increasingly on the support of the seven greater guilds, represented in it first by three, and then by six of their Priors, one for each of the six districts of the city; and by the end of 1282, the Priors had altogether taken over from the Fourteen as the governing body of Florence.[3] The new regime continued the policy of pacification with different methods. While the restoration of the dominant role of the Guelf party deprived the Ghibellines, this time for ever, of the position in the city they had, in part, briefly recovered, legislation designed to restrain family feuds and violence perpetrated by magnates struck at the chief root of public disorder and civic strife.[4] A new magistrate, the Gonfalonier of Justice, was put in command of a popular militia of 1,000, subsequently

[1] Provv., 9, fos. 120ᵛ–121ᵛ (30 Dec. 1298), partly ed. by Gaye, i, pp. 440–2, and Frey 1885, pp. 183–5, no. 18. Cf. Davidsohn, *Forschungen*, iv, p. 499. According to Simone della Tosa, *Annali*, p. 156, the foundation stone was laid on 24 Feb. 1299 ('s'incominciò a fondare il Palagio del Comune di Firenze da San Piero Ischeraggio'). Although this chronicle was not completed until about 1346, its author may have used earlier sources. Giovanni Villani gives a generic date (*Cronica*, viii. 26 (ii, p. 29): 'nel detto anno 1298 si cominciò a fondare il palagio de' priori') which agrees with Simone della Tosa's, since according to him the foundation of the palace took place between the passage of the law of 30 Dec. and the end of the Florentine year 1298 on 24 Mar. 1299.

[2] *Consigli*, i, pp. 48–9 (26 Mar. 1302): 'In consilio quamplurium sapientum virorum, congregatorum coram prioribus et vexillifero in

pallatio novo, in quo ipsi priores et vexillifer pro comuni morantur.' According to Del Lungo in Compagni, *Cronica*, pp. 277–8, the Signoria had established its residence in the palace, or more precisely in one of the houses that were to be used in the construction of the new palace ('dalla congiunzione de' quali doveva . . . formarsi Palazzo Vecchio'), by Mar. 1299, but the words 'in domo sive Pallatio Populi et Comunis Florentie', in documents of that month relating to the purchase of properties, could still refer to the palace of the Cerchi in which the Priors had been staying until 1298 (see ibid. and Preyer 1985).

[3] See Davidsohn, *Geschichte*, ii. 2, pp. 165 ff., 212 ff.; Lori 1980–1.

[4] See Ottokar 1926, pp. 132 ff. (2nd edn., pp. 97 ff.).

of 2,000, and finally of 4,000 citizens, who were true friends 'of the good and peaceful state of the city',[5] and who would help him enforce that state against the disturbers of the public order.

It was to be foreseen that the resentment of the Magnates who had been excluded from government by the Ordinances of Justice of 1293[6] as well as being placed under a discriminatory penal legislation, and who counted among their numbers many of the most powerful and wealthiest families of Florence, should pose a threat to the chief magistracy of the new popular regime. It was therefore essential to make this magistracy safe from attack. After their creation in 1282, the Priors resided, from 1293 together with the Gonfalonier of Justice, in rented property, including a house belonging to the Badia and a palace of the Cerchi;[7] but as early as 1285, one of the councils of the Captain of the People debated a statute concerning the construction of a palace for them.[8] No decision to proceed with this project had, however, been reached by July 1294, when the council of One Hundred deliberated 'about the location of the palace and the valuation of the houses, buildings, and building plots where it is to be built'.[9] Perhaps it was not a coincidence that, according to Dino Compagni, the Magnates were, around that time, conspiring against the leading figure of the regime, the Gonfalonier of Justice Giano della Bella, and that in January 1295 the palace of the Podestà was sacked by a mob.[10] Giano della Bella fell from power and was exiled shortly afterwards, and these events were followed by an abortive rising of the Magnates; at the end of 1296, feuding among noble families once more divided Florence:[11] a contemporary chronicler records that in the following year there were, in the city, 'many feuds', and that 'the Guelf party [had] already split into two factions'.[12] According to another contemporary chronicler, the final decision to go ahead with the building of the palace was caused by these developments: 'it did not seem safe for the Signoria', writes Giovanni Villani, 'to stay where they had previously been residing, that is in the house of the Cerchi', who belonged to the faction of the White Guelfs, behind the church of S. Procolo.[13]

Whatever the immediate cause of that decision, its principal reason was no doubt the lack of a public building which could serve as a permanent residence, during their two-month term of office, for the Priors, the Gonfalonier of Justice, and their notary. That this building could not be the palace in which the Podestà resided was a foregone conclusion. In the city's two-tier structure of government and administration under the first popular regime between 1250

[5] Salvemini 1899, pp. 393, 417–19, 421–2: 'qui sint amatores pacifici et tranquilli status civitatis Florentie'. The militia was complemented by 150 'magistri de lapide et lignamine' and 50 *picconarii*.

[6] See Salvemini 1899, chs. 7 to 9.

[7] The documentation is collected in the appendix to the commentary of Dino Compagni's *Cronica* by Del Lungo, pp. 275–7, cf. ibid., p. 17.

[8] *Consulte*, i, p. 195 (30 Mar. 1285): 'Infrascripta sunt ea statuta que debent asolvi. Primum, statutum quod loquitur de Palatio construendo, quod est sub rubrica "De Palatio Comunis Florentie faciendo", in V° libro'. Cf. Davidsohn, *Forschungen*, iv, p. 499.

[9] *Consulte*, ii, pp. 418–19 (21–2 July 1294; Davidsohn, loc. cit.): 'de loco ubi Pallatium debeat fieri inveniendo; et de extimatione domorum, hedificiorum et terrenorum ubi Pallatium fiat'. The proposal that 'suspendatur dictum negotium' for the duration of the

term of office of the present Priors was defeated, and the decision to proceed in this matter, which had been passed by that council, was confirmed by the general and special councils of the Captain of the People on 22 July (*Consulte*, ii, pp. 420–1).

[10] *Cronica*, i. 16 (p. 46).

[11] Davidsohn, *Geschichte*, iii, pp. 27–30.

[12] Paolino Pieri, *Cronica*, pp. 61–2 : in the second half of 1297, 'avendo in Firenze molte izze et brighe, et già fatta de la parte Guelfa due parti, l'una si dicea Nera, et l'altra Bianca, et erano grandi odi tra' Guelfi. . . . Et allora si discoperse il veleno, ch'e' Fiorentini avean nel cuore . . . et incominciossi a Firenze un gran distruggimento.'

[13] *Cronica*, viii. 26 (ii, p. 30): 'non parea loro essere sicuri ove abitavano innanzi, ch'era nella casa de' Cerchi bianchi dietro alla chiesa di San Brocolo'. On the palaces of the Cerchi, see Preyer 1985.

and 1260, the Podestà had shared executive powers with the Anziani and the Captain of the People, and the new popular regime of 1282 followed the model of its predecessor. At the same time, the distinction of functions this model involved, with the Podestà being placed in an increasingly subordinate position, was reflected in the physical separation of his residence from that of the magistracies of the People. Northern Italian city-republics had been building palaces for their Podestàs from about 1200.[14] Unlike the consuls whom he replaced in the government of the commune, the Podestà was normally a 'foreigner'; elected for twelve, later for six months,[15] he needed a house for himself and his staff. This could be rented property; but it was obviously preferable to provide him with a public building constructed to meet his special requirements.

At the beginning of the thirteenth century, the city had owned a palace in which the Podestà performed his office; whether he also resided in it is not recorded, but is probable.[16] Five years after its destruction in 1235, he transacted judicial business in a house belonging to the Alberti near the church of S. Michele in Orto, which may also have served as his residence.[17] In contrast to this makeshift arrangement, the popular regime established in 1250 decided to build a palace for its magistracies and councils. As in other city-republics, the building of that palace, the present-day Bargello, answered the need to provide space for the administration of the new regime;[18] but it also reflected a civic self-confidence that was compounded by the collapse, in 1250, of Hohenstaufen rule. The foundation of the palace in 1255 was commemorated in an inscription on its façade which uniquely illustrated the ideological significance public palaces *Fig. 1* could assume in the eyes of contemporaries. The new palace was built, the inscription boasts,[19] at a time when Florence was full of wealth, had defeated her enemies, and was rejoicing in her fortune and her power: 'She owns the sea, the land, the entire world; like Rome, she will always be triumphant'. In 1260, the popular regime fell after the Florentine defeat by the Sienese at Montaperti, and subsequently the Podestà took over its palace.[20] After the establishment of the new popular regime in 1282, the city's two-tier structure of government, with its parallel institutions of the Commune and the People, now required a separate residence for the Priorate and its staff. That soon after the creation of the new regime, its councils should have projected the construction of a permanent residence for its government, could only be expected; that the execution of this project took so many years to materialize was, in all probability, primarily due to difficulties in coming to a decision on where to build the new palace.

When, nine years after the debate 'de palatio construendo', the building of the palace was again the subject of a deliberation in one of the councils, the first question mentioned was the place where it was to be built;[21] and when it was finally decided, after another delay of over four

[14] See Paul 1963, pp. 66, 126, 129, 132 ff., 192.

[15] On Florence, see Davidsohn, *Geschichte*, iv. 1, p. 75; *Forschungen*, iv, p. 536.

[16] Davidsohn, *Forschungen*, i, pp. 143–4. He locates this palace near the church of S. Romolo, in the northern section of the present Piazza della Signoria.

[17] Cf. P. Santini 1895, p. 272. The destruction of the 'palatium communis Florentini' in 1236 is recorded in the *Annales Florentini II*, ed. Hartwig 1875–80, ii, p. 41.

[18] On the constitution of the popular regime between 1250 and

1260, see Davidsohn, *Forschungen*, iv, pp. 100–6.

[19] The inscription is ed. ibid., pp. 497–8, and with variants, as recorded in a contemporary manuscript, in MacCracken 1956.

[20] According to Giovanni Villani, *Cronica*, vi. 80 (i, p. 303), Count Guido Novello, the first Ghibelline Podestà of Florence after the battle of Montaperti, took up residence in the palace. He retained this office until 1262 (Davidsohn, *Forschungen*, iv, p. 537). From 1285 onwards, the Podestà is recorded as residing there 'more solito' (Paul 1963, p. 212).

[21] See above, n. 9.

years, to go ahead with the project, no decision on its location had yet been made, for the councils now delegated this decision to the Priors and the Gonfalonier of Justice.[22] The Priors had begun their two-month term of office on 15 December;[23] they had consequently one month and a half to settle a matter which the councils had failed to conclude during a period of many years. They did their job swiftly and effectively with the advice of experienced citzens, 'cum consilio sapientum virorum', who no doubt were familiar with the kinds of argument which had been put forward in the past in favour of one or other of the possible solutions for the siting of the palace.[24]

In general terms, such solutions must have conformed to urbanistic models available for the siting of communal palaces in thirteenth-century Italy. These models entailed the provision, for popular assemblies, of an open space in front of the palace. Chief among these spaces were the cathedral and the market squares, the former represented, among others, by Bergamo, Brescia, and Cremona, the latter, on the site of the Roman forum, by Verona and Vicenza.[25] In Florence, the space between the cathedral of S. Reparata and the Baptistery was so small that in 1296 it was decided to demolish and rebuild elsewhere a hospital which was situated between the two churches, because the faithful were finding it difficult to attend sermons outside the cathedral.[26] The construction there of a new public palace would have been impossible without major clearances. The market square, the Mercato Vecchio, situated on the site of the Roman forum, might have seemed a more practical solution.[27] Here again, there may have been objections owing to inadequate space,[28] as well as to the disturbance the commercial activities were liable to cause. Moreover, at the end of the thirteenth century, the Roman forum no longer constituted the topographical centre of the city. The foundation stone of its third circuit of walls was laid only a few months after that of the new palace.[29] In the vastly expanded area of the walled city, that palace was, in the end, to occupy a central position close to that which the ancient forum had occupied within the Roman–Byzantine nucleus of Florence: about a *Fig. 2* century later, Gregorio Dati locates it 'nearly at the middle of the city', 'quasi nel mezzo della città'.[30] However, the fact which was decisive for the final choice of the site for the palace must have been the existence of a small open space due to the demolition, in 1258, of properties belonging to the Ghibelline family of the Uberti.[31] The ruined buildings and their found-ations had been left waste since then, possibly in order to serve as a deterrent in the Guelf city, and could now provide the new palace with what was to become the first section of a

[22] See above, n. 1: 'quod ipsi domini Priores et Vexillifer nunc in offitio residentes cum consilio sapientum virorum . . . possint eisque liceat . . . providere, deliberare et firmare, in quo loco civitatis . . . pro ipso Comuni morari, stare et residentiam facere debeant . . .'.

[23] The first Priors had begun their term of office on 15 June 1282: Davidsohn, *Geschichte*, i. 2, p. 213.

[24] When the location of the palace was debated on 22 July 1294 in one of the councils a councillor proposed that the site 'should touch, in some part of it, at least three *sesti*' (*Consulte*, ii, p. 420: 'locus predictus tangat in aliqua sui parte tres sextus ad minus'), that is one half of the six districts into which the city was divided. Spilner 1987, p. 295, points out that this implied a position at the centre of the city. On the question of the site, see ibid., pp. 393–401.

[25] Paul 1963, pp. 42–3.

[26] *Provvisione* of 6 June 1296, ed. Pampaloni 1973, pp. 56–8: 'cum

platea ecclesie Sancti Iohannis et Sancte Reparate predicte sit arta et parve capacitatis gentium, ita quod gentes, tempore quo predi-cationes in ea fiunt . . . commode in ea ad audiendum verbum Dei collocari et morari non possunt . . .'. On the hospital of S. Giovanni Evangelista, see Davidsohn, *Forschungen*, iv, p. 396.

[27] Braunfels 1953, p. 198. On the Roman forum, see Lopes Pegna 1962, pp. 83–7. Contemporaries were aware of the location of the forum: cf. Villani, *Cronica*, i. 37 (i, p. 61); on the capitol: 'Questo campidoglio fu ov'è oggi la piazza che si chiama Mercato Vecchio.'

[28] See Davidsohn, *Geschichte*, i, pp. 743–4.

[29] Villani, *Cronica*, viii. 31 (ii, p. 32): on 29 Nov. 1299. Cf. Davidsohn, *Forschungen*, iv, p. 449.

[30] *Istoria di Firenze*, p. 108.

[31] Villani, *Cronica*, vi. 65 (i, p. 286). Cf. Davidsohn, *Geschichte*, ii. 1, pp. 471–2.

piazza.[32] For, as we shall see, the documents recording the purchases of property for the construction of the palace show that an extension of the piazza to the west was being planned from the very beginning.[33]

In the absence of records of payments for work done or projected, these documents constitute the only available evidence for the initial phase of the building operations. Moreover, they are clearly incomplete. Published, mostly in extracts, by Frey in his book on the Loggia dei Lanzi,[34] they are included in two volumes of the Capitoli del Comune, a collection of important state papers such as privileges, treaties, and title deeds, for whose preservation special provision had been made as early as 1322.[35] The records concerning the building of the palace do not therefore constitute a register with consecutive entries, but are in the form of separate documents that were subsequently bound together with other documents. As it is unlikely that all the records that were relevant for the building history of the palace were included in these two volumes, those of them that were can only provide partial evidence for it, even within the context of the purchase of properties on whose foundations the palace was to be constructed.[36]

They allow us, however, to form a fairly clear picture of the projected size of the palace. The houses acquired by the Commune between March and July 1299 extended from the piazza of the Uberti in the north to the Via Bellanda in the east;[37] these must have been considered to mark, at the time when in February its foundation stone was laid, the ultimate boundaries of the palace. The first section of the building to be completed must have been the block containing, on three stories, its three public halls, the Camera dell'Arme on the ground floor, the council hall on the first, and the still undivided hall on the second floor. As has been argued,[38] the northern wall facing the piazza of the Uberti, which by the end of that year was also called 'the piazza of the Florentine Commune', 'platea comunis Florentie',[39] must have formed at first the principal façade of the palace, with the door to the Camera dell'Arme at its centre serving as its principal entrance. This arrangement resembled that of the palace of the Podestà, the Bargello, which, *Fig. 3* with its superimposed halls on its two storeys, must have provided a model for the new palace.[40]

From the extant records it is difficult to chart the progress of the building with certitude. In January 1299 the councils had authorized the bursars (*camerarii*) of the Commune to pay during their two-month term of office up to 1,000 gold florins for the purchase of property and for the use of that property in the construction of the palace,[41] but we do not know until when these payments continued, nor their exact amount. According to the surviving documents, the purchases had been practically completed by the end of January 1300;[42] but as late as June 1301, property was acquired on the site of the palace from the Foraboschi.[43]

[32] Villani, *Cronica*, viii. 26 (ii, p. 30): 'E colà dove puosono il detto palazzo, furono anticamente le case degli Uberti, ribelli di Firenze e Ghibellini; e di que' loro casolari feciono piazza, acciocchè mai non si rifacessono.' On the meaning of *casolare* as 'edificio cadente o diroccato', see Sznura 1975, pp. 30–2.

[33] See below, p. 80.

[34] Frey 1885, pp. 185–90, nos. 20–36, 38–9.

[35] Capitoli, 30 and 43; cf. Marzi 1910, p. 466.

[36] For one such record, see below, n. 43.

[37] See the map at the end of Frey 1885.

[38] Paul 1969, pp. 54 ff.

[39] Frey 1885, pp. 190–1, nos. 40, 41.

[40] Marchini, in Rodolico and Marchini 1962, p. 41.

[41] Frey 1885, p. 185, no. 19 (26 Jan. 1299).

[42] Frey 1885, p. 192, nos. 46–8 (20–2 Jan. 1300).

[43] Capitoli, 43, fo. 183[r–v] (19 June 1301; not in Frey). Leone di Ormanno Foraboschi sells the officials 'ordinatis ad faciendum construi pallatium dominorum Priorum et Vexilliferi', with the consent of his wife, whose dowry the property is, one eighth of houses, of a palace, and of *casolari*, for 3,600 *libbre*. In 1310, the sons of Ormanno and other members of the Foraboschi lineage complained that they had not received 'magnas pecuniarum quantitates' due to them 'pro domibus eorum, terrenis et palatiis, positis infra palatium'. Frey 1885, pp. 198–9, no. 77 (7 Dec. 1310). See also Gotti 1889, pp. 23–4.

As we have seen, the Priors and the Gonfalonier of Justice had taken up residence by March 1302; but building operations had not yet been finished at that time. In 1306, funds were granted for the 'readaptation and covering of the palace or the tower of the palace'; in 1307, a wooden edifice was erected on the piazza to house the new great bell, evidently because there was not yet a tower belfry which was capable of receiving it.[44] If, as has been suggested, it was only subsequently decided to add a gallery at the top of the palace, and to increase the height of the existing tower and furnish it with a belfry for the new bell,[45] this decision may have to be seen in the context of the attempts, during those years, to strengthen the authority of the Commune in the aftermath of renewed civil war.[46] In 1306, a new militia, the 'companies of the People', was established, and in 1307 the office of the Executor of the Ordinances of Justice created.[47] Apart from the palace's being, in its definitive form, 'a more powerful symbol of stability and order',[48] the gallery (*ballatoio*) could also have been considered more effective for its defence than simple battlements.[49] The tower had not yet been finished by 1310 or 1311, when the Priors asked the councils to authorize them 'to construct and complete the tower of the palace of the People', and perhaps not even by 1313.[50] Like that of the Podestà, the palace incorporated an existing family tower, the *torre della vacca* of the Foraboschi, which served as the base of its own tower; Villani gives its height as over 50 *braccia*, that is about 30 metres.[51] This was the maximum height the popular regime of 1250 had allowed for private towers.[52] The Statutes of the Podestà of 1325 contain a law, possibly going back to the time of the building of the palace, to the effect that, 'in order to restrain the arrogance (*superbia*) which used to invest towers', no family tower should henceforth exceed, under penalty of demolition, the height of that of the church of S. Stefano near the palace, which amounted precisely to 50 *braccia*.[53]

The enormous size of the palace, which by far surpassed that of all other Florentine palaces, including that of the Podestà—Leonardo Bruni called it, a century later, a 'fortress of monumental beauty'[54]—could have been conceived as an architectural manifestation of the victorious mood of the new popular regime; it could also be seen as demonstrating the supremacy of the common interest over private abuse of power, over the 'superbia que dudum in turribus

[44] Ibid., pp. 194–5, 196, nos. 61 (19 Aug. 1306), 67 (5 July 1307). [45] Trachtenberg 1988, pp. 22–4.

[46] Ibid., pp. 24–5. On the street battles in 1304, in which many houses and shops were burned down, see Villani, *Cronica*, viii. 68, 71 (ii. pp. 84–5, 89–91).

[47] See Davidsohn, *Geschichte*, iii, pp. 333–5.

[48] Trachtenberg 1988, p. 25.

[49] See below, p. 13.

[50] Provv., Prot., 3, fo. 47ᵛ; Davidsohn, *Forschungen*, iv, pp. 500–1: 'pro murando et complendo turrim pallatii populi . . . et etiam pro palcho et fenestris eiusdem pallatii faciendis.' The entry in the Protocolli of the Provvisioni lacks the dates of the month and the day on which the *provvisione* was passed in 1310, Florentine style, that is between 25 Mar. 1310 and 24 Mar. 1311. See also below, n. 80. On the construction of the tower, see Trachtenberg 1988, pp. 16–25. According to Trachtenberg, the original project, which incorporated the old Foraboschi tower in the fabric of the palace, was altered after the new great bell was completed in 1307, when it was decided to fill in the Foraboschi tower and greatly to increase its height.

[51] *Cronica*, viii. 26 (ii, p. 30): 'la torre de' priori, fondata in su una torre ch'era alta più di cinquanta braccia ch'era de' Foraboschi, e chiamavasi torre della Vacca'. In the version of the *Cronica* which its editor Giuseppe Porta dates after 1333, this passage does not appear; cf. Giovanni Villani, *Nuova Chronica*, ix. 26 (iii, pp. 45–6).

[52] Ibid., vi. 39 (i, p. 264): 'si ordinaro per più fortezza di popolo, che tutte le torri di Firenze . . . si tagliassono e tornassono alla misura di cinquanta braccia e non più, e così fu fatto'.

[53] *Statuto del Podestà*, iv. 41 (p. 338): 'Ut refrenetur superbia que dudum in turribus habebatur nec earum perdictio fiat ulterius in construendo turres . . . statuimus quod nulla persona possit in civitate Florentie . . . murare vel extollere in altum turres vel palatia . . . ultra mensuram illam que redacta est ad squadram cum turri que dicitur Sancti Stephani', which is 'alta bracchiis quinquaginta'. On the height of family towers, see Braune 1983, pp. 97–101.

[54] *Laudatio Florentinae urbis*, ed. Baron 1968, p. 237: 'arx ingenti pulcritudine'.

habebatur'. There must also have been a sense of rivalry with the Sienese, who were building their own palace of government in those years. The planning of the Sienese palace resembled closely, and was nearly contemporaneous with, that of its Florentine counterpart; but while in Siena the project to build a new palace appears to have been initiated a few years earlier, its construction was completed many years later than in Florence.[55] The first mention of such a project in a council occurs in Siena in January 1282, that is three years earlier than in Florence;[56] already at the end of the same year it was decided to appoint 'boni et sapientes homines' to choose the location of the new palace,[57] while in Florence it was not until 1294 that the councils voted on a proposal to find a place where the palace was to be built, and not until December 1298 that they ordered the Priors to choose the site for their new residence.[58] Although in Siena too, the execution of the decision to build the palace was delayed, the choice of the customs house, the Bolgano, at the foot of the Campo, in which at that time the Podestà resided, as permanent palace of the Commune, was made as early as January 1288.[59] The purchase of property adjoining the Bolgano is first recorded in December 1293, to be followed by other such purchases in 1294,[60] and these properties appear for the time being to have been used to house the retinue of the Podestà and the governing magistracy of Nine;[61] it was not until July 1297 that the General Council authorized the Nine to elect a committee of twelve *sapientes* to decide on the first stage of the building of the palace, and not until October of that year that the council voted money for it.[62] By now the Florentines, who took the decision to proceed with the building of their new palace at the end of the following year, had nearly caught up with the Sienese. Having voted to start with a much larger amount of money for the palace than the Sienese,[63] they all but completed it in the space of a few years, while in Siena the construction of the Palazzo Pubblico continued well into the twenties, that of its tower until the end of the forties of the fourteenth century.[64]

There were no doubt also practical considerations that determined the projection of the new Florentine palace on so vast a scale. These can hardly have concerned the administrative functions of the Priorate. At the end of the thirteenth century, the administrative organization of the Florentine government was still relatively simple, and certainly far removed from the complexity it had achieved by the middle of the fifteenth century. A great deal of the day-to-day administration, in particular that concerning public order, remained in the hands of the Podestà or had been recently entrusted to the Captain of the People, who had his own separate residence at the rear of the palace. For the execution of their decisions, the six Priors and the

[55] On the building of the Palazzo Pubblico in Siena, see Donati 1904, pp. 321 ff., and Cordaro 1983, pp. 33 ff. As in Florence, the governing magistracy was at that time housed in private palaces.

[56] Donati 1904, p. 322; *Palazzo Pubblico* 1983, p. 415, no. 28.

[57] Donati 1904, pp. 322–3; cf. *Palazzo Pubblico*, 1983, p. 415, no. 29: 'qui bene et diligenter debeant invenire et ordinare locum et modum et formam, quomodo et qualiter palatium pro Comuni habeatur'.

[58] See above, pp. 5, 6.

[59] Donati 1904, p. 323; *Palazzo Pubblico* 1983, p. 416, no. 44.

[60] Donati 1904, p. 324; *Palazzo Pubblico* 1983, p. 416, nos. 52, 53, 55, 58.

[61] Donati 1904, p. 326; *Palazzo Pubblico* 1983, pp. 416–17.

[62] Donati 1904, p. 327; *Palazzo Pubblico* 1983, p. 417, nos. 71, 72. The communal treasury, the Camera, was authorized to spend 2,000 *libbre* every six months, 'donec finiatur et compleatur palatium'.

[63] Up to 1,000 gold florins every two months: see above, p. 9. In 1298 and 1302, the gold florin was worth 45 *soldi* 11 *denari* and 51 *soldi* respectively in Florence, in 1302, *c*.50 *s*. in Siena: Spufford 1986, pp. 3, 50.

[64] Cordaro, in *Palazzo Pubblico* 1983, pp. 34–5, as against the generally accepted date of 1310 for the completion of the palace: see Donati 1904, p. 334 (but also p. 338). On the building of the Torre della Mangia, Donati, pp. 339–41, and Cordaro 1983, p. 35.

Gonfalonier of Justice had at their service, at the end of the thirteenth century, a notary, a chancellor for their correspondence, and six or seven messengers; for domestic duties during their two-month stay at the palace, they had by 1322 a household staff of seven, one of whom acted as bell-ringer; they were served by two religious who acted as their bursars and as custodians of the armoury of the palace.[65] Before they moved into their new palace, the councils of the People met as a rule in S. Pier Scheraggio,[66] an arrangement which, despite the proximity of the church on the other side of the Via della Ninna, was evidently not satisfactory as a permanent solution. The public palaces that were built in Italy during the thirteenth century provided halls for council meetings, and this was also the case for the first Florentine palace of the People, the Bargello.[67] We do not know the precise date from which the two principal councils of the new popular regime met in its new palace; that of One Hundred did so certainly from March 1312.[68]

Even so, a two-storey building, with the council hall on the first floor as in Northern Italian palaces, could have been considered to provide adequate space; this was the model which had been followed in the Bargello.[69] One reason for planning the new palace on so vast a scale may have been the need to protect the Signoria at a time of recurrent civic strife, when powerful sections of the community were violently opposed to the popular regime. Only two years after the Priors had moved into their new palace, it was attacked by Corso Donati and his followers among the Black Guelfs 'with crossbows and fire', but was successfully defended.[70] For one thing, the palace was designed to be able to accommodate, by day as well as by night, the Priorate's armed guard, which by 1322 numbered sixty men,[71] whose weapons must have been stored in the large hall on the ground floor. Like the corresponding hall in the palace of the Podestà, the Camera dell'Arme[72] served as the armoury from which the Gonfalonier of Justice would have been expected to provide, 'in the case of upheavals', the militia with weapons, including twenty-five crossbows (*balistae*).[73]

[65] Camera del Comune, Appendice, Scritture diverse, no. 1, Inventario 514 (*Provvisioni canonizzate* of 1289), fo. 7ʳ⁻ᵛ: like the Podestà and Captain of the People, the Priors have six *nuntii*. Some time after the magistracy of the Gonfalonier of Justice was created in 1293, when their number at first remained unchanged (Ordinances of Justice of 1293, ed. Salvemini 1899, p. 391), a seventh messenger was added to serve him: he had one such messenger in 1322 (*Statuto del Capitano del Popolo*, ii. 3; pp. 82–3). In 1289, the Priors had a cook, a page, and an unspecified number of *servitores*; by 1322, two pages, a cook, and four *servientes*, one of whom also acted as *campanarius*. On the notary and *scriba*, cf. Ordinances of Justice, loc. cit. See also Davidsohn, *Geschichte*, iv, p. 98; on the two religious, Trexler 1978b, i, p. 325, and below, n. 72.

[66] Gherardi, in *Consulte*, i, p. xii.

[67] See Paul 1963, pp. 112–13; Marchini, in Rodolico and Marchini 1962, p. 156; Paul 1969, p. 17. Even after the Podestà had taken up residence in the Bargello (see above, p. 7), his General and Special Councils sometimes met in churches—around 1280, in the Baptistery (Davidsohn, *Geschichte*, iv. 1, p. 61)—and at the beginning of the 14th cent., like those of the Captain of the People, in S. Pier Scheraggio. This was the case, regularly, between Jan. 1304 and Apr. 1305 (*Consigli*, i, pp. 135–201).

[68] In Feb. 1312, the council had still, as usual, been summoned by the Captain of the People to S. Pier Scheraggio: ibid., pp. 612, 614, *et passim*.

[69] Paul 1969, pp. 18 ff.

[70] Compagni, *Cronica*, iii. 3 (p. 171), Feb. 1304: 'Con balestra e con fuoco combattè il palagio de' Signori aspramente'. Cf. Villani, *Cronica*, viii. 68 (ii, p. 84). In August, it was the turn of the palace of the Podestà to be attacked: Paolino Pieri, *Cronica*, p. 81: 'recaro a la Porta del Palagio il fuoco, et isforzatamente combattero'. See Davidsohn, *Geschichte*, iii, pp. 263, 288.

[71] *Statuto del Capitano del Popolo*, ii. 3 (pp. 83–4): 'debent . . . dormire et bibere et comedere in palatio . . .'.

[72] Davidsohn, *Geschichte*, iv. 1, pp. 250–1. It was under the supervision of two lay brethren of the Cistercian abbey of Settimo.

[73] Ordinances of Justice, ed. Salvemini 1898, p. 393: he was obliged to keep 'in domo dominorum Priorum' 100 shields, 100 helmets, 100 lances, and 25 *balistae*. In July 1301, *balistae* are recorded as being kept 'in pallatio, in quo domini Priores Artium et Vexillifer pro Comuni morantur' (*provvisione* cited in the appendix to Dino Compagni's *Cronica*, p. 278), that were to be got ready for use, presumably in preparation for attacks by the Black Guelfs (cf. Davidsohn, *Geschichte*, iii, pp. 418–19). Although the palace referred to in this document was probably a private house in which the Priors resided before moving to their own new palace, it confirms the latter's role in providing, like the palace of the Podestà, one of the armouries of the republic.

FORTIFICATION

The military functions which the palace was designed to fulfil found their architectural expression in its external structure. In contrast to the open porticoes of civic palaces north of the Apennines, such as those in Bologna, Cremona, and Padua,[74] the Palazzo Vecchio, like other communal palaces of Tuscan towns in the thirteenth century, presents, with its closed ground storey, a façade whose predominant feature is distinctly defensive.[75] In this it was modelled on its predecessor, the palace which now belonged to the Podestà and which in its turn had included elements of urban tower architecture. Like the Bargello, the Palazzo Vecchio incorporated a family tower, had its small windows on the ground storey high above street level, and had similarly narrow entrance doors. Its projecting gallery (*ballatoio*), on the other hand, with its windows and battlements adds a defensive feature that is lacking in the Bargello, but which can be found in family towers.[76] Vasari, when explaining medieval building techniques by which Florentine citizens tried to make their houses safe from attack, describes the wooden *ballatoi* 'from which they judged themselves to be able to defend the principal entrances to the towers' during riots.[77] As late as 1527, the *ballatoio* of the palace of the Signoria served precisely the purpose of defending it against an assault from the piazza.[78] The immense tower of the palace, which Dati called a *rocca*, a fortress,[79] soaring high above the battlements, could also serve to keep watch over the Arno valley and to warn of approaching enemy troops, as it no doubt did during the siege of the city by Henry VII in 1312. Indeed, it may well owe its final completion, as may the construction of its monumental belfry, surrounded in its turn by a gallery, to defensive measures taken by the Florentines after Henry's arrival in Italy two years earlier.[80] At the same time, nothing could have symbolized more impressively the power and the supreme authority of the new popular regime over the great Florentine families than the tower of its palace, whose height was three times the maximum allowed to family towers.[81]

The rustication of the Palazzo Vecchio, which covers the entire façade up to the gallery, has been explained as having been influenced by Frederick II's castles in Southern Italy,[82] as an attempt to imitate the external walls of ancient Roman buildings, such as that of the Forum of

[74] Paul 1963, pp. 53 ff.; Marchini, in Rodolico and Marchini 1962, pp. 22–3.

[75] See Marchini, in Rodolico and Marchini 1962, pp. 23, 29, 32.

[76] See Braune 1983, pp. 115–17.

[77] *Ragionamenti*, in Vasari–Milanesi, viii, p. 13: 'da' quali eglino giudicavano poter difendere l'entrate principali delle torre . . . li quali luoghi, per virtù di queste difese, si difendevano ogni dì dalle scorrerie de' populi della città . . .'.

[78] Nardi, *Istorie di Firenze*, ii, pp. 123–4, on the defence of the Palace during the anti-Medicean rising of 26 Apr. 1527: there were 'pietre grosse assettate e murate a secco d'intorno a' ballatoi in forma di muricciuoli', with which 'si sfondarono e' coperchi de' piombatoi, e cadendo sopra la porta con tanta rovina, fecero discostare i nimici da quella . . .'.

[79] *Istoria di Firenze*, p. 108: 'e sopra il ballatoio di beccatelli e merli è una rocca alta sopra il Palazzo altre braccia sessanta.'

[80] Trachtenberg 1988, p. 25, suggests that the siege 'was probably a major factor behind the final design of the tower superstructure as it evolved' in the years 1310–13. In fact, the decision to complete the construction of the tower, which was taken between 25 Mar. 1310 and 24 Mar. 1311 (see above, n. 50), was probably related to another decision, of November 1310, to strengthen the defences of the city walls (Villani, *Cronica*, ix. 10; ii, p. 152; cf. Davidsohn, *Forschungen*, iv, pp. 449–50). At the beginning of 1311, it was rumoured in Florence that Henry VII, who had entered Milan in December 1310, was planning a campaign against the Guelf cities of Tuscany: Davidsohn, *Geschichte*, iii, pp. 121–2; Bowsky 1960, pp. 79–82.

[81] See Trachtenberg 1988, p. 33 n. 63, who gives the height of the tower up to but excluding the spire as 87m., that is *c.*150 *braccia*. The maximum height permitted for family towers was 50 *braccia*: see above, nn. 52 and 53.

[82] Paul 1969, pp. 84 ff.

Augustus, which was believed to have formed part of the palace of Nerva,[83] and as an example of Tuscan building techniques of the second half of the thirteenth century, designed to make civic and private palaces into symbols of pride and power.[84] But while the flattened blocks used in family towers or tower houses appear to have been smoother than the craggy and projecting ones of the Palazzo Vecchio,[85] both the surviving pillar of the loggia of the Cerchi palace, at the corner of the Via dei Cerchi and Via dei Cimatori, which existed before 1298, and their new palace built probably before 1292, have rustication.[86] If this was the house in which the Priors had been living before moving into their permanent residence, the rustication of their palace could have been influenced by that of the Cerchi palace.[87] That the rustication had defensive functions is unlikely,[88] but it may have been intended to demonstrate the solidity of the wall to which it was applied.[89] The intricate fashion by which the rough-hewn blocks are distributed over the façade, and the evident care taken in the working of the single stones,[90] may have been primarily due to this intention; but unlike the rustication of private buildings, which until the fifteenth century was confined to the ground floor,[91] its extension over the entire façade must have added to the impression of power and impregnability to be conveyed by the palace. About a century after its completion, Goro Dati highlights its two dominant features, as they must have struck contemporaries: 'it is built entirely of stone, of marvellous strength and beauty'.[92]

The closed exterior of the fortified palace may appear to contradict its role as 'palatium populi'; instead of opening out to the citizens, its defensive architecture gives it an inward-looking appearance. Forbidden to leave the palace except on rare official occasions,[93] the Signoria were, during the two months of their residence in it, living in a world of their own, communicating, in the public sphere of their palace, with larger or smaller groups of citizens, but detached from the mass of the people they ultimately represented, and on whom they would look down from the windows or from the gallery. The construction of a platform for them in front of the palace, from which they could address, or at least appear before, the people, *Fig. 4* was designed to go some way towards remedying this situation. Like the Podestà and the Captain of the People, the Signoria had to swear, in a public ceremony on taking up office, to administer it according to the statutes. In the case of the Podestà and the Captain, this ceremony took place in the Cathedral, which also served for meetings of popular assemblies, *parlamenti*; in that of the Signoria, it took place, at first, in the church of S. Pier Scheraggio.[94] But just as that church ceased to be, after the completion of the new palace, the meeting place of the councils of the People,[95] so the Signoria's inauguration ceremony too was moved to the

[83] See Ackerman 1983, p. 31; Sinding-Larsen 1975, p. 192; Tönnesmann 1984, p. 64, on the medieval and Renaissance identifications of the ruins of the Forum of Augustus with the 'palatium Nervae'; Esch 1984, pp. 314–16.

[84] Ackerman 1983, p. 29.

[85] Sinding-Larsen 1975, pp. 167–8.

[86] Ibid., pp. 171–2: its 'rustication . . . does . . . suggest an affinity to the rustication of the main block of the Palazzo Vecchio'.

[87] Preyer 1985, p. 617. See above, p. 6.

[88] E. Roth 1917, p. 9; Piper 1912, pp. 144–5; but see Braune 1983, p. 112 ('ein fortifikatorisches Mittel').

[89] Sinding-Larsen 1975, p. 171.

[90] Ibid.

[91] Ibid., p. 192.

[92] *Istoria di Firenze*, p. 108: 'è tutto di pietre di maravigliosa fortezza e bellezza.' Paul 1969, p. 69, wrongly relates 'di maravigliosa fortezza e bellezza' to 'pietre' rather than to the palace itself.

[93] See *Statuto del Capitano del Popolo*, ii. 3 (p. 86).

[94] Davidsohn, *Geschichte*, iv. 1, pp. 57–8, 84, 96. Cf., e.g., for *parlamenti*, *Consulte*, i, pp. 169, 256, 277–8, ii, p. 512 (1285–95); for the oaths of the Podestà and the Capitano del Popolo, ibid., i, pp. 343, 408–9, ii, pp. 89, 216–17, 331, 362, 377, 405 (1285–94), *Consigli*, i, pp. 33, 60, 91 (1301–3); for that of the Signoria, ibid., pp. 58 (15 June 1302), 82 (15 Feb. 1303: in S. Pier Scheraggio, 'more solito'), 91 (15 Apr. 1503).

[95] See above, p. 12.

palace, to be enacted in front of it[96]—as were the *parlamenti*, on the rare occasions on which they were now summoned.[97] In order to make it possible for the Signoria to appear before the people in conditions which guaranteed a modicum of safety, a platform was built in 1323, alongside the façade of the palace between its two doors on the piazza.[98] The construction of the *ringhiera* can be seen as reflecting the change of the political climate in the city since the turn of the century, when civil strife and the threats of attack by the Magnates on the new constitutional order had formed the background to the building of the fortified palace. In the 1320s, the main threat to the city's security came from abroad, from the Signore of Lucca, Castruccio Castracani, who was expanding his dominion in Tuscany to the gates of Florence; and the Florentines were in those years pressing on with the construction of the third circle of the city's walls.[99] And yet, only three months after the councils had voted funds for the building of the *ringhiera*, Florentine exiles attempted to enter the city with help from inside, and a conspiracy was discovered to abolish the Priorate and the Ordinances of Justice, 'and to subvert the peaceful state of the city'.[100] The conspiracy failed, but less than twenty years later the palace demonstrated its military potential, though in a manner unforeseen by its founders.

Half-way through the fourteenth century, that potential was dramatically borne out by Walter of Brienne's decision, after he had become Signore of Florence in 1342, to make the palace his residence.[101] His predecessor in the lordship of Florence, Charles duke of Calabria, had, after his election as lord and protector of the city for ten years in December 1325, taken up residence in the Bargello;[102] the duke of Athens, who was granted despotic powers for life, followed the example of other Italian despots in taking over the palace of government; the Priors, deprived of their constitutional authority, were moved to an adjoining palace.[103] In order to enhance the defensive functions of his palace, the Duke enlarged the piazza in front of its western façade;[104] so as to provide additional accommodation for his armed retinue and his household, he planned to construct a new building on its east side, to be connected with it by a fortified enclosure.[105] By the time of his expulsion ten months later, the only substantial addition to the fortification of the palace itself was the installation of bulwarks (*antiporte*) in front of its two doors to the piazza, and of iron bars at the windows of the council hall on the

Fig. 5

[96] The inauguration ceremony of the Signoria is described in *Statuta* 1415, v. i. 10 (ii, pp. 501–4).

[97] As on 8 Sept. 1342, when the duke of Athens was created Signore of Florence: Villani, *Cronica*, xii. 3 (iv, pp. 9–10); see below.

[98] Provv., 20, fo. 2ᵛ–ᵛ (27–8 May 1323; Davidsohn, *Forschungen*, iv, p. 501): the councils authorize payments by the bursar of the Camera dell'Arme of up to 100 florins 'pro fatiendo . . . quandam statuam seu ymaginem in sua figura' of Pope John XXII for the façade of the cathedral 'et unam nobilem, pulcram et decentem arengheriam in muris seu iuxta muros palatii populi, in eo loco seu parte ubi videbitur offitio dominorum Priorum et Vexilliferi Iustitie'.

[99] Villani, *Cronica*, ix. 137, 256–7 (ii, pp. 235–6, 300–4); see Davidsohn, *Forschungen*, iv, pp. 451–2.

[100] Villani, *Cronica*, ix. 219 (ii, pp. 282–3); Davidsohn, *Geschichte*, iii, pp. 696–8.

[101] On the Signoria of the duke of Athens, see Paoli 1862. He was elected by a popular assembly on 8 and by the councils on 10 and 11 Sept. 1342.

[102] See Degli Azzi 1908. He had been elected, on 25 Dec. 1325, as

'dominus gubernator, defensor et protector' of Florence and its territory: ibid., pp. 274–5. Villani, *Cronica*, x. 1 (iii, p. 6): 'albergò nel palagio del comune di costà alla Badia, ove solea stare la podestà'. According to Davidsohn, *Forschungen*, iv, p. 505, this passage concerns an alleged new palace of the Podestà, but Villani clearly refers to the Bargello as the residence of Charles of Calabria.

[103] Villani, *Cronica*, xii. 3, 8 (iv, pp. 10, 16). Cf. Paoli 1862, p. 103.

[104] See below, p. 82.

[105] Balie, 2, fos. 72ʳ–74ᵛ; Frey 1885, pp. 205–6, no. 97 (10 Jan. 1343): 'volens pro honorificentia atque magnificentia civitatis . . . et suo suorumque schutiferorum et familie habitaculo novum hedificium construere iuxta eius ducale palatium, aut ipsi palatio novum addere casamentum'; see Lensi, pp. 26–7. Cf. Villani, *Cronica*, xii. 8 (iv, p. 17): 'fece comprendere tutto il circuito dal detto palagio a quegli che furono de' Figliuoli Petri, e le torri e case de' Manieri, e de' Mancini, e del Bello Alberti, comprendendo tutto l'antico gardingo'. For attempts to reconstruct the circuit of the planned extension, see Frey 1885, pp. 89–91, and map in Lensi Orlandi.

first floor.[106] Giovanni Villani, who was an eyewitness of these events, reports that the Duke had been planning a complex of buildings surrounded by 'thick walls and towers and barbicans, so as to create, together with the palace, a large and strong castle', 'per fare col palagio uno grande e forte castello'.[107] The Duke must have considered the palace block itself adequately fortified to be included in this 'castle', or rather enclosure, without major structural alterations.

The beginning and end of his despotic rule demonstrated, at the same time, that there were limits to the effectiveness of that fortification. When he decided, in September 1342, to seize power after having been acclaimed as lord by the populace, the captain of the Signoria's bodyguard allowed him to enter the palace, although, as Villani writes, 'it would have been easy to defend it';[108] and when, on 26 July 1343, the Florentines rose against the Duke, he was forced to capitulate after having been besieged in it for over a week.[109] Soon afterwards, the doors of the palace were restored to their original form and the *ringhiera* rebuilt.[110] The two walls which the Duke had built to the east of the palace[111] remained standing and were to serve, a century and a half later, as the foundations for extensions of its medieval block. Extensions along these lines may have been planned already in 1371, when the councils voted funds for additions to be made to the palace.[112] In the meantime, the walls provided enclosures for a second courtyard, between the palace of the Signoria and that of the Captain of the People on the Via della Ninna.[113]

In 1378, after a period during which the building of an open loggia for the Signoria facing their palace bore witness to their sense of security,[114] the Ciompi revolt suddenly revived its

[106] Villani, loc. cit.: 'fece fare l'antiporte dinanzi al palagio del popolo, e ferrare le finestre della sala di sotto ove si facea il consiglio'; cf. Vasari–Milanesi, i, p. 491: 'per fortificarsi nel palazzo, [facendogli] ferrare tutte le finestre da basso del primo piano, dov'è oggi la sala de' Dugento, con ferri quadri e gagliardi molto'. The two *antiporte* are represented in the fresco of the expulsion of the duke of Athens, originally in the city's prison, the Stinche, and now in the Palazzo Vecchio. Edgerton 1985, p. 83, attributes the fresco tentatively to Taddeo Gaddi; Kreytenberg 1991, pp. 159–64, preceded by Padoan Rizzi and Boskovits (ibid., nn. 26, 27) to Orcagna, 'in direkter Reaktion auf das Ereignis der Vertreibung des Tyrannen . . . 1343/44'.

[107] Loc. cit. above, n. 105.

[108] *Cronica*, xii. 3 (iv, p. 10). [109] Ibid., xii. 17 (iv, pp. 35–6).

[110] Provv., 37, fo. 47ᵛ (27–8 Nov. 1349): the Camera dell'Arme was to receive from the Camera del Comune 200 florins for past and future expenses 'pro constructione arrengherie, que fit iusta palatium populi florentini, et reactationem [*sic*] ianue ipsius palatii'. In 1346, money was allocated for constructing and repairing, 'pro faciendo construi et hedificari et reparari', 'scaleas que fiunt [*Lensi*: fuerint] penes portam palatii populi versus Vachareciam' (Provv., 34, fo. 41ʳ, 21–2 Apr. 1346; Lensi, p. 34, Gaye, i, p. 497), that is the steps next to the principal door. These steps must have been demolished when its *antiporta* was erected. In 1351, it was decided to repair the north door to the Camera dell'Arme (Provv., 38, fo. 229ʳ⁻ᵛ, Gaye, i, p. 502, Frey 1885, pp. 209–10, 10–11 June 1351; see below, n. 122); in the following year, additional funds were granted 'circa reparationem et ornamentum ianue septentrionalis' (Provv., 40, fo. 6ʳ, 12–13 Oct. 1352). See also below, n. 134.

[111] See Sinding-Larsen 1975, pp. 175–8, on the north wall, which later connected, on the ground-floor level, the palace block with the customs house and the Sala dei Cinquecento above it (see below, pp.

40–1). The south wall, in its turn, rose to the level of the mezzanine, as can be seen by comparing the rustication of the façade on the Via della Ninna below the level of that storey with that above it (see Fig. 15). A partly winding staircase was built into the thickness of this wall: cf. Vasari–Milanesi, loc. cit. above, n. 106: 'Aggiunse ancora il detto duca, dirimpetto a San Piero Scheraggio, le mura a bozzi che sono accanto al palazzo, per accrescerlo; e nella grossezza del muro fece una scala segreta per salire e scendere occultamente.' Vasari attributed the design to Andrea Pisano. See also Lensi Orlandi, pp. 41–2. The staircase still exists, but has recently been walled up. See also below, n. 134.

[112] On this project, see Spilner 1993. The *provvisione* of 12–13 Sept. 1371 (Provv., 59, fo. 104ʳ⁻ᵛ; ed. ibid., p. 465) allocated 1,000 florins and further, recurrent revenue 'ad opus addimenti fiendi palatio' of the Signoria 'et acconciamenti palatii supradicti', and decreed that officials were to be elected 'ad ordinandum illud addimentum et illud melioramentum et acconciamentum'. They were elected on 17 Sept. (Sig., Delib., ord. aut., 18, fo. 12ʳ); see also below, App. X. On the additions to the palace in 1508 and 1511, see below, p. 45.

[113] The courtyard came to be called 'Cortile del Capitano'; cf. Stefani, *Cronaca fiorentina*, p. 357 (1379): the Captain 'facea leggere la condannagione . . . in sullo piano della scala del suo cortile'; Francesco Giovanni, *Ricordanze* (see App. I and below, p. 38) on the assassination of Baldaccio d'Anghiari in the palace of the Signoria: 'lo gittorno nella corte del Capitano'. In 1356, the *camerario* of the Camera dell'Arme was authorized to spend 200 florins 'in reparatione et fortificatione palatii'. According to the note in the margin of the *provvisione*, this payment was 'pro reattando columpnas palatii dominorum' (Provv., 43, fo. 6ᵛ, 15–18 July 1356), but this probably refers to the columns of the principal courtyard.

[114] See Lensi Orlandi, pp. 52–6, and below, pp. 86–7.

military function.[115] The revolt also showed, once more, that for the palace to fulfil that function, the Signoria had to have the will to resist external pressure. This was not the case on 21 July 1378, when it capitulated to the demands of the Ciompi and left the palace, although 'it was well provided with everything that was needed'; whereupon 'all the people entered it' and proclaimed Michele di Lando as the new Gonfalonier of Justice.[116] At the end of the following month, the *popolo minuto* was defeated on the piazza by the joint action of the other guilds.[117] Although on this occasion there was no direct threat to the palace, the events of 1378 must have been one of the reasons why two years later the Signoria decided to have the northern door walled up:[118] it was against this door, which led into the Camera dell'Arme, that the Ciompi had pressed on 21 July 1378.[119]

The restoration, after the expulsion of the duke of Athens, of the doors and of the *ringhiera* provided the opportunity to add ornamental features to the façade of the palace. Although these did not significantly detract from the severe monumentality of its external appearance, they reflected, despite their modesty, a measure of change from the impression of unrelieved austerity the façade must have conveyed during the first decades of its existence. A panel was placed above the west portal, consisting of a pediment flanked by two lower niches, with lions on brackets on either side of it and at its base the cross of the People between Florentine lilies.[120] In 1352 or shortly before, the north door to the Camera dell'Arme had similarly placed above it a panel which was surmounted by a broken pediment, and flanked by two niches containing sculpted lions.[121] This panel was installed on the request of the Sixteen Gonfaloniers of the militia companies: the palace, they argued, would appear more 'beautiful and decorous', 'ornatum et decorum', if that door were adorned, 'ornata', in the same way as the west portal.[122] It was probably when, in 1349, the *ringhiera* was restored, that the sculpture of the Florentine lion, the *Marzocco*, was set up at its northern end;[123] about four years later, small gilded sculptures of lions were placed in niches at the four corners of the gallery.[124] It must have been about the same time that armorial bearings used by the republic, including the Florentine lily,

[115] On the Ciompi revolt, see Rodolico 1945 and Brucker 1968. See also below, pp. 89–90.

[116] *Cronaca prima d'anonimo*, in *Tumulto dei Ciompi*, p. 75: 'Il palagio era ben fornito di ciò che bisognava; ma e', com' uomini paurosi, sì ne usciro fuori . . . Allora entrò suso tutto il popolo . . .'.

[117] Ibid., pp. 81–2.

[118] *Diario d'anonimo fiorentino*, p. 410: 'Oggi, a' dì primo d'aprile 1380, i nostri Signori feciono rimurare la Porta del Palagio dentro quella porta ch'è dirimpetto alla Condotta, per bene dello stato di Firenze.' On the following day, all the shops were closed owing to the fear of 'romore nella città'. The palace of the Condotta was situated on the north-east side of the piazza.

[119] Stefani, *Cronaca fiorentina*, p. 333: 'e' posersi in sulla porta del palagio, di verso la Condotta'.

[120] Cf. the following note. In 1345, up to 175 florins were allocated to the Camera dell'Arme for various building works in the palace (Capitoli, 18 [formerly Provv., 214], pt. 2, fo. 68ʳ (11 Aug. 1345)), among it 'pro faciendo certa laboreria supra portam cortilis', which probably relates to this pediment. See Lensi, p. 34; Lensi Orlandi, pp. 48–9.

[121] See above, n. 110, and Lensi Orlandi, p. 49. The lions were still in their niches in the 18th cent. (ibid.); they may have been removed, together with those at the corners of the *ballatoio*, under Grand-

Duke Ferdinand III at the end of that century: see below, n. 124.

[122] Provv., 38, fo. 229ʳ⁻ᵛ (10–11 June 1351), see above, n. 110: 'dictum palatium magis ornatum et decorum appareret, si porta palatii . . . versus palatium more officialium merchantie civitatis Florentie ornaretur et construeretur eo modo et forma prout ornata et constructa est ad presens porta dicti palatii versus viam Vacareccie.'

[123] In 1377, at the time of the war between Florence and Gregory XI (see Battaglia Ricci 1990, pp. 35–6), Franco Sacchetti wrote the following inscription for its crown (*Rime*, no. 193, p. 278): 'Corona porto per la patria degna, | a ciò che libertà ciascun mantegna'. The crown was placed on its head every two months for the inauguration of the Signoria: *Statuta* 1415, v. i. 10 (ii, p. 501): 'apposita corona in capite leonis, ibi in angulo a parte plateae existentis'. Donatello's *Marzocco*, which had been commissioned for the papal apartments at S. Maria Novella, was set up, at the beginning of the 19th cent., on the new platform in front of the palace, where it remained until 1885. It was replaced with a bronze copy and subsequently with a pietra serena copy (see Lensi Orlandi, p. 238).

[124] Matteo Villani, *Cronica*, iii. 72 (v, p. 262): around 1353, the Signoria 'feciono fare quattro leoni di macigno, e fecionli dorare con gran costo, e fecionli porre in su' quattro canti del palagio del popolo di Firenze'. These sculptures were removed under Ferdinand III: Lensi Orlandi, pp. 203–6. See above, n. 121.

the cross of the People, and the arms of Charles and Robert of Anjou, were painted underneath the projection of the gallery, and those of the four *quartieri* and the sixteen *gonfaloni* of the city under that of the tower.[125] There were, at that time, citizens who found these embellishments excessive: Matteo Villani comments that the decision to have carved lions placed at the corners of the palace, and to have them gilded at great cost, was taken by a Signoria who had nothing better to do, 'avendo poco ad attendere ad altre cose'.[126]

INTERNAL DISPOSITION

From the time of its completion, at the beginning of the fourteenth century, the internal disposition of the palace must have reflected the various functions it was designed to fulfil. Like other communal palaces in Northern Italy, and like the palace of the Podestà, the Bargello, it had on each of its floors, one above the other, a large hall.[127] The vaulted hall on the ground floor housed part of the arsenal of the republic, and must thus have impressed the visitor who entered the palace through the northern door and the Camera dell'Arme with the military potential of the palace of the Signoria. From about 1312 the hall on the first floor served for meetings of the councils of the People—later also of that of the Commune; the hall on the second floor, for meetings summoned by the Signoria.[128] Another hall, on the attic floor, was probably even then used by the household staff, whom we later find inhabiting this floor.[129]

Fig. 6

The Priors and the Gonfalonier of Justice had their sleeping quarters on the second floor, the Priors in a hall facing the Via della Ninna, which at first appears to have served as a communal dormitory but was later partitioned, while the Gonfalonier had a separate room from an early date.[130] The Notary of the Signoria and their chancellor must have had their rooms on the same floor, as they did later.[131] Apart from the council hall, which occupied its entire west wing, it is not possible to discover to what use the rooms on the first floor were put at this stage, and the same applies to those of the mezzanine between the first and second floor. The mezzanine must have formed part of the original structure of the palace; it certainly existed by the time of the Duke of Athens' expulsion in 1343.[132] The attic floor, where the kitchen was located, would, as it did later, have provided ample space for the living quarters of the household. According to Marvin Trachtenberg's reconstruction of the fourteenth-century courtyard,[133] balconies with doorways ran along all its sides on the first, mezzanine, and second floor, which would have facilitated circulation within the palace.

[125] In Nov. 1353, the councils granted up to 110 florins 'pro ornamento et rebus opportunis pro ornamento palatii populi florentini, pro picturis que ad presens fiunt in dicto palatio a parte orientali' (Provv., 40, fo. 175ʳ⁻ᵛ, 20–1 Nov. 1353), and in June 1354, 60 florins 'pro faciendo compleri picturas inceptas circa summitatem palatii' (Provv., 44, fol. 28ᵛ–29ʳ; Gaye, i, p. 507, 5–6 June 1354). Some of these armorial paintings still existed in 1792, when they were restored and others added to them: see Mignani 1982, pp. 172, 192–3. See also Rastrelli 1792, pp. 75–6, and Lensi, p. 35.

[126] Loc. cit. above, n. 124. [127] Paul 1969, pp. 17–21.

[128] See below, p. 20. See also App. III.

[129] See below, p. 38. [130] See App. I.

[131] See below, pp. 38, 44.

[132] Its windows facing the piazza are shown in the mid-century fresco of the expulsion of the duke of Athens: see above, n. 106. Lensi, p. 58, following Vasari-Milanesi, ii, p. 436, wrongly assumed that the mezzanine was constructed by Michelozzo; Lensi Orlandi, p. 22, considers it part of the original construction. See now Trachtenberg 1989, pp. 573–4, who however interprets Vasari's account as not referring to the mezzanine; and below, p. 30 and n. 220.

[133] Trachtenberg 1989, pp. 575–83. Plausible as his reconstruction is on architectural grounds, it is not confirmed by documentary or literary evidence. There is also no known record of when such a balcony system was demolished.

The three main floors of the palace thus represented, from the time of its construction, the three principal elements—executive, legislative, and military—of the republican constitution, with the executive occupying, as in the republic itself, the supreme position. Throughout the history of the republic, the second floor remained the exclusive sphere of the Signoria, strictly distinct from the other, more public, ground and first floors; a distinction which was underlined by its being accessible only by internal stairs from the first floor, which in its turn was reached by stairs ascending from the north-west corner of the *cortile*.[134]

If the accommodation provided by the new palace must, at the time of its completion, have far exceeded the requirements of the Signoria, the changes in the executive and administrative structure of the Florentine government which took place in the course of the fourteenth century increasingly filled up the available space.

During the first decades of the century the position of the Signoria within the executive branch of government underwent changes that were bound to affect the use made of the palace. While the constitutional powers of the Signoria, although theoretically vast, were subject to a wide range of statutory limitations,[135] it could be granted extraordinary powers (*balìa*) for specific purposes, particularly in the field of military policy.[136] At the same time, such temporary additions to their constitutional authority were to some extent offset by the increasing importance of committees in decision-making. Soon after the Priors and the Gonfalonier of Justice moved into their new palace, we find them deliberating jointly with twelve citizens, two for each of the six districts into which the city was divided until 1343, or being granted jointly *balìa* with them; in 1321, the participation in government of such 'savi cittadini' was institutionalized by the creation of the magistracy of the Twelve Buonuomini,[137] without whose 'advice and deliberations the Priors should not take any important decisions, nor assume extraordinary powers'.[138] The Twelve Buonuomini were soon to be joined by the Nineteen (from 1343 Sixteen) Gonfaloniers of the militia companies, a magistracy definitely established in 1306;[139] from 1366 onwards, legislative bills required their assent, as well as that of the Twelve, before being presented by the Signoria to the councils.[140] While these two magistracies thus developed into statutory collegial institutions—they came, in fact, to be called the Colleges—the Signoria frequently made use of consultative committees, *consulte* or *pratiche*, which were summoned by the Gonfalonier of Justice to advise on important business such as

[134] On the 14th-cent. stairs of the palace, see below, pp. 36, 37; they were destroyed when Vasari created the new system of stairs. A fragment of the internal stairs which ascended from the mezzanine and a newel post headed by a *Marzocco* came to light during the restoration campaign in the palace between 1908 and 1929 (see Lensi Orlandi, pp. 240 ff.). There were also, probably from the time of the foundation of the palace, spiral stairs built in the thickness of the west wall, which rose from the ground level to the first floor and which are now walled up (Fig. 19). I owe this information to Ugo Muccini. Another, partly spiral, staircase rising from the ground level to that of the mezzanine still exists in the thickness of the wall which the duke of Athens had built on the side of the Via della Ninna as part of his projected enclosure (see above, n. 111): cf. Vasari–Milanesi, i, p. 491, who, probably correctly, ascribes its construction to the Duke: 'nella grossezza del muro fece una scala segreta per salire e scendere occultamente.' According to Lensi, p. 34, and Lensi Orlandi, p. 48, the location of the stairs in the courtyard is documented by a *provvisione* of 1346 which assigns funds 'pro faciendo construi et

hedificari et reparari scaleas que fiunt penes portam palatii populi versus Vacharecciam . . .' (see above, n. 110). But *scaleas* must here refer to the steps in front of the principal door of the palace, which must have been partly demolished three years earlier, when the duke of Athens had that door fortified (see above p. 15).

[135] Cf. *Statuto del Capitano del Popolo*, ii. 3 (pp. 78–88).

[136] Davidsohn, *Geschichte*, iv. 1, pp. 70, 102–3; Pampaloni 1953, pp. 267–9. On the authority (*balìa*) granted to the Signoria between 1310 and 1326 to appoint their successors, see Najemy 1982, pp. 79 ff.

[137] Davidsohn, *Geschichte*, iv. 1, p. 103; Guidi 1981, ii, pp. 55–8.

[138] Villani, *Cronica*, ix. 128 (ii, p. 230): 'che sanza loro consiglio e diliberazione, i priori non potessono fare niuna grave diliberazione, né prendere balìa'. The law establishing the Twelve in fact forbade the Signoria to ask the councils for grants of *balìa* without the consent of that magistracy: Najemy 1982, p. 89.

[139] Davidsohn, *Geschichte*, iii, pp. 333–5; iv. 1, pp. 165–6.

[140] See Marzi 1910, pp. 573–7.

legislation and foreign policy; they were composed of office-holders representing their magistracies and of private citizens.[141]

The gradual introduction of collegial institutions into the Florentine system of government, as well as the increasingly regular use by the Signoria of advisory committees,[142] necessitated the provision of space for their meetings. It was obviously essential for the Signoria to be able to conduct its business separately from meetings in which other citizens also participated in either a mandatory or advisory capacity; at the same time, it was equally desirable that such meetings should take place in the vicinity of its audience chamber. The Saletta on the second floor could accommodate small meetings; for larger ones, there was, certainly by the late fourteenth century, a large room adjoining the audience chamber, the present Sala dei Gigli.[143]

As for the councils, the two of the Podestà and the two of the Captain of the People were reduced to two altogether after the death in 1328 of the duke of Calabria, who had ruled the city during the preceding years.[144] At first, the council of the People[145] met in the palace of the Signoria in the large hall on the first floor,[146] that of the Commune in the palace of the Podestà, as its predecessors had done; but after part of the Bargello, including the roof over its council hall, had been destroyed by fire in 1332,[147] the council of the Commune too assembled in the council hall of the palace of the Signoria.[148] After 1328, that hall also fulfilled a new function as a result of the reform of the electoral system which took place in that year. The council hall was now used by electoral commissions in their periodical 'scrutinies' for eligibility to office, as well as for the sortition (*tratta*), that is for the extraction from the pouches of names of citizens who had thus been declared eligible for the 'three highest offices', the Signoria, the Gonfaloniers of companies, and the Twelve Buonuomini. Since this procedure took place every two, three, and four months respectively, it constituted a not insignificant function of the council hall;[149] the *tratta* of the other offices that were filled by way of sortition took place in the audience chamber of the Signoria.[150]

The constitutional reforms adopted after the short-lived rule of the duke of Athens in their turn affected the palace. As a result of the division of the city into four districts, the old *sestieri*

[141] See Pampaloni 1953, pp. 290–3; Guidi 1981, i, pp. 89–91.

[142] See Brucker 1977, pp. 281–90.

[143] See App. III.

[144] Davidsohn, *Geschichte*, iii, p. 864; iv. 1, p. 62.

[145] Its full name was council of the Captain and the People; the full name of that of the Commune was council of the Podestà and the Commune. The shorter names were finally adopted in 1396: Guidi 1981, ii, pp. 141, 142.

[146] See *Consigli*, ii, pp. 687–8: on 12 Feb. 1315, the council of One Hundred and the two councils of the Captain of the People meet in the 'pallatium populi', on 14 Feb., those of the Podestà 'in pallatio Comunis'. The legislative procedure may be exemplified by the following entries in the Lib. Fab., 12, fos. 54ʳ–55ᵛ (26–7 Apr. 1322): a bill was first presented to the council of One Hundred, then, consecutively, to the Special and to the General council of the Captain of the People, in the 'palatium populi', i.e. the Palazzo Vecchio, and finally to the General and Special councils of the Podestà in the 'palatium Comunis', i.e. the Bargello.

[147] Villani, *Cronica*, x. 182 (iii, p. 165).

[148] The council of the Commune assembled in the Palazzo Vecchio in May and July 1333 (Provv., 26, fos. 22ʳ, 33ᵛ), and whenever, in the following years, its meeting place is recorded in its registers, we find it meeting there. Cf. e.g. Provv., 27, fos. 2ᵛ, 6ʳ (1335), 51, fo. 9ʳ (1341), 32, fos. 1ʳ, 173ʳ (1342), 33–8 (1344–51), *et passim*. As a result of the fire, it was decided to vault the council hall of the palace of the Podestà. In Nov. 1345, Neri Fioravanti was paid for the roof, by which date the restoration of the hall must have been practically completed (Paatz 1931, pp. 309–12). The council of the Commune continued to meet in the Palazzo Vecchio: cf. Provv., 34, fol. 23ᵛ (1346), 168ᵛ (1347). The Statutes of 1415 establish the fine for 'quicumque ex consiliariis consilii populi, vel Communis . . . non venerit . . . ad consilium . . . in sala palatii dominorum priorum, in qua moris est consilia congregari' (*Statuta* 1415, V. i. 187; ii, p. 662).

[149] On the electoral reforms of 1328, see Najemy 1982, pp. 99 ff. Cf. *Statuta* 1415, V. i. 7 (ii, p. 486).

[150] Ibid., v. i. 8 (ii, p. 489). For the respective regulations in the statutes of 1355, see Guidi 1981, i, pp. 171–2.

being replaced with *quartieri*, the number of Priors was increased from six to eight. Additional living space had consequently to be found for the two additional Priors, and this was no doubt achieved by repartitioning their dormitory.[151] During the second half of the century, the appointment of short-term commissions endowed with special powers became established practice in matters where speed and secrecy were at a premium, and these commissions, whose members might be as few as eight but could, including the Signoria, amount to nearly seventy,[152] would meet in the palace. Even after the Ordinances of Justice, the Magnates, although excluded from government, continued to take some part in the administration of the republic;[153] they may have been assigned a separate room, the Sala dei Grandi,[154] to keep them apart from the *popolani* who frequented the palace of the People.

The increase in the size of the Signoria after 1343 also brought with it an increase in the number of their personal servants (*donzelli*); but far more important for the accommodation in the palace was the increase of their guard from sixty to a hundred, which had already taken place by 1325.[155] The Statutes of 1355, like those of 1322, still laid down that the *fanti*, who were under the command of a captain, had, like the *donzelli*, to 'sleep, drink, and eat' in the palace; by 1415, the Statutes required them merely to 'bibere et comedere' there, provided they remained 'continue' in the city; later that century, a number of the *famigli* spent the night in the palace.[156] On the day of the Pazzi conspiracy, 26 April 1478, about fifty members of the *famiglia* were present.[157] On this occasion, the guard performed its original military function to defend the Signoria and its palace.[158] Normally they were used by the Signoria for a variety of jobs, such as locking the city gates; seven of them were employed as ushers.[159] By the beginning of the fifteenth century, the *famiglia* included eighteen musicians, a herald, a clock attendant, four bell-ringers, twelve, instead of the original seven, messengers, and five, instead of two, religious.[160] By the middle of the century, it amounted to about 140 men.[161] The abolition, between 1355 and 1415, of the obligatory residence in the palace for most of its guard may have partly been due to the need to find additional accommodation for the growing number of magistracies which were to be provided with offices in the palace.

Far more far-reaching in their effect on the palace than the constitutional changes and the growth of the Signoria's household during the fourteenth century was the increasing complexity and specialization of the executive branch of the government, a development which gathered speed in the last decades of that century. Functions that had previously been the province of the Signoria or of *ad hoc* commissions were now entrusted to permanent or

[151] See App. I.

[152] Pampaloni 1953, p. 267.

[153] Guidi 1981, ii. pp. 125–9.

[154] See App. V.

[155] Statutes of the Captain of the People of 1355, ii. 2, Statuti del Comune di Firenze, 10, fo. 61ᵛ: eight *donzelli*; *Statuta* 1415, V. i. 13, (ii, p. 507): nine *donzelli*. On the *fanti*, *Statuto del Capitano*, ii. 3 (pp. 83–4: correction of 1325). On the *famiglia* in the 14th cent., see Davidsohn, *Geschichte*, iv. 1, pp. 98–9.

[156] Statutes of 1355, ii. 2 (loc. cit., fo. 62ʳ⁻ᵛ): 'dormire, bibere et comedere in Palatio populi et Communis Florentie in quo morantur Priores Artium et Vexillifer Iustitie'; *Statuta* 1415, V. i. 15 (ii, p. 515): 'bibere et comedere in palatio populi'. Sig., Delib., sp. aut., 34, 169ᵛ–171ʳ (29 Dec. 1475), amendments of the reform of the *famiglia* of 8

Nov. (fos. 163ᵛ–169ᵛ): 'I famigli [che] hanno a dormire in palagio dormino in luogho ordinato per loro . . .'. By the same amendments, the number of *donzelli* who were obliged to sleep in the palace was reduced to two.

[157] Provv., 169, fo. 28ʳ⁻ᵛ (23–7 May 1478): on that day, 'ci si trovò circa cinquanta del numero della famiglia'. See below, p. 39.

[158] Ibid.

[159] On the *famiglia* in the 15th cent., see Brucker 1983.

[160] *Statuta* 1415, V. i. 15, 41–2 (ii, pp. 511–17, 541–9).

[161] Sig., Delib., ord. aut., 91, fos. 9ᵛ–10ʳ (21 Sept. 1466). Brucker 1983, p. 4.

quasi-permanent magistracies, with the result that public offices proliferated: 'there have never been so many offices', writes Gino Capponi in 1420.[162] This development coincided with, and was partly caused by the expansion of the city's territorial state, which culminated, in 1406, in the acquisition of Pisa and its territory, to be followed, in 1411 and in 1421, by that of Cortona and Livorno.[163] The Otto di Guardia, established in 1378 and increasingly powerful as the magistracy in charge of the internal security of the republic, which after 1400 wielded extensive authority in the Florentine dominions as well,[164] had their office in the palace. So did the Dieci di Balìa, who after 1384 were elected in times of war or threat of war to take charge of the conduct of military operations and of foreign policy.[165] Another magistracy which was accommodated in the palace was that of the Monte Officials, which administered the consolidated public debt; established in 1342–7, it had become one of the corner-stones of the republic's fiscal system.[166] Thus the three magistracies which had to watch over the internal and external security of the republic and its financial solvency had their offices in the palace of the Signoria—not surprisingly, since they now formed, together with the Signoria and its two Colleges, the extended executive branch of the government. In 1429 they were joined by the newly established Conservatori delle Leggi, whose duty it was to prevent citizens from engaging in illegal political activities and to check their rights to officeholding.[167] After the acquisition, in 1421, of Livorno and of Porto Pisano, the office of the Sea Consuls was set up, with wide powers not only over shipping but also over the economy of the newly acquired territories of Pisa and Livorno, and indeed of Florence itself, and over the defences of Pisa and their ports. Shortly afterwards, this magistracy, consisting of six members, was divided into a Florentine and a Pisan branch, the former having its office in the palace.[168] These major magistracies were joined by a number of minor ones, such as the Ufficiali delle Castella; and all these magistracies would employ staff who would work with them in the palace.[169] But the most important section of the administrative staff whose work took place in the palace was the chancery; and the chancery in its turn was affected by the developments in the political and administrative structure of the republic from the late fourteenth century onwards.

The expansion of the business of the executive branch of government was reflected in the organization of the chancery. In the early fourteenth century, the Signoria had been served by two notaries, one of whom, the chancellor, was in charge of its correspondence.[170] While the Notary of the Signoria was elected for the two-month period of its office, the *cancelliere dettatore* was appointed for longer and renewable one-year terms, with the result that he not only normally served over long periods, but could effectively enjoy life-time tenure.[171] The same applied to the third notary who worked in the palace, the Notary of Legislation, who drew

[162] Gino Capponi, *Ricordi*, p. 35: 'Li ufici sono in più numero fussono mai . . .'.

[163] See Chittolini 1979, pp. 309–10, 313–18.

[164] Antonelli 1954, pp. 8–9, 11; Brucker 1977, pp. 214–16; Zorzi 1988, pp. 42 ff. [165] Pampaloni 1953, pp. 270 ff.

[166] Barbadoro 1929, ch. 9; Molho 1971, pp. 64 ff.

[167] Brucker 1977, p. 489; Guidi 1981, ii, pp. 351–2.

[168] Mallett 1959, pp. 157 ff., 1969, pp. 21 ff.

[169] A list of officials 'che stanno in detto Palazzo', which Benedetto Dei compiled in 1470, includes those of the customs administration,

who in fact at that time were accommodated in the new customs house facing the east side of the palace: *Memorie storiche*, fo. 27ʳ⁻ᵛ: '. . . stanno nel Palazzo Maggiore . . . Dieci della Balìa . . . Uffiziali del Monte . . . Otto di Guardia . . . Conservatori delle Leggi . . . Maestri di dogana . . . Consoli del Mare . . . Maestri del Sale . . . Maestri della Gabella . . . Camarlinghi di detti uffizi . . .'.

[170] See above, pp. 11–12.

[171] Thus Chello Baldovini held this office, with interruptions, between 1297 and 1334 (Marzi 1910, pp. 58, 68), Coluccio Salutati from 1375 to his death in 1406 (ibid., p. 134).

up and registered the laws that had been enacted by the councils.[172] After the introduction, in 1328, of elections by lot for the Signoria and other magistracies, the *notaio delle riformagioni* was also the keeper of electoral records; but this responsibility had become so onerous by the late fourteenth century, that in 1375 it was decided to entrust electoral business to a separate department of the chancery under a *notaio delle tratte*.[173] In 1437, the 'chancery of letters' was subdivided into two sections dealing with correspondence with foreign states and with the Florentine dominion respectively,[174] a division which was largely due to the growth of the territorial state.

The establishment of resident or quasi-resident embassies in the course of the fifteenth century contributed to the growth and diversification of diplomatic activities, and hence increased the work of the members of the chancery who dealt with the correspondence of the Signoria and, in times of war, with that of the Dieci di Balìa. The secretarial assistance required by the Otto di Guardia must in its turn have been greatly increased as a result of the far-reaching additional responsibilities this office assumed as the result of the expansion of the republic's territory.[175] Other magistracies which operated from the palace, such as the Ufficiali del Monte and the Notary of the Tratte, also required secretarial help. The growing volume of secretarial business transacted in the palace led to the appointment of additional assistance to various members of the chancery. Thus while, at the time of Salutati, the chancellor of the Signoria had, like the Notary of Legislation, one assistant (*coadiutor*) only, when in 1453 the two new departments of the chancery of letters were temporarily reunited, its head had no fewer than four assistants.[176] After the reform of the chancery in 1483, its total personnel under the First Chancellor amounted to ten; in 1487, its size was increased to at least sixteen.[177]

The chancery reform of 1483 had as its main object the rationalization of the business of the various departments of the chancery by combining them in one large department, under the direction of the First Chancellor. Bartolomeo Scala belonged to the inner circle of the Medici regime, and it was hardly a coincidence that his reform had been preceded by a far-reaching reorganization of its institutional structure. The creation, in April 1480, of the council of Seventy as the supreme council of the regime and of the republic, with its two committees for foreign and financial affairs respectively, was the second of the two major constitutional reforms between 1434 and 1494 which were designed to consolidate and reinforce the ascendancy of the Medici and their supporters within the framework of the republican constitution. The first of these reforms had taken place in 1458, after the Mediceans had triumphantly prevailed over the republican opposition, when the new council of One Hundred was placed above the two ancient councils of the People and of the Commune.[178] While the growth of the

[172] Ibid., pp. 52, 69, 82, 88, 120–2. Ser Piero di Ser Grifo, who was Notary of the *Riformagioni* from 1348 to 1378, came to be identified with this office to such an extent that he was called 'Piero delle Riformagioni'.

[173] Ibid., pp. 116, 118, 140. Coluccio Salutati was at first appointed also to this office. On the growing business of the *notaio delle riformagioni*, cf. the *provvisione* of 1374 which provided him with a colleague, because the Signoria knew the 'multiplicationem scripturarum et laboris . . . que circa ipsum

Reformationum Officium subcreverunt' (ibid., pp. 577–8).

[174] Ibid., pp. 196–7. In 1453, the two sections of the chancery were temporarily reunited; by Jan. 1459, they had again been separated (ibid., pp. 214, 231). [175] See above, p. 22.

[176] Marzi 1910, pp. 214, 220. In 1457, the number of assistants was increased to six, but was reduced by Benedetto Accolti after he was elected chancellor in 1458: Black 1985, pp. 140–1.

[177] Marzi 1910, pp. 249–52; Brown 1979, pp. 186–90.

[178] See Rubinstein 1966, pp. 113–16.

political and administrative business transacted in the palace was a gradual process, the creation of the Seventy and its two committees immediately affected the space available there. The meetings of the Cento could be easily accommodated in the council hall on the first floor; but the Seventy, which became the effective centre of government as well as the apex of the legislative pyramid, required a separate, and smaller, room where it could meet more frequently and in greater secrecy, and so did its committee in charge of foreign affairs, the Otto di Pratica.[179]

BUILDING OPERATIONS

How did the government deal with the problem of adapting its palace to meet the requirements of an ever-expanding administration which was to be housed in it, a problem which was compounded by the constitutional reform of 1480? There were two alternative solutions: to convert existing space to the use of offices, or to extend the building to the east, as the duke of Athens had planned to do. In the first half of the century, a number of magistracies, such as the Conservatori delle Leggi and the Ufficiali dei Pupilli, were accommodated at ground level by enclosing and partitioning the porticoes of the courtyard;[180] in 1429, Brunelleschi was paid for work he was carrying out for the Ufficiali del Monte.[181] Antonio Manetti writes that Brunelleschi built for them and their staff offices in the palace, and appears to locate these

Fig. 7 rooms under the porticoes of the courtyard of the Captain of the People.[182] But this would have been an isolated attempt to relieve pressure by building office space on to the east façade; it was not until 1444 that a project to extend the palace to the rear was adopted. 'At the time of these Priors', writes Ser Ricco Spinelli of the Signoria of July–August 1444 (he was the notary of their successors), 'it was decided to extend the palace of the Signoria in the direction of the palace of the Captain', that is to the east; and 'with regard to the building operations for this extension, five citizens were appointed', among them Neri Capponi and Cosimo de' Medici.[183]

[179] See below, pp. 33–4. [180] See below, pp. 26–7.
[181] Molho 1977. Brunelleschi, 'capomaestro de' lavorio del Monte', was paid, on 28 Feb. 1429, 8 florins by the Monte 'per rimunerazione di sua faticha in detto lavorio', out of a sum of up to 300 florins.
[182] See Antonio Manetti, *Vita di Filippo Brunelleschi*, pp. 54–5: 'Occorse ne' tempi della sua giovanezza, che s'ebbe a murare nel Palagio de' Priori l'uficio e resedenza degli uficiali del Monte e la stanza de' loro ministri che è in quello luogo, dov'erano la maggiore parte logge con colonne fatte a pompa del palagio ed a bellezza, che si possono ancora vedere . . .'. The last two clauses would make no sense if Manetti was referring to the courtyard of the palace, where the Ufficiali del Monte are also not recorded among the magistracies which before the middle of the century had their offices in the porticoes: see below, n. 200. That the offices of the Monte were on the ground level and not, as Lensi Orlandi argues, on the attic floor above the wall built by the duke of Athens (p. 72), is borne out by two contemporary accounts of the lightning which struck the palace in Nov. 1511: by Piero di Bernardo Masi, *Ricordanze*, fo. 152ʳ (I owe this reference to Caroline Elam), and by

Giovanni Cambi, *Istorie*, in *Delizie*, xxi, pp. 274–5. The account of this event in Bartolomeo Masi's *Ricordanze*, pp. 82–3, appears to be based on that of his brother Piero. Piero Masi writes that the lightning struck 'ne la chortte a piè di Davite [by Donatello], el quale Davitte era già nel chortile del palazo de' Medici . . . e anchora . . . a piè della ischala che saglie in palazo . . . e dette ne le istanze degli uficiali del Monte . . . e più dette detta saetta sopra la portta del palagio da latto di fuori e ghuastò una de l'arme che sono sopra detta portta . . .'.
[183] *Priorista* of Ser Ricco Spinelli, *ad* July–Aug. 1444 (on his election as Notary of the Signoria of Sept.–Oct., cf. Marzi 1910, p. 500): 'Al tempo di questi priori si diliberò che 'l palagio de' Signori si cresciessi di verso el palagio del Capitano e furono deputati 5 cittadini circa della muraglia di detto accrescimento . . .'; Paolo Pietrobuoni, *Priorista*, fo. 146ᵛ: 'Al tempo de' detti Signori . . . si vinse di crescere il palagio de' Signori et fecesi fondamenti nella corte del capitano dove oggi è fatta la doghana. Costorono detti fondamenti un tesoro, et saria suta una riccha cosa.' One of the Priors was Bartolomeo Michelozzi, the father of the architect. Pietrobuoni finished his *Priorista* in 1459.

In fact, on 17 July 1444 the Balìa, which two months earlier had been created for five years,[184] imposed on Jewish money-lenders a fine of 6,000 florins; and this sum was to be used 'for the restoration and adornment and refurbishment of this palace of the People and the Commune of Florence and especially of the hall of the councils of the People and the Commune'.[185] This hall, the present Sala dei Dugento, had been in 1419 the object of restoration work which was important enough to justify the appointment of Operai from among the leading citizens of the regime; they arranged for this purpose the transport by the river Serchio of eight fir trees from the Apuan Alps.[186]

The councils had passed the law creating the Balìa at its first reading with exceptionally narrow majorities, and the promise to refurbish their assembly hall may have been influenced by the regime's desire to appease the opposition. However, the renovation of the council hall had to wait for nearly thirty years.[187] As for the building of an extension of the palace at its rear, the principal reason for the failure to carry out this project, after foundations had been constructed at great cost in the courtyard of the Captain of the People,[188] has to be sought in the decision taken by the Balìa on 21 July to build a customs house in order to help prevent 'the frauds that are being committed' in failing to pay the gate tolls.[189] The decision of the location of the Dogana was left to the Signoria and their Colleges as well as to the customs officials themselves, but by September 1445 'nothing had as yet been decided', 'about the construction of the aforesaid customs house'.[190] To make a start with this building, 'which at present is evidently in the common interest', the councils of the People and the Commune allocated to it up to 6,000 florins, or rather what remained of the identical sum which in the preceding year had been earmarked by the Balìa for the 'new extension' ('nove amplificationi') of the palace.[191] But once that work had been awarded first priority, its execution suffered in its turn from more urgent claims being made on the money that had been assigned to it. In the following January, the Signoria diverted the money to the payments of the city's soldiers, the ensuing loss of funds for the customs house to be made up by revenue from taxes to be levied later in 1446.[192] The Dogana was in the end built with these funds at the rear of the palace, that

[184] Cf. Rubinstein 1966, p. 74.

[185] Balìe, 26, fos. 52ᵛ–53ʳ: 'in refectione et ornatu et aptatione huius palatii Populi et Communis Florentie et presertim sale consiliorum Populi et Communis'. The Operai were elected on the following day, 'pro tempore quousque pecunia assignata pro suprascripto opere perficiendo durabit et donec tota in dicto opere expendatur' (Sig., Delib., sp. aut., 29, fo. 5ʳ⁻ᵛ, 18 July 1444). According to Lensi, pp. 52–3, the Operai were elected in 1446, but N. Santini 1919, pp. 18–19, to whom he refers, cites the *provvisione* of 17 July and the deliberation of 18 July correctly under the year 1444. Lensi Orlandi, pp. 62–3, follows Lensi in dating the *provvisione* 1446. On the fine, in reality a tax, of 6,000 florins, which had been imposed on five Jewish money-lenders and their partners, see Cassuto 1918, pp. 131–3, and Ciardini 1907, pp. xvii–xviii. See also below, n. 229.

[186] Monte Comune, 3619, fo. 150ʳ (17 May 1419): 'otto legni d'abete per fare achonciare la sala del palaccio del chonsiglio'. The four 'uficiali diputati sopra l'achoncimo della sala del palagio de' Signori' were Niccolò di Franco Sacchetti, Niccolò di Giovanni da Uzzano, Tommaso di Neri Ardinghelli, and Antonio di Tedice degli Albizi (ibid., fos. 209ʳ–211ʳ, 16 Sept. 1419).

[187] See below, p. 32.

[188] See Pietrobuoni, loc. cit. above, n. 183.

[189] Balìe, 26, fo. 53ᵛ (21 July): 'fatto examinare intorno agl'inghanni e fraude si fanno a detta gabella si cognosce manifestamente che grande utile sarebbe che detta gabella avesse una dogana, nella quale si pesasse e vedessi quelle cose che entrano et eschano'. According to Saalman 1965, p. 32 n. 15, the Dogana was built, in 1444, at the same time as the renovation of the courtyard, of the Sala dei Dugento, and of the Sala dei Gigli was begun; but see the following note.

[190] Provv., 136, fo. 170ʳ⁻ᵛ (22–3 Sept. 1445): since 'ad predictam doganam construendam nichil fuit ordinatum per eos, quibus data fuit auctoritas', the Ufficiali del Monte and the Maestri della Gabella delle Porte were now put in charge of deciding 'de loco in quo dicta dogana fieri debeat'.

[191] 'Et pro dicta expensa . . . detur ci . . . quicquid superest de pecunia assignata nove amplificationi palatii populi florentini . . . Et in computatione dicte pecunie assignate de amplificatione, que vigore presentis devolvitur ad opus dicte dogane, ubi evidenter ad presens resultat utilitas comunis, post perfectam doganam usque ad dictam summam' which had originally been assigned to the extension of the palace, 'satisfieri . . . debeat dicte amplificationi . . . quando deliberaretur quod in ea fiat prosecutio . . .'.

[192] Balìe, 26, fo. 125ʳ⁻ᵛ (17 Jan. 1446).

is in the area which according to the original plan would have provided the space for its extension.[193]

There is no trace of any major construction work being undertaken in the palace until 1454, although the next Balìa, of 1452, decreed in its turn the restoration of the council hall, which was 'multum vetusta' ('very old'), ordered the Signoria to elect five Operai for the purpose, and allocated to this project, for two years, one *denario* per *libbra* that was paid to the city's mercenaries.[194] But early in 1453 the war which the Florentines and their new ally Francesco Sforza were waging against Venice was taking a turn for the worse with military setbacks for the duke of Milan in Lombardy, while Florence was being threatened from the south by king Alfonso of Naples, whose troops had invaded Tuscany in the preceding year.[195] As a result, the Balìa decided in March that the money which was thus to be retained from the soldiers' wages was, for one year, to be used 'for the expenses of the present war'[196]—a decision which was in its turn revoked five months later in view of the great expenses the Operai had already incurred for work in the council hall, whose continuation was 'in truth most necessary'.[197] During these years of intermittent warfare miltary expenditure was high, the tax burden heavy, and the fiscal problems of the republic such that there could hardly be a case for increasing that burden to meet expenditure that was not strictly necessary.[198] It may not therefore have been a mere coincidence that the project which had been shelved after 1444 was revived precisely during the months when negotiations were taking place at Lodi, leading to the conclusion of peace in April 1454. The building campaign which was planned in February 1454 differed, however, in one important respect from that projected in 1444. There was no longer any question of making additions to the palace or of restoring its council hall only. A radical building campaign was to renovate it by restoring the courtyard to its original form and adding to its decoration, 'so that the palace' of the Signoria 'be restored and adorned in its lower part around the loggias which are arranged there'; Operai were ordered to be elected to attend to this work.[199] The Signoria had already decided a fortnight earlier to have removed 'all the partitions between the columns that sustain the walls of the said palace on the side of the said courtyard . . . and . . . up to the principal wall of the said palace, that is the places where the Ufficiali dei Pupilli, the Sei di Mercanzia, the Conservatori delle Leggi, and other officials are accustomed to meet', and this

[193] It is shown on Pietro del Massaio's maps of Florence of 1469–72 (cf. Boffitto and Mori 1826, pp. 8–12); see Fig. 2.

[194] Balìe, 27, fos. 36ᵛ–37ʳ (30 Aug. 1452): 'Item quoniam sala in qua fiunt consilia populi et comunis palatii dominationis est multum vetusta et in suis sedibus consumpta', with 'non multo honore comunis', it is decreed that 'possit et debeat refici et aptari ubi opus esse videbitur, etiam quantum ad palcum superius dicte sale, eo modo et forma . . . prout ordinabitur . . . per quinque operarios eligendos . . . Et quod pro faciendo debitam expensam . . . pro tempore duorum annorum . . . sit assignatum . . . quicquid . . . retrahetur . . . de retentione unius denarii parvi fienda pro qualibet libra de omni eo quod in futurum solvetur . . . pro expensa guerre sive stipendiariis sive capitaneis vel conducteriis . . .'. Cf. Cambi, *Istorie*, in *Delizie*, xx, p. 302: the Signoria elected Piero de' Medici as one of the five Operai; see below, n. 201.

[195] *Storia di Milano*, vii, pp. 40 ff. Cf. Matteo Palmieri, *Annales*, pp. 164–5.

[196] Balìe, 27, fo. 111ᵛ (13 Mar. 1453): the 'retentiones' which had been decreed 'sint assignate pro expensis presentis guerre'.

[197] Balìe, 27, fos, 142ᵛ–143ʳ (17 Aug. 1453): 'considerato re vera summe necessarium esse . . . prosequi dictum opus sale predicte et maxime cum dicti operarii fecerunt magnas expensas . . . in legnaminibus et aliis opportunis . . . et operarii remanerent in debito iam contracto obligati . . . dictum assignamentum . . . sit ex nunc a die qua fuit revocatum . . . restitutum'.

[198] On the fiscal pressure during the years of intermittent war, see E. Conti 1984, pp. 208–9.

[199] Provv., 144, fo. 69ʳ⁻ᵛ (13–14 Feb. 1454), ed. Fabriczy 1904, p. 100: 'ad finem . . . quod palatium ipsorum Dominorum consequatur eius reaptationem et habeat eius ornamentum in suis partibus inferioribus circa lodias ibidem ordinatas'. For this purpose the Operai were allocated 400 florins.

decision had been carried out on the same day.[200] The Signoria had also decided that the work of demolition and restoration in the courtyard was to follow the instructions of the Gonfalonier of Justice, Matteo Morelli, and of Cosimo de' Medici's younger son Giovanni, who was one of the Priors. The councils now took the matter out of their hands by ordering that the Signoria elect three Operai for this job. The Signoria did so with the proviso that the Operai were to carry on with it until it was completed, and re-elected Giovanni's brother Piero, who had already been elected in 1452, as one of them.[201] Cambi enumerates the magistracies which as a result lost their rooms in the courtyard: they were, beside the Ufficiali dei Pupilli and the Conservatori delle Leggi, the Sea Consuls, the Six of Arezzo, and the Regolatori delle entrate e delle uscite; 'and they did this,' he adds, 'so that the palace should be less restricted (*più libero*) and more spacious and beautiful'.[202] In May, the Operai were also authorized to 'break through a wall which existed in the Sala dei Grandi', in order to create a passage (*andito*) to the office of the Notary of Legislation,[203] although a law passed in the preceding month had expressly forbidden 'any office . . . to destroy, remove, or raise any wall' inside the palace, with the exception of any such wall in the courtyard, 'and other aforesaid work which had been begun'[204]—a reservation which indicates that officials other than the Operai had been taking advantage of the building operations to have walls pulled down or erected, in order to improve their working conditions, and perhaps to find space for magistracies which had been dislodged from the colonnade of the courtyard. At least some of these magistracies must have been fitted in elsewhere in the palace, possibly on the first floor or in the Camera dell'Arme; in 1470, Benedetto Dei lists the Conservatori delle Leggi and the Sea Consuls among those who 'stanno nel Palazzo'.[205] For, despite what Vasari wrote a century later, the explicit objective of the building campaign which was launched in January 1454 was to restore the palace to its former beauty, and consequently involved the reduction rather than the increase of the space available in it for the administration of the republic.

The records relating to the restoration campaign do not identify the architect who was put in charge of it. Michelozzo is recorded in 1457 as *maestro della muraglia* of the palace.[206] The

[200] Sig., Delib., ord. aut., 75, fo. 14ᵛ (29 Jan. 1454), ed. Fabriczy 1904, p. 99: '. . . deliberaverunt quod . . . infra in curia . . . destruantur ac in totum inde omnino removeantur omnes parietes existentes inter columpnas substinentes mura dicti palatii ex latere dicte curie . . . et ab archis columpnarum infra usque ad murum principalem dicti palatii, videlicet in locis ubi solent congregari Officiales pupillorum et Conservatores legum, Sex Aretii et alii officiales dicti Comunis . . .'. The demolition of the partitions took place on 29 Jan.: *Priorista* Gaddi, fo. 181ᵛ: 'A dì xxviiii di giennaio si levorono via . . . tutte le stanze degli ufici erano sotto gli archi nella corte del Palagio de' Signori.'

[201] Provv. cit. above, n. 199. The Signoria was to elect the Operai within three days; they did so on 14 Feb., 'ad perficiendum dictum opus pro tempore usque ad perfectionem'. The other two Operai were Andrea di Tommaso Minerbetti and Tommaso di Francesco Davizi. On Piero's election in 1452 (Sig., Delib., ord. aut., 75, fo. 20ʳ), see above, n. 194. That in contrast to the election of Operai in Aug. 1452, which was decreed by the Medicean Balìa, election was now decreed by the statutory councils of the People and Commune, may point to a reaction on their part to the decision of the Signoria to

act on their own initiative without following normal procedure, and may even have anti-Medicean overtones.

[202] *Istorie*, in *Delizie*, xx, p. 322: 'e questo feciono perché il Palazzo fussi più libero e spazioso e bello'.

[203] C. Strozz., 2a ser., 53, fos. 159ᵛ–160ʳ, partly ed. Gaye, i, p. 561, deliberation of the Signoria and Colleges of 9 May 1454: the officials elected 'ad destruendum certa loca sive muramenta in parte inferiore palatii . . . possint et debeant . . . rumpi facere murum qui est in Sala de' Grandi pro fieri faciendo anditum in locum Reformationum.' See App. V.

[204] Provv., 145, fos. 3ᵛ–5ᵛ (10–11 Apr. 1454); see below, n. 215.

[205] *Memorie storiche*, fo. 27ʳ�ⁿ; cf. above, n. 169. After the suspension of the state galley sailings in 1480, the three Sea Consuls who resided in Florence were in their turn suspended (Mallett 1959, p. 160).

[206] See Caplow 1970, ii, p. 627. It can hardly have been a coincidence that one of the Priors who decided in 1444 to build an extension of the palace at its rear was Michelozzo's father: see above, n. 183. Saalman 1965, n. 15, assumes that Michelozzo was the architect of the Dogana, which was constructed instead.

earliest evidence naming him as architect of the *cortile* is provided by the artists' biographies in Antonio Billi's *Libro* composed between 1481 and 1530: Michelozzo 'put up the columns or pillars in the loggia of the courtyard in the palace of the Signoria in Florence'.[207] This statement is the source of one in another collection of lives of artists, according to which Michelozzo 'had the columns and piers' of the courtyard 'replaced'.[208] In 1550, a few years after the composition of the *Anonimo Magliabechiano*, Vasari expanded this succinct information in the first edition of his *Lives*: on Michelozzo's return to Florence, he writes, 'in the palace of the Signoria it proved necessary to replace some columns in the courtyard'. Owing to the risk that the palace could collapse when the existing columns were removed, no one dared to undertake this task; Michelozzo, however, carried it out so successfully, that he was rewarded by being made a
Fig. 8 member of one of the Colleges.[209] It was only in the second edition of the *Lives*, in 1568, that Vasari attributed to him a wide-ranging and thoroughgoing building campaign in the palace, which went far beyond the initial job of restoring the courtyard porticoes. His account, in the Life of Michelozzo, has been accepted by all historians of the palace as authoritative, and Michelozzo's contribution in restructuring its interior and in 'modernizing' its courtyard is accordingly seen as a landmark in its history.[210]

Vasari's exceptionally detailed description of Michelozzo's work in the palace—no other building activity prior to his own receives so minute a treatment in the *Lives*—falls into two parts. The first[211] greatly expands the brief account of Michelozzo's restoration of the porticoes contained in the first edition of the *Lives* by offering a structural analysis of the courtyard. In the 1550 edition, Vasari pointed out the danger involved in removing its columns prior to repairing them;[212] in 1568, he recapitulates that the palace 'had begun to be threatened with collapse, because some columns of the courtyard were weakened, owing to the great weight they had to carry', and adds that this may also have been due 'to the weakness of the foundation, and perhaps also because they had been made of badly joined and badly made pieces'.[213] Michelozzo, having successfully dealt with a similar problem in Venice, rescued the palace from the danger of collapse by adopting technical methods which Vasari describes in detail. This description is clearly based on a close examination of the structure of the loggia of the courtyard and of the weight sustained by its columns—an examination which had become possible, and indeed necessary when, five years after the first edition of the *Lives*, Vasari himself had succeeded Battista del Tasso as Duke Cosimo's architect for the palace.

[207] Billi, *Il Libro*, p. 323: 'in Firenze al palazzo de Signori messe le colonne, o pilastri nella loggia del cortile.' On the date, p. 313.
[208] *Anonimo Magliabechiano*, p. 97: 'Fece rimettere le colonne e i pilastri nel cortile della loggia, palazzo delli Signori.' On the date (between 1537 and 1546), ibid., pp. xviii–xx. Michelozzo's columns were encased in 1565 as part of the decorations for the marriage between Francesco de' Medici and Joanna of Austria.
[209] Vasari 1550, p. 328: 'Ritornatosi poi a Fiorenza, bisognò nel palazzo della Signoria rimettere alcune colonne nel cortile . . .'. As Fabriczy 1904, p. 56, has shown, Vasari confused Michelozzo with an homonymous citizen of another district who had been a member of the Colleges, which the architect Michelozzo never was. Vasari may have obtained this erroneous information from someone

interested in Florentine genealogy, such as Vincenzo Borghini.
[210] Vasari–Milanesi, ii, pp. 434–8. See e.g. Lensi Orlandi, pp. 63–72, and recently Trachtenberg 1989, pp. 568 ff.
[211] Vasari–Milanesi, ii, pp. 434–5.
[212] Vasari 1550, p. 328: 'de le quali [colonne] a infiniti volsero dar la cura, e dubitando che 'l palazzo per lo peso non ruinasse, nessun la volse mai.' See above pp. 26–7.
[213] Vasari–Milanesi, ii, pp. 434–5: 'Standosi dunque Michelozzo in Fiorenza, il palazzo pubblico della Signoria cominciò a minacciare rovina, perchè alcune colonne del cortile pativano; o fusse ciò, perchè il troppo peso di sopra le caricasse, oppure il fondamento debole e bieco, e forse ancora perchè erano di pezzi mal commessi e mal murati.'

Thus far, Vasari's description, in the second edition of the *Vite*, while much more detailed, conforms to the earlier accounts of the restoration of the courtyard, including his own. Like these, it also agrees with the text of the decision taken by the Signoria in January and confirmed by the councils in February 1454, to restore the porticoes of the courtyard to their original form, although neither of these decrees mentions the name of the architect who was put in charge.[214] Neither of them, moreover, refers to any work to be undertaken in the palace in addition to the restoration of the porticoes; the decree passed by the councils in February expressly states that the *reaptatio* of the palace was to be carried out 'in suis partibus inferioribus', 'in its lower part'; and this proviso was reaffirmed two months later, when the councils forbade any interior demolition except in so far as it related to the restoration of the courtyard columns and the walls which they sustained.[215] In October, when the councils decided to allocate additional funds to the building work in the palace, they again specifically referred it to the loggia, as the 'opus lodiarum et columnarum inferioris partis palatii', but added that the money was also destined for other embellishments, 'aliis ornatibus dicti palatii'.[216] During the following years, the allowance 'for the new work in the palace', 'pro opere novo palatii', was annually renewed; but as late as 1460, it was pointed out that 'the work of the restoration of the palace could not remain as incomplete' as it then was 'without the disgrace of the Signoria and great inconvenience to their officials and household'; whereupon the councils voted a special allowance, for one year, of 1,000 florins, for the *muraglia palatii*.[217] It is probable that these additional allocations were partly used for the new windows and the decorations of the courtyard.

In the second part of his account of Michelozzo's work,[218] Vasari affirms that Michelozzo, having installed the new columns, some of them 'with eight sides' and with capitals 'carved in

[214] See above, nn. 199 and 200.

[215] *Provvisione* of 10–11 Apr. 1454, fos. 4^v^–5^r^, see above, p. 27, '. . . non possit aut debeat etiam vigore cuiuscumque deliberationis vel precepti undecumque et a quocumque officio cuiuscumque dignitatis et condictionis procedentis destrui aut tolli vel elevari aliquis murus vel hedificium seu pars eius in dicto palatio quoquo modo . . . non obstante privilegio Prioratus vel Vexilliferati Justitie', on penalty of 1,000 florins and registration as tax debtor. 'Predicta tamen non habeant locum quantum ad opera iam incepta et ordinata et designata tam circa columpnas remittendas inferius in dicto palatio quam circa muros et alia circa dicta opera incepta et prout per operarios ad ea deputatos ordinatum fuit.'

[216] Provv., 145, fos. 178^v^–179^r^ (11–12 Oct. 1454; Fabriczy 1904, pp. 101–2): 'Adtento quod fuit inceptum opus lodiarum et columnarum inferioris partis palatii Dominationis pro magnificentia et ornatu dicti palatii et quod non extat assignamentum quo mediante ad perfectionem deduci possit, et melius quidem fuisset non incipere, quam sic inceptum et imperfectum dimictere', it is decided that for one year 12 *denari* 'pro libra qualibet' be deducted from all payments to mercenaries and paid for this work in two-monthly instalments. This money is to be spent exclusively 'in opere lodiarum palatii predicti et aliis ornatibus dicti palatii', as decided by its Operai.

[217] Their allowance (see above, nn. 199 and 216) was renewed for one year in 1455 (Provv., 146, fos. 304^r^–305^r^, 30–1 Dec. 1455), 'pro perfectione dicti operis, quod, prout per iam incepta in illo comprehenditur, valde decorum et magnificum resultabit', in 1456 (Provv., 147, fos. 138^v^–139^r^, 29–30 Oct.), 1457 (Provv., 148, fos. 342^v^–343^r^, 10–12 Oct.: 'pro muraglia palatii'), 1458 (Balie, 29, fos.

69^v^–70^r^, 25 Oct.), and in 1459 (Provv., Dupl., 169, fos. 77^v^–78^v^, 31 July–2 Aug.). In 1460, the Signoria having realized that 'opus reparationis palatii dominationis sic imperfectum prout ad presens est permanere absque dedecore ipsius dominationis et magno ipsius officialium et familie incommodo non posse', the councils decreed that the Camera dell'Arme was to receive for one year for the 'muragla palatii' one half 'de pecunia opere' of S. Croce, S. Spirito, and Carmine, which were to be compensated by being given their 'assignamentum integrum pro uno anno ultra tempus pro quo . . . factum fuerat' (Provv., 151, fo. 153^r^–154^v^, 24–30 July). In 1461, money from the fine on two Jewish bankers was invested in Monte credits for the Operai of the council hall, interest to be paid until their work was completed, and in 1463 a portion of the fine on another Jewish money-lender was assigned 'pro opere muragle palatii' (see below, n. 229). In 1468, the Signoria decided to allocate certain moneys which remained in the hands of the Ufficiali dei Ribelli, whose office 'de proxime finivit', to the Operai 'muragle et reparationis palatii', since they saw that this was necessary 'pro aptando et reparando quedam valde necessaria in palatio' (Provv., 158, fos. 169^r^ 170^v^, 11–13 Jan. 1468). The restoration of the porticoes of the courtyard must have been completed well before 1466, when Francesco di Domenico *detto* Monciatto was commissioned to supply benches for them 'cum spalleriis intarsitis' measuring about 90 *braccia* in length, 'que . . . sunt panche lodie existentes in palatio' (Sig., Delib., ord. aut., 91, fo. 19^r^, 16 Oct. 1466). I am grateful to Caroline Elam for her help with the preceding references.

[218] Vasari–Milanesi, ii, pp. 435–8.

the modern fashion, others round',[219] not only reduced the weight of the walls which they sustained, but also 'rebuilt the entire courtyard from the arches upward, with a series of windows in the modern style, like those Cosimo had made in the Medici palace'; he also furnished the mezzanine with round windows (*tondi*) in order to give it more light,[220] and he decorated the walls of the courtyard with 'graffiti of rustic stonework' and with 'golden lilies that are still to be seen'. Over and above this, he carried out extensive interior renovations. On the second floor, he partitioned the hall that had served as communal dormitory of the Priors into separate rooms for them; on the attic floor, he created a similar set of rooms for the household staff of the Signoria; he adorned their chapel, as well as many rooms and ceilings near it, by 'decorating these with golden lilies on blue ground'; he had the old ceilings on both the second and first floors replaced with new ones *all'antica*. Finally, he furnished the stairs with a richly adorned door in the courtyard and rebuilt their steps with *pietraforte* up to the second floor, where he installed a door to protect the access to the Signoria, and he repaired the bell-tower. Altogether, he improved the palace to such an extent that his work was universally commended, and beside other rewards, he was made a member of the Colleges. At this point, Vasari takes up, in conclusion, the thread of his brief account in the first edition of the *Lives*.[221]

Vasari tries to counter criticisms that he had dealt with Michelozzo's building campaign at excessive length by arguing that Michelozzo's was the only major attempt, before he himself had become the architect of the palace, to remedy the shortcomings of its original construction. He thus attributed to Michelozzo the many evident renovations in the 'modern style' which he discovered when he surveyed the palace prior to presenting to Duke Cosimo his own proposals for the renovation of its interior. The contemporary evidence raises serious doubts about the reliability of his account.[222] His assertion that Michelozzo was responsible for the partition of the Signoria's 'dormitory' into separate rooms may have been due to these rooms having struck him as being of relatively recent date. Since we have precise evidence that the rooms of the Signoria were demolished and rebuilt in 1463, at a time when Michelozzo was living at Ragusa, it is highly unlikely that they had been constructed by him in 1454.[223] The sumptuous ceilings on the first and second floors, which Vasari attributed to Michelozzo, belong to the renovation campaign on those floors which did not gather momentum until after his death in 1472;[224] and the chapel of the Signoria, as it existed in Vasari's day, which he says Michelozzo adorned, was

[219] The columns were encased with stucco in 1565: see Allegri and Cecchi, pp. 277–8.

[220] The passage ('per dare lume alle stanze di mezzo che son sopra alle prime, dov'è oggi la sala dei Dugento') is somewhat obscure, but surely refers to the mezzanine, and not, as Trachtenberg 1989, pp. 573–4, states, to the attic. The words 'sopra alle prime' stand for 'sopra alle stanze del primo piano', in which 'there is now the Sala dei Dugento'.

[221] Vasari–Milanesi, ii, p. 438: 'E finalmente bonificò e restaurò di maniera questo palazzo, che ne fu da tutta la città commendato, e fatto, oltre agli altri premij di Collegio, il quale magistrato è in Firenze onorevole molto'; see above, n. 209. On the *porta della Catena*, see below, n. 271.

[222] Similar doubts have been raised about the reliability of Vasari's attribution of the Palazzo Medici to Michelozzo: Preyer 1990, pp. 67 ff.

[223] Rinuccini, *Ricordi*, p. xc: the Signoria of Jan.–Feb. 1463 'feciono . . . gittare in terra le camere dove abitavano, per rifarle e racconciarle, e questo feciono a dì 26 di Febbraio'; see App.

I. On Michelozzo's residence at Ragusa, see Caplow 1972.

[224] See below, pp. 32–3: they had been 'nuovamente facti' in Aug. 1475 (Op. Pal., i, fos. 5ʳ–6ʳ). According to Fabriczy 1904, p. 59, Michelozzo 'wird also wohl die Modelle für die drei Säle dei Dugento, de' Gigli und dell'Udienza geliefert haben, die dann auch nach seinem Tode für die Ausführung bindend waren', but his only evidence apart from Vasari in support of this hypothesis is a letter of Giovanni da Gaiole to Ludovico Gonzaga of 3 May 1471 (cit. in Braghirolli 1879, p. 272) which refers to his being engaged 'in una opera del palagio di Signori d'uno palcho per la sala molto ornato'. Fabriczy (ibid.) identifies this room with the Sala dei Dugento, whose ceiling and frieze accord, in his view, with what we would expect from Michelozzo. But Giovanni da Gaiole does not mention Michelozzo in his letter: 'Io sarei venuto costì . . . solo ò lasciato, perchè io sono in una opera del palagio di Signori . . .'. He later collaborated in the manufacture of that ceiling, and may have been commissioned for it even before the old ceiling was destroyed in 1472: see below, pp. 32, 59.

not constructed until 1511.[225] In view of all these flaws in Vasari's account of Michelozzo's interventions, the question arises whether he was, as has been generally accepted on Vasari's authority, the architect of the new windows facing the courtyard on three stories. That the new windows *alla moderna* were designed in imitation of those Cosimo de' Medici had constructed in the courtyard of his palace, may well be possible; at the same time, the architect of Duke Cosimo may have found it politic to stress their similarity.[226]

If aesthetic considerations dominated the first major building campaign in the palace during the fifteenth century, the restoration of the porticoes of the courtyard and the new windows facing it, the same was true of the far more extensive interior renovation which was launched about fifteen years later. Indeed, the work which was carried out during the 1470s and at the beginning of the 1480s on the first and second floors can be seen as the final realization of the project to embellish the palace which had been launched, unsuccessfully, as early as 1444.[227]

The law of August 1470, which allocated funds to the renovation of the three largest rooms on those floors, emphasizes the connection with the earlier project by stating that 'it is a long time since it was ordered that the council hall and the one above it . . . should be restored and embellished'.[228] In April 1469, the councils had, following the precedent of 1444, earmarked 2,300 florins from a fine of 4,100 florins which were to be paid to the Monte by a Jewish banker for the restoration of the *sala* and of the audience chamber of the Signoria on the second, and of the council hall on the first floor. The Operai del Palazzo were to present plans for this work to the Signoria and Colleges for their approval.[229] But in the following month practically all the money which had been assigned to the palace was, as in 1444, diverted to another purpose, this time to the repair of the walls of Castrocaro and of Facciano;[230] and now, instead of

[225] See below, pp. 45–6.
[226] Cf. Preyer 1990, p. 70: '. . . la seconda edizione offre un ritratto di Michelozzo che sembra calcolato per farlo apparire il braccio destro di Cosimo de' Medici.' [227] See above, p. 25.
[228] Provv., 161, fos. 86ʳ–87ʳ, Op. Pal., 1, fo. 2ʳ⁻ᵛ (17–21 Aug. 1470); Fabriczy 1904, pp. 108–10: 'Considerando . . . quanto tempo è che s'ordinò che la sala del consiglio et quella di sopra . . . si dovesse acconciare et ornare . . . et che molte volte vi s'è disegnato varii assegnamenti . . . et poi per e bisogni occorrenti al vostro Comune si sono mutati et volti a luoghi et a cose più necessarie, come è la riparatione delle vostre forteze . . .', it is decreed that for two years from 1 Sept. 1470, the *Opera della sala* was to receive every month 100 florins 'di quegli che si ritrahessino della gabella della tracta del grano . . . Et similmente dell'entrata della casa della Mercatantia . . . s'intenda assegnato [for the same period] alla detta opera fiorini 100 larghi il mese.'
[229] Provv., 160, fos. 11ᵛ–12ʳ (20–1 Apr. 1469), partly ed. by N. Santini 1919, pp. 116–17, and Fabriczy 1904, p. 109 n. 1: it had previously been decided that of the 4,100 florins owed by Isaac from Bologna 'fussi assegnata al Monte per . . . pagare a chi conducesse in Porto Pisano grano uno fiorino largho per moggia', and if anything was left over it could be spent for the purchase of corn; but 'considerando la ricolta gratia di dio . . . apparecchiarsi buona, et desiderando acconciare il palagio della habitatione' of the Signoria 'in quello modo che sia degno all'onore di tucto questo popolo', it was now decided 'che . . . fiorini duemilatrecento larghi che restano a pagarsi per detto Isahac al detto Monte in anni quattro [i.e. in four yearly instalments] . . . s'intendano . . . essere assegnati al camerario o vero depositario degli Operai della muragla del palagio . . . per

l'Opera della sala del consiglio et per la sala grande de sopra et per la audientia del detto palagio'. On the fine, or tax, imposed on Jews in 1444, see above, n. 185. As in that year, the fine to which Isaac from Bologna was condemned in 1468, 'per havere usato carnalmente con femine cristiane', amounted originally to 6,000 florins, reduced to 4,100 florins if paid early: Provv., 159, fos. 148ᵛ–149ʳ (30 Sept.–1 Oct. 1468); see N. Santini 1919, pp. 115–16. In 1461 and again in 1463, 1,000 florins out of fines on Jewish money-lenders had been assigned to the palace (ibid., p. 116 n. 2; Ciardini 1907, pp. 53–4; Cassuto 1918, pp. 138–9, 200–1). In 1461, it was decided that the money from the fine that had recently been imposed on two other Jewish bankers, Bonaventura da Volterra and his father Manuele, which had been received by the Monte, was to be invested in Monte credits 'sub nomine opere sale consilii', and the interest from them was to be paid to the Opera 'donec dicta sala foret perfecta' (Provv., 152, fos. 48ᵛ–49ᵛ, 30 May–2 June 1461). Of the 4,000 florins which Sabato da Pistoia had been fined in 1463 for having had sexual intercourse with a Christian prostitute, up to 1,000 florins were allocated 'in opere . . . muragle' of the palace and 2,000 florins to the *argenteria* of the Mensa of the Signoria (Ciardini 1907, doc. xii). In 1461, the 1,000 florins constituted only a fraction of the fine of 22,000 florins Vitale da Montalcino had to pay for having lent money after his permit to do so had expired.
[230] Provv., 160, fos. 46ʳ–47ʳ; N. Santini 1919, pp. 117–18 (10–13 May 1469). The Captains of the Guelf Party, to whom this sum was now assigned, were however required to give 300 florins of it to the Opera of the palace, 'per potere pagare più spese fatte in spalliere e altre cose per ornamento del palagio'.

postponing once more the interior renovation of the palace, the councils decided to replace the funds of which the *opera* had been deprived with an assignment to it, for two years, of 2,400 florins, to be paid in monthly instalments of 200 florins from September 1470.[231] It was, however, only shortly before the end of these two years that the Signoria ordered, in June 1472, that their *sala magna* and their audience chamber be demolished, 'so that they could be rebuilt anew'[232] and on the 29th of the same month, the day before they ended their term of office, 'the old ceiling of the council hall was pulled down, so that a new ceiling could be installed' in it.[233] In 1473, further funds were granted to the Operai, amounting to one quarter of the total sum they were due to have received between 1470 and 1472, again payable in instalments, the final one in October.[234] The Operai clearly did not consider these recurrent grants to be adequate and, while work was in progress, wanted them to be complemented by the same kind of regular income which the Operai of the Cathedral received.[235] Accordingly in 1473, the Signoria, having been reminded by them that their 'assegnamento è piccolo', and 'wanting the work to be finished without having, at present, to touch the pockets of the citizens', proposed that they be awarded the proceeds from a tax that was to be levied on foreign artisans and merchants who had come to Florence in order to exercise their craft or business, 'per fare alcuno exercitio'.[236] But these new assignments proved, in their turn, insufficient, for in the month during which the second payment of this tax was due,[237] the councils awarded the Operai the sum of 600 florins, as well as two *soldi* from fines imposed by the Otto di Guardia.[238] Despite this additional funding, the Signoria asked the councils three years later, since work in the palace was not yet finished, to increase the tax on foreigners, which was 'small considering the great profit they make from the places in which they live'.[239]

The ceiling, and then the frieze and architrave, of the council hall were completed by August 1475 and December 1478, in all probability by Giuliano da Maiano, Francione, Monciatto, and Giovanni da Gaiole.[240] These men were probably also the four *maestri* who executed the ceiling and frieze of the Udienza, the cost of which was estimated in December

[231] See above, n. 228: 'e decti danari di questo nuovo assegnamento si spendino pe' predetti Operai in ornamento di dette sale et altri luoghi necessarii per ornamento di detto palagio.'

[232] C. Strozz., 2a ser., 53 (17th-cent. extracts from the Deliberazioni of the Signoria), fo. 174ᵛ (1 June 1472), partly ed. Gaye, i, p. 571, with the wrong date, 12 June 1473: 'Deliberaverunt quod die Jovis que erit dies 25 presentis mensis junii per magistros ad hoc deputatos debea[n]t destrui sala magna et audientia dictorum Dominorum dicti palatii ad hoc ut reficia[n]tur de novo, prout idcirca est ordinatum.'

[233] Rinuccini, *Ricordi*, p. cxx: '. . . a dì 29 di giugno, si gettò in terra il palco vecchio della sala del consiglio, per racconciare e fare di nuovo detto palco, e così di poi si seguitò di lavorare.'

[234] Entrata e uscita del camarlingo del Monte, 1473, Monte Comune, 1523, fo. 705: 'Operai del palagio . . . per acchoncimo et adornamento de la sala del consiglio deono dare a dì 27 di marzo fi. 200 larghi per loro ad Antonio Martegli, uno de' detti operai e per lui a Pierfrancesco e Giuliano de' Medici, loro dipoxitarii . . .'. Further payments of 200 fl. each were to be made in April, May, July, August and October.

[235] See Grote 1960, pp. 111–12.

[236] Provv., 164, fos. 73ᵛ–74ʳ (2–3 June 1473): 'desiderando che tale opera si finisca, et non volendo al presente toccare le borse de'

cittadini', *maestri* in the building and furniture trade were to pay 20 *soldi* a year, others, such as 'chi vende veli, veletti, fa mercerie, o venditori di calze', etc., 40 *soldi*.

[237] The taxes were due within one month from the passage of the law and then annually during the first month of the year.

[238] Provv., 165, fo. 5ʳ–ᵛ, Op. Pal., 1, fo. 107ᵛ (2–5 Apr. 1474). A year later, the councils again voted supplementary funding for the Operai, which was once more derived from fines on transactions by Jewish money-lenders, but this time levied on Christians who had invested money with them: see below, n. 247.

[239] Provv., 168, fos. 146ᵛ–147ʳ (19–21 Nov. 1477): 'considerando l'opera del palagio non essere finita . . . et non volendo tocchare per questo le borse de' nostri cittadini', the Signoria requests the councils to increase 'decta taxa [che] è picchola rispecto al gran danaio' the foreigners 'cavano da questi paesi, ne' quali vivono'.

[240] Op. Pal., 1, fos. 5ᵛ–6ʳ (29 Aug. 1475); 2, fo. 3ᵛ (19 Dec. 1478). The names of the four 'maestri che feciono il . . . palcho della sala del consiglio' were no doubt identical with those who subsequently made its architrave and frieze, as recorded in the deliberation of the Operai of 30 Dec. 1478, ibid. fo. 3ʳ; cf. below, Ch. 2, nn. 130, 133. But see now Cecchi 1994, p. 150. On 27 Nov. 1481 Giuliano da Maiano and Francione were allotted outstanding payments for their work on the frieze and architrave (Op. Pal, 2, fo. 54v).

1475, as well as those of the Sala dei Gigli.[241] The still undecorated ceiling of the Sala dei Gigli appears to have been completed by August 1475, its frieze by February 1477.[242] The new doorway between these rooms, on which Benedetto da Maiano worked together with his brother Giuliano and with Francione, who jointly executed the inlaid panels, was completed in 1480.[243] The wall in which it was installed must have been constructed in 1472 if the 'demolition' of those rooms involved the existing partition between them.[244] Vasari, who wrongly believed that only at this point was the originally undivided large hall on the second floor partitioned into two rooms, attributed this work to Benedetto da Maiano, and admired the technical achievement in carrying it out.[245] The renovation campaign of the 1470s was virtually concluded, in 1482, with the decoration of one of the walls of the Sala dei Gigli with frescoes by Domenico Ghirlandaio; the frescoes that had been commissioned for the other walls were never executed.[246] The long delays to which the campaign was subjected must have interfered considerably with the activities which took place in those rooms: as early as June 1473, the Signoria pointed out that without adequate funds, 'this work would take a long time and thus cause excessive discomfort to the Signoria' and to other citizens.[247] That the campaign was not concluded sooner may have been partly due to insufficient funding, after 1478, as a result of the war of the Pazzi conspiracy,[248] although much later, in 1487, it was successive Operai who were blamed for having failed to complete the work which they had initiated.[249]

Fig. 33

Protracted over ten years, the renovation campaign of the 1470s added unprecedented splendour to the great rooms of the first and second floor; it did not add to the space available. Before it was completed, there arose the need to find a room for a new council, which, owing to its nature, could not be accommodated in the council hall.

The creation, in April 1480, of the council of Seventy after Lorenzo de' Medici's return from the peace negotiations in Naples, illustrates once more the impact of politics on the history of the Palazzo Vecchio. Designed as the supreme council of the republic's government and legislation, it secured and enhanced Lorenzo's position in Florence after the crisis of the war of the Pazzi conspiracy. It also increased the influence of the inner circle of the regime: established in the first place for five years, successive extensions of its term of office made the new council, together with its personnel, into a virtually permanent institution. This distinguished it sharply

[241] Op. Pal., 1, fo. 5[r-v] (2 Dec. 1475): Domenico da Prato, 'debeat palcos et alia hedificia et ornamenta palatii noviter per dictos magistros facta . . . mensurare', except for the ceiling and ornaments of the Sala dei Gigli, because '[ad] palcum adhuc ornamenta non sunt posita et restat quia adhuc non est fulcitum'. On 8 Aug., this ceiling had been referred to as unfinished (Provv., 166, fos. 119v–120r, 8–9 Aug. 1475), which must relate to its 'ornamenta', for on 20 Aug. all three ceilings were recorded as 'nuovamente facti' (Op. Pal., 1, fo. 5r).

[242] Op. Pal., 1, fo. 9[r] (24 Feb. 1477): the frieze of the council hall should not cost more, 'sed potius minus', than that of the 'sala dominorum', that is the Sala dei Gigli.

[243] Op. Pal., 2, fo. 7[r] (20 Apr. 1480): Giuliano da Maiano and Francione are to complete 'portam legnaminis audientie' by 20 June; fo. 52[v] (21 Dec. 1480): payment to Benedetto da Maiano of *l*.419 *s*.12 'pro ianua marmi intus et extra audientie dominorum'. On 27 Nov. 1481 they were allotted outstanding amounts for this work (fo. 54v). Ed. Poggi 1909*b*, pp. 158–9.

[244] See above, n. 232.

[245] Vasari–Milanesi, iii, pp. 341–2. Lein 1988, p. 39, suggests that it was not Benedetto, but Giuliano da Maiano and Francione, who were responsible for the construction of the wall, A. Cecchi 1994, pp. 151–2, that it was Giuliano da Maiano. On the earlier partition of the hall see App. III.

[246] See below, pp. 61–5.

[247] Provv., 164, fos. 73[v]–74[r], cit. above, n. 236: '. . . manchando il danaio conoscono che tale opera sarebbe lunga, che passerebbe con troppo gran disagio della Signoria e di tutti i cittadini della città.' In Apr. 1475, one half of the fines of 12% that were to be levied on Christians who since 28 Feb. had borrowed money from Jews, and on Jews who had lent it to Christians, was allocated to the Opera of the palace, the other half to the fortress of Volterra (Provv., 166, fos. 41[v]–43[r], 27–8 Apr. 1475); but a few months later, it was decreed that the entire amount 's'intenda . . . appartenere a decta forteza di Volterra' (ibid., fos. 129[v]–130[r], 8–9 Aug. 1475).

[248] On the fiscal problems the city was facing by the end of the war, see Rubinstein 1966, p. 197.

[249] See below, pp. 68–9.

from the ancient legislative councils of the People and the Commune and the more recent one of the Cento, whose membership changed every four and six months respectively. Its institutionalized nature also distinguishes it from the informal consultative committees which were summoned by the Signoria and which it now, for all practical purposes and with clearly

Fig. 9 defined powers, replaced.[250] The council hall on the first floor was unsuitable for its meetings, and not only because of the size of that hall.[251] Owing to its permanent function in the executive branch of government, it was imperative that the new council should be able to meet at any time of the day, independently from the schedule of council meetings in the Sala dei Dugento, and in conditions of secrecy which that large hall could not supply. A room on the mezzanine, no

Fig. 10 doubt the large room facing the Via della Ninna, was converted into the council room of the Seventy.[252] Separated from, though close to, the residence of the Signoria, it would have provided greater privacy than the much more public hall on the first floor. The council's powerful committee for foreign affairs, the Otto di Pratica, which replaced the Dieci di Balìa in its turn on a quasi-permanent basis,[253] was assigned an adjoining room, which had been used by that magistracy in times of war.[254] In 1483 it was decided to concentrate the secretarial staff of the chancery in the mezzanine,[255] which had become the principal centre of political power and activity in the palace. At the same time, the relative modesty of the rooms of the Seventy and of the Otto di Pratica must have offered a striking contrast to the splendour of the newly renovated rooms on the floor above, just as the legal position of Lorenzo de' Medici as a private citizen contrasted with his *de facto* supremacy. The location and decoration of the council chamber of the Seventy reflects its position in the structure of government during the last period of the early Medici regime in more senses than one.

The removal, in 1483, of the major part of the chancery to the mezzanine[256] completed the redistribution of office space on that floor which had begun two years earlier after the creation of the council of Seventy. This redistribution reflects, to a certain extent, that of political power in the republic. While the Signoria had effectively lost, after 1480, most of its remaining authority to the Otto di Pratica, which had become a virtually permanent magistracy in charge of foreign policy and diplomacy, the council of Seventy, of which it was a committee, had further reduced the powers of the ancient legislative councils of the People and of the Com-

[250] Rubinstein 1966, pp. 199–203, 208–10; Mallett, in Lorenzo de' Medici, *Lettere*, v, Excursus 1.

[251] It was only on rare occasions that greatly enlarged consultative committees met in the Sala dei Dugento. One such consultation, of over 200 citizens, for instance, took place in it on 2 July 1458 to debate the difficult economic situation the city was facing (Cons. e Prat., 55, fos. 23ʳ–29ᵛ).

[252] The *sala* of the Seventy was located next to the audience chamber of the Dieci, as emerges from the decision of the Operai of 1 Jan. 1481 to have benches made 'nella sala de' settanta, che è all'entrata della Audienza de' Dieci' (Op. Pal., 2, fo. 94; Gaye, i, p. 576; see below, Ch. 2, n. 131). It had previously served as their *sala*, and chancery staff continued to call it 'sala decem balìe': cf. e.g. Tratte, 11, fos. 2ᵛ–3ʳ (6 Apr. 1482), 48ʳ (15 Apr. 1483), 83ʳ (2 Jan. 1484). Since the audience chamber of the Dieci was, before 1502, situated on the mezzanine (see below, n. 333), and since there is no reason to assume that its location had been changed from what it had been in 1481, this provides cogent evidence for that of the council of Seventy.

[253] Unlike the Dieci di Balìa, the Otto di Pratica were, like the

council of Seventy, which elected the members of the Otto every six months from its midst, a virtually permanent institution. In 1482, at the beginning of the Ferrara war, they were temporarily transformed into the Dieci by the addition of two members, and in this capacity retained the same personnel until the end of 1486. See Rubinstein 1966, p. 200.

[254] Otto di Pratica, Delib., 1, fo. 15ʳ (20 Oct. 1480): 'qui cum in auditorium decemvir[or]um convenissent de more'. In Oct. and Dec. 1481, they met in the audience chamber of the Camera dell'Arme (ibid., fos. 38ʳ: 'auditorium Camere Armorum', 41ʳ: 'in Camera Armorum').

[255] When Bartolomeo Scala reformed the chancery in 1483 (see Brown 1979, pp. 182 ff.), he assigned to its ten secretaries and assistants, including those in charge of the electoral records, their 'residentiam in loco, in quo consuevit stare notarius Extractionum cum suis coadiutoribus' (Marzi 1910, pp. 250–1, 604). In 1502, the Notary of the Tratte had his office on the mezzanine (see below, p. 44); as in the case of the Dieci, it may be safely assumed that he had remained there, with his records, during the intervening period.

[256] See above, p. 23.

mune, and, as a council of first instance, those of the Cento. The Seventy and the Otto di Pratica constituted the definitive institutional organization of Medici ascendancy before the fall of the regime in 1494; with the location of the Seventy on the mezzanine floor, it had finally established a physical presence in the palace.

This presence, which reflects a change in the system by which the regime had hitherto exercised control over government and legislation, also affected the relations of the head of the regime to the palace. Before 1480, Lorenzo, like his father and grandfather, would have been entitled to participate in the business that was conducted there as a member of magistracies, of one of the councils, or of consultative committees; thus during the war of the Pazzi conspiracy he was, from June 1478 until November 1479, one of the Dieci di Balìa. As a member of the council of Seventy, whose term of office was periodically extended, his presence in the palace became a virtually permanent entitlement.

THE PALACE AS ADMINISTRATIVE CENTRE IN THE FIFTEENTH CENTURY

Successive changes in the interior of the palace, as well as the scarcity and casualness of contemporary evidence on the distribution of its rooms among the various magistracies and committees which worked or met in them, make it difficult to draw an adequate picture of how it functioned as the seat of the republic's government and the principal centre of its administration. The conversion of the palace into a ducal residence after 1540 left, of the major rooms of the fourteenth-century block, only the council hall, the Sala dei Gigli, and the audience chamber of the Signoria structurally intact apart from the installation of new doors; and the drastic conversions that took place in 1865 after Florence had become, for a few years, the capital of the kingdom of Italy,[257] made further inroads into the arrangement of the rooms in the republican period. In so far as that arrangement can be deduced from documents that are not directly related to building operations, the resulting picture is bound to be in many respects elusive and haphazard. Minutes of committees often provide evidence of their place of meeting, inventories of movable objects indicate the rooms in which they were kept, and contemporary histories, memoirs, and *novelle* sometimes provide valuable information. None of these sources, however, offers an overall picture of the interior before the abolition of the republican government in 1532; even the one source which comes closest to doing so by taking the reader from the attic to the ground floor and successively identifying rooms in which objects were kept, the inventory of 1471,[258] is incomplete. The attempt to obtain an overall picture of the use of the interior at any given moment is further hampered by the fact that, owing to the mounting pressure on accommodation, which was further increased by the restoration of the courtyard in 1454, magistracies were liable to be moved to other offices, while committees would meet in

[257] Lensi Orlandi, pp. 223–7.
[258] Camera del Comune, Scritture diverse, Masserizie, no. 5, Inventario 512, fos. 1ʳ–18ᵛ. Doris Carl is preparing an edition of this inventory; a section of it (fos. 13ᵛ–15ʳ) is edited in Carl 1983. See also App. I.

whatever room happened to be available. The following survey of the interior arrangement before the constitutional reforms of 1494 and 1502, which had far-reaching effects on that arrangement, is therefore necessarily incomplete and at some points tentative. It nevertheless should convey a general impression of the functioning of the palace of government in one of the few surviving city-republics, at a time when most of the old communal palaces in Northern and Central Italy had been transformed into residences of princes or their representatives.

Fig. 11

Starting from the ground floor (Ground plan I), the space provided for offices and meetings was, after the restoration of the porticoes of the courtyard, confined to one large hall, the Camera dell'Arme. By the second half of the eighteenth century, this hall, which originally served as a repository of weapons and ammunition,[259] had been divided up into no fewer than six rooms.[260] The officials of the Camera dell'Arme, who were in charge of military expenditure and of a variety of payments on behalf of the Signoria,[261] had an audience chamber in this hall,[262] as had, in 1515, the Otto di Pratica.[263]

The stairs to the first floor rose from the north side of the courtyard (Ground plan II),[264] about half of which was taken up by the council hall, the present Sala dei Dugento. In the fifteenth century, this hall served for the meetings of the councils of the People and of the Commune and of other councils, such as, after 1458, the council of Cento, as well as for the holding of the electoral scrutinies.[265] While these were in progress, the votes were counted and the names of candidates registered by chancery officials, who were assisted by religious, in a recess within the council hall which was called the *secretum*.[266] The council hall occupied, like the Camera dell'Arme underneath it, the whole of the west wing of the first floor. No hard evidence has been found for the use in the fifteenth century of the other rooms of that floor, which were later converted by Vasari into the apartment of Cosimo I; but there is a strong likelihood that the first floor provided space for the audience chamber of the Otto di Guardia and for the room of the captain of the palace guard, as well as for the sacristy.[267]

[259] See above, n. 73.

[260] Ground plans of the Palazzo Vecchio, *c.*1775, Prague, Staatsarchiv, Familienarchiv der Habsburger in der Toskana, Inv. VII.2/1 (photocopy in the Kunsthistorisches Institut in Florenz; I am grateful to Irene Hueck for drawing my attention to these plans, and to Giuseppe Pansini for helping me to date them), no. 71: 'Pianta del Piano Terreno di Palazzo Vecchio di S.A.R.' Cf. Alfredo Lensi's report on the restoration of the Camera dell'Arme in 1910, quoted in Lensi Orlandi, p. 241. In 1504, a payment was made for the construction of internal stairs, '. . . per fare la schala alla camera dell'arme nella volta': Op. Pal., 10, fo. 63ᵛ (30 June 1504).

[261] Davidsohn, *Geschichte*, iv. 1, pp. 113–14; Guidi 1981, ii, pp. 280–1.

[262] It was used by the Operai del Palazzo: cf. e.g. Op. Pal., 1, fo. 5ʳ (26 Oct. 1475), 5ᵛ (13 Mar. 1480), 12ʳ (1 Jan. 1482), 4 (1486), *passim*: 'in audientia camere armorum'; cf. Marzi 1910, p. 476.

[263] The magistracy of the Otto di Pratica, which had been abolished in 1494, was re-established after the Medici restoration in 1512. Niccolò Michelozzo, Machiavelli's successor as Second Chancellor, records, in his notarial register, a decision taken in 1515 by the Otto di Pratica 'in audientia inferiori . . . magistratus Octovirorum Pratice . . . posita iuxta cameram Armorum' (Notarile antecosimiano, M. 530, fos. 79ᵛ–80ʳ), that is close to the office of the Camera dell'Arme, which at that time evidently occupied part of the hall.

[264] The fullest discussion of the vexed question of the stairs of the palace in the 14th and 15th cents. is in Trachtenberg 1989, pp. 589–94, see also above, n. 134. It should be added that the possibility of a stairway 'beginning [in the courtyard] in front of the tower base' is not, as Trachtenberg suggests, 'precluded by the occupation of the area by a juridical bench'. This bench, which Davidsohn (quoted ibid., n. 25) mistakenly located in the Palazzo Vecchio, was in fact situated in the Bargello, the palace of the Podestà, who was the head of the Florentine judiciary ('in claustro palatii Communis').

[265] *Statuta* 1415, v. i. 4 (ii, p. 486). See also above, p. 20.

[266] See App. VI.

[267] The inventory of objects in the palace in 1471 lists the 'chamera del capitano de' fanti' and the 'sagrestia' after the 'sala del chonsiglio' and before the 'chamera dell'arme' (Inventory 1471, fos. 12ᵛ–14ʳ), and Giovanni Cambi, in his account of the lightning which struck the palace on 4 Nov. 1511, refers to the audience chamber of the Otto as being next to the room of the Captain: 'venne giuso nella chamera del Chapitano de' fanti, ch'è a lato a l'udienza degli Otto, e forò la volta' (*Istorie*, in *Delizie*, xxi, pp. 274–5. The Otto di Pratica having been abolished in 1494, the reference must be to the Otto di Guardia.) Piero Masi, who records the same event in his *Ricordanze*, writes that the lightning, after having struck the ground floor, 's'agirò per l'udienza degli Otto' (fo. 152ʳ). The inventory of 1471 also lists, after the room of the Captain, a room described as 'il diluvio': in 1475, it

The mezzanine (Ground plan III) between the first and the second floor provided accommodation for the chancery, at times of war for the Dieci di Balìa, for the Otto di Pratica, and, from 1480 to 1494, for the council of Seventy; the Sala dei Settanta must be the large room facing the Via della Ninna.[268] The section of the chancery which was in charge of the electoral records had its office here, possibly as early as the fourteenth century; in 1483, as a result of the reform of the entire chancery, its ten secretaries and assistants were assigned rooms 'in the place where the Notary of the Tratte and his assistants used to stay'.[269] The Notary of Legislation, who retained his autonomy from the main body of the chancery, appears in his turn to have had his office in the mezzanine.[270]

The internal stairs which ascended from the first floor reached the second floor (Ground plan IV) in a small antechamber in front of the Sala dei Gigli. At the top of the stairs there was, in the late fifteenth century, a door called the *porta della Catena*, or briefly *la Catena*; during the Pazzi conspiracy, the Gonfalonier had it barred in order to prevent the conspirators from entering the second floor.[271] Next to the *Catena* was the office, the *scrittoio* (as distinct from the bedroom), of the Notary of the Signoria.[272] From this anteroom, one could turn right to the Saletta, a small council room which was often used for consultative meetings;[273] turning left, one entered (from 1476 past Verrocchio's bronze *David*[274]) the *sala* of the Signoria, the Sala dei Gigli. Here too consultative meetings were held, members of the Colleges would assemble and other citizens would wait before being admitted to the audience chamber of the Signoria, who also would take meals in their *sala*.[275] From the Sala dei Gigli one could then enter, from about that time through the magnificent marble doorway made by Benedetto da Maiano,[276] the Udienza. Inside this room, whose centre must have been occupied by the table around which the Signoria held their meetings,[277] there was, presumably in its south-west corner, a substantial structure containing the altar of the Signoria as well as a tabernacle;[278] in 1501, a small door was made in this chapel to the passage in front of the audience chamber.[279] This passage

was decreed that 'i famigli [che] hanno a dormire in palagio dormino in luogho ordinato per loro chiamato il diluvio [MS dulivio] et non altrove' (see above, n. 156). The name may be due to the room having been liable to be flooded, in which case it was probably on the ground floor. See also App. IX.

[268] See above pp. 22, 34. [269] See above, n. 255.

[270] See App. V. On the Notary of the *Riformagioni* see Marzi 1910, pp. 250, 252.

[271] See below, n. 295. Cf. Op. Pal., 1, fo. 83 (10 May 1476): payment for the sculpture by Verrocchio of David, 'positi penes et apud hostium catene' (see below). On 31 Aug. 1512, the enemies of the Gonfalonier Piero Soderini forced the *Catena* and entered the Sala dei Gigli (Jacopo to Francesco Guicciardini, 3–4 Sept., Francesco Guicciardini, *Carteggi*, i, p. 96). A few months after the abolition of the Signoria, a wooden gate (*rastrello*) was installed at the *Catena* (Op. Pal., 15, fo. 27ʳ, 27 Oct. 1532: payment 'per fattura et legname del rastrello del Capitano alla catena'). Vasari writes that Antonio Pollaiuolo 'lavorò alla porta della Catena' (Vasari–Milanesi, iii, p. 293), and that Verrocchio's *David* was placed 'al sommo della scala, dove stava la catena' (ibid. iii, p. 360), which could imply that the door, which he believed had been installed by Michelozzo (ibid. ii, p. 437), no longer existed. *Catena* probably refers to a chain or bar which could be placed across the door (see Tommaseo–Bellini,

Vocabulario Universale Italiano: 'sbarra, serraglio, ritegno'). In Vasari's time, the stairway was also still secured 'at the top and halfway up', 'in cima ed a mezzo', by two portcullises (*saracinesche*) 'per i casi de' tumulti', which Vasari equally ascribed to Michelozzo (Vasari–Milanesi, ii, p. 437).

[272] In 1475, it was decreed that no member of the *famiglia* was allowed to take anyone 'di quegli che non hanno a mangiare alle spese della mensa su passato la saletta dove sta la catena et è il luogho del notaio de' Signori' (law on the reform of the household, Provv., 166, fos. 263ʳ–269ʳ, 8 Nov.–31 Dec. 1475).

[273] See e.g. Cons. e Prat., 54, (1456–7): meetings normally take place in the Saletta or the Udienza. [274] See below, p. 56.

[275] See App. III. [276] See below, p. 60.

[277] Cf. Jacopo Nardi's account of the events which in April 1529 led to the fall of the Gonfalonier Niccolò Capponi: 'Avvenne adunque che la sera d'un giorno nel quale s'erano fatte alcune consulte nella audienza della signoria, cadde al prefato gonfaloniere disavvedutamente una lettera mandata a sua eccellenza, e per caso rimase occultata sotto la lunghezza del tappeto del desco, sopra il quale il gonfaloniere l'aveva posata insieme con sue altre scritture . . .'. (*Istorie di Firenze*, ii, p. 154). This table is recorded, three years later, in the inventory of the palace: 'uno desco . . . con un tappeto assai buono' (Inventory 1532, fos. 162ᵛ–163ʳ).

[278] See App. IV. [279] Ibid.

contained, on the right, the privy (*necessarii*) and on the left the office of the First Chancellor.[280] Since he was responsible for the correspondence of the Signoria and for the registration of their deliberations, it was obviously desirable that his office be close to their audience chamber. The passage, which had two windows onto the courtyard,[281] led to the small bedroom of the Notary of the Signoria, who like the latter had to sleep in the palace during his two-month term of office, and then to the room of the Gonfalonier of Justice at its south-west corner. With one window onto the piazza and another onto the Via della Ninna, this room headed, as the largest and most prestigious of the bedrooms of the Signoria, the *camere* of the Priors which all faced the Via della Ninna.[282] Next to the room of the Gonfalonier, facing the piazza, was that of the Notary of the Signoria.[283] The rooms of the Priors were assigned, in pairs, to the four districts (*quartieri*) of the city, beginning with that of S. Spirito and ending with that of S. Giovanni. Before they were reconstructed, probably with more solid partitions, in 1463,[284] these rooms may have resembled the cells of a monastic dormitory.[285] They were all accessible from a corridor with windows on the courtyard. This *andito* was wide enough for small consultative meetings to be held in it. Called *fra le camere*, it had, at its east end, a window which overlooked the second, external, courtyard between the palace of the Signoria and that of the Captain of the People and, after its construction, the customs house,[286] and which was hence called 'Cortile del Capitano' or 'della Dogana'. It was from this window that in 1441 the *condottiere* Baldaccio d'Anghiari was thrown into that courtyard by men of the Signoria's household staff who had been hiding in the Saletta next door.[287] Through this room one returned to the antechamber of the Sala dei Gigli, thus completing the circuit of the second floor.

From this anteroom, a narrow flight of stairs led to the kitchen on the floor above;[288] as these stairs ascended opposite the entrance of the room in which the Signoria took their meals,[289] they made it possible to serve them with a minimum of inconvenience. The attic floor provided accommodation for the *famiglia*, the household staff. In 1471, it contained eleven rooms (*camere*) for the servants, the *donzelli*, of the Signoria,[290] others for their paymaster, the *spenditore*, the cook, and the bell-ringers, the *campanai*, whose room also served as the dining-room of the household staff. The religious, the *frati*, of the palace, had a room and a *saletta* on this floor.[291] Another room, the *barberia*, was used by the barber, the

[280] Cambi, *Istorie*, in *Delizie*, xxi, p. 275: 'chome s'usciva dell'Udienza per andare alle chamere, a mano ripta erano e neciessari, e a mano mancha era la Chancielleria delle lettere'. This room had a self-locking door: see Leonardo Morelli's account of the unsuccessful attempt to capture the palace cited below, n. 295: 'certi ... fanti perugini [of archbishop Salviati], che essendosi nascosi nella Cancelleria e serrato l'uscio, per aspettare loro tempo, non lo poterono mai riaprire, che era serrame alla saracinesca'. Cf. Machiavelli, *Istorie fiorentine*, viii. 7 (in *Opere*, p. 821): 'in modo era la porta di quella [cancelleria] congegnata, che, serrandosi, non si poteva se non con lo aiuto della chiave, così di dentro come di fuora, aprire'. See below, p. 39. Benedetto da Maiano was paid in 1480 for the door of the closet ('hostii necessarii'): Op. Pal., 2, fol. 52ᵛ (9 Dec. 1480).

[281] See App. II. [282] See App. I.

[283] In 1502, the Gonfalonier Piero Soderini 'congiunse alla camera sua ordinaria la camera del notaio de' Signori' (see below, p. 44, and App. I). The room in which he worked was, in 1475, the anteroom in

front of the entrance to the Sala dei Gigli from the stairs. See above, n. 272.

[284] 'E più feciono i sopradetti signori di Gennaio e Febbraio gittare in terra le camere dove abitavano, per rifarle e raconciarle' (Rinuccini, *Ricordi*, p. xc.; see above, n. 223, and App. I).

[285] E.g. in S. Croce: cf. Gaye, i, p. 558 (30 Dec. 1448): 'constructum est in conventu ... dormitorium magnum ... cum cameris.'

[286] See above, pp. 25–6. [287] See App. I.

[288] Cf. Vasari's letter to Cosimo I of 28 Jan. 1561 (Vasari–Frey, i, p. 600): '... la scala che va sopra in cucina diritta et agiata, che racconcia quel ricetto dove risponde il salotto della Duchessa tanto bene, che dal principio al suo fine mostra comodità, ingegnio et bellezza molto maggiore'.

[289] That is, the Sala dei Gigli: see App. III.

[290] They are recorded, with the names of their occupants at that time, in the inventory of the palace of 1471 (Inventory 1471, fos. 2ʳ–4ᵛ).

[291] Ibid., fo. 5ʳ.

barbitonsor;[292] Cosimo de' Medici was locked into it in September 1433 before being taken to the palace's prison, the *alberghettino*, halfway up the tower.[293] A winding staircase led to it from the battlemented walk along the covered gallery surrounding the palace; both of them *Fig. 12* served the Signoria for recreational as well as for military purposes.[294]

The final phase in the history of the palace under the early Medici had been preceded by an event which had once more brought into action its original function as the fortified residence of the government. The Pazzi conspiracy had, like the Ciompi revolt one hundred years earlier, suddenly reminded the Florentines of this function; but while in 1378 the Signoria had failed to take advantage of the palace's fortification and internal security devices, on 26 April 1478 the Gonfalonier of Justice successfully resisted archbishop Salviati's attempt to seize it. Francesco Salviati's retinue had unwittingly locked itself on the second floor into the chancery, since its door could only be opened with a key, and the Gonfalonier ordered the door at the top of the stairs in front of the Sala dei Gigli to be barred, 'so that those who were below it could not ascend the stairs, and those who were above it were captured.'[295] While the access to the second floor was left to the household[296] to defend with spits and such other weapons as they could lay their hands on, the Signoria, who at first had sought refuge in the tower, showered stones from the gallery on Jacopo de' Pazzi and his armed followers, who were attacking the palace from the piazza.[297]

The revolution of 9 November 1494 demonstrated in its turn the effectiveness of the defences of the palace, whenever the Signoria was determined to make use of them. After Lorenzo de' Medici's death in April 1492, his son and successor Piero had become increasingly unpopular; his decision to back the king of Naples against the republic's traditional ally, the king of France, during Charles VIII's Italian campaign had led to the invasion of the Florentine dominions by the French army and to Piero's capitulation to the King. On his return to Florence, Piero was refused admission to the palace with his armed guard: the precedent of the Pazzi conspiracy now acted against the Medici, instead of against their enemies. The great bell of the palace was rung to call the people to the piazza; and in the ensuing rising, Piero fled from the city.[298]

[292] Ibid., fo. 4ᵛ.

[293] Cosimo records that, on having been summoned to appear before the Signoria, he had ordered 'che io andassi su di sopra, e dal Capitano fui messo in una camera che si chiama la barberia' (Fabroni 1789, ii, p. 96).

[294] Cf. Bartolomeo Scala, *Excusatio Florentinorum* of 1478, in Fabroni 1784, ii, p. 179: 'Habet in summo aedificii Palatium duas quasi porticus, tectam alteram, sine tegumento alteram, in modum duplicis coronae ad deambulandi usum fabricatas … Ea non modum ornatius faciunt Palatium, et commoditatem deambulandi et sub tecto et sub dio praebent, sed belligerandi et arcendi … invasorem pulcherrime faciunt facultatem.'

[295] Leonardo Morelli, *Cronaca*, in *Delizie*, xix, p. 193: 'fe serrare la catena, acciocchè chi fussi di sotto, non potessi salire più su, e quegli chi erano di sopra furono presi.' Cf. Rinuccini, *Ricordi*, p. cxxvii; Poliziano, *Congiura* (1958), pp. 37–9; Poliziano, *Congiura* (1856), pp. 95–7. See above, p. 37.

[296] At the time of the attack, there were about fifty members of the *famiglia* in the palace: on 27 May 1478 the Signoria was author-

ized by the councils to reward them for having courageously helped to defend the palace, although they had been 'quasi sanza arme', so that, 'a offendere chi voleva malignare', they had to do so with stones and spits and similar weapons, 'con sassi e con ischedoni e con simili arme'. Only three *donzelli* had not done their duty and were consequently sacked: Provv., 169, fos. 28ʳ⁻ᵛ, 23–7 May 1478. However, as early as 28 and 29 Apr., a number of *donzelli* had been *cassati* by the Signoria: Sig., Delib., ord. aut., 94, fos. 37ᵛ, 38ʳ.

[297] *Synodus florentinus*, in Fabroni 1784, ii, p. 144: 'Magistratus … arreptis candelabris, arreptis verubus, cum alia arma non haberet, invasorem detrudit, turrim ascendit'; Bartolomeo Scala, *Excusatio Florentinorum*, ibid., p. 179: 'in deambulacra conscendit, et illic aditibus clausis se tutatur; atque inde Jacopum Pazium … cum globo armatorum accurrentem … lapidibus e deambulatris magnis jactibus deturbat, arcetque Palatio.'

[298] Parenti, *Storia fiorentina*, I, pp. 121–5; Rinuccini, *Ricordi*, pp. clii–cliii; Landucci, *Diario fiorentino*, pp. 73–5.

REPUBLICAN REFORM

The abolition, after Piero's flight, of the institutional reforms of the Medici regime, and the recovery by the Signoria of its full constitutional powers, were bound to affect the palace.[299] With the abolition of the council of Seventy and of the Otto di Pratica, confirmed by the *parlamento* of 2 December, the mezzanine floor lost the prominent role it had played after 1480; the political point of gravity reverted, for the time being, to the second floor, where the Signoria with its two Colleges was from now onwards to fulfil its extensive functions, without being any longer constrained by Medicean controls. The *parlamento* sanctioned the restoration of the republican system of government in force before the establishment by the Medici of their political ascendancy; the Signoria was once more to be elected by lot, and with the abolition of the Medicean councils of Seventy and One Hundred, the ancient councils of the People and of the Commune were to recover their exclusive right to legislate. The intention was to restore the structure of government which Florence had possessed before 1434. In fact, this programme was replaced shortly afterwards with a far more radical one, which affected the development of the palace much more profoundly than such a restoration would have done. On Savonarola's initiative, the councils voted, three weeks later, to establish, in their place, a Great Council, to be in charge both of legislation and of election to public office, to which all citizens who themselves (or whose forebears over three generations) had been made eligible for government office—that is for the Signoria and its Colleges—were automatically admitted.[300] Their number turned out to be well over 3,000 and, to render possible meetings of the new council, it was at first decided to convene it in three rotating sections. Even so, the statutory quorum rendered meetings difficult to accommodate in the council room on the first floor.[301] As a result, the Great Council decreed, on 14 May 1495, that Operai del Palazzo be appointed, 'to find a place' for the meetings, since 'the present hall . . . is inadequate for them, without discomfort to so great a number of citizens'.[302] This discomfort must have contributed to the frequent failure to reach the quorum required for the meetings; but when, as a result of this situation, it was decided, in August, to abandon the division of the Great Council into three sections and to have it meet in its entirety, with a quorum of no less than 1,000, the construction of a new hall became indispensable. This explains also why this construction, which was entrusted to Monciatto and Cronaca under the supervision, as architect, of Antonio da Sangallo, was carried out at record speed, so that as early as February 1496 the first election in the council could take place in its yet uncompleted new hall.[303]

Fig. 13 The new hall, whose ceiling was not completed until 1498,[304] was partly built above the customs house opposite the eastern façade of the palace. This was the only space where a substantial addition was possible. The duke of Athens had been planning to extend the palace in this direction, and had begun the construction of two walls adjoining it on the north and

[299] For this and the following, see Rubinstein 1960, pp. 151 ff.

[300] See Rubinstein 1954, pp. 154 ff.

[301] The larger of the two ancient councils which used to meet there had 285 members. *Statuta* 1415, v. i. 185 (ii, p. 660).

[302] Frey 1909, p. 113, no. 3, under 11 May. See Rubinstein 1954, pp. 172, 174; the law was passed on 11 and 14 May.

[303] Wilde 1944, pp. 67–8; Rubinstein 1954, pp. 175–6. Its first meeting took place on 25 Feb., and not on 26 Apr. (ibid., p. 179), on which day a religious ceremony inaugurated the continuous use of the new hall. See Landucci, *Diario fiorentino*, p. 129.

[304] Wilde 1944, p. 68.

south sides, but was expelled from Florence before he could carry out his project.[305] Early in the fifteenth century, the Ufficiali del Monte appear to have been accommodated outside the east wall;[306] the far more ambitious decision to build a new council hall opposite that wall opened a new chapter of the history of the palace under the republic, and initiated a development which under Cosimo I and Ferdinand I was finally to result in its extension as far as the Via dei Leoni.

The establishment of the Great Council had been inspired by the Maggior Consiglio of Venice; its hall had as its principal model that of its Venetian counterpart; even its measure- *Fig. 14*
ments were almost identical.[307] At the same time, the large number of citzens whose attendance was required at the meetings of the council would in any case have necessitated a vast hall to accommodate them. There were moreover considerable differences in the interior arrangement of the two halls, the most important being the location of the tribune of the Signoria, which in Venice was at one of the short walls of the hall, in Florence at one of its long walls.[308] Contrary to received opinion since the publication of Johannes Wilde's fundamental study of the hall, this must have been not the east wall facing the entrance to the hall, but its west wall.[309] Considerations of conciliar procedure alone would point to this conclusion; in the former case, in order to reach its seat, the Signoria would have had to cross the entire width of the hall across the councillors' benches.[310] This would have been in sharp contrast to the customary arrange-ment in the old council hall on the first floor, where the Signoria had direct access to its *residenza* from its rooms,[311] as well as to that in the hall of the Maggior Consiglio in Venice.[312] The location of the Signoria's tribune appears to be confirmed by Vasari's statement that it was 'at the centre of the façade towards the east',[313] and by Giannotti's that next to it there was a door leading to 'una stanza chiamata il segreto'.[314]

There were, by February 1497, 'two doors through which the citizens enter the hall'.[315] As in Venice, they were situated on either side of the tribune of the Signoria. The principal entrance was from a passage (*andito*) through which the citizens could reach the new hall from the top of the stairs in front of the old council hall on the first floor of the palace. This *andito*, situated on the northern side of the Cortile del Capitano, was in the form of an open loggia

[305] See above, pp. 15–16. [306] See above, pp. 22, 24.
[307] Wilde 1944, pp. 70, 74–5. [308] Ibid., p. 75.
[309] This is also the conclusion reached by Newton and Spencer 1982, pp. 47 ff., as a result of the application of ultrasonic technique to the investigation of its walls. See for this and the following, App. VIII.
[310] Isermeyer 1964, p. 105, assumes, without any supporting evi-dence, that there was a passage between the benches of the council-lors from the altar which he, like Wilde, locates on the west wall, to the *loggia* of the Signoria opposite.
[311] As can be seen in Vasari's painting of that hall, on the ceiling of the Sala dei Cinquecento, in which the tribune of the Signoria is shown along the south wall of the Sala dei Dugento (Fig. 49).
[312] In Venice, the Signoria entered the council hall from the ante-room behind its tribune.
[313] Vasari–Milanesi, iv, p. 450 (Life of Cronaca): 'nel mezzo della facciata che è volta a levante'. See App. VIII.
[314] *Discorso intorno alla forma della repubblica di Firenze*, in Giannotti, *Opere*, i, p. 20: 'per una porta che era allato a quello [i.e. the *tribunale della Signoria*] entrava in una stanza chiamata il

segreto . . .'. Vasari states (loc. cit.) that a second door, on the other side of the Signoria's tribune, led to the *specchio*, that is a room in which the register of tax debtors was kept. In 1507, a payment 'pro mansione speculi' is recorded (Sig., Delib., ord. aut., 109, fo. 209ᵛ, 31 Aug. 1507), without indication of its location. According to the Statutes of 1415 (v. i. 311 (ii, p. 803)) an office for the *specchio* was to be constructed 'in loco praestantiarum', the tax office in the Via delle Prestanze, the present Via dei Gondi. Giannotti, who, as former Second Chancellor, knew the hall well while it was still serv-ing as the meeting place of the Great Council, does not mention the existence of such a room with access to that hall. Isermeyer's (1964, p. 105) suggestion that the *segreto* and the *specchio* mentioned by Vasari were in 'seitlich vom Gonfaloniersitz in den Saal vorspringenden hölzernen Flügelbauten' is, in the light of Giannotti's statement, untenable. The two *aliette*, which he identifies with such structures on the Venetian model (see Frey 1909, pp. 121, 123, nos. 70, 77, 95), were surely wings of the tribune of the Signoria. See Apps. VII and VIII.
[315] D. Cecchi, *Riforma sancta et pretiosa*, p. 185: 'avete dua porte donde entrano e cittadini nella sala.'

whose roof was supported by columns; their installation was completed in April 1497.[316] The second door must have been located at the southern end of the west wall, so that members of the council could enter their hall by crossing the courtyard of the Captain at its southern end, next to the Via della Ninna. It was at this side of that courtyard that Cronaca constructed, in 1507, stairs to the hall of the Great Council, which finally made it possible to reach it directly from street level, rather than through passages connecting it with the palace.[317]

The creation of the Great Council had brought about a far-reaching change in the political structure of Florence, and this change necessarily affected the palace of its government. In contrast to the councils of the People and of the Commune, whose membership changed three times a year, and to the council of One Hundred, whose membership changed twice, that of the Great Council was, for all practical purposes, like that of the Maggior Consiglio of Venice, hereditary and permanent. In charge of legislation as well as of elections, the sovereignty of the Florentine people was effectively vested in it. Guicciardini called it the 'anima del governo populare' and the 'fondamento della libertà',[318] Giannotti the 'corpo che era il signore di tutta la Repubblica'.[319] Savonarola, who more than anyone else had been responsible for its establishment, believed that, as the foundation of the new 'governo civile', it was God's gift to the Florentines.[320] A Latin inscription which in 1496 was installed in its hall warned the citizens that the council was 'from God, and whoever should try to ruin it will come to a bad end'.[321] Under the new republican regime introduced in December 1494, the hall of the Great Council thus became not only its most conspicuous, but also its symbolic centre. When the council was abolished after the return of the Medici in September 1512, the conversion of its hall into barracks for the palace guard was universally lamented, for 'to have such a splendid tribune of the Signoria brought great reputation and honour to the city';[322] and when, after the short-lived restoration of the republican regime in 1527, the hall was cleared by young Florentines and returned to its original function, this was seen as a demonstration of patriotism.[323] Having been officially inaugurated, in April 1496, with a sermon delivered in it by Savonarola, the hall was now, before the first meeting of the council on 1 May 1527, 'purged and expiated by the priests with holy water, according to the usage of religious ceremonies'.[324]

In a less spectacular fashion, the construction of the hall released space in the main block of the palace, in so far as the old council hall was no longer required for meetings of the councils that had been abolished in 1494. It now provided office space for magistracies such as that responsible for Arezzo, which in 1503 had its *scriptoio* there;[325] but its principal function was to

[316] Landucci, *Diario fiorentino*, p. 146: 'E a dì 21 [of Apr.], fu fornito di porre quelle colonne di marmo a l'andito che va di Palagio nella Sala grande, di verso la Mercatanzia.' In Dec. 1495, the Signoria had ordered columns from the chapel of Piero de' Medici to be brought to the palace: ibid., n. 2. The loggia of the *andito* is visible in the painting, of *c*.1500, of the execution of Savonarola (Fig. 40).

[317] Cambi, *Istorie*, in *Delizie*, xxi, p. 226. Cf. Sig., Delib., ord. aut., fo. 209[r-v], 30 June and 31 Aug. 1507, on payments 'pro schala' of the council hall, the work being carried out under Simone del Pollaiuolo, il Cronaca, 'architettore di detta muraglia'. See also below, p. 45.

[318] Guicciardini, *Dialogo*, pp. 101, 103.

[319] *Discorso*, cit. in Giannotti, *Opere*, i, p. 18.

[320] *Trattato circa el Reggimento . . . di Firenze*, iii. 2 (pp. 476–7): 'Ciascun cittadino fiorentino . . . bisogna prima che creda questo Consiglio e civile governo essere stato mandato da Dio . . .'.

[321] Landucci, *Diario fiorentino*, p. 126: 'diceva, che tal Consiglio era da Dio, e chi lo cerca guastare capiterà male'. See below, p. 73.

[322] Ibid., p. 333: 'la qual cosa dolse a tutto Firenze . . . Ed era di grande riputazione ed onore della città avere sì bella residenza.' For the meaning of *residenza*, cf. Frey 1909, p. 123, no. 95: 'ad residentiam magnificorum Dominorum . . . in sala magna consilii'. See also App. VIII.

[323] Nardi, *Istorie di Firenze*, ii, p. 132.

[324] Landucci, *Diario fiorentino*, p. 129; Nardi, *Istorie di Firenze*, ii, p. 133: 'essendo netta e purgata la sala da ogni lordura, fu eziandio purgata e espiata da' sacerdoti con l'acqua santa secondo l'uso delle cerimonie sacre.'

[325] Op. Pal., 10, fo. 45[r], 10 Mar. 1503.

serve as the meeting place for the new council of Eighty, whose personnel, including *ex officio* members, in fact amounted to about 150 citizens.[326] Designed as a legislative council of first instance which also elected ambassadors and commissars, it could also act, with the addition of other, specially summoned citizens, as a large advisory committee, a *pratica larga*, of the Signoria. Piero Soderini, who was elected in 1502 Gonfalonier of Justice for life, preferred large to small *pratiche*, and as a result the size of their membership ranged from 50 to as many as 400.[327] Such meetings could also take place, as *pratiche* had normally done before 1494, on the second floor.[328] Smaller advisory committees, *pratiche strette*, were now regularly summoned by the Dieci, renamed in 1494 *Dieci di Libertà e Pace*. Until 1502, these meetings were presumably held in the large room on the mezzanine which between 1480 and 1494 had served as council chamber of the Seventy. After the election of Piero Soderini as Gonfalonier of Justice for life, part of that floor was converted for the use of the Gonfalonier and his wife, and as a result the Dieci were deprived of their office and *sala* there.[329]

PIERO SODERINI GONFALONIER OF JUSTICE FOR LIFE

The transformation, in 1502, of the Gonfalonierate of Justice into an office for life constituted yet another landmark in the political history of the palace. Until that date, the Gonfalonier served, like the Priors, for two months, during which period he shared with them the living-quarters on the south side of the second floor. His room was larger and better furnished than those of the Priors; situated at the south-west corner, it had, as we have seen, two windows and a view over the piazza.[330] Even so, it was hardly adequate as a permanent residence, and certainly not for a Gonfalonier who, like Piero Soderini, was married. Women had in the past been strictly forbidden to spend the night in the palace;[331] that Argentina Malaspina should take up residence in it with her female retinue was a drastic departure from this rule, which was widely resented. According to Cerretani, it was Argentina's move into the palace which was responsible for the conversion of part of the palace into a residence for the Gonfalonier and herself, and the creation on the gallery (*ballatoio*) of a roof-garden.[332]

In view of the scarcity of available space, an apartment for the Gonfalonier could be created only at the expense of other magistrates. Parenti writes that, in order to 'set up a suitable

[326] Giannotti, *Discorso* cit. (n. 314 above), p. 25: 'una sala, chiamata la sala degli Ottanta, che è al mezzo della scala'. On the membership of the Eighty, see Cooper 1985, p. 92.
[327] Cooper 1978, pp. 80–1.
[328] Cambi writes, on Piero Soderini's flight from Florence in 1512, that he had left the palace 'sanza saputa de' Signori, ch'erano a sedere nel chonsiglio degli 80 colla praticha, insulla sala dell'Udienza' (*Istorie*, in *Delizie*, xxi, p. 308; cf. App. III). Cf. also Agostino Vespucci's letter to Machiavelli of 14 Oct. 1502 (Machiavelli, *Opere*, p. 1033): 'Riccius ... cum esset in Consilio octuaginta virorum ... descendit schalas, in Chancelleriam se proripit ...'.
[329] The location of their audience chamber is not recorded in the minutes of subsequent *pratiche*: cf. *Consulte e Pratiche 1505–1512*, *passim*).
[330] See App. I.
[331] *Statuto del Capitano del Popolo* of 1322, ii. 3 (p. 84): 'Et ipsi berrovarii non permictant aliquam mulierem intrare palatium

populi, que hospitetur in eo de nocte . . .'. In 1464, the herald of the Signoria, Francesco Filarete, was temporarily sacked because, as Cristoforo Landino writes to Lorenzo de' Medici in his defence, 'vinto dalle lusinghe d'una feminella è tanto trascorso che, dimentichatosi della maiestà del luogho, la condusse furtim in Palagio et in chamera sua due giorni la tenne. Errore certo non mediocre maculare el luogho e' quale debba di religione et castità esser pieno' (ed. Zippel 1892, pp. 369–70).
[332] *Storia fiorentina*, p. 320: 'la moglie del quale g[i]untta in palazo co non pochi servidori e serve si dette hordine a rassettare quello luogho, et ... si murò intorno al ballatoio g[i]ardini murati ne' quali a uso d'ortti pensili si pose moltissimi frutti.' On 27 May 1502, the Operai record a payment 'per la portatura di 24 carretate' of earth 'per ... gl'orticini del Gonfaloniere' (Op. Pal., 10, fo. 27r; cf. fos. 50v–51r). Soderini's wife did not move into the palace until Feb. 1503: see below, n. 336.

residence in the palace', Piero Soderini 'joined to his ordinary room that of the Notary of the Signoria, and from it he descended by a spiral staircase to the room of the Dieci di Balìa, which he occupied in its turn together with their *sala* and with other rooms of the chancellor of the *tratte*', both of which magistracies received new quarters.[333] Cerretani records that 'new rooms having been created for the Gonfalonier and his household and wife', a barred gate (*rastrello*) was installed in the passage leading to the chancery of the *Riformagioni*—a measure which caused great offence, 'although he said that it was taken for his security'.[334] Parenti too implies that the conversion carried out by Soderini was criticized, but was 'put up with'.[335] What shocked the Florentines in particular, he says, was that the palace was now, 'contrary to custom', filled with women who used the stairs and could be seen standing at the windows.[336] The Gonfalonier was blamed for their behaviour: he should keep them in his own house, and not 'in the public palace'.[337]

By taking over the rooms of the Dieci and of the chancery of the *Tratte* on the mezzanine,[338] as well as the room of the Notary of the Signoria next to the Gonfalonier's room on the second floor, Piero Soderini created an apartment on two floors which was connected by stairs for his private use[339] and protected by a barred gate near the top of the stairs from the first to the mezzanine floor.[340] Soderini appears to have left some of the rooms on the mezzanine to his wife and her retinue;[341] this may have been the reason for his apparent annexation of yet another room, on the first floor, probably the room which in 1505 was called his 'sala di sotto', his 'lower *sala*'.[342]

[333] *Istoria fiorentina*, II.II.133, fo. 67^{r-v} (Nov. 1502): '. . . fu etiam sua prima cura parare stanza in palazzo a suo proposito, onde congiunse alla camera sua ordinaria la camera del notaio di Signori, et di quella per una scalla in chocciola scese giù nella habitatione de' X della Balìa, et quella ancora per suo uso occupò insieme con la loro salla et altre stanze del cancelliere delle Tratte, datto a questo nuovo luogo, et sendone 'sclusi detti X, a loro si consegnò nuova habitatione . . .'. Cerretani, *Ricordi*, p. 73: 'dipoi havea cincistiato il palazo et fatto de le trate una chucina et dipoi uno chancello . . .' (see following note). Biagio Buonaccorsi writes to Machiavelli on 3 Nov.: 'Essi hoggi cominciato ad assettarli [i.e. Piero Soderini] la audientia de' Dieci nel modo sapete; et la nostra cancelleria [i.e. the Second Chancery] per hora servirà a' Dieci nel modo sapete, et la sala a noi' (Machiavelli, *Opere*, p. 1043). In 1507, Betto di Luca Buchi was paid 'per la manifactura delle spalliere dell'Udienza de' X et per le cancellerie' (Sig., Delib., ord. aut., 109, fo. 210r, 30 Oct. 1507). Cf. Cerretani, loc. cit. above, n. 332: '. . . si dette hordine a rassettare quello luogho, et fatto dell'audienza de' dieci della ghuerra et delle tratte stanze per suo habitare . . .'. See also App. I.

[334] *Storia fiorentina*, p. 315: '. . . et im palazo si fe' nuove stanze pel ghonfaloniere e sua famiglia e donna et dalla finestra della croce andare alle riformag[i]oni si fe' un rastrello di legname che si serrava, cose che offendevano molto con tutto che dicessi erano per sua sichurtà . . .'. Cerretani gives additional information on this gate in his *Ricordi* (see n. 333); he writes that Soderini had 'dipoi [fatto] . . . uno chancello alla finestra di vetro della crocie chon uno sportelino picholissimo dove s'entrava, et questo voleva perché voleva sapere chi andava su a' signori et non voleva si sapessi chi andava alli altri'. See App. V.

[335] Loc. cit. above, n. 333: 'di che si fece tacitamente alquanto discolpare, pure si sopportò, non havendo ardire persona per contradire. Interpretavasi tale cosa dalli emoli suoi diversamente, ma taceasi per al presente.'

[336] *Istoria fiorentina*, II.II.133 fo. 88v (Mar. 1503): 'Intanto etiam venutane il carnasciale, la donna sua per ferma stanza si transferì ad habitare in Palazzo, et riempiutosi di donne il Palazzo, et viste stare alle finestre di quello, et le scale frequentarsi da donne fuori del consueto, si giudicava cosa indegna.' Argentina Malaspina moved into the palace on 19 Feb. 1503: Landucci, *Diario fiorentino*, p. 254.

[337] *Istoria fiorentina*, cit., fo. 95r (Apr. 1503): '. . . rinfacciandoli e portamenti delle donne, et biasimando l'haversi usurpato per lui le habitationi del Palazo assegnate a' Dieci della Balìa et alle Tratte; pertanto restituissi el tolto, et tenessi le donne a casa sua, non nel publico Palazzo.'

[338] The conversion of the mezzanine was begun only two days after Piero Soderini took up residence in the palace on 1 Nov. (Landucci, *Diario fiorentino*, p. 251): see Biagio Buonaccorsi's letter to Machiavelli of 3 Nov. cited above, n. 333.

[339] On 23 May 1503, Sandro de' Vetri was paid for a 'tondo della schala del Gonfaloniere facto di nuovo': Op. Pal., 10, fo. 51r.

[340] See above, n. 334. On the 'finestra della croce' see App. V.

[341] See Varchi, *Storia fiorentina*, ii, p. 183: the Mediceans who during the siege of Florence in 1529–30 were kept under arrest in the palace of the Signoria were staying 'sotto le loro [i.e. the Signoria's] camere nelle stanze già di Madonna Argentina al piano della croce', that is the mezzanine: see App. V. The number of these citizens amounted to nineteen. See also App. I.

[342] On 31 Oct. 1505 Francesco and Lorenzo Ruspoli *linaiuoli* were paid for 'braccia 7 di tela per le finestre della sala del Gonfaloniere di sotto'. This room is distinguished from his *audientia*: they are also paid for 'braccia 6 di tela . . . per fare gli sportelli inpannati nella audientia del Gonfaloniere': Frey 1909, p. 135, no. 235. This surely was one of the rooms which Morto da Feltre decorated with grotesques, for Vasari writes that his decoration had been destroyed 'per racconciare le stanze del Duca Cosimo', that is Cosimo I's rooms on the first floor: Vasari–Milanesi, v, p. 204. See below, Ch. 2, n. 288.

Both the addition to Soderini's residential quarters and the special arrangements for his security were in sharp contrast to the easy terms of equality to which the Signoria, including the Gonfalonier, had been used during their two-month stay in the palace. To critics of Soderini, they demonstrated in tangible fashion the danger of Soderini abusing his new constitutional position as Gonfalonier for life. Cerretani's account shows how Florentines could connect the changes which he made in the palace with his alleged autocratic tendencies: immediately after describing the creation in it of an apartment for Soderini and his wife, he writes that 'he took counsel with between 12 and 16 citizens'.[343]

This apartment evidently required new furnishings. In March 1503, the *capomaestro* of the palace, Baccio d'Agnolo, was paid for 'a large cupboard [*armario*]', 'a cupboard with predella', and 'a small cupboard [*credenza*] with intarsia'.[344] It was also newly decorated; in May, Davide Ghirlandaio was paid for a *tondo* of St Peter and St Paul, in June Domenico di Domenico for a *tondo* of St Thomas the Apostle and St Thomas Aquinas, 'for the room of the Gonfalonier',[345] and in May, Francesco di Piero di Donato for painting the room of the Notary of the Signoria, 'which is nowadays for the use of the Gonfalonier'.[346]

The creation, within the confines of the palace, of an apartment for the Gonfalonier of Justice at the expense of existing office accommodation, rendered necessary the addition of space which could be used for the latter. New space could be created by filling, on the north and on the south side of the second courtyard, the gap between the customs house and the hall of the Great Council, and the main block. Work on this building operation, which coincides with the construction of the stairs to that hall, proceeded in two phases. Cambi writes that around 1507 an 'addition was made to the palace' of the Signoria, 'from the palace to the great hall of the General Council towards S. Piero Scheraggio', that is on the south side.[347] *Fig. 15*
Many payments for this building work, for which the enclosure wall built by the duke of Athens on the side of the Via della Ninna was used as a foundation,[348] are recorded in 1508,[349] among them for 176 cartloads of masonry debris (*calcinacci*) in August and for 92 cartloads of stones in December.[350] The same procedure was followed, three years later, on the north side. The passage (*andito*) between the first floor and the hall of the Great Council, which after 1495 had served as the principal access to that hall, was now integrated into a new wing.[351] This *Fig. 16* wing, faced, in Cambi's words, with 'rusticated stones like the rest of the palace', had, above that passage, on the level of the second floor, a room which was assigned to the First Chancellor: he lost his office as a result of the decision to construct a separate chapel outside the

[343] *Storia fiorentina*, p. 315 (cf. n. 334): 'Consigl[i]ava le cose con 12 in 16 ciptadini'. On the criticism of Soderini's use of his powers, see Bertelli 1971, pp. 347; Cooper 1978; Butters 1985, pp. 78–82, 175; cf. Guicciardini, *Storie fiorentine*, pp. 270–3.
[344] Op. Pal., 10, fo. 45ʳ, A. Cecchi 1990a, p. 39, n. 92 (10 Mar. 1503).
[345] See below, Ch. 2, n. 286. [346] See ibid.
[347] *Istorie*, in *Delizie*, xxi, p. 226: 'si fece quella agiunta al Palazzo de' Magnifici Signori dal Palazzo alla sala grande del Chonsiglio gienerale di verso S. Piero Scheraggio.' On the new stairs, see above, p. 42. [348] See above, pp. 15–16.
[349] Sig., Delib., ord. aut., 110, fos. 200ʳ–204ʳ (30 Apr. to 31 Dec. 1508).
[350] Ibid., fos. 201ʳ (31 Aug.), 202ᵛ–203ᵛ (31 Dec. 1508). Cerretani records: 'Im questi dì [Dec. 1509] sendo finito tra la sa[la] del

chonsiglio e 'l palagio de' signori quella ag[i]unta dirimpetto a S. Piero Scheraggio si messe la portta di marmo rosso che va dalla chortte del palagio de' signori in sala del chonsiglio' (*Ricordi*, p. 217).
[351] Cambi, *Istorie*, BNF, MS II.III.69, fo. 157ᵛ, ed. *Delizie*, xxi, pp. 275–6: the Operai del Palazzo 'alzorono sopra la porta di Doghana di verso la Merchatanzia di pietre abozzate, chom'era el resto del palazzo, e feciono dua finestrati insu dua anditi, che l'uno di sopto va nella sala nuova del Chonsiglio Gienerale . . . e in su l'altro andito, che viene di sopra, e al piano della sala de l'Udienza, feciono la Chancelleria, ché dove è la porta della Chancelleria insu detta sala, era una finestra che ghuardava in Dogana.' This window was on the north end of the east wall of the Sala dei Gigli, that is, of the wall which was frescoed by Ghirlandaio.

audience chamber of the Signoria, to replace the altar which had up to then served as their chapel.[352]

Figs. 17, 51 The new chapel was designed to enhance the appearance of the floor which was rescued for the Signoria; at the same time, it provided a far more dignified setting for the rooms of the Gonfalonier on that floor than the haphazard arrangement of the space between those rooms and the audience chamber of the Signoria. Had it been completed before the fall of Soderini, it would have constituted the crowning piece of the conversions which he had initiated in the palace after his election but its decoration was not completed until 1515.[353] On 1 September 1512 he was deposed, having been forced to flee the city; it was later believed that his downfall had been predicted by the lightning which had struck the palace the year before.[354] A fortnight after his expulsion, the Medici regime was restored, and shortly afterwards the term of office of the Gonfalonier reverted to the statutory two months of the Signoria;[355] yet Piero Soderini's initiative in converting part of its palace into his permanent residence was not destined to remain an isolated incident in the history of the building. Three decades later, that initiative was to form a precedent, if not a model, for the transformation of the republican palace of government into a ducal residence for Cosimo I.

[352] '. . . fecionosi fare di nuovo la Chapella loro di Palazzo, ch'era prima un senpricie altare nella loro Udienza, allato alla porta de l'entrata de l'Udienza, che solo una pancha divideva la chapella da l'Udienza, e feciolla da l'uscio che andava tralle chamere de' Signori, ché chome s'usciva dell'Udienza per andare alle chamere, a mano ripta erono e neciessari, e a mano mancha era la Chancielleria delle lettere . . . e feciono ditta [MS ditto, *ed.* di tutto] chapella chome al prexente si vede, e rifeciono gli agiamenti dove sono al prexente allato alla chamera del notaio de' Signiori; e lla Chanciellleria si

rifecie, ché alzorono . . .' (continued above, n. 351). See App. IV.

[353] See below, pp. 77–8.

[354] Machiavelli, *Discorsi sopra la prima deca di Tito Livio*, i. 56 (*Opere*, p. 139): 'sa ciascuno ancora, come, poco innanzi che Piero Soderini . . . fosse cacciato e privo del suo grado, fu il palazzo medesimamente da uno fulgure percosso.' On the lightning which struck the palace in Nov. 1511, see above, n. 267, and App. IX.

[355] Stephens 1983, pp. 66–7.

2

THE INTERIOR DECORATION OF
THE PALACE

By the beginning of the fourteenth century, it was becoming customary for town halls to be decorated with paintings. By far the most magnificent example of such early decoration of public palaces is provided by the Communal palace of Siena. Constructed almost exactly at the same time as the Palazzo Vecchio, the Palazzo Pubblico must have had its council hall decorated from the moment that hall was completed: a document of 1314 refers to earlier paintings on its walls, and probably in the following year Simone Martini began to cover almost the entire space of one of them with his fresco of the *Maestà*.[1] In 1330, he was commissioned to paint the castles of Montemassi and Sassoforte. The representation of the former, with the equestrian portrait of Guidoriccio da Fogliano, occupies part of the opposite wall to the *Maestà*.[2] Between 1337 and 1340, Ambrogio Lorenzetti frescoed the three main walls of the audience chamber of the government of Nine. The Sala del Mappamondo and the Sala dei Nove are still resplendent with these paintings. In contrast to this wealth of decoration in Siena, no mural pictures from that century have survived in the Palazzo Vecchio. The principal reason for this has no doubt to be sought in the conversions which the medieval palace, unlike its Sienese counterpart, underwent during the following two centuries, culminating in those executed by Vasari when the palace was transformed into the ducal residence. However, the scarcity of documentary and literary evidence of such pictures may also indicate a corresponding paucity of figurative, as against ornamental, decoration during this period.

The earliest known record which relates to decorative work being carried out in the Palazzo Vecchio is of 1318.[3] This could in fact refer to ornamental decoration, such as is still visible on some of the walls and ceilings of the mezzanine and the second floor.[4] According to Vasari, *Fig. 20* writing in the middle of the sixteenth century, there still existed, in a room which in his day was occupied by the *depositeria*, a portrait by Giotto of duke Charles of Calabria kneeling before the Virgin.[5] This painting must have been executed between 1326 and 1328, when the duke was

[1] See below, n. 11. On the *Maestà*, Martindale 1988, pp. 14–18, 204–09.

[2] There is now a voluminous literature on the controversial authorship and date of the Guidoriccio fresco; see ibid., pp. 40–1, 44, n. 16, Seidel 1982, and Martindale 1986.

[3] Provv., 15, fo. 181ʳ; Gaye, i, p. 452 (2 June 1318): the present and future *camerarii* of the Commune are to pay the religious in charge of the Camera dell'Arme, Fra Lorenzo, up to 200 florins, to be spent 'particulariter in reparatione, magisterio et opere et picturis

murorum et voltarum palatii populi'.

[4] See Lensi Orlandi, pp. 33–5. Most of the ornamental decorations in the style of the 14th cent. are, however, due to 19th- and early 20th-cent. restoration.

[5] Vasari–Milanesi, ii, p. 436. According to Lensi Orlandi, p. 35, the *depositeria* was on the mezzanine floor; that it was in Vasari's day in the attic ('dov'è oggi la Depositeria') emerges from his statement that it belonged to the 'ordine di stanze comode per la famiglia del palazzo' which he constructed 'di sopra' the rooms of the Signoria on

Signore of Florence, since his death in the latter year was followed by a reaction against despotic rule.[6] It may have been in the course of legislation which was then enacted in order to reform and strengthen the republican institutions of Florence that the councils decreed that henceforth none of her foreign magistrates might have executed in his palace 'any picture or sculpture, whether figurative ('alicuius ymaginis') or of armorial bearings, on external or internal walls, or on slabs', unless it represented a religious subject or the arms of the Papacy, of Charles of Anjou or his descendants, or of the king of France. Existing decorations which fell under this ban were to be obliterated or removed.[7] Another exemption concerned paintings 'of any victory or acquisition by the Florentine Commune of cities or castles'.[8] The law of June 1329 refers specifically to the residences of the three foreign officials, the Podestà, the Captain of the People, and the Executor of the Ordinances of Justice, and to the walls of the city. The Podestàs, who during the periods of Angevin rule had been nominated by the Anjous,[9] must have decorated the houses in which they resided, including the Bargello, with their armorial bearings and with other paintings or sculptures.[10] The law of 1329 does not apply to the palace of the Signoria, but the fact that it exempts from its prohibitions representations of victories and of territorial acquisitions is relevant to the decoration of that palace as well.

As we have seen, the earliest record of mural decoration in the Sienese Palazzo Pubblico refers to representations of the acquisition of *castelli*. In March 1314, when ratifying the submission of Giuncarico, the General Council decreed that this castle 'be painted in the palace of the Commune of Siena, where the councils meet, and where other *castelli* which had been acquired by the Commune of Siena have been painted.'[11] These latter paintings no longer exist, but the *castello* in the recently discovered fresco on the wall opposite the *Maestà* has been identified with Giuncarico.[12] The fresco above it moreover relates to the acquisition of two other *castelli*, which Simone Martini was commissioned to paint in 1330 'nel palazzo del Comune'.[13] In 1363 or 1373, Lippo Vanni painted in the same council hall a victory of the Sienese over a mercenary company in the Valdichiana.[14]

In 1329 then, victories and territorial aggrandisement were two subjects which the Florentines allowed to be represented in the palaces of their three foreign magistrates. Were they represented in the palace of their government? Two paintings, one of a victory over the White Guelfs and the Ghibellines near the *castello* of Pulicciano in 1302,[15] the other of the conquest of the *castello* of Montaccianico in 1306, are recorded in contemporary Florentine documents. Both these, however, were in the Bargello, the palace of the Podestà.[16] There are

the second floor (see App. I). In 1520, the *depositeria* was on the second floor: in the inventory of that year, the 'stanza de la depositeria' is listed as being next to the *camera* of the Gonfalonier: Inventory 1520, fos. 11ʳ–12ʳ.

[6] Giovanni Villani, *Cronica*, x. 107–8 (iii, pp. 102–5).

[7] Law of 20 June 1329, ed. partly N. Santini 1919, p. 17; Seidel 1982, p. 41: 'aliquam picturam seu sculpturam alicuius ymaginis vel armorum in muro, lapide vel pariete'.

[8] '. . . nisi esset pictura pro aliqua victoria vel aprehensione alicuius civitatis seu castri, facta pro Comune Florentie.'

[9] Davidsohn, *Geschichte*, iii, pp. 621–3; *Forschungen*, iv, pp. 547–9.

[10] It may have been due to the destruction of armorial bearings as

ordained by the law that so few of them from the 14th cent. have survived, as Uccelli 1865, p. 193, suggests.

[11] Ed. Seidel 1982, pp. 36–7 (30 Mar. 1314): 'quod dictum castrum pingatur in palatio Comunis Senarum ubi fiunt Consilia, ubi sunt picta alia castra acquistata per Comune Senarum.'

[12] Seidel 1982, pp. 30–3. [13] Ibid., p. 25.

[14] Borghini 1983, pp. 224, 226.

[15] Davidsohn, *Geschichte*, iii, pp. 243–5. According to Davidsohn, it was 'an die Mauer des Podestà-Palastes gemalt', but the payment to the painter—Grifo di Tancredi—is made for paintings 'quas fecit et facit in palatio Comunis Flor. de facto Pulliciani' (ibid. iv. 3, p. 221 n. 4: on p. 221, he locates the painting in the palace of the Signoria, but 'in palatio Comunis' must refer to that of the Podestà).

[16] Ibid. iii, pp. 325–7, and iv. 1, p. 328. Cf. Ortalli 1979, pp. 63–4.

references in two fifteenth-century sources to what may have been a painting of a battle in the palace, but could also have been a commemorative inscription. In his *Life* of Dante of 1436, Leonardo Bruni refers to 'parole scritte in palagio' about the victorious battle of Campaldino in 1289,[17] while in his *History of the Florentine People* he states that these words may be read 'in publicis monumentis'.[18] *Monumenta* is ambiguous: it might mean 'annals', as Donato Acciaiuoli took it in his vernacular translation of 1473 of Bruni's work, rendering 'in publicis monumentis' as 'nelle publiche scripture'.[19] But whatever the nature of this commemoration, it must have been located in the palace of the Signoria, for the chancellor of Florence would not have written of any other building 'in palagio'. If the commemoration was in fact an inscription, it may have accompanied a painting of the battle, but the words could also have been inscribed on one of the walls of the palace without being connected with any such painting.[20] In the 1380s, when he was a member of the Otto di Guardia, Franco Sacchetti wrote a sonnet which he had inscribed in their audience chamber and which probably did not accompany a painting.[21] Other inscriptions without paintings may have existed in the fourteenth-century palace.

Most of the paintings which are recorded as having been executed in the palace during the fourteenth century represent saints. Of these, the most prestigious was the panel of St Bernard which Bernardo Daddi painted in 1335 for the chapel of the audience chamber of the Signoria.[22] The dedication of their chapel to St Bernard of Clairvaux may have been primarily due to the fact that the guardianship of the Camera dell'Arme had been entrusted to religious monks of the Cistercian abbey of Settimo;[23] but other considerations may have contributed to the choice of St Bernard as patron saint of the chapel of the Signoria and hence of the palace itself.[24] In particular, his reputation as a peacemaker must have had a special appeal at a time of endemic civic unrest.[25] Among the banners that were kept in the chapel in 1532, there was still one 'with the inscription "Pax", which was said to be that of St Bernard'.[26]

In 1377, ten florins were paid for a painting of St Christopher, 'on the landing of the stairs of the palace': he was a popular saint in public palaces, as he was believed to provide protection against sudden deaths and accidents.[27] A year later, Antonio Vanni received eight florins for a

[17] Ed. Baron 1928, p. 53.

[18] Bruni, *Historiae Florentini populi*, p. 78: 'ita scriptum est, quod gibellinos apud Campaldinum profligassent', because 'honestius visum est gibellinos superatos scribere quam Aretinos, ne pars quoque illa Aretinorum, quae socia et amica et studio partium coniuncta fuerat, notaretur'. This passage must have been written in 1423 (not 1421): Baron 1955, ii, p. 611, n. 14.

[19] *Historia fiorentina*, Sig. fv6ᵛ: 'Questa victoria nelle publiche scripture è chiamata victoria optenuta . . . contro a ghibellini . . .'. For the date see Garin 1954, p. 277.

[20] See Ortalli 1979, p. 63 n. 86. [21] See below, p. 51.

[22] In June 1432, the Signoria decided to have the panel (*tavola*), the predella, and the chapel of the altar of St Bernard cleaned, because the panel was blackened by the smoke from incense, 'la quale trovano fu dipinta nel 1335 per maestro Bernardo dipintore, il quale fu discepolo di Giotto' (transcribed in Vasari–Milanesi, i, pp. 466–7, from the inventory of the palace in Carte di corredo, 65, fo. 8ʳ⁻ᵛ; see below, n. 109, and App. IV). The attribution to Bernardo Daddi was probably derived from his name having been inscribed, together with the date of execution, on the panel; there do not seem to be sufficient grounds for doubting the reliability of this attribution, as does Lesher 1979, pp. 89–90. Milanesi's assumption that the altarpiece repre-

sented the *Vision of St Bernard* has become received opinion (see e.g. Lesher 1979, pp. 87–9), but is hypothetical and not supported by the entry in the inventory, which does not mention the subject of the altarpiece. It could have represented an image of the saint similar to one on a panel in the Badia a Settimo which was painted around 1300: see *Bernardo di Chiaravalle* 1990, p. 29 and fig. 3.

[23] See Davidsohn, *Geschichte*, iv. 1, p. 113, and *Forschungen*, iv, p. 499.

[24] His feast day, 20 Aug., was celebrated in Florence as the 'festa del palagio de' Signori': Giusto d'Anghiari, *Diario*, fo. 93ʳ.

[25] See Lesher 1979, pp. 71–2.

[26] Inventory of 1532, fo. 162ᵛ: 'una bandiera scrittavi dentro "Pax", che dicono di S. Bernardo'. In 1444, 'uno pennone azzurro con lettere dicono pax' was kept in the *camera* of the Gonfalonier of Justice (Carte di corredo, 65, fo. 40ʳ). St Bernard was also widely known as the alleged author of a moral treatise for the laity on household government, the *De gubernatione rei familiaris* or, in the vernacular translation, *Lettera a Raimondo*. On the wide diffusion of this treatise cf. Perosa 1981, p. 110.

[27] Sig., Delib., ord. aut., 20, fo. 56ᵛ (31 Aug. 1377): to Angelo [Gaddi?] 'pro figura Sancti Christophori supra scalas palatii'. In 1441, the passage (*andito*) between the audience chamber of the

painting, whose subject is not indicated, to be executed 'above the door of the hall of the palace', that is probably as a *soprapporta* for the door to the council hall on the first floor.[28] Inside the audience chamber on the second floor, there was a picture of St Thomas the Apostle, for which Franco Sacchetti composed an inscription.[29] The picture may have formed part of the 'paintings' and the 'adornment' of that room, for which the councils allocated 125 florins in August 1385.[30] The two marble angels placed above the door of the room, for which Jacopo di Piero Guidi was paid 25 florins in July 1386, no doubt belong to the same decoration campaign.[31]

Some of these religious subjects may have been invested with political meaning. This was the case with a number of other paintings of which records survive. By 1400, above a door of the *sala dei Priori*, that is the present Sala dei Gigli, there was depicted the wheel of fortune.[32] This painting was accompanied by a sonnet[33] reminding the members of the Signoria of the pitfalls of power, in terms familiar from the medieval topos of the fickleness of fortune, but adjusted to fit the political realities of a city-republic. Its opening lines, 'Se la Fortuna t'ha fatto signore', may well have been taken to refer to the Florentine system of electing the Signoria by lot, and the advice not to trust in the security of one's position—'chi de lo stato più si rassicura talor, cadendo, sente più dolore'—to the ruling regime, the *stato*.[34] But the topos of the changeability of fortune, a popular subject in vernacular Italian literature of the second half of the fourteenth century,[35] may during that period have had a special political significance in Florence. The sonnet was probably composed by Ser Ventura Monachi, chancellor of the Signoria between 1340 and 1348[36] (it is attributed to him in a number of Florentine manuscripts), who had witnessed the sudden rise and fall of the duke of Athens as lord of Florence. Following the expulsion of the Duke, Florentine politics were marked by a sharp increase in the number of 'new men', *gente nuova*, who entered government for the first time, resulting in greater social as well as political mobility.[37] Conservatives such as Matteo and Filippo Villani deplored the fact that 'every vile artisan of the community wants to attain the rank of the Priorate and of the highest offices of the Commune . . . and likewise the other citizens of poor intelligence and recent citizenship', and that the government of the city had 'come in no small part into the hands of men who had recently arrived' from its territory and from outside it.[38] The sonnet could have been designed to remind such men of the vagaries of fortune, but also to warn the

Signoria and its *camere* was adorned with another painting of St Christopher: see below, n. 99.

[28] Sig., Delib., ord. aut., 21, fo. 27ʳ⁻ᵛ (30 Aug. 1378): 'pro pictura, quam fecit . . . supra hostium sale palatii'.

[29] See below, p. 51. In the Sienese Palazzo Pubblico too, a representation of St Christopher was joined by one of the *Incredulity of St Thomas*; in 1408, Taddeo di Bartolo painted in the Concistoro a—lost—'figura domini nostri Jesu Christi et Sancti Thome' (Southard 1978, pp. 378–9).

[30] Provv., 74, fo. 92ʳ (7–12 Aug. 1385; Gaye, i, p. 531): 'Pro solvendo expensas factas vel faciendas de proximo pro picturis et ornamento Audientie palatii Dominorum et pro picturis coperture cappelle dicte Audientie . . .'.

[31] Lensi, p. 47, from the Archives of the Opera del Duomo. Jacopo di Piero Guidi had, in 1384 and 1385, sculpted the reliefs of Faith and Hope for the spandrels of the arches of the Loggia de' Lanzi and was at that time working on those of Fortitude and Temperance (see Wundram 1967–8, p. 202).

[32] See Donato 1991, p. 91. Representations of the wheel of fortune abound in medieval art, but the painting in the Palazzo Vecchio appears to be one of the earliest recorded examples of it in a public building in Italy. Possibly in the late Trecento, the marble pavement of the cathedral of Siena was decorated with a wheel of fortune: Cust 1901, p. 29; Aronow 1985, p. 44. In 1342, Boccaccio describes such a wheel in his *Amorosa Visione*, canto 31 (p. 139).

[33] *Rimatori del Trecento*, pp. 75–6. The sonnet had previously been published by Monaci 1873, p. 22 (repr. in Marzi 1910, p. 82).

[34] Cf. Rubinstein 1971, pp. 317 ff.

[35] See Flamini 1891, pp. 512 ff.; Li Gotti 1940, pp. 114–16.

[36] Marzi 1910, pp. 79–81.

[37] See Brucker 1962, pp. 105 ff., 160.

[38] Ibid., pp. 52–3. Matteo Villani, *Cronica*, ii. 2 (v, p. 120): 'ogni vile artefice . . . vuole pervenire al grado del priorato e de' maggiori ufici del Comune . . .'; Filippo Villani, *Cronica*, xi. 65 (vi, p. 452): 'il quale era venuto in parte e non piccola in uomini novellamente venuti dal contado e distretto di Firenze . . . e di gente venuta assai più da lunga'.

members of the Signoria, whatever their social background, not to abuse their power lest they lose it.[39] If the sonnet for the wheel of fortune was composed before Ventura Monachi's death in 1348, it could have served as a precedent for the far more complex and articulate civic message which Franco Sacchetti tried to convey, in the 1380s, through his verses for the palace. This message reminds us of that contained in the imagery and the inscriptions of Ambrogio Lorenzetti's frescoes of the Buon Governo in the Palazzo Pubblico in Siena, painted about half a century earlier. The sonnet Sacchetti had inscribed in the audience chamber of the Otto di Guardia, when he belonged to that magistracy,[40] praises love of fatherland, 'amar la patria', as the one virtue which more than any other makes it great and powerful, 'alta e possente', shuns self-interest, and always wishes to fight for the common good, 'pel ben comune combatter sempre ha voglia'.[41]

It is unlikely that Sacchetti's sonnet was meant to accompany an allegorical painting.[42] There is no reference in its title to such a destination, and the Otto had only recently become a permanent magistracy[43] and may not yet have had a fixed audience chamber which would have justified the commissioning of a fresco. The verses, on the other hand, which he composed for the audience chamber of the Signoria were inscribed, in his own words, next to the representation of the *Incredulity of St Thomas* above a door inside the Udienza,[44] which was probably painted in or after 1385,[45] shortly after he had composed his sonnet for the Otto. The verses take up the theme of the common good with which that sonnet ends and make it their principal subject. The second and third of the three triplets admonish the Signoria to aim unreservedly and openly, 'la mente intera e franca', in all their actions, at the common good, without which 'every kingdom . . . fails'.[46] This political message contrasts with the opening words of the verses, where St Thomas urges the onlookers to 'touch the truth' as he had done, and thus to believe 'in the supreme justice in three persons'. The exhortation to search after truth, repeated in the second and third triplet, provides the link between all three triplets,[47] but concerns primarily secular rather than religious truth: the Apostle's admonition, in the first triplet, to believe in the supreme justice of the Trinity is referred to the administration of justice: 'esalta ognun che fa ragione'.[48] Sacchetti invests the biblical theme of the Incredulity of St Thomas with a civic meaning which is entirely at variance with patristic and scholastic interpretations of John 20: 27.[49] Sacchetti was keenly interested in theology[50] and in his *Exposition of the*

[39] 'Se la fortuna t'ha fatto signore / dispensa e guarda ciò che vuol misura: / non esser del cader senza paura / quando fermezza credi aver maggiore.'

[40] Its title reads: 'Sonetto di Franco, essendo degli Otto de la Guardia, e ne la loro audienza descritto' (*Rime*, pp. 352–3, no. 227, see Battaglia Ricci 1990, pp. 41–5).

[41] 'Amar la patria sua è virtù degna / sovra ogn'altra a farla alta e possente . . .'.

[42] As Cohn 1958, p. 69, and Donato 1988, p. 1126, suggest. Battaglia Ricci 1990, p. 43, argues that 'fino a prova contraria è più corretto pensare che il sonetto . . . sia stato scritto su un muro (o su una tavola) . . . da solo . . .'.

[43] See Antonelli 1954, p. 8.

[44] 'Questi sono certi versi che Franco fece porre sopra la porta dentro a l'audienza de' signori, dove san Tomaso mette la mano nella piaga di Cristo' (*Rime*, p. 374, no. 243; Battaglia Ricci 1990, p. 33).

[45] Sacchetti had been staying in the palace in March and April

1384, when he was one of the Priors.

[46] '. . . perch'ogni regno sanza questo manca' (loc. cit. above, n. 44).

[47] 'Toccate il vero com'io . . .'; 'La mano al vero . . .'; 'Cercate il vero . . .' (ibid.).

[48] On St Thomas as a symbol of justice in the civic iconography of late 14th- and 15th-cent. Tuscany, see Southard 1978, pp. 100–2, and Donato 1988, pp. 1198–1200.

[49] Cf. e.g. St Augustine, *In Ioannis Evangelium tractatus CXXIV*, tract. 121, cap. 20; cf. ibid., tract. 40, cap. 9: 'Quid est enim fides, nisi credere quod non vides?' A panel of the *Incredulity of St Thomas*, of *c*.1420 (*Uffizi* 1979, p. 551), has on its frame the first triplet of Sacchetti's verses, and must have been influenced by the painting in the Udienza (Donato 1988, pp. 1198–9). See Southard 1978, pp. 100–2, for later examples of paintings of St Thomas in public palaces in Tuscany, as 'a logical image for a communal palace'.

[50] Delcorno 1989, pp. 295–6.

Gospels, he stresses the all-importance of faith.[51] That he should interpret an image of the Apostle touching the wounds of the risen Christ as conveying a political message shows the length to which he was prepared to go to provide the palace with texts that could teach the Signoria and other magistrates fundamental civic values.

The shift from religious to secular themes in the iconography of the Palazzo Vecchio in the second half of the fourteenth century is, however, carried furthest in a cycle of Famous Men which was painted around the same time on the second floor in the Saletta. The cycle is first recorded in an early fifteenth-century manuscript containing copies of twenty-two epigrams in Latin hexameters composed for the *aula minor* of the palace by Coluccio Salutati,[52] who was chancellor of Florence from 1375 until his death in 1406. The cycle follows the model of Petrarch's *De viris illustribus*, which in its turn had provided the programme for the decoration of the Carrara palace in Padua,[53] but also uses Filippo Villani's biographies of famous Florentines.[54] The first version of Villani's text was completed in 1381/2, or shortly afterwards, and corrected by Salutati;[55] his epigrams must consequently have been written, and the paintings they were designed to explain executed, after that date, and in all probability after 1385, when the decoration of the Udienza of the Signoria was taken in hand.[56] That the *aula minor* for which Salutati composed the epigrams was identical with the Saletta is confirmed by a decision of the Signoria in 1451 to pay Filippo Lippi for restoring some of the paintings of famous men 'in salecta palatii dominorum'.[57] Ten years later, the Signoria allowed the sons of Poggio Bracciolini, the Florentine chancellor who had died in 1459, to have their father's portrait painted 'in Saletta Palatii'.[58] At that time, there must have already been in that room a portrait of another famous chancellor, Leonardo Bruni, who had died in 1444,[59] and one of Salutati himself, whose portrait is recorded as having been painted in the palace.[60] The paintings of famous men, no doubt frescoes, may have been destroyed as a result of the restoration campaign on the first and second floors in the 1470s.[61]

The cycle of Famous Men in the Saletta breaks with tradition in the decoration of the palace not only in that it entailed the mural decoration of an entire room, but also in that its subject is secular: no biblical or Christian heroes are included in it. Inspired by Petrarch—one half of the famous men can be found in the *De viris illustribus*—the cycle of the Saletta constitutes the earliest evidence of the impact of the *studia humanitatis* on the decoration of the palace. In

[51] *Sposizioni dei Vangeli*, in Franco Sacchetti, *Opere*, ii, pp. 119–21 ('De Fide').

[52] Ed. Hankey 1959. On the programme of the cycle, see Donato 1985, pp. 126–48; Rubinstein 1987, pp. 29–32; on the date of the manuscript (BLF, MS. Conv. soppr., 79), see ibid., p. 29 n. 5; on the classical sources of the epigrams, see Guerrini 1992 and 1993.

[53] See Mommsen 1959, pp. 130–74. Salutati acquired a copy of the *De viris illustribus*, with the supplement by Lombardo della Seta, in 1380 or 1381 (Ullman 1963, p. 193).

[54] *De origine civitatis Florentiae et eiusdem famosis civibus.*

[55] Coluccio Salutati, *Epistolario*, ii, p. 47, iv, p. 487 n. 2; Witt 1983, p. 196 n. 55.

[56] See above, p. 50.

[57] Sig., Delib., ord. aut., 71, fo. 40ᵛ (19 Apr. 1451): 'Fratri Filippo fratri Carmelitorum de Florentia pictori fi. unum largum pro emendo colores pro repingendo et reactando Dantem Arrigherium et alios

famosos viros [del. homines] in salecta palatii dominorum.' I owe this reference to Brenda Preyer.

[58] The decree of 28 Feb. 1461 is ed. in Gaye, i, p. 563, and Walser 1914, p. 416, from C. Strozz., 2a ser., 177, p. 173.

[59] Bruni's portrait is documented by its inscription, which is copied in Biblioteca Vaticana, Cod. Vat. lat. 6267, fo. 87ᵛ: 'Carmina scripta sub imagine domini Leonardi de Aretio picta in palatio dominorum priorum de Florentia, viz. in salecta'. The first two lines of the quatrain read: 'Hic, Leonarde, tibi facies depicta, sed altum / Ingenium libris pingitur omne tuis'. I am grateful to James Hankins for this reference. Another 15th-century copy of this epigram (BNF, II. IX. 148, fo. 295ᵛ) identifies its author as Carlo Marsuppini, Bruni's successor in the chancery.

[60] BNF, MS Magl. VII, 1125, fo. 51ᵛ (*c*.1500) contains an epitaph for a portrait of Salutati in the palace: see Donato 1985, p. 127.

[61] See above, pp. 32–3.

contrast to those of the Paduan cycle, however, the famous men of the Saletta do not belong exclusively to classical antiquity. The Roman statesmen and generals are followed by the emperors Constantine and Charlemagne, and are preceded by two other world emperors, Ninus and Alexander. While Petrarch had omitted poets and philosophers from his biographies, which were concerned with men of action only,[62] Salutati's programme includes five poets, all but one of the fourteenth century.[63] Nearly all the Romans represented in this programme belong, like those in Padua, to the republican era;[64] but unlike the Paduan cycle, devised for a princely residence, the Florentine one carries, in the figures of Brutus (the first consul), Cicero, and Cato, a republican message. Brutus established Roman liberty; the sword which killed Cicero also killed that liberty.[65] The programme also had a particularly Florentine dimension.

The first Brutus had been portrayed as an exemplar of civic virtue in a fresco which dominated the council hall of the wool guild;[66] and Charlemagne figures in the Saletta cycle, not only as one of the world emperors.[67] Celebrated in Florence as the second founder of the city, he is described, in his epigram, as 'rex gallorum' and praised for having subdued the Lombard tyrants, 'longobardos tyrannos'.[68] Florence recognized the Emperor as her supreme overlord, but also had a long tradition of alliance with the French monarchy. It is possible that the term 'Lombard tyrants' contains a veiled reference to Giangaleazzo Visconti, with whom the Florentines were at war from 1390, and against whom they succeeded, in 1396, in enlisting French assistance.[69] This could indicate the 1390s as a possible date for the execution of the cycle. Similarly, the references to conspiracies, in the epigrams for Cicero and Cato, may relate to the discovery, in 1393, of a conspiracy against the ruling group which resulted in exile for the Alberti and which helped Maso degli Albizzi to establish a dominant position in the aristocratic regime.[70] But the main connotation of the programme's Florentine connection is cultural rather than political. Its five poets are all Florentines, or allegedly Florentines: as in Filippo Villani's biographies, they are Claudian, who was believed to have been born in Egypt of Florentine parents,[71] Dante, Petrarch, Boccaccio, and Zanobi da Strada. Villani writes that 'after the Caesars, the pagans honoured most highly the poets' and, while Rome had only four famous native poets, Florence had five, 'and is nourishing others'.[72] Like Villani's biographies, this part of the programme of the Saletta was inspired by the literary patriotism which was reflected in the decision of the councils to erect memorials for four Florentine poets in the Cathedral. This decision—which was not carried out—was taken in 1396. With the exception of Claudian, the

[62] '. . . de his tantum, qui bellicis virtutibus aut magno rei publicae studio floruerunt' (quoted by Mommsen 1959, p. 150 n. 75).

[63] See below.

[64] They are, in this sequence, Lucius Brutus, Furius Camillus, Scipio Africanus, Curius Dentatus, Fabius Maximus, Marcus Marcellus, Caesar, Cicero, Fabricius Luscinus, and Cato Uticensis.

[65] Brutus: 'Regibus expulsis in libertate quirites / Asserui . . .'; Cicero: '. . . at ipsum / Antonii gladius, libertatemque peremit'; Cato: 'Eiciensque animam, mea liber ad astra redivi'.

[66] See Morpurgo 1933 and Ruck 1989, who dates the fresco between 1342 and 1378 (pp. 125–6). The *titulus* for Brutus, who figures in the fresco as a judge, endowed him with the four cardinal virtues: he is 'prudente, giusto, forte, temperato'.

[67] The others are Ninus, Alexander, Augustus, and Constantine.

[68] 'Rex ego gallorum Karolus cognomine magnus / Perdomui gentes longobardosque tirannos / Nactus et imperium mea te Florentia muris / Fortibus armavi romanis civibus auctam.' See Rubinstein 1942, pp. 215–17.

[69] Brucker 1977, pp. 155–7. Cf. Witt 1976, p. 64, on the impact of the French alliance on the language of the Florentine chancery.

[70] Ibid., pp. 90 ff.

[71] Filippo Villani, *De origine*, p. 6: '. . . noster concivis est . . . Cuius parentes . . . mercaturae gratia migravere . . .'.

[72] Ibid.: 'Sane post Caesares, poetas invenimus summo honore apud Gentiles fuisse susceptos . . . Igitur cum iam quinque insignes et famosos poetas urbs nostra Florentinorum genuerit . . . et alios nutriat . . . ab hoc feliciori beneficio placet rem de qua loquor inchoare . . .'.

poets were the same as those represented in the Saletta.[73] The mural decoration of that room may well belong to the same time.[74]

As we have seen, the cycle of Famous Men in the Saletta is known to us through its epigrams, which are copied in a fifteenth-century manuscript.[75] Another fifteenth-century manuscript preserves a Latin poem by Roberto de' Rossi said to be inscribed 'apud figuram', 'by the figure', of Hercules 'in a hall of the palace of the Signoria'.[76] The manuscript contains inscriptions copied, around 1468, by Jacopo Cocchi Donati, a member of the Medicean *reggimento* who must have known the palace intimately.[77] Roberto de' Rossi belonged to the humanist circle of Salutati and Bruni and was one of the earliest Florentine translators from the Greek; a scion of an ancient Magnate family, he was often summoned by the Signoria to their consultative committees.[78] While Salutati was alive, it was unlikely that an inscription for the palace would have been composed by anyone but the humanist chancellor of Florence, the author of the epigrams in the Saletta; the sonnet can accordingly be dated with some confidence between Salutati's death in 1406 and Roberto de' Rossi's in 1417; in the absence of a humanist in the chancery, he was the kind of citizen the Signoria would have asked to compose a learned inscription for their palace. In Roberto de' Rossi's poem, Hercules declares that he had 'strangled the twin serpents, routed ungrateful towns, and overcome cruel tyrants'.[79] In his epigram on Charlemagne, Salutati had praised Charles for having 'subdued the Lombard tyrants';[80] in the poem, the reference to serpents in its turn links the 'tyrants' with the lords of Milan through the device of the coat of arms of the Visconti, the *biscione*. The 'ungrateful towns' are probably meant to refer to the Tuscan cities which had sided with Giangaleazzo against Florence.[81]

Fig. 21 Hercules was represented on the great seal of Florence.[82] According to Roberto de' Rossi, Florence, as 'virtutis imago', bore a close likeness to Hercules.[83] About the time when he composed the sonnet, Goro Dati, in describing the city's emblems (*segni*), explained Hercules' presence on its seal as being due to his having 'routed all the tyrants and wicked rulers, as the Florentines have done'.[84] The comparison between Hercules and Florence occurs again in a speech Cavalcanti puts into Rinaldo degli Albizzi's mouth in 1426.[85] A similar meaning,

[73] Poggi 1988, ii, p. 132, no. 2082. Instead of Claudian, the lawyer Accursius was to receive a memorial. See Borsook 1980, p. 76.

[74] Salutati's epigram for Charlemagne in its turn points to that time: see above, p. 53. [75] See above, n. 52.

[76] Ed. Donato 1991, p. 84 n. 2: 'Carmina infrascripta, que sunt apud figuram Erculis in aula palatii magnificorum Dominorum Populi et Comunis Florentie, fuerunt edita per virum doctissimum Robertum de Rossis de Florentia.' The poem had previously been published by Manetti 1951, pp. 46–7.

[77] Donato 1991, p. 85. Jacopo Cocchi Donati was Prior in 1446, 1450, and 1466, and a member of the Medicean Balìa of 1458, 1466, and 1471.

[78] See Martines 1963, pp. 108–9, 256–7; Brucker 1977, pp. 286 *et passim*.

[79] 'Ipse premens geminos elisi parvulus angues, / disieci ingratas urbes, sevosque tirannos / oppressi . . .'. Donato 1991, p. 84.

[80] 'Perdomui gentes longobardosque tirannos': see above, n. 68.

[81] See Donato, loc. cit.

[82] See Passerini 1869; Ettlinger 1972, pp. 120–2; Collareta 1986.

[83] '. . . virtutis imago / nunc michi persimilis, talem Florentia

sedem | exibuit . . .'. On Hercules as exemplar of virtue, cf. Salutati's interpretation of him in the *De laboribus Herculis*, composed in 1381–2, for which see Witt 1983, pp. 216–17.

[84] *Istoria di Firenze*, p. 127: 'Il sesto [segno] è l'Ercole, il quale portano ne' suggelli del Comune . . . a significazione, che Ercole fu giogante, che andava spegnendo tutti i Tiranni, e inique signorie, e così hanno fatto i Fiorentini.' The classical source for the notion of Hercules as a slayer of tyrants was probably Seneca: cf. e.g. *Hercules Oetaeus*, 5–6: 'perfidi reges iacent / saevi tyranni'; 56–7: 'quanta enim fregi mala, / quot scelera nudus'; *Hercules Furens*, 936–7: 'non saevi ac truces / regnent tyranni'.

[85] *Istorie fiorentine*, iii. 2 (p. 47): 'Voi sarete domatori della pravità dei tiranni; e ciascheduno di voi fia un nuovo Ercole, il quale domò tanti pessimi tiranni. I vostri antichi domarono le superbe e tirannesche potenze che circondavano questo popolo . . .'. In 1473, Landino, when interpreting Hercules in the *Disputationes Camaldulenses*, in his turn describes him as a slayer of tyrants, but without reference to Florence, which the client and panegyrist of the Medici may have preferred to omit (cf. *Prosatori latini del Quattrocento*, pp. 762, 764).

additional to the *virtutis imago* of the Florentine seal, may well have attached to the *figura Erculis* in the palace.

Was this *figura* a sculpture or a painting, and where exactly was it located? Another manuscript, of the second half of the century, containing Roberto de Rossi's sonnet states that it was incised on marble, which would suggest a sculpture. A third fifteenth-century manuscript appears to settle the matter by describing the epigram as belonging to a painted image of Hercules, 'ad imaginem Herculis ibidem depicti'.[86] Jacopo Cocchi Donati locates the Hercules 'in aula palatii', which, to a citizen who was well acquainted with the palace, could refer only to the council hall, the Sala dei Dugento, as distinct from the *sala Dominorum*, the Sala dei Gigli. At the end of the century, Antonio Pollaiuolo's three large paintings of the labours of Hercules were transferred from the Medici palace to that hall; that the hero had been painted in it earlier could have made the council hall an obvious choice for the hanging of these paintings.[87] If the *figura Erculis* was executed at the time when Rossi wrote his epigram for it, it could have provided an addition to the cycle of Famous Men in the Saletta: Hercules was sometimes represented in Italy as belonging to such cycles.[88] Similarly, the marble sculpture of David by Donatello, which the Signoria acquired in 1416 from the cathedral workshop[89] and had set up in its *sala*, the Sala dei Gigli,[90] could be seen as complementing the cycle in the Saletta. David was one of the three biblical heroes among the Nine Worthies, a theme which enjoyed great popularity in France as a subject for mural decoration after the publication, at the beginning of the fourteenth century, of Jacques de Loguyon's Alexander romance; early in the fifteenth century it was represented in mural paintings in castles near Bolzano, in Piedmont, and at Foligno.[91] By setting up a statue of David in their *sala*, the Signoria added to the secular cycle of Famous Men in the nearby Saletta a biblical figure which, while conforming to the traditional religious imagery of the palace, provided a pendant to the image of Hercules in the council hall.[92]

Fig. 22

[86] See Donato 1991, pp. 84, 89 n. 37. *Ibidem* here refers to the location of the painting of the wheel of fortune (see above, pp. 50–1) and probably means 'in the palace'.

[87] If the *figura* of Hercules was in fact, as it appears, a painting, it may have been removed in the course of the renovation campaign on the first and second floors in the 1470s. See above, pp. 32–3.

[88] In the 14th cent., Hercules was one of the *uomini famosi* whom, according to Ghiberti, Giotto painted in the Castelnuovo at Naples for King Robert of Anjou (*Commentari*, p. 33). Sonnets describing the paintings in the Castelnuovo, which have been convincingly attributed to Giovanni di Firenze, the author of the *Pecorone* (see Stoppoli 1977, pp. 17 ff.), have been edited by de Blasiis 1900. According to Galvano Fiamma, *Opusculum*, pp. 15–17, Azzone Visconti had Hercules included among the nine Famous Men he had painted in his palace at Milan.

[89] Poggi 1988, i, p. 78, no. 425 (6 July 1416): the Operai del Duomo, 'considerato quodam bullettino eis transmisso' by the Signoria in July, 'in quo continetur in effectu quod dicti operarii teneantur mictere ad palatium . . . dominorum quandam figuram marmoream David existentem in dicta opera, omnibus sumptibus et expensis dicte opere, omni mora et dilatione postposita', they decide to have that statue sent to the palace of the Signoria. On 27 Aug., Donatello was paid five florins 'pro pluribus diebus quibus stetit [evidently in the palace] una cum eius discipulis in aptando [*stanziamenti* of the Operai, ibid.: 'in compiere e ac-

conciare'] et perficiendo figuram Davit' (ibid., p. 78, no. 426). Herzner 1978, pp. 60 ff. argues that the statue which was transferred to the palace in 1416 was not identical with the one the Opera had commissioned from Donatello in 1408 (Poggi 1988, i, p. 75, no. 406), but had been commissioned from him by the Signoria in 1412 for their palace. But it is hardly likely that the Signoria should have ordered the Operai to send 'quandam figuram marmoream David existentem in dicta opera' to their palace if it had commissioned that statue shortly before, and that Donatello should have been paid in the following month for work 'in aptando', or to 'acconciare', the statue (see preceding note and Janson 1957, p. 5).

[90] The sculpture was placed against a wall which on the orders of the Signoria was painted with lilies, no doubt those of the house of Anjou, on blue ground: Giovanni di Guccio was paid on 20 Aug. 1416 'per dipignere gigli nel champo azurro nel muro dove è posta la detta figura di David in palagio de' Signori' (Poggi 1988, i, p. 79, no. 427).

[91] See Schroeder 1971, pp. 41–2, 84 ff.; on the fresco in the castle of Manta in Piedmont, d'Ancona 1905; on the cycle of *uomini famosi* at Foligno, Salmi 1919 and Messini 1942.

[92] The comparison of David with Hercules must have been familiar in Florence, at least to readers of Dante's *Monarchia*, where he draws a parallel between David's victory over Goliath and that of Hercules over Antaeus (II. 9, 11).

Like the Roman citizens in the Saletta, David is praised, in the Latin epigram which was added to his statue, no doubt on its base,[93] as an exemplar of patriotic virtue. While Salutati's epigrams, however, following classical and Petrarchan models, praise the actions of the men they present to the onlooker, the *titulus* for David is couched in generalized patriotic terms: 'Pro patria fortiter dimicantibus etiam adversus terribilissimos hostes deus prestat auxilium', 'God helps those who fight bravely for their country even against the most terrible enemies'.[94] In 1416, David, the Jewish hero who had single-handed slain Goliath, could be seen in Florence as a symbol of the city's past struggles to preserve her dominion, and indeed her independence, against superior odds. When the Signoria ordered Donatello's *David* to be transferred to their palace, the city had shortly before been freed from the danger of another Neapolitan invasion of Tuscany by the death of King Ladislas; a danger which had threatened Florence from the south, just as the duke of Milan, Giangaleazzo Visconti, had been attacking her from the north. Largely single-handed, the city had faced intermittently over a period of twenty-four years two monarchies that were superior to her in territory as well as in manpower. The young David facing Goliath was the one of the Nine Worthies most fitting to symbolize the Florentine stand during those years. A contemporary chronicler writes that after the death of King Ladislas in 1414, the city enjoyed a decade of peace:[95] by 1416, the Signoria may well have felt that the moment had come to mark this happy turn of events by setting up the statue of the biblical hero in the room in which magistrates and visitors would wait before entering their audience chamber.

In doing so, they created a new tradition in the figurative decoration of the palace. In 1476, the government acquired from Lorenzo and Giuliano de' Medici another sculpture of David, *Fig. 23* by Verrocchio, and placed it, as a pendant to Donatello's marble *David*, outside the Sala dei Gigli at the top of the stairs.[96] In 1495, after the fall of the Medici regime and the flight of Piero de' Medici, the bronze *David* by Donatello was brought from Piero's palace to the Palazzo Vecchio; in 1504, Michelangelo's *David* was set up on its *ringhiera*.[97] As far as the statues that were destined for the internal decoration were concerned, the Signoria must have realized the advantages, in a public palace whose wall-space was severely restricted and which was in constant use, of sculptures over mural decorations. Moreover, the wealth of sculptural production in Florence during the fifteenth century offered ample opportunities of acquiring existing sculptures without having to commission new ones.

There is a gap of nearly a century between the mural decoration of the Saletta and that of the Sala dei Gigli, whose execution by Ghirlandaio in 1482 concluded, for all practical purposes,

[93] On 17 Aug. 1416, glass inlays were commissioned for it: 'per le tarsie di vetro della basa e becchatelli della detta figura' (Poggi 1988, i, p. 79, no. 427).

[94] The epigram, with the variant 'dei' for 'deus' and 'praestant' for 'prestat', is copied in Schrader 1592, fo. 78ᵛ, with the note that it was 'adscriptum' to the statue of David. As Monica Donato has shown (Donato 1991, p. 91), the original inscription, as recorded in an early 15th-cent. manuscript, had 'deus' instead of 'dei'. It will be suggested below, p. 65, that the word was changed into the plural when the new cycle of Famous Men was painted in the Sala dei Gigli (this supersedes the hypothesis in Rubinstein 1987, p. 41 n. 100, that the entire inscription could have been added to the statue on this occasion). 'Pro

patria fortiter dimicantibus': cf. Livy, 1. 24. 2, 'pro sua quisque patria dimicent'; 5. 30. 5, 'ne eam patriam, pro qua fortissime felicissimeque ipsi ac patres eorum dimicassent, desererent'.

[95] Domenico Buoninsegni, *Storia di Firenze*, p. 7: 'E stettono poi i Fiorentini in pace circa dieci anni.'

[96] Op. Pal., 1, fo. 8ʳ (10 May 1476): payment of 150 florins to Lorenzo and Giuliano de' Medici 'pro pretio . . . del Davit habiti ab eis, deinde positi penes et apud hostium Catene pro ornamento et pulcritudine ac etiam magnificentia palatii'. See Passavant 1969, pp. 173–4.

[97] See below, p. 70.

the wide-ranging renovation campaign of the interior of the palace which had been initiated after 1469.[98] During the intervening period, the Signoria continued fourteenth-century tradition by commissioning paintings of religious subjects, chiefly over doors and for the landings of stairs. In 1441, a St Christopher was painted in the passage between its audience chamber and its sleeping quarters;[99] in 1447, Filippo Lippi was paid 40 *libbre* for a painting of the *Vision of St Bernard*, which was to be placed above the door of the chancery,[100] for which Luca della Robbia was commissioned two years later to sculpt a small cupid.[101] According to the *Anonimo Magliabechiano*, Filippo Lippi also painted a panel of the Annunciation 'above the stairs'.[102] According to Vasari, Filippo Lippi's pupil Francesco Pesellino painted an *Adoration of the Magi* which was placed 'a mezzo scala', that is on the first-floor landing,[103] and Antonio Pollaiuolo executed a St John the Baptist for the *porta della Catena* at the top of the stairs,[104] probably as a painted or sculpted *soprapporta*. A lunette of the *Annunciation*, in its turn for the stairs,[105] which has been attributed to Giovanni del Ponte, still exists in the space outside the Sala dei Dugento towards the courtyard.[106] Unless earlier such representations have remained unrecorded, the subjects of these paintings appear to show a shift to Marian iconography, which would have been in keeping with the central position the Virgin occupied in the life and teachings of the patron saint of the palace, St Bernard, as well as with an increased perception of the Virgin as protector of Florence, after the dedication to her of the Cathedral had been solemnly reaffirmed in 1412.[107] At the same time, momentous political developments could leave their mark on the decoration of the palace: the alliance with the new ruler of Milan, Francesco Sforza, was celebrated in 1451 by having the painting 'of a shield with the arms of the duke of Milan placed above and in front of the door of the audience chamber of the Signoria'.[108]

Fig. 24

Fig. 25

It was to the chapel in their audience chamber that the Signoria paid special attention. In 1432, they had Bernardo Daddi's altarpiece cleaned because it was 'entirely blackened by smoke from incense'.[109] In 1454, the Signoria bought from a refugee from Constantinople an

[98] See below, pp. 61–4.

[99] Francesco Giovanni writes of the Signoria of Sept.–Oct., of which he was a member (*Ricordanze*, C. Strozz., 2a ser., 16, fo. 22ᵛ): 'Ancora facemo fare ... le dipinture di esse [i.e. its rooms] et il Santo Christofano che è nell'andito.' See above, p. 38 and n. 27. In the Palazzo Pubblico in Siena, Taddeo di Bartolo painted a St Christopher over the door to the antechapel in 1408. See Southard 1978, pp. 99–100.

[100] Baldinucci 1845, i, pp. 508–9, from a register of the Provveditori di Camera of 1446–8, which it has not been possible to trace, for 16 May 1447: 'per aver dipinta l'immagine di Maria Vergine e di san Bernardo, che doveva collocarsi innanzi alla porta della cancelleria'; cf. Vasari–Milanesi, ii, p. 67: 'fece in detto palazzo un San Bernardo, sopra un'altra porta'. This painting is probably identical with the *Vision of St Bernard* in the National Gallery in London, no. 248 (Fig. 24); see Davies 1961, pp. 291–3, Marchini 1975, p. 207.

[101] Gaye, i, p. 559, from the Carte Strozziane, Sept./Oct. 1449: 'Luca della Robbia fa uno spiritello sopra la porta della cancellaria de' Signori Priori.'

[102] *Anonimo Magliabechiano*, p. 105: 'Et nel palazzo detto, sopra la schala, è di sua mano una Nunziata', and, following him, Vasari–Milanesi, ii, p. 617: 'dipinse in tavola un'Annunziata, sopra una porta'.

[103] Ibid. iii, p. 36: 'gli fu dalla Signoria di Fiorenza fatto dipignere

una tavola a tempera, quando i Magi offeriscono a Cristo; che fu collocata a mezza scala del loro Palazzo ...'. Francesco Pesellino died in 1457.

[104] Ibid. iii, p. 293: 'In palazzo della Signoria di Fiorenza lavorò, alla porta della Catena, un San Giovan Battista.' On the *porta della Catena*, see above, p. 37.

[105] See below, n. 184.

[106] I am grateful to Miklos Boskovits for this attribution. On Giovanni del Ponte see Salvini 1934. Cf. in particular his *Annunciation* in the Vatican Museum, ibid., p. 21 and fig. 7.

[107] See Bergstein 1991, pp. 675–9.

[108] Commission of Jacopo d'Antonio of 17 Dec. 1451, quoted in Fubini 1982, p. 294 n. 4*bis*. Dieci, Delib., cond. e stanz., 19, fo. 14ʳ: Jacopo is paid on 17 Dec. 1451 *l*.52 'pro pictura unius scuti cum armis ducis Mediolani positi supra et ante hostium audientie dominorum'. A second payment to him of *l*.52 is recorded on 29 July 1452 'pro pictura scuti cum armis ducis Mediolani, quod est appositum in sala audientie dominorum' (ibid., fo. 31ʳ), that is in the Sala dei Gigli. The treaty between Florence and Francesco Sforza had been concluded in July 1451.

[109] '... feciono nettare e ripulire la tavola, predella e cappella dell'altare di San Bernardo, la quale era tutta affummicata e nera per lo fummo degl'incensi': see above, n. 22, and App. IV.

allegedly fourth-century copy of the Greek Gospels.[110] A few weeks later, they commissioned Neri di Bicci to gild and paint with the images of Moses and St John the Baptist and the symbols of the four Evangelists a wooden tabernacle constructed *all'antica* for the cupboard in which were kept the Gospels and the Pandects[111] that had been taken from Pisa after the conquest of that city in 1406.[112] In January 1455, Neri helped Vittorio Ghiberti to paint the cartoon for a tapestry for the back of the *ringhiera*.[113] By 1457, this tapestry was being used for the two-monthly inauguration of the Signoria and for other ceremonies on that platform: the Signoria of July–August writes in a testimonial for the Flemish weaver that this 'admirable work', which covered a vast expanse of the palace's wall, 'is resplendent with such craftsmanship, that it is a most delightful and famous sight to all'.[114] It was during the year 1454 that Michelozzo restored the porticoes of the courtyard and these commissions have to be seen as forming part of an attempt to improve the decoration of the palace. In 1468, the Signoria

Fig. 26 commissioned from Verrocchio a magnificent bronze candlestick for their *sala*, which was eventually set up in their chapel.[115] But these were minor improvements in comparison with the project which was launched in the following year.

In April 1469, the councils assigned 2,300 florins to the restoration and adornment of the council hall, the *sala grande di sopra*, that is the Sala dei Gigli, and the audience chamber of the Signoria.[116] About a century earlier, the sum allotted to decorating the Udienza had been 125 florins;[117] even bearing in mind the devaluation of the currency during the intervening period,[118] and the fact that three rooms instead of one were involved, the difference is indicative of the magnitude of the projected restoration campaign. Its importance is borne out by the councils' instruction to the Operai del Palazzo to submit projects for these restorations (*acconcimi*) to the Signoria and their Colleges to enable them to choose one of them, so that work on the restoration could begin.[119] The following decade saw the transformation of the

[110] Pietrobuoni, *Priorista*, fo. 167[r–v]. See App. IV.

[111] Neri di Bicci, *Ricordanze*, p. 17 (15 Aug. 1454): 'feci 1° Muisè e quattro animali de' Vangelisti e nel frontone Santo Giovanni Batista e intorno al detto Muisè e animali feci gigli d'oro e drento il quadro dipinto' in 'uno tabernacholo di legniame fatto a l'antica: cholonne da llato, di sopra architrave, freg[i]o, chornic[i]one e frontone', which he gilded, and which 'à stare d'atorno a uno armare dove istano le Pandette e uno altro libro, il quale vene de Ghostantinopoli . . .' (see App. IV). He had completed his commission by the end of August.

[112] Pietrobuoni, *Priorista*, fo. 167[r–v]. See App. IV.

[113] *Ricordanze*, p. 23 (24 Jan. 1455): 'Richordo che più dì fa Vetorio di Lorenzo di Bartolo [Ghiberti] . . . mi richiesi gli dovessi aiutare cholorire e disegniare 1° modello d'una ispaliera che di nuovo s'à fare di panno d'arazo per la ringhiera de' Signori di Firenze . . .'.

[114] 'Patens benemeritus' (ed. C. Conti 1875, pp. 95–6, 2 July 1457) for Lieven Giellisz from Bruges (see Göbel 1928, p. 377), 'artifex excellentissimus in contexendis mirabilique figurarum componendis pannis thapetalibus'. The tapestry, which he wove 'inter caeteros pro nostra republica . . . profecto ita splendet artificio, ut iucundissimum ac celeberrimum sit spectaculum cunctorum; circiter mille trecentenos cubitos quadratos palatii nostri quod cohoperit, ridere facit.' Lensi, pp. 59–60, who quotes this document, translates the last clause wrongly. In 15th-cent. Italy, the cubit, an ancient measure of length, could be taken to be equivalent, as in Rome, to *c.*44.5 cm., or to a *braccio*: Günther 1988, p. 227 (I am grateful to Charles Hope for this reference).

[115] Gaye, i, p. 569: Verrocchio was to be paid eight florins 'a conto

d'un candelabro di bronzo, che egli haveva cominciato per la sala dell'audienza; il restante dev'essere fissato da [Carlo di] Nichola di Messer Vieri [*Gaye:* Verri] de' Medici' (29 June 1468), and on 23 Sept. 1469 (p. 570): 'fiorini 40 per un candelabro lavorato e scolpito a similitudine di certo vaso'. Gaye's text, derived from the 17th-cent. copies in the Carte Strozziane, evidently omits the first name. Nicola di Vieri de' Medici died in 1454. Carlo di Nicola di Vieri de' Medici was Gonfalonier of Justice in May–June 1468, and the inscription on the base of the candlestick, 'MAGGIO E GIVGNO MCCCCLXVIII', must have been designed to record the fact that it was under the Signoria of those two months that the candlestick was commissioned. On the candlestick, now in the Rijksmuseum in Amsterdam, see Valentiner 1950, pp. 98–101, Passavant 1969, pp. 171–2, and Adorno 1991, pp. 53–5. In Apr. 1480, the candlestick was in the chapel of the audience chamber: Verrocchio was paid three florins 'pro saldatura candelabri bronzi, quod stat in cappella audientie dominorum' (Op. Pal., 2, fo. 59[r]; Gaye, i, p. 575, 20 Apr. 1480).

[116] See above, p. 31. [117] See above, p. 50.

[118] See Spufford 1986, pp. 7, 24: the gold florin was worth *c.*72 *soldi* in 1385 and between 89 and 92 in 1469.

[119] Provv., 160, fo. 12[r] (20–1 Apr. 1469; see above, Ch. 1, n. 229): 'Et a ciò che si pigli migliore forma et facciasi più degna opera, si provede che inanzi si cominci alcuno de' sopradetti acconcimi, che gl'operai del Palazzo predetto siano tenuti in una volta o più trovare il modo et la forma di tali acconcimi delle due sale et Audientia . . . et debbonsi examinare pe' Signori et Collegi che pe' tempi saranno', and those which have been approved by them 'si possino et debbino principiare . . .'. See above, p. 31, and App. X.

public areas of the palace; in its course, the relative austerity of the earlier decoration was superseded by the decorative art of the Florentine Quattrocento.[120] While the council hall was one of the principal beneficiaries of this campaign, special attention was paid to the decoration of the *sala* and the audience chamber of the Signoria on the second floor, where it was complemented by the acquisition, in 1476, of Verrocchio's bronze *David* for the landing outside the former.[121] In 1478, the Signoria also planned to replace with a new painting the fourteenth-century altarpiece in their chapel, which in 1432 they had been satisfied to have cleaned; but neither Leonardo da Vinci, nor Ghirlandaio, to whom the commission was reallocated five years later, executed it.[122] On the other hand, the council hall received, in 1486, a large new altarpiece, painted by Filippino Lippi;[123] it was the last side-product of the campaign to decorate the first and second floors in Renaissance style which had been set in motion in April 1469.

In August 1470, the councils decided to press on with the restoration, after the Signoria had pointed out how often in the past money that had been destined for it had been diverted to more urgent needs[124]—as had happened in 1444[125]—and assigned to the Operai 200 florins a month for two years to be spent on it.[126] Two years later, in June 1472, the Signoria ordered their *sala magna*, that is the Sala dei Gigli, and their audience chamber to be 'demolished' and rebuilt; later in the same month, the old ceiling of the council hall, the Sala dei Dugento, was destroyed in order to replace it with a new one.[127] By that time, work on one of the ceilings, probably that of the Sala dei Dugento, had been going on for over a year.[128] The magnificent new ceilings were being installed in 1475—those of the Sala dei Gigli and of the Udienza were subsequently gilded[129]—and the friezes below the ceilings by the end of 1478.[130] In 1481, a more modest ceiling was commissioned for the room of the new council of Seventy.[131]

Fig. 9

The coffers of the ceiling of the Sala dei Gigli are adorned with rosettes and with the *fleurs-de-lis* of the Anjou, those of the Udienza with the cross of the Florentine People. On

Figs. 27, 28

[120] Wackernagel 1981, p. 62. [121] See above, p. 56.

[122] Sig., Delib., ord. aut., 94, fo. 5ᵛ (1 Jan. 1478; Milanesi 1872, pp. 227–8, no. 1; Beltrami 1919, p. 5, no. 10): 'ad pingendum et de novo fabricandum tabulam altaris capelle S. Bernardi dicte Dominationis site in palatio populi . . . cum ornamento, qualitate, modo et forma' to be declared by the Operai. A week earlier, the Signoria had commissioned Piero Pollaiuolo for the same work, to be painted 'eo modo et forma et prout et sicut apparet in modello et seu in pictura existente' (Sig., Delib., Dupl., 19, fo. 470ʳ, 24 Dec. 1477; Milanesi 1872, p. 227, n. 1). On 20 May 1483, the Signoria 'locaverunt tabulam altaris cappelle eorum palatii Domenico Tommasi Curradi vocato il Grillandaio' (Sig., Delib., Dupl., 24, fo. 407ᵛ; Lensi, p. 115: 15 May). See also below, n. 202.

[123] See below, p. 66. [124] See above, 31.

[125] See above, p. 25. [126] See above, p. 32. [127] Ibid.

[128] Giovanni di Domenico da Gaiole writes to Marquis Ludovico Gonzaga on 3 May 1471 from Florence (quoted by Braghirolli 1879, p. 272): '. . . io sono in una opera del palagio di Signori d'uno palcho per la sala molto ornato'. See above, Ch. 1, n. 224.

[129] See above, pp. 32–3 and A. Cecchi 1994, p. 148.

[130] See above, p. 33. The frieze of the council hall was meant to be completed by 25 Jan. 1478 (see below, n. 133) and was referred to on 19 Dec. as having been completed (Op. Pal., 2, fo. 3ʳ; not in 1480, as Rubinstein 1987, p. 33 n. 32). On the artisans who executed the ceilings and friezes, see A. Cecchi 1994, p. 150. On the decoration of the Sala dei Gigli, see also Hegarthy 1988.

[131] On 1 Jan. 1481, the Operai had decided that the Sala dei Settanta was to be furnished with benches and backs (*spalliere*) 'tutto di noce' with 'cornice morta et tarsie et di sopra architrave, fregio, cornicione', 'intorno a detta sala' (Op. Pal., 2, fo. 9ʳ; Gaye, i, p. 576). On 1 Feb., a design for this work having, in accordance with the reform of Nov. 1477, been displayed for one month at the door of the Camera dell'Arme (cf. App. X), they had commissioned the *legnaiuolo* Francesco di Agnolo *alias* La Cecca, who had supplied the *modellum* and had quoted them the lowest estimate, with carrying out this work (Op. Pal., 2, fos. 9ʳ 10ʳ; Gaye, i, pp. 576 7; cf. fo. 9ʳ, 15 Jan.: it was to be done in the 'sala que vulgariter dicitur sala de' LXXta'; on Francesco di Agnolo *alias* La Cecca, see Vasari–Milanesi, iii, pp. 195–204, and Milanesi's comment, ibid., pp. 205–9). Francesco di Agnolo had completed his job by 19 May 1481, when he was paid *l.*393 *s.*6 'pro spallieris et panchis . . . que sunt braccia 58', and *l.*4 for the *modellum* (Op. Pal., 2, fo. 53ʳ). Six months later, on 29 Nov., the Operai commissioned the ceiling (ibid., fo. 11ʳ: 'locaverunt palchum sale LXX et rivellinum in ea faciendum'); but it was only at the end of 1486 that they paid *l.*65 *s.*15 'pro manifactura palchi sale LXXta' (Op. Pal., 4, fo. 20ᵛ, 4 Dec.), *l.*170 for 4,250 *pezzi d'oro* 'missis in palcho et in aliis adornamentis in dicta sala', and *l.*300 'pro depingendo dictum palchum' (ibid., fo. 21ʳ, 22 Dec.; see below, n. 182; they also paid on that day for four 'finestris vitrei' and on the 29th 'pro fattura et legnaminibus [MS: legnaminis] hostii audientie decem virorum in sala [L]xxta', ibid.).

the frieze of the Sala dei Gigli, graceful Florentine lions hold wreaths surrounding the arms of the city and the People and of the Guelf party, while the frieze of the Udienza is adorned with lions' heads. The cross of the People on its ceiling may have been intended to remind the Signoria that this was the palace of the People.[132] In the Sala dei Dugento, the Florentine lily and the cross of the People alternate with the keys of St Peter, to present Florence as a Guelf city—ironically, the frieze was scheduled to be completed by late January 1478, on the eve of the war with the Papacy after the Pazzi conspiracy.[133]

Fig. 29 In the same year in which the ceilings were being installed in the Sala dei Gigli and the Udienza, work began on the door of the new wall between these two rooms, which must have been erected after their 'destruction' three years earlier.[134] The reliefs of the marble frame of the *Fig. 30* door, sculpted by Benedetto da Maiano, represent variations on classical themes, as found on Nereid sarcophagi; even the figures of Charity and Temperance on its capitals are fashioned *all'antica*.[135] In their elegant playfulness they contrast with the gravity of the figures which *Fig. 31* Benedetto placed on the architraves of the door: on the side of the Udienza, in front of an inscription with Solomon's admonition, 'Diligite iustitiam qui iudicatis terram', a seated Justice, on that of the Sala dei Gigli, a standing St John the Baptist. The elaborately inlaid *Fig. 32* panels of the door on this side, which were completed by the end of 1480, the work of Giuliano da Maiano and Francione and their workshop, represent Dante and Petrarch standing above bound volumes of their works;[136] it has been suggested that the design for the intarsia had been provided by Botticelli and Filippino Lippi.[137]

This is the first time that we find Justice represented in the palace. The monumental figure of the cardinal virtue which, jointly with a personification of the Common Good and accompanied by the same inscription, dominated after 1340 the audience chamber of the government of Nine at Siena, may have served as a model for that of the Florentine Signoria; if so, it is surprising that it had not been followed earlier. The figure of John the Baptist as the principal patron saint of Florence conforms to the traditional imagery of the palace; standing between two torches *all'antica* flanked by putti, it crowns the secular imagery of the door with a religious motif. Dante and Petrarch had been portrayed in the Saletta as famous Florentines and eulogized by Salutati in his epigrams. Another Florentine chancellor, Leonardo Bruni, had, without wanting to derogate from Boccaccio's merits, singled out Dante and Petrarch as the poets whose fame belonged 'to the glory of our city', and Ficino had interpreted the *Divine*

[132] See above. p. 7.

[133] Op. Pal., 1, fo. 9ʳ; Gaye, i, p. 573 (24 Feb. 1477): 'locaverunt ad faciendum dictum fregium [*sc.* of the Sala dei Dugento] quattuor magistris eorum usitatis cum hoc quod dicti magistri debeant ipsum fregium fecisse per totam diem xxv mensis ianuarii proxime futuri.' The *magistri* were Giuliano da Maiano, Francione, and Giovanni da Gaiole.

[134] See above, pp. 32–3. The decree of 1 June 1472 states that the demolition and reconstruction were to be carried out 'per magistros ad hoc deputatos' without giving their names. Lein 1987, p. 41, suggests that they were Giuliano da Maiano and Francione.

[135] See Rubinstein 1987, p. 33 ff.

[136] Giuliano da Maiano and Francesco di Giovanni *alias* Francione and partners were each paid 400 *libbre* for one half 'ianue legnaminis' on 9 Dec. 1480 (Op. Pal., 2, fo. 52ʳ; Gaye, i, pp. 575–6). The books are identified by the titles on their spines: Dante's 'Convivio',

'Monarchia', 'Vita Nova', 'Commedia', and Petrarch's 'Pistole', 'Fortune', 'De vita solitaria', 'Sonecti', 'Confessiones', 'Illustribus'. The book Petrarch is holding is his *Trionfi*, and he is pointing at the first line of the first chapter of the *Trionfo della morte*, which reads: 'Quella leggiadra e gloriosa donna' ('questa' for 'quella' is well attested by Florentine manuscripts of the *Trionfi* of the second half of the 15th cent., at least two of them of Medicean provenance. I owe this information to Nicholas Mann). This may be an allusion to the death in 1476 of Simonetta Cattaneo. Lorenzo writes in his *Comento*, after Mar. 1480 (p. 155), that her death was universally mourned in Florence. He had composed, soon after Simonetta's death, four sonnets lamenting it, and in his comment on them he quotes the last line of the same chapter of the *Trionfo della morte*: 'Morte bella parea nel suo bel volto' (p. 156; on the variant 'volto' for 'viso', see n. 26). See also Rochon 1963, pp. 246–8.

[137] See Chastel 1982, p. 111 (Botticelli); A. Cecchi 1994, pp. 152–3.

Comedy in Neoplatonic terms.[138] Giuliano da Maiano and Francione were paid for the intarsias of the door in December 1480; during that year, Cristoforo Landino was composing his monumental commentary on the *Divine Comedy*,[139] which he presented to the Signoria after its printing had been completed in Florence on 30 August 1481.[140] The oration on Dante, the 'primo splendore del nome fiorentino', which he pronounced on that occasion, must have been delivered in the Sala dei Gigli next to the portrait of the poet.[141] By 1480, the *Divine Comedy* had been printed several times in other Italian cities. Landino's *Commentary* accompanied its first Florentine edition. In the long proem which he addresses to the Signoria, he claims to have liberated the *Commedia* from the barbaric corruption inflicted on it by foreign commentators and to have restored Dante 'after long exile to his fatherland'. In the aftermath of the war of the Pazzi conspiracy, Landino triumphantly reaffirms the hegemony of the Florentine language in Italy, and in an apologia that he inserts in the proem he defends Dante against the charge of having lacked patriotism, and eulogizes Florence and her outstanding citizens.[142] Landino was a protégé of Lorenzo de' Medici and a friend of the First Chancellor, Bartolomeo Scala; he may have advised the Signoria on the decorative programme for the second floor of their palace.[143] Dante and Petrarch had been portrayed, around 1450, together with Boccaccio, whom Landino considered greatly inferior to Petrarch,[144] among other famous Florentines in the villa of the Carducci at Legnaia;[145] they now received a far more prestigious public memorial in the palace of the Signoria.

Two years later, the inlaid portraits came to form part of a new cycle of Famous Men, of which only one section was completed. Was that cycle included in a decorative programme for the Sala dei Gigli which preceded the completion of the marble doorway with its intarsia panels? If the 'demolition' of this room, as ordered in 1472, involved that of the fourteenth-century fresco of the wheel of fortune on one of its walls,[146] plans for a new mural decoration may well have been considered during the following years, while the work on the new wall between the Sala dei Gigli and the Udienza and its marble doorway was in progress.[147] Yet it was not until the end of August 1482 that the councils authorized payments for a painting of the Virgin and St Zenobius in the Sala dei Gigli and decreed that part of the funds that had been allotted to the Operai could be used for additional decoration in the palace.[148] Shortly afterwards, the Operai decided that Ghirlandaio be paid 300 *libbre* for 'part of the painting of

Fig. 33

[138] Preface to the *Lives of Dante and Petrarch*, in Bruni, *Humanistisch-philosophische Schriften*, p. 51: 'la fama di questi due poeti grandemente riputo appartenere alla gloria della nostra città.' On Dante's and Petrarch's fame in the 15th cent., see Dionisotti 1965 and 1974, on Dante's fame, Garin 1967. On Ficino's Neoplatonic interpretation of Dante, see below, n. 142.

[139] See above, n. 136; Cardini, in Landino, *Scritti*, i, p. 97.

[140] Ibid. i, p. 167. The presentation copy is BNF, Inc. Banco rari, 341; it does not yet include any of the engravings after Botticelli. See Lightbown 1978, i, pp. 55–8; Vinti 1992.

[141] Landino, *Scritti*, i, pp. 169–74.

[142] See Baron 1966, pp. 346–8, 352–3; Cardini 1973, pp. 108 ff., and Dionisotti, art. 'Landino, Cristoforo', in the *Enciclopedia dantesca*; the proem is ed. in Landino, *Scritti*, i, pp. 100–64 (cf. pp. 136–7). Ficino praised the *Commentary* extravagantly in a letter included in the proem (pp. 153–4). On Ficino's and Landino's

Neoplatonic interpretation of the *Divine Comedy*, see Chastel 1982, p. 100, Dionisotti 1965, p. 363, and, in particular, Field 1986.

[143] He was appointed one of the six secretaries of the Signoria in 1483: Marzi 1910, pp. 603, 604. On his friendship with Scala, Brown 1979, p. 203. See below, p. 65.

[144] Cf. Landino, *Scritti*, i, pp. 137, 138: 'A Dante successe Francesco Petrarca. Che uomo, immortale Dio, e di quanta ammirazione degno! . . . Seguitò el Boccaccio molto inferiore a lui . . .'. See Tanturli 1992, p. 17.

[145] See Horster 1980, pp. 178–80; Spencer 1991, pp. 38–41.

[146] See above, p. 50. [147] But see below, p. 63.

[148] Provv., 173, fos. 83ᵛ–85ʳ (27–31 Aug. 1482): for the 'pictura della 'magine di Nostra Donna et di San Zanobi'. 'Et volendosi far fare per l'advenire pegli Operai del Palagio pe' tempi existenti più alchuna dipinctura per ornamento del palagio, lo possino fare et pagare la spesa pur di decti assegnamenti . . .'.

St Zenobius executed in the *sala* of the Signoria'.[149] The decision to commission this painting from him must have been taken before the passage of the law of 31 August, after two of the Operai had been put in charge, in May 1482, of commissioning a 'figuram seu inmaginem Sancti Zenobii'.[150] St Zenobius was one of the city's patron saints. His image and those of his two deacons, executed in intarsia by Giuliano da Maiano in the Sacrestia delle Messe of the Cathedral, occupied since 1465 the central position on its east wall;[151] but there is no record of his having been previously portrayed in the palace. To have him depicted now not only added to the palace's religious imagery. It also complemented the statue of St John the Baptist, above the new marble doorway to the Udienza. St Zenobius, who was believed to have helped to save the city from conquest by the Goths in 405[152] may, moreover, have acquired, in the wake of the war of the Pazzi conspiracy, an additional significance for the Florentines. In October we find the decoration being planned to cover the entire room, and to include other *imagines* beside that of the Saint. The extended project was entrusted to a group of artists: Ghirlandaio was commissioned to paint 'the image of St Zenobius and other images' on the wall facing the new marble doorway and also to collaborate with Botticelli in painting that wall; Perugino, replaced in December by Filippino Lippi, was to paint the wall towards the piazza; and Piero Pollaiuolo the opposite wall, on the side of the stairs.[153] But only Ghirlandaio carried out his commission, probably jointly with his brothers Benedetto and Davide.[154] In April 1483, the Operai declared that he had completed 'the picture of St Zenobius with its appendages'. In November of that year, when its cost was assessed, the order of its subjects was reversed, and St Zenobius' principal 'appendages' specified: the Operai now describe it as 'the painting of the famous men around St Zenobius'.[155] They do not describe the subjects of the projected paintings on the three other walls. In the end, Bernardo Rosselli was commissioned in 1490 to paint the three walls with gold on blue ground,[156] no doubt with the *fleurs-de-lis* of the house of Anjou.[157]

In the absence of specific documentary and visual evidence, it is impossible to reconstruct the planned decoration of the entire room. The part which was executed, however, leads to the conclusion that it would have consisted of a cycle of Famous Men, which would have been complemented by the portraits of Dante and Petrarch on the panels of the marble doorway.

Fig. 34

[149] Op. Pal., 2, fo. 55ʳ; Gaye, i, pp. 577–8 (*s.d.*, between 31 Aug. and 31 Oct. 1482): 'Visa quadam provisione per oportuna consilia edita de mense augusti prox. preteriti [see preceding note] et opere facto per Dominichum Thomasi del Grillandaio pictorem in pariete sale superioris [*ed. om.* superioris] Dominorum a latere Doane', he is to be paid 300 *libbre* 'pro parte picture Sancti Zenobii facta in sala Dominorum'.

[150] Op. Pal., 2, fo. 12ᵛ (22 May 1482): Ridolfo Ridolfi and Mazzeo Mazzei are authorized 'ad locandum ... in sala Audientie ... figuram seu inmaginem Sancti Zenobii'.

[151] See Haines 1983, pp. 139, 147–8. Margaret Haines has kindly suggested to me that the intarsia in the Sacrestia delle Messe must have served Ghirlandaio as model for his representation of the saint.

[152] Giovanni Villani, *Cronica*, i. 61. (i, p. 85).

[153] Op. Pal., 2, fo. 13ʳ⁻ᵛ (5 Oct. 1482; Gaye, i, p. 578). The walls are specified as follows: 'faciam sale ... versus doanam', 'facia[m] sale ... versus plateam, videlicet faciam finestrarum', and 'faciam putei'. The well was at the centre of the courtyard, and the Operai refer to the wall on the side of it and not, as Lensi Orlandi states (p. 89), to a painting to be made of 'il prospetto di un pozzo che si trovava nella Sala della Signoria'. The Operai add that 'non teneantur ad

aliquam solutionem fiendam dicto Dominicho, sed solvi debeat de pecuniis [*Gaye:* operariis] dicti comunis ad id propterea deputatis'.

[154] Francovich 1926, pp. 730, 734, and n. 35.

[155] Op. Pal., 2, fo. 14ᵛ (18 Apr. 1483): 'declaraverunt Dominichum pictorem integre perfecisse picturam Sanctii Zenobii cum suis appartinentii.' On 31 Dec. 1482 (ibid., fo. 14ʳ, Gaye, i, p. 579) they had established the price of the painting of St Zenobius 'cum omnibus suis circumstantiis [*sic*]' at 60 florins, and also decided that he be paid for a painting 'prope dictum Sanctum Zenobium, que postea extinta fuit', obviously because it did not meet with the approval of the Operai. Ghirlandaio was still being paid in 1485 *l.*34 *s.*15 'pro parte picture parietis ... Sancti Zenobii' (Op. Pal., 4, fo. 16ʳ, 18 Feb. 1485). Op. Pal., 2, fo. 15ʳ (25 Nov. 1483): 'pictura hominum famosorum circum circa S. Zenobium'.

[156] Op. Pal., 4, fo. 26; Gaye, i, p. 583 (24 Sept. 1490): he is paid *l.*676 and *s.*9 'pro pictura tribus parietibus aule dominationis omnibus suis sumptibus, exceptuato auro et azurro'.

[157] The wall against which Donatello's *David* had been placed in 1416 had been painted, at that time, with 'gigli nel champo azurro': see above, n. 90.

Neither is it possible, on the basis of the available evidence, to say at what point the programme was worked out. It may have been done between May 1482, when the decision was taken to commission a painting of St Zenobius for the Sala dei Gigli, and October, when Ghirlandaio and four other artists were entrusted with the mural decoration of the entire room, and Ghirlandaio was ordered to paint 'other images' as well as that of the saint.[158] On the other hand, it is arguable that a plan to decorate the room with a cycle of Famous Men was considered after its 'destruction' in 1472 and already existed when Giuliano da Maiano and Francione portrayed two such men on the panels of the new marble doorway.[159] Whatever the date of the entire programme, the figure of St Zenobius must have been meant to retain in it the central position he occupies in Ghirlandaio's fresco—a position which accords with the exclusive reference to the saint in Ghirlandaio's original commission. Seated in a square space defined by four arches inserted into the central arch of Ghirlandaio's fictive façade and flanked by his two deacons, St Eugenius and St Crescentius,[160] St Zenobius blesses the spectators, who can detect, through the lateral opening on the left, the cupola of the Cathedral, where the saints' relics were preserved. The religious message of this largest section of the fresco is emphasized by the relief painted in the lunette above the entablature of the closed arch behind St Zenobius, which represents the Christ child, supported by the Virgin and adored by two angels, Christ and the saint blessing those present in the room. So far, Ghirlandaio's fresco conforms, though in a more ambitious fashion, to the dominant iconographic tradition of the decoration of the palace. At the same time, its civic significance is underlined by the Florentine lily on the frieze of the entablature of the fictive arch and by the two lions placed on either side of it, one of them holding the standard of the People, the other that of the city of Florence.[161] Lions and lily form, as it were, a link between the ecclesiastical space occupied by St Zenobius with his deacons, and the secular one occupied by figures standing against a background of a windswept sky, in the cornice of the windows on either side of the central arch. They are Roman citizens regarded since antiquity as exemplars of civic virtue.[162] On the left are Brutus the first consul, Mucius Scaevola, and Camillus, on the right, Decius Mus, Scipio Africanus, and Cicero. They are *Figs. 35, 36* portrayed in chronological order, and their lives span the time of the Roman republic. In Salutati's cycle too, the famous men of the republic ranged from Brutus to Cicero;[163] in the new cycle, the republican heroes would probably have been followed by famous men of later periods. It is unlikely that the figures on the other three walls would have been citizens of the Roman republic: the last of Salutati's Roman heroes, Cicero, takes us to the eve of its fall, and the portraits of Roman emperors in the spandrels of the fictive arch[164] might indeed already foreshadow a chronological extension of the programme, to include, like Salutati's, the Roman empire and possibly the Middle Ages. In its uncompleted form, the mural decoration of the room conveys a message of republican patriotism.

[158] Op. Pal., 2, fo. 13ʳ (5 Oct. 1482; Gaye, i, p. 578): 'ad . . . pingendam inmaginem Sancti Zenobii et aliarum inmaginum'.

[159] See above, pp. 32–3, 60.

[160] Cf. Davidsohn, *Geschichte*, i, p. 196; Kaftal 1952, nos. 79, 102, and 319.

[161] The picture of the lion on the right was almost entirely destroyed in 1589, when a door was constructed in the east wall to create an access to the new Sala delle Carte Geografiche: see Allegri–Cecchi 1980, pp. 303, 394.

[162] For this and the following, see also Rubinstein 1987, pp. 36 ff.

[163] See above, p. 53.

[164] The roundels in the spandrels of the fictive arch contain portraits of the Roman emperors based on antique coins, as do the two tablets held by putti on the entablature of the marble doorway (cf.

It is a message which belongs to the Florentine Trecento tradition of republicanism as reformulated and reinforced by humanists such as Leonardo Bruni. Florence had been founded by the Romans before their liberty had been destroyed, Bruni had argued, and not by Caesar as the medieval legend had it. The Florentines had inherited from those Romans their own love of liberty so that the heroes of the Roman republic were their true ancestors.[165] Yet, if we compare the epigrams which accompany the portraits of the Roman citizens in Ghirlandaio's fresco with those in the Saletta, we find a subtle though unmistakable shift of emphasis from the republicanism of their actions to their patriotism. Salutati praised Brutus the first consul for having liberated the Romans from the tyranny of their kings: 'in libertate quirites asserui'. In Ghirlandaio's fresco, his patriotism is given a different slant: Brutus figures here as the defender of the fatherland, as 'assertor patriae'. According to Salutati, Cicero and the liberty of Rome had perished together. Here Catiline trembles before Cicero's consular authority, 'tremuit nostras Catilina secures'.[166]

There are also Medicean overtones in Ghirlandaio's fresco. Camillus had been recalled from exile by the Romans, as Cosimo had been by the Florentines;[167] Decius Mus, who immolated himself by charging into the ranks of the enemy and thus secured victory, was clearly meant to prefigure Lorenzo who, allegedly at his peril, went to the king of Naples to negotiate peace at the end of the war of the Pazzi conspiracy;[168] while Cicero's action in suppressing Catiline's conspiracy would remind the Florentines of the failure of the Pazzi and other conspirators to kill Lorenzo; and humanists of his circle compared Lorenzo with Scipio.[169] Such more or less veiled allusions to the Medici, and Lorenzo in particular, do not detract from the overriding theme of civic virtue as exemplified by the heroes of the Roman republic; indeed, their portraits could be read as singling out Cosimo and Lorenzo as modern exemplars of that virtue. The central figure of the fresco may have recalled the image of St Zenobius, the protector of Florence, which dominated the north sacristy of the Cathedral, where Lorenzo had found safe refuge after his brother had been killed.

In so far as the fresco was meant to convey an ideological as well as a patriotic message, that message must have reflected the political climate in Florence after the war. Medicean ascendancy had been greatly reinforced by the constitutional reform of April 1480 which followed on the conclusion of peace; yet after 1480, as before, that ascendancy presupposed the survival of the traditional constitutional structure of the republic. The new council of Seventy, while consolidating Lorenzo's supreme position, had also increased the political influence of the leading citizens of the regime, and depended for its periodical renewals on the votes of the

Dobrick 1981), and the programme of the cycle of Famous Men probably included emperors.

[165] *Laudatio Florentinae urbis*, in Baron 1968, p. 245. Of the Roman generals and statesmen he lists as exemplars of civic virtue, four were portrayed by Ghirlandaio.

[166] Cf. Rubinstein 1987, p. 37, and n. 71.

[167] The comparison is made in a poem addressed by Carlo de' Massimi in 1473 to Lorenzo, ed. Roscoe 1796, ii, p. 47; for the date, cf. Lorenzo de' Medici, *Protocolli*, p. 500 (13 Nov.): 'A Carlo Maximo, risposta pe' versi havuti, latine'. Carlo de' Massimi, who was a member of the Roman noble family of the Massimi, studied law at Pisa between 1474 and 1475: Verde 1973–94, iii. 1, pp. 212–13.

[168] When, in 1516, the Florentine chancellor Marcello Virgilio Adriani compared, in his funeral oration for Lorenzo's son Giuliano, Lorenzo's action of going to Naples with that of Publius Decius Mus and of his son, who like his father vowed himself to death before joining battle, he no doubt followed the traditional interpretation of the Roman consul's portrait in the Sala dei Gigli: 'Notissima omnibus sunt quae Deciorum secutus exemplum Neapoli pro vobis . . . egerit . . .' (ed. MacManamon 1991, p. 34).

[169] See Chastel 1982, pp. 251–3, and Rubinstein 1987, p. 38 n. 74. The portrait of Scipio was probably also meant to allude to his perilous journey to Africa to conclude a treaty of peace and friendship with King Syphax (Livy 18. 17. 10–12). In 1578 this episode provided the source for one of Allori's paintings in the Salone at Poggio a Caiano: see Cox-Rearick 1984, pp. 104–5.

statutory councils. During the war, Lorenzo had been condemned by his enemies abroad and at home as a tyrant; it was expedient, even imperative, for the regime to demonstrate its respect for traditional civic values, as well as for what remained of the ancient republican institutions.[170]

Since the cycle of Famous Men in the Saletta has disappeared, Ghirlandaio's fresco is the only surviving painting in the palace which shows the influence of humanism on its mural decoration before the end of the republic. His Roman citizens wear antique dress and armour, and their attributes are represented *all'antica*, but no great effort seems to have been made at archaeological accuracy.[171] Their epigrams, on the other hand, in Latin hexameters, conform to classical models; they were probably composed by the humanist chancellor of Florence, Bartolomeo Scala,[172] or by his friend Cristoforo Landino, another prominent humanist and Medicean client, who joined him in the chancery in the following year.[173] It may have been on this occasion that the inscription that had been added to Donatello's marble *David*, when the statue was set up in the Sala dei Gigli in 1416, was amended.[174] Its patriotic message could now be read as fitting the pagan Roman citizens of Ghirlandaio's fresco as well as the biblical hero, and in its epigram *deus* could accordingly be changed into *dei*, so that it was now not God, but the gods who helped 'those who fight bravely for their country'.

Why was the mural decoration of the Sala dei Gigli left unfinished? One reason for this may have been financial. As we have seen, in August 1482 the Operai were authorized to use part of their assignment for additional work 'for the ornament of the palace';[175] but in March, the councils had been asked to vote taxes on the ground that the city lacked the resources to meet its current needs,[176] and the war of Ferrara, which broke out in the following month, was bound to involve large military expenses.[177] In October 1481, they had decided that, since the money which had been voted in 1480 for the rebuilding of the walls of Empoli had proved to be insufficient, and since 'for the time being work on the decoration of the palace could be postponed in favour of so worthy a cause', two-thirds of the funds that were allocated to the Opera of the palace be diverted to the fortification of Empoli for four years.[178] The Signoria may have been reluctant to go on with a decoration campaign which had been begun over ten years earlier and which had cost far more than had been foreseen.[179] It may therefore have instructed the Operai who took up their office on 1 January 1483 not to proceed with the programme as planned by their predecessors. The need to cut back expenditure was probably also responsible for the long delays in the painting and gilding of the ceiling of the Sala dei Gigli, for which payments were recorded in 1483[180] but which was not completed until 1489 by

[170] See Rubinstein 1966, pp. 227–8.
[171] Rubinstein 1987, pp. 40–1.
[172] On Scala's poetry, see Brown 1979, pp. 272–4.
[173] See above, p. 61 and n. 143.
[174] See also above, n. 94. [175] See above, p. 61.
[176] '. . . trovandosi la città senza alcuno provedimento di danari, co' quali si possa satisfare agl'occorrenti bisogni' (*provvisione* of the council of Cento of 5 Mar. 1482, quoted by E. Conti 1984, p. 293).
[177] See Mallett 1988.
[178] Provv., 172, fos. 106ʳ–108ᵛ (12–15 Oct. 1481): since 'l'opera del palagio . . . ha alchuni assegnamenti et che per hora le cose appartenenti all'ornamento del palagio si posson soprasedere per fare una opera tanto degna . . .'.
[179] See above, pp. 31–2.

[180] Op. Pal., 2, fo. 56ᵛ (18 Apr. 1483): 'Iohanni Clementis pictori' *l*.108 'pro eius labore et auro et coloribus pro faciendo picturam et seu pingendo unum quadrum et partem de aliis circa illum existentibus in palco sale audientie dominorum'; (25 Oct.): 'Filippo Iuliani pictori' *l*.96 'pro parte picture duorum quadrorum ut incipit pingere in palcho sale dominorum'. For subsequent payments for the ceiling, cf. ibid., fos. 57ʳ (10 Dec. 1483), 57ᵛ (7 Apr. 1484); 4, fos. 16ʳ (18 Feb. 1485), 24ᵛ (9 Apr. 1489), 25ʳ (16 Dec. 1489), 25ᵛ (26 Feb. 1490). On 12 May 1488, and again on 9 Apr. 1489, the Operai handed to one of their number, Antonio di Bernardo Miniati, 'curam perfectionis . . . palchi aule dominationis videlicet picture' (Op. Pal., 4, fos. 8ʳ, 10ʳ); it was probably as a result of this that Bernardo Rosselli was put in charge of painting the ceiling: on 23 Dec. 1488, he was paid *l*.600 'pro parte picture et mectere in auro dictum palchum' (ibid., fo. 24ʳ; Gaye,

Bernardo Rosselli, and of that of the Udienza, which was executed by him as late as 1494, while the ceiling of the Sala dei Dugento remained ceiling ungilded.[181] However, at the end of 1486 the ceiling of the Sala dei Settanta was gilded.[182] The term of office of the Seventy had been extended for five years in September 1484, and at least one other such extension had been made practically certain.[183] The Seventy had become a virtually permanent institution and it may have been felt that the meeting place of the preeminent council of the regime deserved a more dignified decoration than it must have possessed up to then.

Fig. 37 The only major contribution to the figurative decoration of the palace between the completion of Ghirlandaio's fresco and the construction of the new hall of the Great Council after the fall of the Medici regime was thus Filippino Lippi's altarpiece for the old council hall, the Sala dei Dugento.[184] That hall had, like the Sala dei Gigli and the Udienza on the floor above, received a new ceiling and frieze, but no mural decoration. The history of the internal decoration of the palace during the last two decades of the Medici regime reflects some of the character and ambiguities of that regime. The constitutional reform of April 1480 further eroded, by creating the council of Seventy, the powers of the ancient councils of the People and of the Commune and reduced even those of the Medicean council of One Hundred.[185] The council hall on the first floor, having been adorned with a sumptuous ceiling, was now in 1486 further enriched by Filippino Lippi's magnificent altarpiece.[186] It represents the Virgin with the Florentine patron saints St John the Baptist, St Victor, and St Zenobius, as well as the palace's patron saint, St Bernard; like Ghirlandaio's fresco of St Zenobius in the Sala dei Gigli, it thus conveys a civic as well as religious message.[187] One may wonder whether the magnificent decoration of the most public rooms of the palace, the Sala dei Gigli and the Sala dei Dugento,

i, p. 582), and on 16 Dec. 1489, he was paid *l*.319 *s*.11 'pro residuo' of *l*.1,779 *s*.1 'pro pictura et de omnibus aliis expensis factis in dicto palcho excepto quod in auro' (Op. Pal., 4, fo. 25ʳ, Gaye, i, p. 583). Lensi, p. 74, appears to identify the 'sala audientie' with the Udienza; in fact, it refers to the Sala dei Gigli. Cf. e.g. Op. Pal., 4, fo. 16ʳ (18 Feb. 1485): payment to Ghirlandaio of *l*.34 *s*.15 'pro parte picture parietis seu faciei Sancti Zenobii aule audientie dominorum': see above, n. 155, and App. III. On the ceiling of the Udienza, see following note. See also above, pp. 59–60, and below, p. 69.

[181] On 9 July and 12 Aug. 1494, Bernardo Rosselli was paid *l*.602 *s*.15 *d*.8 and *l*.200 respectively 'pro parte picture palchi audientie dominorum', and on 17 Sept., *l*.205 'pro residuo' of *l*.1,335 *s*.5 *d*.8 'pro manifactura et magisterio picture et mictere in auro supradictum palchum' (Op. Pal., 4, fos. 34ᵛ, 35ʳ).

[182] Op. Pal., 4, fo. 21ʳ (22 Dec. 1486): payment to Girolamo di Giovanni *battiloro l*.170 for 4,250 'pezzi auri de magnis missis in palcho et in aliis adornamentis in dicta sala de' [L]xxta'; payment to Giovanni di Chimenti *pictori* 'pro depingendo dictum palchum et alia in dicta sala' (see above, n. 131). There are at present no traces of gilding on the ceiling of the large room on the mezzanine which we have identified as that of the Seventy (see above, p. 34). The ceiling was restored during the restoration of the interior of the palace between 1908 and 1929: see Lensi Orlandi, p. 257. On the ceiling of the Sala dei Dugento, see Lensi, p. 354.

[183] See Rubinstein 1966, pp. 207–9. The Seventy were in fact reconfirmed in Feb. 1489 and again in Sept. 1493.

[184] See below. On 31 Dec. 1482, the Operai paid five florins to have the image of the Virgin 'above the stairs by which one goes to the council hall', 'restored or washed' (Op. Pal., 2, fo. 14ʳ; Gaye, i, p. 579: 'pro faciendo reflorere seu lavare immaginem Virginis Marie site supra scalam, per quam itur in sala consilii)'. This decision must refer

to the lunette of the Annunciation attributed to Giovanni del Ponte: see above, p. 57. Milanesi, in Vasari–Milanesi, iii, p. 322 n. 3, states that in 1487 Botticelli painted 'un tondo per la sala dell'Udienza del Magistrato dei Massai della Camera', which has been identified with the *Madonna della Melagrana*; but until 1533, when this magistracy was abolished (see Uccelli 1865, p. 111), the office of the Massai della Camera was in the Bargello, not in the palace of the Signoria. On the *Madonna della Melagrana* see *Uffizi* 1979, p. 178; Lightbown 1978, ii, pp. 65–6.

[185] See above, pp. 33–4.

[186] The inscription on the painting gives 20 Feb. 1485/6 as its date of completion. Its price was established on 7 Apr. (Op. Pal., 4, fo. 4ʳ; Poggi 1909c, pp. 307–8). Albertini records in 1510 that 'nella sala del consiglio antiquo è la tavola di Philip' (*Memoriale*, A viʳ). In the 1568 edition of the *Vite* (Vasari–Milanesi, iii, p. 474), Vasari writes that Filippino Lippi 'fece nel palazzo della Signoria la tavola della sala dove stavano gli Otto di Pratica'. The 1550 edition of Filippino's Life (p. 503) gives the same location, but in the Life of Baccio d'Agnolo, Vasari states that the painting was still in the Sala dei Dugento (p. 807: 'dove è la tavola di Filippino'; these words are omitted in the 1568 edition). The magistracy of the Otto di Pratica was abolished in 1560 (see Diaz 1976, pp. 97, 104); after its creation in 1480, it had been meeting in the room of the Dieci di Balia on the mezzanine (see above, p. 34). As Lensi, p. 115 n. 68, observes, the altarpiece had probably been moved by that time from the Sala dei Dugento, to make place for the tapestries that had been commissioned by Cosimo I. The painting is now in the Uffizi, no. 1568. Like the Udienza of the Signoria, the council hall had an altar: see App. VI.

[187] St Victor owed his status as Florentine patron saint to the Florentine victory over the Pisans at Cascina on his feast day in 1364.

was designed to demonstrate to the political class, the *reggimento*, of Florence that the conciliar institutions of the republic still mattered, while Filippino's altarpiece demonstrated the enduring tradition of civic patriotism.

It is tempting to seek to detect, in the transformation the palace underwent in the second half of the fifteenth century, the hand of the Medici.[188] The restoration of its courtyard followed on the construction of the new family palace of the Medici only a few years earlier, and was probably by the same architect.[189] Vasari later compared the *cortile* windows *alla moderna* with those Cosimo had installed in the courtyard of his palace.[190] Cosimo, as well as his son Piero, were Operai del Palazzo, the former in 1444, the latter in 1452 and 1454; Lorenzo belonged to that office in 1479, in 1486, and from 1488 until his death.[191] But so, in 1470 and 1476, did Jacopo de' Pazzi, the builder of the Pazzi palace, where he had employed Giuliano da Maiano.[192]

Lorenzo's grandfather and his father had both been Operai at critical moments in the building history of the palace. In July 1444, when Cosimo, and in August 1452, when Piero were elected,[193] the renovation of the council hall had been decided by a Balìa, that is by a Medicean council which for a number of years had been endowed with extensive powers to ensure the safe passage of legislation. That on both occasions the decision to renovate the council hall should have been taken shortly after the creation of these special councils points to the urgency with which this matter was being treated by the ruling group.[194] In January 1454, it was the turn of a Signoria of which Cosimo's younger son Giovanni was a member, to decree the restoration of the courtyard. The work was to be carried out under his and the Gonfalonier's supervision; in the following month, Giovanni's brother Piero was elected one of the three Operai.[195] There can be little doubt that Cosimo, who from the 1440s onwards, in addition to the construction of his new family palace, was engaged in extensive building programmes for religious institutions,[196] took a lively interest in the restoration of the palace of the Signoria. Would Lorenzo follow in the footsteps of his grandfather after succeeding his father as head of the regime?

A few months before Piero de' Medici's death in December 1469, the councils had assigned a large sum to the renovation of their hall and of the *sala* and the audience chamber of the Signoria, but shortly afterwards that sum was diverted to fortification work in the Florentine dominion.[197] Was it mere coincidence that the renovation project was revived in August 1470, a month after the rejection by the council of Cento in July 1470 of a reform bill by which Lorenzo had been hoping to increase the security of the regime?[198] The focal point of that project was the renovation of the council hall; accordingly, the Operai who were in office in

[188] See e.g. Trachtenberg 1989, pp. 607–8.

[189] See above, pp. 30–1.

[190] Vasari–Milanesi, ii, p. 436: '. . . con ordine di finestre alla moderna, simili a quelle che [Michelozzo] per Cosimo aveva fatto nel cortile del palazzo de' Medici'.

[191] Tratte, 904, fo. 114ᵛ. This corrects the dates in Rubinstein 1966, p. 220 n. 1. See App. X.

[192] On the Pazzi palace (*c*.1458–69), see Moscato 1963. After the execution of Jacopo de' Pazzi for his part in the conspiracy against Lorenzo and the confiscation of his properties, Giuliano da Maiano and his brothers Benedetto and Giovanni put in a claim of 1,800 florins for work done in the palace and in the Pazzi villa at Montughi (ibid., pp. 70–8). As one of the three Operai in 1470 and 1476, Jacopo de' Pazzi probably also held this office in the intervening years, when

Giuliano and Benedetto were commissioned for the decoration campaign in the palace of the Signoria (see App. X). Bucci, in Bucci and Bencini 1971–3, i, p. 76, considers the ceiling of the Sala dei Dugento 'similissimo a uno dei soffitti originali di Palazzo Pazzi'. See also Haines 1983, pp. 167–9.

[193] See above, Ch. 1, nn. 183, 194, 201.

[194] The former council was created in May 1444, the latter in July 1452; see Rubinstein 1966, pp. 18, 21.

[195] See above, Ch. 1, n. 201.

[196] Wackernagel 1981, pp. 229 ff; on the date of the beginning of the building of the Palazzo Medici, see Hyman 1968, pp. 135–6, and Kent 1979 (who dates it to 1444).

[197] See above, p. 31. [198] Rubinstein 1966, pp. 178–80.

1469 were called 'Operarii Palatii et Sale Consilii'.[199] Lorenzo may have been trying to curry favour with the council members by encouraging the long overdue restoration of their meeting place.

Although Lorenzo is first recorded as one of the five Operai of 1479, it is highly probable that he was involved in the decisions of their office during the renovation campaign, which was finally started in 1472. Medici involvement in the initial stage of that campaign is shown by the fact that in 1472–3 the banking company of Pierfrancesco and Lorenzo's brother Giuliano de' Medici acted as depositaries of the Operai.[200] When in November 1478, Lorenzo was elected one of the Operai, this was the first election to their office to be conducted in accordance with the new regulations which had been decreed a year earlier, after its activities had come in for stringent criticism; as its most prominent member, he took in it the place which had previously been occupied by Jacopo de' Pazzi, killed in the Pazzi conspiracy.[201] After the mural decoration of the Sala dei Gigli had effectively come to a standstill in 1483, he was chosen to supervise another decorative project whose execution had in its turn been delayed. In May 1483, when the Signoria reallocated to Ghirlandaio the new altarpiece for the chapel of their audience chamber, for which Leonardo da Vinci had previously been commissioned, they put Lorenzo in charge of the new commission.[202] Ghirlandaio had recently completed his fresco of Famous Men in the adjoining room; the composition included veiled, or not so veiled, references to Lorenzo and to his exploits during the crisis of the Pazzi conspiracy; the author of the accompanying epigrams has to be sought in Lorenzo's humanist circle; it is possible, indeed probable, that Lorenzo himself contributed to the programme for the mural decoration of the entire room. On the other hand, an event which took place a few years later casts some doubt on his active involvement in the decoration programme during the seventies and early eighties. In February 1487, the councils passed a law which extended the term of office of the Operai from one to five years.[203] The preamble of this law[204] contains criticisms of the way in which earlier Operai had discharged their duties. The different artistic preferences of successive Operai, it observes, had made some of them address themselves to the brilliantly gilded panelled ceilings ('laquearia auro fulgentia'), others to concentrate on the marble doorway ('fores marmoreas'), and yet others on the mural paintings and altarpieces ('ad picturas parietum vel altaria'). As a result, many of these works were lacking ultimate completion, and the delays in their execution made them appear partly new and partly old. These shortcomings, the preamble concludes, could be avoided if the same Operai were to serve for longer periods than one year; and the Signoria proposed accordingly that the Operai be henceforth elected for five years.[205] Elections to this office had taken place in November of each year, with effect from

[199] Op. Pal., 1, fo. 1ʳ.

[200] Monte Comune, 1523 (Entrata e uscita del Camarlingo del Monte, 1473), fo. 705: 'Operai del Palagio di nostra M.S. per acchoncimo e adornnamento de la sala del conxiglio deono dare a di 27 marzo fi. 200 . . . ad Antonio Marttegli, uno de' detti Operai e per lui a Pierfrancesco e Giuliano de' Medici loro dipoxitarii . . .'. For a payment to the same in 1472, Monte Comune, 1966, fo. 478. On the firm of Pierfrancesco and Giuliano de' Medici & Co., see de Roover 1970, p. 23. [201] See App. X.

[202] Sig., Delib., Dupl., 24, fo. 407ᵛ; Lensi, p. 115 (20 May 1483): 'locaverunt tabulam altaris cappelle eorum palatii Domenico

Tommasi Curradi vocato il Grillandaio, quam facere debet in qualitate et eo modo et forma prout et sicut . . . videbitur et placebit Magnifico viro Laurentio Pieri Cosme de Medicis.' The supervision of the commission to Leonardo had been left to the Operai: see above, n. 122.

[203] Provv., 177, fo. 110ʳ⁻ᵛ (10–13 Feb. 1487).

[204] I am grateful to Caroline Elam for drawing my attention to the text of the preamble.

[205] The aesthetic preferences ('voluptates et desideria') differ 'in viris presertim prestantibus', 'propter diversitatem ingeniorum', as can be clearly seen 'in opere presentis curiae', of the palace of the

1 January;[206] that this reform should have been decreed as much as nine months in advance of the election of the next Operai may well be an indication of mounting dissatisfaction with the incomplete state in which the ceiling of the council hall and the mural decoration of the *sala* of the Signoria had been left after 1482. That Lorenzo, his brother-in-law Bernardo Rucellai, and Lorenzo's client and confidant, the *provveditore* of the Monte, Antonio di Bernardo di Miniato Dini, were elected to serve for the next five years,[207] may indicate the principal source of these criticisms.

In the event, the new Operai did not make any major contribution to the interior decoration of the palace.[208] In view of the accusation levelled against their predecessors of having left unfinished work that they had commissioned, it might have been expected that they would now have tried to remedy these shortcomings. A few months after they had taken up office, in fact, they put Antonio di Bernardo in charge 'of the completion . . . of the ceiling of the *sala* of the Signoria, that is of the painting' of it;[209] in December 1488, they paid Bernardo Rosselli 'for part of his painting' of the ceiling,[210] and in December 1489 the residue of what was owed to him for his work.[211] Finally, in September 1490, they commissioned him to paint the three walls of that room which had been left undecorated seven years earlier, with gold on blue ground.[212] Evidently by that time all hope had been abandoned that its mural decoration, of which only Ghirlandaio had executed his share, could still be completed. It was hardly a coincidence that all but one of the painters who in 1482 had been commissioned with the decoration were employed by Lorenzo de' Medici to fresco his recently acquired villa at Spedaletto.[213] Even so, when in October 1492 the Signoria proposed the extension of the five-year term of the Operai who had been elected in 1487, it did so on the grounds that, since they had so diligently provided 'for many ornaments of the walls and the ceiling' of its *sala*, it would be expedient to confirm them in their office for another quinquennium.[214]

Signoria, 'cuius prefecti et operarii modo ad laquearia auro fulgentia, modo ad fores marmoreas, quandoque ad picturas parietum vel altarium convertuntur. Et sic quisque pro captu suae naturae diversis ornamentis laetatur et illis intendit. Unde accidit quod nulli tali ornamento extrema manus imponitur, et ob talem dilationem unum atque idem opus in parte novum, in parte vetustum apparet. Et credentes non ita futurum si operarium officium maius sit tempore unius anni', they were henceforth to be elected 'modo et tempore consueto', but for five years. See also below, n. 214.

[206] See App. X. The *provvisione* states that apart from the extension of their term of office, the Operai were to be elected as before, that is by the Signoria, the Colleges, and the council of Cento, in November of each year.

[207] The other two members of the office were Bernardo del Nero and Giovanni Serristori: Op. Pal., 4, fo. 6ᵛ. All the Operai belonged to the council of Seventy; Lorenzo was the only one of them who, as far as we know, had previously held that office. After his death, he was replaced, as in other magistracies, by his son Piero. Cf. Tratte, 904, fo. 114ᵛ.

[208] See the *stanziamenti* of the Operai during their term of office in Op. Pal., 4, fos. 16ʳ ff. On 15 Nov. 1488, they appointed, 'absente Laurentio de Medicis eorum collega', the Medici bank as their depositary (Op. Pal., 4, fo. 8ᵛ; see Brown 1992, p. 129); in 1491, Lorenzo de' Medici *et socii* are again recorded in this capacity (Op. Pal., 4, fo. 27ᵛ, 28 Feb.).

[209] Op. Pal., 4, fo. 8ʳ (12 May 1488): 'concesserunt curam perfectionis putei Doane ac etiam palci aule dominationis videlicet picture.' The delegation is reconfirmed on 9 Apr. 1489 (ibid., fo. 10ʳ).

[210] See above, n. 180.

[211] Ibid.: 'pro residuo' of *l.*1,779 *s.*1 'pro pictura . . . in dicto palcho excepto in auro', for which the *battiloro* Papio Palmierini was being paid separately. On 6 Dec. 1489 he was paid *l.*528 *s.*7 'pro parte' of *l.*4,021 *s.*7, 'de qua summa debet etiam habere lib. 800. Sunt pro auro dato pro dicto palcho . . .'.

[212] Op. Pal., 4, fo. 26ʳ; Gaye, i, p. 583 (24 Sep. 1490); see above, n. 156.

[213] See Chastel 1982, pp. 171–2; Horne 1908, p. 353: a contemporary report from Florence (probably addressed to Ludovico il Moro) lists Botticelli, Filippino Lippi, Perugino, and Ghirlandaio as having 'facto prova di loro ne la capella di papa Syxto excepto che Philippino. Ma tutti poi allo Spedaletto del M.co Laur.o . . .' Spedaletto near Volterra was acquired by Lorenzo in or after 1486: see Elam and Gombrich 1988, p. 482 and n. 9.

[214] Provv., 183, fos. 47ʳ–48ʳ (17–27 Oct. 1492): as the present Operai 'a principio fuerunt deputati pro quinque annis ea praecipue ratione, ut sine interruptione opera quae inceperentur perficerentur antequam ad aliud manus imponeretur, et cognoscentes per eos utiliter fuisse provisum multis ornamentis et parietum et laquearium sale superioris ob ipsorum solertem curam et diligentiam, et ob id utile fuisse eos in officio confirmare . . .'. See above, n. 205, and App. X.

The Medici regime fell in November 1494. The creation, in December, of the Great Council led to the decision, in the following year, to build a new hall to accommodate what turned out to be 1,000 or more of its over 3,000 members.[215] This offered new and, owing to the vast empty spaces of its walls, unique opportunities for mural decoration. But these opportunities were not seized until 1503, over seven years after the construction of the hall had been practically completed. There may have been several reasons for this delay. Savonarola, who had been chiefly responsible for the creation of the Great Council, may have wished the decorative 'superfluities' which he criticized in monasteries and churches[216] to be avoided in the hall of the council which he called God's gift to Florence.[217] On the other hand, the frequency of meetings in the hall may have encouraged the Signoria to put off work that was liable to interfere with the activities of the council. It was not until May 1498, a few days before Savonarola's execution, that Antonio da Sangallo and Baccio d'Agnolo were commissioned to decorate the chapel of the hall and Filippino Lippi to paint its altarpiece.[218] He had, twelve years earlier, painted the altarpiece for the old council hall. After his death his commission was given to Fra Bartolomeo. At first it had obviously been intended to embellish the new hall by using works of art which had belonged to the Medici and had been confiscated after Piero's flight.[219] In 1476, the Signoria had bought from the Medici Verrocchio's bronze *David*;[220] in December 1495,

Figs. 38, 39 Donatello's bronze *David* and his *Judith and Holofernes* were taken from the palace of the Medici to that of the Signoria.[221] In the end the *David* was set up in its courtyard, the *Judith* on

Fig. 40 the *ringhiera* where it was, in 1504, replaced by Michelangelo's *David*,[222] while the three large paintings of Hercules' labours by Antonio Pollaiuolo were hung in the old council hall.[223] Of the sculptures transferred from the Medici palace, only the 'marble or bronze heads', no doubt most or all of them antique, which the Signoria had expressly destined 'for the new hall',[224] may in the end have been used for its decoration, unless this plan too was abandoned. On the other hand, the *Virgin Adoring the Child*, which Filippo Lippi had painted for the chapel of the

Fig. 41 Medici palace and which had also been taken to the palace of the Signoria,[225] must have temporarily provided an ideal altarpiece for its new hall, since the two saints with the Virgin are St John the Baptist and St Bernard.

[215] See above, pp. 40–1.

[216] Steinberg 1977, pp. 51–2. [217] See above, p. 42.

[218] Frey 1909, pp. 120–1, no. 68 (18 May 1498). Filippino Lippi's commission is mentioned in Antonio da Sangallo's and Baccio d'Agnolo's contract.

[219] Frey 1909, p. 106, no. 7 (9 Oct. 1495): 'ut dictas statuas . . . ponant in dicto palatio . . . in illis locis, in quibus videbitur dictis operariis vel in sala nova'. See Wilde 1944, p. 76.

[220] See above, p. 56.

[221] Landucci, *Diario fiorentino*, p. 119: 'E a dì 9 di dicembre 1495, si portò in Palagio de' Signori un Davitte ch'era in casa Piero de' Medici, e posesi in mezzo della corte'; p. 121: 'E adì 21 di dicenbre 1495, si pose in sulla ringhiera del Palagio de' Signori, a lato alla porta, quella Giuletta di bronzo, ch'era in casa Piero de' Medici'. (On 'Giuletta' as a variant of 'Giuditta', see Natali 1988, pp. 20–1.) It can hardly have been a coincidence that the Gonfalonier of Justice in Dec. 1495 was Antonio Manetti, the biographer of Brunelleschi, who was known in Florence as a lover of architecture: see below, Ch. 3, n. 142.

[222] See below, p. 72. On the later locations of these sculptures, see Janson 1963, pp. 79–80, 199–201. On the placement of the *David* on

the *ringhiera*, see the critique by Parks 1975 of the political interpretation proposed by Levine 1974. Weil-Garris 1983, p. 386, suggests that by being placed next to the door of the palace, both the *Judith* and the *David* 'were transformed into portal-guardians'.

[223] See below, n. 273.

[224] Müntz 1888, p. 102; Frey 1909, p. 114, no. 8 (14 Oct. 1495): 'consignentur operariis palatii Florentini pro sala nova dicti palatii'. The 27 *teste*, one of them 'una testa di bronzo di cavallo', were handed over on the same day by the syndics of the Medici property.

[225] Müntz 1888, p. 104; Frey 1909, p. 115, no. 14 (11 Dec. 1495): the Signoria 'deliberaverunt, quod precipiatur sindicis illorum de Medicis quatenus dent et consignent pro cappella palatii . . . operariis dicti palatii omnia ornamenta cappelle . . . videlicet omnia paramenta et ornamenta altaris dicte cappelle.' These must have included the panel of the chapel of the Medici palace, which is described in the 1492 inventory of the properties of Lorenzo de' Medici as representing 'una Nostra Donna che adora il figl[i]uolo ch'ell' à innanzi a'piedi e uno san Giovanni e uno sancto Bernardo e Dio [*ed.* dicie] padre colla cholomba innanzi, di mano di . . .' (*Inventario di Lorenzo il Magnifico*, p. 23). The *Libro di Antonio Billi*, which was composed

It was not until 1502, four years after Filippino Lippi's contract, that another work of art was commissioned for the hall of the Great Council. A large statue of the Saviour was then ordered from Andrea Sansovino, to stand on the centre of the entablature of the *tribuna* of the Signoria, above the seat of the Gonfalonier of Justice.[226] This tribune had been constructed in 1499/1500 by Baccio d'Agnolo[227] and was in all probability situated, contrary to received opinion, not on the east, but on the west wall.[228] With its seats for the Priors and the Gonfalonier, its wings (*aliette*),[229] and a gilded entablature which was twelve *braccia* wide, it must have formed, like its counterpart in Venice, the most impressive part of the furnishing of the hall, which included a gallery with two rows of seats along the walls and benches across the hall for the members of the council. The altar, or chapel, which was situated opposite the *tribuna* of the Signoria, the work of Antonio da Sangallo and Baccio d'Agnolo,[230] was large enough to contain the frame of the altarpiece which, in its final form, measured 4.44 by 3.06 metres.[231] The rich woodwork of the hall's furnishing must have provided, by 1500, its principal, perhaps only, ornament; after the fall of the republican regime in 1512, it was destroyed when the hall was converted into barracks for soldiers. Landucci went so far as to say, with bitter irony, that 'all Florence grieved less about the change of regime than about [the loss of] that beautiful wooden furnishing which had cost so much'.[232]

Like the subject of Filippino Lippi's altarpiece, that of Andrea Sansovino's sculpture was religious, but both had civic overtones. The revolution of 9 November 1494 had taken place on the Saviour's feast day;[233] Fra Bartolomeo, who six years after Filippino's death in 1504 was put in charge of the altarpiece with the proviso that he follow the design Filippino had not executed,[234] included in his painting of the Virgin, St Anne and 'all the other protectors' of Florence and the saints 'on whose feast days she had achieved victories'.[235] In Fra Bartolomeo's painting, St Anne is the most prominent of these saints, figuring second to the Virgin. In 1343, on her feast day, the Florentines had risen against the duke of Athens, just as on the Saviour's

Fig. 42

between 1481 and 1530 (see Schlosser–Kurz 1964, pp. 189–90), states that Filippo Lippi painted 'nel palazo de' Medici una tavola, la quale è oggi nel palazo de' [*ed.* di] Signori, che vi si messe, quando loro furno fatti rubegli' (cf. *Anonimo Magliabechiano*, p. 105). In all probability, this panel was used as the altarpiece of the hall of the Great Council pending the completion of Filippino Lippi's and, subsequently, Fra Bartolomeo's painting. The panel has been identified with the painting of the *Virgin Adoring the Child* with St John the Baptist and another saint, who is no doubt St Bernard, in Berlin (Staatliche Museen, Preussischer Kulturbesitz, Gemäldegalerie, cat. no. 69): see Oertel 1942, pp. 73–4, Marchini 1975, p. 212, and Acidini 1990, pp. 84–5. It measures 127 x 116 cm., and would accordingly have occupied less than one half the space of Fra Bartolomeo's projected altarpiece, which in its unfinished state measures 444 x 306 cm. In 1502, the altar was described as 'altare Verginis' (Frey 1909, pp. 125–6, no. 127, 10 June 1502). On 3 June, Francesco di Niccolò di Tommaso was commissioned 'ad mictendum aurum in ornamento' of its *tabula* (ibid., no. 126).

[226] Frey 1909, p. 126, no. 128; Poggi 1909*a*, pp. 144–6 (10 June 1502); 'super cornicione residentie . . . Dominorum et in medio dicti cornicionis super capud, ubi residet magnificus Vexillifer Iustitie.'

[227] See Wilde 1944, p. 73. Cf. Frey 1909, pp. 121, 123, 125, nos. 77, 99, 124.

[228] See App. VIII.

[229] The suggestion, in Isermeyer 1964, p. 105, that the *aliette* were wooden *Flügelbauten*, which contained the Secretum and the Specchio, is unacceptable: see App. VI.

[230] See above, n. 218. The altar was completed by June 1502, when the cost 'ornamenti legnaminis cappelle sive altaris' was estimated: see Frey 1909, pp. 125–6, no. 127 (10 June).

[231] Wilde 1944, pp. 73–4.

[232] Landucci, *Diario fiorentino*, p. 333: 'la qual cosa dolse a tutto Firenze, non la mutazione dello stato, ma quella bella opera di legniame di tanta spesa. Ed era di grande riputazione ed onore della città avere sì bella residenza . . .', that is the tribune of the Signoria.

[233] That is, of the dedication to the Saviour of the first Lateran Basilica. The law of the *parlamento* of 2 Dec. 1494, which had abolished all Medicean institutions, had made the 9th November a perpetual holiday, to be celebrated with a solemn mass in the Cathedral (Frey 1909, p. 113, no. 1). The *provvisione* of 11 Jan. 1345, which had declared the 26th July a public holiday 'annis singulis in futurum', is ed. in La Sorsa 1902, pp. 218–20. See also Crum and Wilkins 1990, pp. 148–50.

[234] Marchese 1878–9, ii, p. 603, no. 6 (26 Nov. 1510); 'cum eisdem condictionibus et forma'.

[235] Vasari–Milanesi, iv, pp. 198–9: 'nella quale sono tutti e' protettori della città di Fiorenza, e que' Santi che nel giorno loro la città ha aute le sue vittorie'. See Steinberg 1977, pp. 100–5.

day 1494 they had expelled another 'tyrant', Piero de' Medici. Both these days had been declared public holidays to commemorate the victory of republican liberty over tyranny. Andrea Sansovino did not execute his sculpture,[236] and Fra Bartolomeo had not completed his altarpiece when the republican regime was abolished after the return of the Medici in September 1512.[237] Had these works been set up in the hall of the Great Council, they would have echoed the republican message with which Donatello's *Judith and Holofernes* had been invested in 1495. For just as, early in the century, Donatello's marble *David* had been transformed by an inscription from a prophet into a republican hero, so now the words inscribed in that year on the *Judith*'s base changed the symbolic meaning of the statue from the triumph of humility over pride into that of the victory of liberty over tyranny: she had been placed there by the citizens as an exemplar of the salvation of the commonwealth, 'exemplum salutis publicae'.[238] When the statue stood in the garden of the Medici palace,[239] it had on its column an inscription with the warning that just as in the person of Judith humility had vanquished pride, so 'kingdoms fall through luxury, cities rise through virtue'.[240] A second inscription recorded that Piero di Cosimo had dedicated the statue, as a memento for the citizens to serve the republic, to 'liberty and fortitude'.[241] This second inscription was headed by the words 'salus publica', and may have been added after his victory over the anti-Medicean faction in September 1466.[242] Bertoldo's medal commemorating the Pazzi conspiracy had SALUS PUBLICA inscribed below the bust of Lorenzo. The words that were carved in 1495 on the pedestal of the *Judith* could thus have been designed to emphasize, in contrast to Piero's dedication and Bertoldo's medal, the true meaning of 'salus publica' in a republic.[243]

It was in keeping with the impression of austerity which must have been conveyed by the walls of the new hall in the first years of its existence that they contained from 1496, instead of a mural decoration, two inscriptions which admonished the assembled citizens to safeguard the republican constitution. The use of didactic inscriptions, not necessarily accompanying

[236] Wilde 1944, p. 76.

[237] In Vasari's time, the unfinished altarpiece was in the chapel of Ottaviano de' Medici at S. Lorenzo (Vasari–Milanesi, iv, p. 198); it is now in the Uffizi, no. 1574. See also below, p. 95.

[238] See Janson 1963, p. 198; Natali 1988, p. 25.

[239] '. . . in orto dicti palatii Pieri de Medicis' : Frey 1909, p. 106, no. 7 (9 Oct. 1495).

[240] 'Regna cadunt luxu, surgunt virtutibus urbes / Caesa vides humili colla superba manu.' This inscription, which was 'In columna sub Iudith in aula medicea' at the time of Cosimo's death in 1464 (Bartolomeo Fonzio, *Zibaldone*, BRF, MS Ricc. 907, fo. 143ʳ (9 Aug. 1464), cited in Gombrich 1953, p. 83 n. 4, Janson 1965, p. 198), was included by Gentile Becchi in a collection of his poems (Oxford, Bodleian Library, MS Lat. Misc., c. 81, fos. 120ʳ–131ᵛ (fo. 120ʳ⁻ᵛ): see Grayson 1973, p. 290, who dates this collection of poems by Lorenzo di Piero de' Medici's tutor in the 1460s). On Judith representing virtue, see Erffa 1970.

[241] 'Salus publica. Petrus Medices Cos. Fi. libertati simul et fortitudini hanc mulieris statuam quo cives invicto constantique animo ad rem pub. [se?] redderent dedicavit' (Passerini, in Ademollo 1845, p. 758 n. 39, from a manuscript in his possession).

[242] Cf. Natali 1988, pp. 26–7, on the dating of this inscription. After the preceding restoration and reinforcement of the Medicean controls of the republican constitution, the title of the highest magistracy had been changed, in 1459, from *Priores artium* to *Priores*

libertatis, with the obvious purpose of demonstrating respect for that constitution.

[243] The other statue by Donatello which had been confiscated and taken to the palace may have given rise to a similar ideological reinterpretation. In the Medici palace, the bronze *David* had on its base, 'Sub statua David ceso Gulia in area Cosmiana ad animandos pro patria cives' (Bodl. MS cit. above, n. 240, fo. 126ʳ; these lines are copied twice, first separately on fo. 125ᵛ, with 'area', and then, followed by the poem, on fo. 126ʳ, with 'arca', clearly a scribal error), and an inscription, equally the work of Gentile Becchi: 'Victor est quisquis patriam tuetur. / Frangit iniusti deus hostis iras. / En puer grandem domui tyrannum. / Vincite cives' (ed. Grayson 1973, p. 296, cited by Agosti, in *Giardino di San Marco* 1992, p. 104 n. 142). A slightly different version of this inscription, with the title 'in domo magnifici Pieri Medicis sub Davide eneo' has been published by Sperling 1992, p. 218, from another manuscript which she dates between 1466 and 1469. (According to Sperling, the poem was composed in the 1420s and related to the war between Florence and Filippo Maria Visconti, but the authorship of Becchi excludes this hypothesis.) The 'tyrant' whom the young David had vanquished could be taken to prefigure any of the powerful rulers such as Giangaleazzo Visconti and, more recently, King Alfonso of Naples, whom Florence had resisted, much as the inscription under Donatello's marble *David* had celebrated the biblical hero as an exemplar of civic resistance against powerful enemies.

paintings, had been a fourteenth-century tradition.[244] In the hall of the Great Council, they had a specific political function. One of them, in the vernacular, warned the citizens against the summoning of *parlamenti*, which Savonarola condemned as potential instruments of despotic rule and which, on his initiative, had been abolished in 1495;[245] the other, in Latin, encapsulated his belief in the divine source of the republican reform by stating that the council had been established by God, and that ill would befall anyone who sought to ruin it.[246]

It was not until 1503 that the Signoria decided to give Leonardo da Vinci the commission to execute the mural decoration in the hall.[247] Although the decision would have been taken by the whole Signoria and voted upon by them jointly with the two Colleges, it is highly probable that it was due to the initiative of Piero Soderini, who by that time had been Gonfalonier of Justice for life for about one year. Soderini, after he had taken up this office on 1 November 1502, had been busy converting a section of the palace into a residence for himself and his wife Argentina Malaspina.[248] This involved extensive decorative work, as well as the commissioning of two paintings of saints for Soderini's room; payments for these tondi were made in May and June 1503.[249] The decision to put Leonardo in charge of the mural decoration of the council hall must be seen in the context of his evident concern with embellishing the palace. In May 1504 Leonardo had promised to complete the cartoon for his painting by the end of February 1505;[250] as he was making less progress than had been hoped, Michelangelo was commissioned, later in 1504,[251] to paint, in Vasari's words, 'l'altra facciata'[252] or, in Michelangelo's, 'la metà della sala'.[253] It is now generally assumed that Leonardo and Michelangelo were each to paint one half of the wall on either side of the tribune of the Signoria.[254] This assumption is confirmed by a contemporary diary. Cerretani records, among events of October 1505, that Leonardo 'began to paint the wall of the council hall above the place of the Twelve Buoni Uomini'.[255] Their seats were on one side of the tribune of the Signoria;[256] Leonardo must therefore have been commissioned to decorate one half of the wall at which the tribune of the Signoria was situated, Michelangelo the other half.[257] The location of their paintings would have followed the model of the hall of the Maggior Consiglio in Venice, where Guariento's fresco of the

[244] See above, pp. 49–52.

[245] See Villari 1887–8, i, p. 309, and n. 1.

[246] Landucci, *Diario fiorentino*, p. 126: 'Nella qual sala fu posto due epitaffi di marmo, l'uno era in volgare e in versi; l'altro in latino. El vughare . . . in sentenzia diceva: Chi vuol fare parlamento vuol torre al popolo e' reggimento. L'altro ch'era in latino diceva, che tal Consiglio era da Dio, e chi lo cerca guastare capiterà male.'

[247] The original contract is not extant; a supplementary contract, of 4 May 1504 (Frey 1909, pp. 130–1, no. 175), states that it had been concluded 'più mesi fa'. Leonardo received the key to the Sala del Papa in the convent of S. Maria Novella on 24 Oct. 1503 (Beltrami 1919, p. 81, no. 130). The room was to serve him for his work on the cartoon, which he now promised to have completed by the end of Feb. 1505. [248] See above, pp. 43–5.

[249] See above, p. 45. [250] See above, n. 247.

[251] The contract has not survived. Paper which had been supplied to Michelangelo for his cartoon was paid for on 31 Oct. 1504 (Isermeyer 1964, p. 118); it had been glued together early in that month (Hirst 1988, p. 25).

[252] Vasari–Milanesi, vii, p. 159.

[253] To Giovan Francesco Fattucci [end of Dec. 1523], in

Michelangelo, *Carteggio*, iii, p. 7: 'io avevo tolto a fare la metà della sala del Chonsiglio di Firenze.'

[254] See e.g. Wilde 1944, p. 80, Barocchi 1962, pp. 252–3, Kemp 1981, p. 236. But see Isermeyer 1964, pp. 89, 121.

[255] *Ricordi*, pp. 115–16 (between entries for 9 and 14 Oct. 1505): 'Im questo tempo L(eonar)do da Vincci, maestro grandissimo e fiorentino, di pittura, cominc[i]ò a dipignere la sala del consiglio in quella faccia sopra dove stanno e 12 buoni huomini.' If this passage relates to the first half of Oct., it would seem to contradict Leonardo's own statement (see below, n. 259); but this apparent discrepancy could be due to Cerretani's intending only to provide an approximate date for when Leonardo began to paint in the hall. Cerretani's *Ricordi*, the autograph of which has recently been found in the Vatican Library, was published for the first time in 1993.

[256] The seats of the other of the two Colleges of the Signoria, the Sixteen Gonfaloniers, must have been on the other side of the tribune. Cf. Giannotti, *Discorso intorno alla forma della Repubblica di Firenze*, in *Opere*, i, p. 18: '. . . la Signoria . . . andava in sala a sedere al suo tribunale; dove già erano comparsi . . . i Collegi, che sono XVI . . . ed i XII Buoni uomini.'

[257] On the location of the tribune, see App. VIII.

Coronation of the Virgin was painted above the *tribunale* of the Signoria.[258] As in Venice, the eyes of the members of the council would have been likely to be turned in this direction, and it was this wall which would have been the obvious choice for the mural paintings.

Leonardo probably began to transfer his composition from the cartoon to the wall in the spring of 1505;[259] by the time he left Florence a year later,[260] he may have completed what was probably the central section of his painting of the battle of Anghiari, *The Fight for the Standard*.[261] Michelangelo completed only the cartoon of the battle of Cascina, *The Bathers*.[262] Leonardo's painting and Michelangelo's cartoon are known to us only through sixteenth-century copies, but preparatory drawings help to reconstruct some of the entire compositions.

Fig. 43
Fig. 44

Both the *Battle of Anghiari* and the *Battle of Cascina* were designed to commemorate Florentine victories. In 1503, Florence was in the eighth year of her war against Pisa, which had rebelled against Florentine rule in 1494 during the French campaign in Tuscany. The victory over the Milanese forces under Niccolò Piccinino in the battle of Anghiari in 1440 had been the last major victory the Florentines had achieved before the Pisan war, and as such offered a sharp contrast to its setbacks; the battle of Cascina in 1364, which was celebrated in Florence on the feast of St Victor, had been won against Pisa. But the message of the planned mural decoration was not limited to the nostalgic celebration of past victories. In his widely read *Decades*, Flavio Biondo described the battle of Anghiari as 'a unique example in our time' of a battle 'which was similar to those of antiquity';[263] in the *Fight for the Standard*, Leonardo painted a violent encounter of lightly armed horsemen. The composition of the scene, whose principal historical source was probably Neri di Gino Capponi's *Commentarii*, may have been influenced by a fifteenth-century cassone-painting of the battle;[264] but it may also have reminded the spectator of the light cavalry which was becoming increasingly common in contemporary warfare. Introduced into Italy during the second half of the fifteenth century, when Venice began to employ Albanian stradiots, it was less heavily armed than the conventional cavalry and hence far more mobile and adaptable; it was used by Florence during the Pisan war.[265] The tumultuous engagement depicted by Leonardo could serve to demonstrate to the citizens who were assembled in the council hall, and who had ample evidence of the procrastinations of *condottieri* during the campaign, what military action could be like. As for his choice of the fight for the standard as the centrepiece of his painting, this episode had a special

[258] On the location of this tribune, see Wolters 1983, pp. 290–1.

[259] Frey 1909, p. 133, no. 210 (14 Mar. 1505): the Cathedral workshop is to furnish the materials 'pro conficiendo ponte pro pictura Leonardi de Vincio fienda in sala magna consilii'. Cf. also ibid. nos. 206, 207, 209. Leonardo's entry in the Madrid manuscript, according to which he began to *colorire* in the palace on 6 June 1505, is taken by Pedretti 1968, pp. 54–8, to mean that Leonardo began to paint the *Battle of Anghiari* at that point: 'Addì 6 di giugno 1505 in venerdì al toco delle 13 ore, cominciai a colorire in palazo. Nel qual punto del posare il pennelo, il tenpo si guastò ... Il cartone si stracciò, l'acqua si versò ...' (Leonardo da Vinci, *Madrid Codices*, v, p. 1). It is, however, more probable that these words are meant to record an event which occurred when Leonardo was beginning, on that day, to paint in the palace (see Kemp 1981, p. 238). According to Isermeyer 1964, p. 95, he had finished the cartoon of the *Fight for the Standard* by Mar. 1505.

[260] He received permission from the Signoria on 30 May 1506 to absent himself from Florence for three months, to enable him to work for Georges d'Amboise at Milan: Vasari–Milanesi, iv, p. 44 n.

[261] See e.g. Wilde 1953, p. 71: 'in all probability, planned for a place in, or near, the centre'; Gould 1954, p. 120.

[262] According to Condivi, *Vita di Michelangelo*, p. 44, the cartoon was completed after his flight from Rome, in the summer of 1506; but cf. Isermeyer 1964, p. 120; Hirst 1988, pp. 42–5. On the date of Michelangelo's Uffizi studies for the cartoon of the *Battle of Cascina*, ibid., p. 34; 'in all probability made in the late summer of 1504'.

[263] *Historiarum ... libri XXXI*, p. 572. For this and the following, see Rubinstein 1991, pp. 281–3.

[264] Cederlöf 1959.

[265] Mallett 1974, pp. 152–3.

bearing on two of the treasured possessions of the republic that were kept in the room of the Gonfalonier of Justice, the standards of Niccolò Piccinino and of the duke of Milan, which had been captured during the battle of Anghiari.[266]

Michelangelo's painting of the false alarm before the battle of Cascina may in its turn have been designed to convey a message related to military policy. His source for the composition of this scene was the Florentine chronicle of Filippo Villani. Villani extols the initiative of the Florentine commissioner, Manno Donati, contrasting it with the negligence of the professional captain, Galeotto Malatesta, and records the participation in the army of 'Florentines who had voluntarily joined on horseback in order to do honour to their fatherland'.[267] By the time Michelangelo was commissioned to paint 'half of the hall', in the autumn of 1504, Machiavelli, with whom he had collaborated in an unsuccessful project to starve Pisa by diverting the Arno,[268] had begun to canvass for the introduction of a native militia which, he hoped, would help to solve the problems posed by mercenary soldiers.[269] The militia, which to begin with was to be levied in the Florentine territory, the *contado*, was finally established by a law passed by the Great Council in December 1506.[270] Had Michelangelo transferred his painting from the cartoon to the wall, it could have served the Signoria to persuade the members of the council of the advantages of a military reform of which many of them were critical[271] by reminding them of the city's great victory at Cascina. This victory over Pisa's *condottiere* John Hawkwood had been won after the Florentine commissioner had taken over the command of the army. Manno Donati had ordered the false alarm to be raised as a warning to his troops to be on the alert, and the representation of the bathing soldiers' panic could in its turn have been read as a warning to the Florentines not to indulge in personal comfort at the present time of danger.[272]

The expulsion of the Medici and the construction of the new hall of the Great Council also affected the decoration of the main palace block. Of the works of art which were taken from the Medici palace to the Signoria in 1495, the three large paintings of *Labours of Hercules* by Antonio Pollaiuolo were hung in the old council room on the first floor, where they must have offered a striking contrast to Filippino Lippi's altarpiece of the Virgin with saints.[273] The passage which connected the palace with the new hall was furnished with marble columns that had, in their turn, been requisitioned from Medici property.[274] In view of the prestigious role of the new doorway leading from the old council hall to this passage and from there to the hall of the Great Council,[275] there was a strong case for providing it with a frame which was comparable to that of the doorway between the Sala dei Gigli and the Udienza. This was achieved

[266] See Rubinstein 1991, p. 282 n. 41.

[267] Filippo Villani, *Cronica*, xi. 97 (vi, p. 493): 'de' Fiorentini, che per onorare loro patria di volontà erano cavalcati'.

[268] See Villari 1895–7, i, pp. 483 ff.

[269] Rubinstein 1972, pp. 13 ff.

[270] See Bayley 1961, pp. 254 ff.

[271] Ibid., pp. 253–4. On the question of Machiavelli's influence on the programme of the paintings by Leonardo and Michelangelo, cf. Rubinstein 1991, pp. 283–5.

[272] Kemp 1981, p. 243.

[273] On 17 May 1497, Betto Buchi *legnaiuolo* was paid seven *soldi* 'per più concimi et opere, messe a conciare gli Ercoli nella sala vechia'

(Frey 1909, p. 119, no. 48). Cf. Francesco Albertini's *Memoriale* of 1510, A vi\u02b3, where the paintings are attributed to Verrocchio: 'Nella sala del consiglio antiquo è la tavola di Philip et li tre quadri grandi di Hercole in tela del Verrocchio.' On Pollaiuolo's *Labours of Hercules*, see Wright 1994.

[274] See above, pp. 41–2. Landucci, *Diario fiorentino*. p. 146: 'E a dì 21 [Apr. 1497], fu fornito porre quelle colonne di marmo a l'andito che va di Palagio nella Sala grande, di verso la Mercatantia.'

[275] When this doorway was used by the members of the Great Council for the first time on 25 Feb. 1496, after an opening had been made in the wall, it was 'inbastito, e non v'era ancora fornito nulla' (Landucci, *Diario fiorentino*. p. 126).

by the artist who designed the reliefs of that frame, most probably Baccio d'Agnolo, and the sculptor who executed them, possibly Benedetto da Rovezzano.[276]

Fig. 45 Like Benedetto da Maiano's reliefs for that doorway, those of the new doorway of the Sala dei Dugento were derived from antique prototypes; but while Benedetto had borrowed from sarcophagus reliefs, here the frieze and the base of the columns imitate Roman trophy motifs,[277]
Figs. 46, 47 which are interspersed with representations of modern weapons. The relevance of these trophies to the republic's military power is underlined by the inscription SPQF on the shields, which at the same time refers to the Roman origins of the city.[278] A second marble doorway, of
Fig. 48 which the column bases only were completed, was installed at the far end of the south wall.[279] It is portrayed in Vasari's painting for the ceiling of the Sala dei Cinquecento, of *Antonio*
Fig. 49 *Giacomini Addressing a Council Meeting*.[280]

In 1500 and 1501, Baccio d'Agnolo was paid for furnishings in the Udienza and its chapel,[281] but most of the decorative work on the second floor after the construction of the Sala dei Cinquecento was due to the conversion of part of that floor and of the mezzanine into an apartment for Piero Soderini and his wife. The registers of the Operai record a large number of payments from December 1502, the month after Soderini took up his office as Gonfalonier for life, to June 1503, for work done in his rooms, the 'stanze del Gonfaloniere'.[282] In January 1503, the Operai commissioned Baccio d'Agnolo and Giuliano da Sangallo to carry out restoration work in Soderini's apartment as ordered by him;[283] in March, Francesco di Piero di Donato is paid for having painted his *camera*, and in May, that of the Notary of the Signoria which had been taken over by the Gonfalonier.[284] These two rooms must have had richly decorated ceilings, since large amounts of gold leaf were acquired for them.[285] In May, Davide

[276] On the authorship of the marble doorways of the Sala dei Dugento, see Vasari–Milanesi, v, p. 351: 'In compagnia de' medesimi [i.e. of Cronaca and others] fece la scala . . . e di mischio le colonne e porte di marmo della sala che oggi si chiama de' Dugento': cf. above, p. 42. Baccio d'Agnolo was *capomaestro* of the palace workshop from 24 May 1498 until June 1503, with an interruption between July and Dec. 1500 (Frey 1909, p. 121, nos. 74, 100, 104, p. 128, no. 152). See now A. Cecchi 1990*a*, pp. 40–1, who proposes the attribution of the reliefs to Benedetto da Rovezzano. Since Benedetto returned to Florence in 1505, this would mean that the reliefs were executed after that date, rather than at the time when Baccio was *capomaestro*. In that case, the marble frames of the two doorways must have been previously undecorated, as it is highly unlikely that they were put in place only in or after 1505. The fact that one of these doorways has reliefs only on its column bases may indicate that the sculptural decoration of the doorways, which was evidently not completed, had proceeded in two stages.

[277] Cf. the friezes on two trophy pillars then at S. Sabina in Rome (Bober and Rubinstein 1986, p. 206, no. 175).

[278] See Rubinstein 1987, pp. 42–4. After Florence had, in 1865, temporarily become the capital of Italy, the Sala dei Dugento was converted into a waiting-room for the deputies who met in the Sala dei Cinquecento and the door was moved to its present position on the south wall: see Lensi Orlandi, p. 225; Allegri and Cecchi 1980, p. 392.

[279] On 17 May 1497, payments were made 'per pulitura di tre colonne di mischio verde', of 'una colonna di mischio', as well as of 'altre colonne di granito' (Frey 1909, p. 119, nos. 46, 47).

[280] Cf. Vasari, *Ragionamenti*, in Vasari–Milanesi, viii, p. 212.

[281] Op. Pal., 10 fo. 8ᵛ; Frey 1909, p. 123, no. 104 (30 Dec. 1500): 'A Bartholomeo d'Agnolo capomaestro della sala' *l.*467 'per parte del coro fa su nella cappella de' Signori et . . . residentia della Audientia de' Signori'; fo. 16ᵛ, Frey 1909, p. 124, no 117: on 12 June 1501, he is paid *l.*477 'per resto del coro fece nela Chappella della Audientia della Signoria' and for the 'cornicione facto alla residentia de' decti Signori in decta Audientia', and on 11 Aug. 1502 (fo. 34ʳ; Frey 1909, p. 127, no. 138), *l.*190 for benches etc. 'facte per l'udientia de' Magnifici Signori, dove seghono e venerabili Collegi'. See also Frey 1909, p. 124, nos. 109, 114, 115.

[282] Cf. Op. Pal., 10, fos. 38ʳ–55ʳ (20 Dec. 1502 to 17 June 1503); Frey 1909, pp. 127–8.

[283] '. . . acconcimina mansionum domini Vexilliferi in palatio Dominorum' (Op. Pal., 9, fo. 84ᵛ; Frey 1909, p. 127, no. 141 (15 Jan. 1503). They were also to execute what he ordered 'circa cavallum et leones existentes penes finestram crucis'. One of these may have been the small *Marzocco* on the top of the newel post of the fragment of stairs to the second floor on the mezzanine: see above, Ch. 1, n. 134. On the *finestra della croce*, see App. V. Giuliano da Sangallo was shortly afterwards to succeed Baccio d'Agnolo as *capomaestro* of the palace (Frey 1909, p. 128, no. 152, 17 June 1503).

[284] Op. Pal., 10, fo. 48ʳ; Frey 1909, pp. 127–8, no. 145 (15 March 1503): he is paid 55 florins 'per havere dipinto la camera del M.co Gonfaloniere in palagio de' Signori et altrove in decto palagio'; fo. 50ʳ; Frey 1909, p. 128, no. 147 (10 May 1503): he is paid 18 florins for painting the 'camera dove stava el notaio de' Signori, che ogi [*ed.* ogni] è per uso del Magnifico Gonfaloniere'. See above, p. 44.

[285] Op. Pal., 10, fo. 49ᵛ (29 Apr. 1503): Lorenzo di Michelangelo *battiloro* is paid *l.*31 *s.*10 for 900 *pezzi d'oro* for the *chamera di sopra*,

Ghirlandaio was paid for a tondo representing St Peter and St Paul; in June, Domenico di Domenico for another representing St Thomas the Apostle and St Thomas Aquinas, both for the room of the Gonfalonier. St Peter was Piero's patron saint, while from the time when, over one hundred years earlier, Sacchetti's sonnet had been inscribed in its audience chamber, St Thomas the Apostle's image conveyed a civic message to the Signoria.[286] According to Vasari, Morto da Feltre decorated his room on the first floor[287] with grotesques which 'were considered very beautiful'.[288] By the time that the decoration of the Gonfalonier's apartment had been completed, it must have acquired the measure of dignity which could be expected of the residence of the head of the republic.

The decision to build a new and more spacious chapel for the Signoria forms a further step in the adaptation of the old republican palace to its new role.[289] The decoration of the chapel was taken in hand as soon as it was constructed: in August 1511, Ridolfo Ghirlandaio was paid for part of its decoration,[290] and equal payments for his work continued until October 1512.[291] In December, Baccio d'Agnolo was paid for work on the wooden furnishings of the chapel, and other such payments are recorded in the following year; and since he was again *capomaestro* of the palace, he must have played a leading role in devising the decoration of the new chapel.[292] The final payments to Ridolfo Ghirlandaio are recorded as late as January 1515. Two of these payments were made by the Operai 'per commissione', 'by order', of Lorenzo de' Medici the Younger,[293] since August 1513 at the head of the new regime. The Medici had, soon after their return to Florence, resumed the family's traditional involvement with the Opera of the palace. In January 1513, Giuliano de' Medici, Lorenzo's predecessor in the government of the city, was elected by the Balìa one of the five Operai,[294] whose term of office was, in December, extended by the Balìa for another two years in view of the fact that they had taken many

that is on the second floor, of the Gonfaloniere, and Francesco di Bernardo *battiloro l.*18 *s.*11 for 530 *pezzi d'oro* for the 'stanza dove stava el notaio de' Signori'. On 31 Oct. 1504, he was paid 'per resto di pezi 5,200 d'oro', which had in part been used 'per dorare la cigna e 'l bronchone e la ghirlanda al gighante', that is of Michelangelo's *David*, and in part for *l'audienzia del Gonfaloniere* (Op. Pal., 10, fo. 67ʳ; Frey 1909, p. 132, no. 189).

[286] Op. Pal, 10, fo. 53ʳ; Frey 1909, p. 128, nos. 149 and 150 (31 May and 8 June 1503). Davide Ghirlandaio, whose painting is now in the Palazzo Pitti (Galleria Palatina, inv. 1890, no. 6063), was paid ten, Domenico di Domenico *mazziere* eight florins. See also above, pp. 51–2.

[287] See above, Ch. 1, n. 342.

[288] Vasari–Milanesi, v, p. 204: he painted 'a Pier Soderini, allora gonfalonieri, la camera del palazzo a quadri di grotesche, le quali bellissime furono tenute; ma oggi, per racconciar le stanze del Duca Cosimo, sono state ruinate e rifatte'. Milanesi, ibid., pp. 201–2, argues that the decoration attributed by Vasari to Morto da Feltre was in fact the one for which Francesco di Piero di Donato was paid in Mar. 1503 (see above n. 284), but this is unlikely. On Morto da Feltre, see Venturi 1910 and Thiem 1961, pp. 2–4 and n. 10.

[289] See above, pp. 45–6.

[290] Sig., Delib., ord. aut., 113, fo. 235ʳ (30 Aug. 1511): 'per parte della dipintura della cappella della Signoria' (70 florins).

[291] For entries of payments for the chapel in the registers of the Deliberazioni of the Signoria in 1511 and 1512, see Lesher 1979, pp. 214–16: for entries in those of the Operai in 1513–15, ibid., pp. 215–16, and Frey 1909, p. 136. On 26 Jan. 1515, Ghirlandaio was paid *l.*200 *s.*19 *d.*9 'per resto de la dipintura de la capela de' Signori . . . la quale fu stimata fior. 280 d'oro' (ibid., no. 249).

[292] See A. Cecchi 1990*b*, pp. 42–3.

[293] Op. Pal., 15, fo. 11ʳ; cf. Frey 1909, p. 136, no. 248 (20 Jan. 1515): 'A Ridolfo del Grillandaio dipintore lire 70 piccioli per parte della pittura fatta nella cappella del palagio per commissione del Magnifico Lorenzo de' Medici'. This entry in the register of the Operai has always been taken to refer to Lorenzo di Piero de' Medici's commission of the paintings in the chapel (e.g. by Lensi Orlandi, p. 121), but Ridolfo Ghirlandaio must have received his commission by the time he began working there in 1511 (the Operai's register for that year is not extant). Lorenzo's 'commissione' only concerns the final payments to Ridolfo Ghirlandaio, which were made in instalments; one of these is recorded, on the same day, as being made 'per ordine decto' of the Signoria (Op. Pal., 15, fo. 11ᵛ). Lorenzo was in Rome from Sept. 1514 to May 1515 (Butters 1985, pp. 245, 263). At a critical point in his relations with the regime's leading citizens (ibid., 237 ff.), he may have felt it expedient to show that he was emulating his grandfather's artistic patronage.

[294] Balìe, 43, fos. 109ᵛ–110ᵛ (10 Jan. 1513); see App. X. As in the 1470s (see above p. 32), they were to receive revenues from taxes on foreigners, as well as judicial taxes from parts of the Florentine dominions.

decisions concerning the 'ornamento grande et utile' of the palace.[295] One of these was no doubt to complete the mural decoration of the new chapel. This raises the question whether this decoration, as executed by January 1515, corresponded to the original programme of the decoration, which must have been in existence when Ridolfo Ghirlandaio began working in the new chapel in 1511, or whether that programme was modified after the fall of the republican government in the following year. The images of the four evangelists in the cruciform coffers of the ceiling, as well as the representation of the vision of St Bernard in the lunette above the altar, clearly constitute an attempt to reproduce the iconography of the altar and of the tabernacle of the audience chamber,[296] while that of St John the Baptist, who is represented standing in a fictive niche opposite the new altar, under an *Annunciation* with the church of the *Fig. 51* Santissima Annunziata in the background, conforms to the traditional religious imagery of the palace.[297] Unlike Fra Bartolomeo's unfinished altarpiece for the hall of the Great Council, *Fig. 17* however, the altarpiece by Ridolfo's disciple Mariano da Pescia[298] lacked any civic references. It is, moreover, doubtful whether the thirty-two inscriptions on the walls and ceiling[299] formed part of the original programme. They follow, in their turn, a tradition which goes back to the fourteenth century.[300] Their Latin texts, however, are all but devoid of republican themes. Consisting mostly of quotations from the Bible and from early Christian authors, they are meant to teach moral lessons. The few of them which convey a political message, such as the warnings of the dire consequences of disunity and the entreaty to love one another inscribed on either side of the figure of St John the Baptist,[301] are of so general a nature that they could be made to apply to a nascent principate as well as to a republic.

[295] Balìe, 43, fo. 184ʳ (30 Dec. 1513): 'havendo inteso come per decti Operai si sono disegnate e ordinate molte cose, maxime in ornamento grande et utile di questo palagio'. See Lensi, p. 109.

[296] See above, pp. 49, 58, and App. IV.

[297] On the decoration of the chapel see Thiem 1961, pp. 8–13, who identify Raphael's ceiling of the Stanza della Segnatura as the probable model for Ridolfo Ghirlandaio's of the chapel.

[298] Vasari–Milanesi, vi, p. 542: 'di mano del quale è un quadro di Nostra Donna con Cristo fanciullo, Santa Lisabetta, e San Giovanni, molto ben fatti, nella detta cappella di Palazzo'. In 1532, the altarpiece was described as representing Christ with saints (Inventory 1532, fo. 126ᵛ: 'Una tavola d'altare . . . con la figura di N.S. et altri Santi con ornamento messo d'oro tutto intorno'). Sometime before 1843, Fra Mariano's altarpiece had been replaced with a painting of St Bernard

(Moisè 1843, pp. 131–2), which appears to have been in the tabernacle in 1893, when it was dated in 'un tempo assai posteriore' to the decoration of the chapel (C. Conti 1893, p. 55). At the time of Milanesi's edition of Vasari's *Vite* in 1878–85, Mariano da Pescia's painting was in the Uffizi (Vasari–Milanesi, vi, p. 542 n. 5); it is now again in the chapel.

[299] They are transcribed in Lesher 1979, pp. 107–12.

[300] See above, pp. 50–2.

[301] 'Hoc est praeceptum meum ut diligatis invicem sicut dilexi vos' (John 15: 12); 'Omne regnum in se ipsum divisum desolabitur et domus supra domum cadet' (Luke 11: 17); 'Concordia parve res crescunt, discordia vero maxime dilabuntur' (Sallust, *Bellum Iugurthinum*, 10. 6); 'Reddite quae sunt Caesaris Caesari et quae sunt Dei Deo' (Matthew 22: 21).

3

THE PIAZZA DELLA SIGNORIA*

There are no records of the deliberations which determined the location of the new palace of the Signoria, but there can be no doubt that a major reason for the final choice was the availability of an open space which, however small, could be used as a square in front of the building.[1] The palace of the Podestà, the Bargello, while bordering on the Piazza S. Apollinare,[2] had no square of its own, which may have been considered a disadvantage. Civic buildings in many Northern Italian cities faced open spaces,[3] and so above all, by the time a decision about the location was reached, did the new palace of the commune of Siena which was beginning to be built on the Campo.[4] Unlike the Sienese, however, the Florentines did not choose the market square, the Mercato Vecchio, as the site of their new civic palace. Possibly they preferred it to be close to the palace of the Podestà.

Subsequent legislation stressed the importance of the piazza 'for the decorum' of the palace of the Signoria;[5] but apart from aesthetic considerations, there were practical reasons for placing the building on a square. Although by the end of the thirteenth century the popular assembly, the *parlamento*, had long lost its original role in Florentine political life, it still met regularly for the swearing in of the Podestà and, under the new popular regime, of the Captain of the People, the Priors, and the Gonfalonier of Justice. In the case of the Podestà and the Captain, it assembled in the Cathedral, in that of the Priors and the Gonfalonier of Justice, as a rule in the church of S. Pier Scheraggio.[6] Once the Priors and the Gonfalonier of Justice had moved into their new palace, they began to use the small square in front of it for these ceremonies; as early as 1306 they are recorded as having delivered their oath of office 'in platea palatii'.[7] This ceremony, which took place six times a year, was performed after 1323, when the *ringhiera* was constructed, on this platform outside the palace,[8] as was the handing over of the banners to the Gonfaloniers of the civic militia, for which the piazza was being used from an

* This chapter is an expanded version of Rubinstein 1978.

[1] See above, p. 8.

[2] On 21 Jan. 1255, two houses were purchased 'iusta plateam sancti Appolenaris . . . sive in angulo eiusdem platee', to serve for the building of the new palace (Frey 1885, p. 124, no. 1).

[3] There is no comprehensive study of Italian city squares in the 14th cent.

[4] Braunfels 1959, pp. 94, 121; Cordaro 1983, pp. 33–4.

[5] Frey 1885, p. 199, no. 81; Pampaloni 1973, p. 32 (3 Feb. 1319): 'pro decore et fortificatione palatii populi Florentini'.

[6] See e.g. *Consulte*, i, pp. 343, 408, ii, pp. 89, 216–17, *et passim*; *Consigli*, i, pp. 33, 58, 60, 82, *et passim*; *Statuto del Capitano del*

Popolo, i. 1, p. 11; Statutes of the Capitano del Popolo of 1355, Statuti del Comune di Firenze, 10, fo. 3ʳ; Davidsohn, *Geschichte*, iv. 1, pp. 57–9. After his office was created in 1307, the Executor of the Ordinances of Justice too was sworn in that church.

[7] Cf. e.g. *Consigli*, i, p. 297 (15 Dec. 1306). However, for the time being, and probably until the construction of the *ringhiera* in front of the palace, the ceremony appears as a rule to have been held in the church of S. Pier Scheraggio. The council register of votes cast in 1323 and in the following years until 1326 (Lib. Fab., 12) does not record the swearing in of the Signoria.

[8] See preceding note, and above, pp. 14–15.

early date.[9] Before the new palace was built, the *parlamento*, at a time when it still met to debate political decisions and when none of the churches would provide adequate space for it, would be summoned to one of their squares—as it was in 1280, when Cardinal Latino proclaimed his peace treaty between the Guelfs and the Ghibellines on the piazza of S. Maria Novella[10]—or to the cathedral.[11] After 1323, on the rare occasions on which *parlamenti* were held to decide on political issues, it was from the *ringhiera* that the Signoria addressed the assembled citizens and asked them to consent to their proposals.[12]

The handing over of the banners of the civic militia to the Gonfaloniers of its companies recalls the military function of the piazza, which must have been in the minds of the Priors and their advisers when they decided on the site of the palace. The ease with which the existing communal palace, in which the Podestà resided, was captured by a mob in 1295,[13] could at least partly be attributed to the lack of an open space in front of it, in which the government could collect reinforcements. The Ordinances of Justice of 1293–5 had raised the numbers of the militia to no less than 4,000 men;[14] in order to deploy such numbers for the defence of public order, it was obviously highly desirable for the Priors and for the Gonfalonier of Justice, who commanded the militia, to be able to dispose of a large space close to their palace. When it was decided, in April 1301, to straighten the Via S. Procolo, this was partly justified with the argument that it would allow the troops of the *contado* militia safer access to the seat of the government.[15] A decree of 1319 on the compulsory acquisition of property for the widening of the piazza in its turn justifies this action on military as well as on aesthetic grounds, 'pro decore et fortificatione palatii populi'.[16]

Fig. 52 While the existence of the *platea Ubertorum* must have largely determined the choice of the site for the new palace, purchases of property in December 1299 show that from the very beginning the Commune was planning to create a second piazza in front of its west façade.[17] Again, this may have been primarily due to aesthetic considerations: to surround the palace on two sides with a piazza was bound to add to its appearance of magnificence. There was also a strong case to be made on practical grounds for adding to the space which the original square had provided, which could hardly have been adequate for the military and ceremonial requirements of the Signoria. The growth of the Florentine population, which had led to the decision of 1284 to build a new circuit of walls, the third *cerchio*, no doubt contributed to the enlargement by the Commune of church squares.[18] Much the same applied to the small piazza of the

[9] This ceremony was performed at first two and after 1328 three times a year 'in publico parlamento in platea pallatii populi more solito congregato', in the presence of the Podestà, the Captain of the People, and the Executor of the Ordinances of Justice, who handed over the banners: cf. Lib. Fab. 12, *passim*.

[10] Davidsohn, *Geschichte*, ii. 2, p. 165.

[11] Four such meetings are recorded between 1280 and 1298: *Consulte*, i, pp. 169, 256, 298, ii, p. 311.

[12] See below, p. 89. [13] See above, p. 6.

[14] See above, pp. 5–6.

[15] *Codice dantesco* 1950, p. 87, Pampaloni 1973, p. 125 (28 Apr. 1301): 'eo quod populares comitatus absque strepitu et briga magnatum et potentum possunt secure venire per eandem [*sc.* viam] ad dominos priores et vexilliferum iustitie cum expedit.' The Via San Procolo 'protenditur versus burgum de la Plagentina'; cf. Davidsohn,

Forschungen, iv, pp. 525–6: the street is the present Via Pandolfini and its continuation, the Via dell'Agnolo.

[16] Frey 1885, p. 199, no. 81; Pampaloni 1973, p. 32 (3 Feb. 1319); Spilner 1987, p. 405 and n. 65 (5 and 19 July 1319): officials to be in charge of this operation were appointed on 19 July and authorized to levy a tax on anyone who benefited from the enlargement of the piazza.

[17] Frey 1885, p. 190, no. 40 (9 Dec. 1299): purchase of a house 'prope plateam comunis Florentie'.

[18] See the documents ed. in Pampaloni 1973, pp. 70–7 (S. Maria Novella, 1288), 85 (S. Spirito, 1294), 56–8 (S. Giovanni, 1296). The widening of the Piazza S. Giovanni, which involved the demolition of the hospital of S. Giovanni, was justified on the grounds that the piazza was so 'arta et parve capacitatis gentium' that the people could not attend sermons 'commode in ea'.

Uberti. As a result, by 1302, at which date the Priors are for the first time recorded as residing in it, the palace faced an open space which took up part of the southern half of the present Piazza della Signoria, and which according to a decree of 1307 formed part of the 'piazza around the palace', 'platea existente iuxta seu circa pallatium populi'.[19] The two sections of the piazza thus provided the palace, by that time, with fairly spacious access from two sides. This was reflected in its external and internal structure—its two doorways on the north and on the west side respectively, and its halls on each of the three floors facing in both directions. At the same time, the original northern area still formed the main part of the piazza, and accordingly the north façade of the palace, with its centred doorway, continued to provide the principal access to it.[20] There does not seem to be any practical reason why this situation should not have lasted. Yet as early as 1304, we find the councils granting money to be spent 'in amplificando plateam palatii',[21] and during the following eight decades, the widening of the western section of the Piazza della Signoria remained one of the chief objectives of the Commune's urban policy.

Fig. 3

The first phase of this policy lasted until 1320. In 1307 and 1320, the Priors in office were given full powers for this purpose, similar to those their predecessors of December 1298 had received for the purchase of property for the construction of the palace.[22] The successive widening of the piazza necessitated levelling and paving. This had been necessary from the start, for the open space resulting from the demolition of Uberti property must have been uneven,[23] and the same applied to the space gained by the destruction of houses on the west side of the palace. In 1306, the councils granted money 'for the paving of the piazza with slabs or bricks';[24] yet as late as 1330, they responded to a complaint about its bad state of repair, as a result of which 'it is not as easy to walk on it as on other piazze . . . all of which are paved'.[25] This clearly referred to both the northern and western sections, the latter having been extended further west in 1319;[26] and the councils accordingly decreed that the piazza 'be levelled and paved, partly with stones and partly with bricks'.[27] They may have been persuaded to do so by the argument that the Piazza della Signoria 'should be more decorous and even' than any other square or street in Florence, 'ad honorem Communis et decorem palatii'.[28] After the extension in 1319 of its western section, the only obvious direction for the widening of the piazza was to

[19] Frey 1885, p. 196, no. 68, *Consigli*, I, ii, p. 333 (31 July–2 Aug. 1307).

[20] See Paul 1969, pp. 55–6. Del Badia 1907, p. 8, had already suggested that 'in principio la porta d'ingresso del palagio era volta a settentrione'.

[21] Frey 1885, p. 194, no. 58; *Consigli*, i, p. 181 (21 3 Dec. 1304). When, in 1310 or 1311, the councils allocated money for the completion of the tower of the palace (see above, p. 10), they also wanted it to be used 'pro platea eius palatii crescenda et amplianda' (Provv., Prot., iii, fo. 47ᵛ; Davidsohn, *Forschungen*, iv, pp. 500–1).

[22] Frey 1885, p. 195, no. 65; *Consigli*, I, ii, p. 318 (6–7 Apr. 1307): 'quod priores et vexillifer presentes habeant baliam et arbitrium amplificandi plateam pallatii'; the same powers are granted to the Signoria of July–Aug.: Frey 1885, p. 196, no. 68; *Consigli*, i/2, p. 333 (31 July–2 Aug. 1307). Frey 1885, p. 201, no. 85 (4 Sept. 1320): they are given full powers 'de platea et super platea palatii populi . . . crescenda, amplianda et elarganda', for which purpose they may 'destruere et destrui facere domos et quecumque hediffitia' they wish. These powers expired at the end of their term of office, that is on 14 Oct.

[23] Cf. Villani, *Cronica*, viii. 26 (ii, p. 30): 'di que' loro casolari feciono piazza'. See above, Ch. 1, n. 32.

[24] Frey 1885, p. 195, no. 62; *Consigli*, i, p. 288 (19–22 Sept. 1306): 'causa lastricandi seu matonandi plateam dominorum priorum et vexilliferi'.

[25] Provv., 214, fo. 30ᵛ; Davidsohn, *Forschungen*, iv, p. 502 (9–11 Aug. 1330): 'cum platea circumposita palatio populi florentini . . . sit in aliqua parte bassa aliquave demissa et alibi lapidosa propter fondamenta domorum, adeo quod per eam non bene itur sicut per alias plateas [et] vias civitatis Florentie, que omnes lastricate sunt, et quod nullus est ibi locus, per quem commode possint currere equi'. The work is to be carried out according to the instructions which will be given by 'illis personis' whom the present Signoria and its successor will elect for this purpose.

[26] See above, p. 80.

[27] Above, n. 25: 'quod dicta platea equetur et lastricetur partim de lapidibus partimque matonibus'.

[28] Ibid.: 'et quod ipsa platea magis deberet esse decora et equa quam aliqua alia platea vel via civitatis . . . ad honorem Comunis et decorem palatii . . .'.

extend that area northwards, and thus to bring it into line with the original northern section of the piazza. There were, however, formidable obstacles in the way of such a policy, for it would have involved the destruction of property belonging to S. Romolo, of its cemetery, and ultimately of the church itself. In fact, after the Priors had once more been given, in 1320, extensive powers to widen the piazza where they found it most expedient,[29] no more is heard about the extension of the piazza. Short-lived as it was, the despotic rule of the duke of Athens proved to be a turning point in the history of the piazza.

His project, launched after his election in 1342, to transform the palace of the Signoria into 'a large and strong castle', 'uno grande e forte castello',[30] included its piazza. On its east side, the palace backed, at that time, on to a complex of buildings which were now designed to form part of the enlarged ducal palace, thus creating a fortified enclosure. On the south side, it faced the nave of the church of S. Pier Scheraggio across the narrow Via della Ninna; on its remaining two sides, it was surrounded by the piazza, which was divided into two sections by the church of S. Romolo and the neighbouring houses and cemetery. For the Florentines, this constituted hardly more than an inconvenience and an aesthetic defect[31] at a time when the city had been enjoying internal peace for many years; for the Duke, whose authority, unlike that of the republican government, was based on military force, it was liable, apart from detracting from the splendour of his residence, to constitute a dangerous obstacle to the effective deployment of his troops in an emergency. According to Giovanni Villani, the Duke unsuccessfully petitioned Pope Clement VI for permission to demolish S. Romolo, S. Cecilia, and S. Pier Scheraggio.[32] The demolition of these three churches together with adjoining properties would not only have extended the western area of the piazza still further west as well as northwards, but it would also have created a new section of the piazza on the south side of the palace, which would consequently have been surrounded by it on three sides. When the Duke was expelled from Florence in August 1343, he had already begun to put his plan into practice by having houses belonging to S. Romolo and its cemetery demolished.[33] In December 1345, the councils granted a petition from S. Romolo's prior that he and his church be indemnified for the losses they had sustained,[34] but this was not the end of the story. Four years later, the prior once more petitioned the Signoria, now jointly with his parishioners, but this time for the church and its houses to be demolished and rebuilt elsewhere in the parish. There was no question of asking for papal permission; all that was considered necessary 'de ipsa translatione fienda' was a licence from the vicar of the bishop of Florence.[35] There can be little doubt about the official inspira-

[29] See above, n. 22: 'in ea parte et partibus et prout et sicut expedire viderint'.

[30] Giovanni Villani, *Cronica*, xii. 8 (iv, p. 17). See above, p. 16.

[31] Matteo Villani, *Cronica*, vii. 41 (vi, p. 38): 'la chiesa di Santo Romolo . . . impedia molto la piazza'.

[32] Giovanni Villani, loc. cit. See also Spilner 1987, pp. 409–10.

[33] See the petition of the prior of S. Romolo to the Signoria, asking to be indemnified for losses sustained on that occasion, which is inserted in the *provvisione* of 9–10 Dec. 1345 (Frey 1885, pp. 207–8, no. 102a): 'quod pridem dominus Gualterus, Athenarum dux . . . ut platea vestri palatii amplior fieret et pulcrior, domos, apotecam et cimiterium, que dicta ecclesia habebat in et super dicta platea . . . funditus destrui fecit.' Cf. the petition of Giovanni dell'Antella and

his brothers for damages relating to six small houses 'iuxta plateam et prefatam ecclesiam sancti Romuli' which had been demolished on the Duke's orders (Frey 1885, p. 208, no. 102b, 9 Dec. 1345), and Spilner 1987, p. 411 nn. 84, 88, 8 Apr. 1346). One side-effect of these demolitions was the creation of a new street from the piazza to the Via del Garbo (the present Via Condotta), which was probably identical with the present Via delle Farine: Spilner 1987, p. 410 and n. 81.

[34] See preceding note. It was decided to indemnify the prior, the amount to be agreed by a specially appointed committee.

[35] Provv., 37, fos. 8ᵛ–9ʳ, Frey 1885, pp. 208–9, no. 104 (16–17 Sept. 1349): the Signoria agreed to the petition 'habita primo licentia a vicario domini episcopi florentini de ipsa translatione fienda'. The

tion of the petition: the open space made available by the demolition and rebuilding, to be financed—at a time when, a year after the Black Death, the Commune was in dire financial straits—by the Company of Orsanmichele,[36] was to serve the 'public use' of both sections of the piazza, as well as its decorum, by having it continue 'by a straight line'[37] 'ita quod recta linea procedat'. The additional space gained for the piazza at last made it possible to extend the northern boundary of its original northern area along its entire length. This development necessarily affected the perspective of the palace, whose northern and western façades could now be seen from an ideal vantage point on the north-west corner of the piazza;[38] and it was in keeping with it that in 1351 the councils decided to have the north door of the palace modelled on its west one, on the ground that this would much improve its aspect.[39] At the same time, it was also decided to pave the entire piazza 'pro decore' of the palace, thus enhancing 'the obvious usefulness and beauty of that piazza'.[40]

The duke of Athens had provided the Florentines with a programme for the expansion of the piazza and until its completion some forty years later, the Commune followed this programme with remarkable perseverance. The church of S. Romolo was demolished in 1356 and subsequently rebuilt further north, and now faced the piazza with its main entrance.[41] Between 1374 and 1382, the south side of the piazza was transformed by the building of the Loggia.[42] The church of S. Pier Scheraggio remained intact but S. Cecilia, the third church which, according to Giovanni Villani, the Duke had planned to have demolished, was razed to the ground in 1386 and rebuilt further back. As in the case of S. Romolo, the houses bordering on the piazza next to it were also rebuilt and aligned with the church, though with its apse and not with its entrance. The building operation which followed the demolition of S. Cecilia and of the houses on the west side of the piazza in August 1386[43] completed the enlargement begun at the turn of the century. In addition, one of the two principal streets by which one entered the piazza, the Via Calzaiuoli, was widened between 1389 and 1391. Only a few of the buildings which surrounded the piazza at that time have survived, but its size has remained practically unchanged until today.

Fig. 53

petitioners argued that the *translatio* of the church would serve 'pro decore civitatis Florentie et maxime platee [Frey *om.* platee] palacii dominorum'. On the delay in carrying out this decision, see Spilner 1987, pp. 415–16. It may have been partly due to the projected location for the new church having proved inadequate: see Frey 1885, pp. 210–11, no. 107, 10–11 June 1351).

[36] Its captains were to contribute 500 florins towards the cost of this building operation, additional costs having to be met from the sale of houses and by the church of S. Romolo: ibid.; cf. the complete text of the *provvisione* in Provv., 37, fos. 8ᵛ–9ʳ ('pro ecclesia Sancti Romuli').

[37] Ibid.: 'ad usum publicum convertendum tam in platea una cum alia platea dominorum priorum et pro decore ipsius platee, ita quod recta linea procedat et sit ista platea'.

[38] Cf. Manetti, *Vita di Filippo Brunelleschi*, pp. 59–60: 'Fece di prospettiva la piazza del palagio de' Signori . . . stando fuori della piazza o veramente al pari, lungo la faccia della chiesa di San Romolo, passato il canto di Calimala francesca . . . donde si guarda 'l palagio de' Signori, in modo che due faccie si veggono intere, quella che è volta verso ponente e quella che è volta verso tramontana.'

[39] See above, Ch. 1, n. 122.

[40] Frey 1885, pp. 209–10, no. 106 (10–11 June 1351): 'pro decore dicti palatii et totius civitatis Florentie et pro evidenti utilitate et pulcritudine ipsius platee esset tota lastricanda mattonibus seu lateribus'. The Sixteen Gonfaloniers had complained about the poor condition of the piazza, which was particularly noticeable at times of rain and wind, in the latter case because of the 'pulvis et lapides, qui et que nunc [*ed.* numero] abundant in et super ipsa'; cf. Spilner 1987, p. 415 n. 100. The paving of the piazza is first recorded in 1306: see above, p. 81.

[41] Matteo Villani, *Cronica*, vii. 41 (vi, p. 38), writes that the church was demolished on the order of the Signoria on 20 Nov. 1356. In view of the fact 'quod ipsa ecclesia, prout patet notorie, noviter est destructa', officials were appointed to be in charge of its rebuilding: Frey 1885, pp. 212–14, no. 113 (21 Nov. 1356). In a consultative meeting held on 24 Nov., it was proposed that the church should not be longer than 30 *braccia*, that 'reponatur ubi est via nova', and that it should face the piazza: Cons. e Prat., 1, fo. 181ʳ; Spilner 1987, p. 452 n. 103.

[42] See below, pp. 86–7.

[43] Documents in Frey 1885, pp. 221 ff. See Braunfels 1953, pp. 118–20; Spilner 1987, pp. 432–3; Zervas 1987, pp. 75–6.

In December 1385, the Operai del Duomo had been put in charge of repaving the piazza, to be completed by the following July.[44] They deliberated on this project in April 1386 and, since on the same day they elected a *capomaestro* for the piazza for five months from 1 June, they must have realized that they would not be able to keep to the original deadline.[45] Work began on the following day.[46] Two months later, 'on Saturday 4 August, many houses around the piazza of the Signori were wrecked and pulled down, in order to widen the said piazza.'[47] A payment made in 1388 to two masters who took part in this operation shows that it was carried out at great speed over the weekend, for they worked on it during three days and three nights.[48] The demolitions, which involved the church of S. Cecilia and the house of its prior as well as private property,[49] were at variance with the councils' decision of December 1385, since they necessitated additional paving[50] for which no provision had been made at that time. In fact, the demolitions took place, contrary to normal procedure, without prior consent by the councils. The councils had occasionally granted the Signoria full powers for the compulsory purchase and demolition of private property; but these powers were confined to the Signoria in office at the time,[51] and no such powers had been granted to that in office in July/August 1386.[52] It was only after S. Cecilia and many houses bordering on the piazza, 'iuxta dictam plateam', had been demolished, that the Signoria sought the assent of the councils to actions that were necessitated by the demolitions: the owners of the demolished properties had to be indemnified, the church with the prior's house had to be rebuilt elsewhere in the same parish, 'with the consent of the bishop',[53] whose consent to their destruction had evidently not been sought,[54] 'the pars nova' of the piazza had to be paved and its exact boundaries determined.[55] It may well be indicative of the annoyance of council members at the high-handed procedure of the Signoria that the council of the People rejected their bill three times.[56] After its third rejection, the Twelve Buonuomini advised that the Signoria take a strong line with the council, and that 'in future

[44] The *provvisione* of 9–11 Dec. 1385 is ed. in Frey 1885, pp. 218–9, no. 127.
[45] Frey 1885, p. 220, no. 131 (13 Apr. 1386): 'operarii . . . deliberaverunt, quod platea dominorum priorum amactonetur'; p. 219, no. 130 (13 Apr.): 'eligerunt Johannem Juntini in capud magistrum dicte platee pro tempore . . . quinque mensium, incipiendorum in chalendis Junii.'
[46] *Diario d'anonimo fiorentino*, p. 465: 'Oggi, a' dì 2 di giugnio 1386, si cominciò amattonare la Piazza de' nostri Signiori.'
[47] Ser Naddo da Montecatini, *Memorie storiche*, p. 85: 'a' dì 4 d'agosto, in sabato, si guastò e mandò in terra molte case che erano intorno alla piazza dei Signori, per rallargare detta piazza.' Cf. *Diario d'anonimo fiorentino*, p. 466: 'Oggi, a' dì IIII d'agosto 1386, si cominciò a disfare le case d'in sulla Piazza . . . Cadde il campanile di Santa Cicilia a' dì VIIII d'agosto.' A *provvisione* of 1389 (Provv., 77, fos. 309ʳ–312ʳ, 19–20 Feb.) lists the owners of the houses which in Aug. 1386 'fuerunt destructe' 'pro ampliando et ornando plateam palatii dominorum', among them the Parte Guelfa 'pro una domo cum aliquibus apothecis' and the Arte dei Legnaiuoli 'pro quadam domo cum turri'. In June, the Cathedral Operai decided on the sums to be paid to them and to others who had claimed compensation for demolished properties (Frey 1885, p. 239, 19 and 30 June).
[48] Frey 1885, p. 221, no. 134 (13 Nov. 1388): 'pro eorum salario trium dierum et trium noctium, qui steterunt die IV Aug. 1386 ad

destrui faciendum domos pro amplitudine platee dominorum priorum'. On demands, addressed to the Cathedral Opera as late as 1388 and 1389 for money owed since 1386 as a result of the widening of the piazza, see Spilner 1987, p. 429 n. 147.
[49] See above, n. 47, and Frey 1885, pp. 224–7, no. 136 (14–16 Aug. 1386): 'pro ampliando plateam palatii . . . fuerunt destructe et continue diruuntur quam plures domus, apotece et hedificia posite et existentia iuxta dictam plateam, ac etiam ecclesia sancte Cecilie cum domo habitationis rectoris . . .'.
[50] Ibid.: 'quod pars, que noviter remanet platea ob destructionem . . . debeat amattonari . . . prout alie partes platee . . .'.
[51] See above, n. 22.
[52] Cf. Lib. Fab., 42, fos. 97ʳ ff. (July–Aug. 1386).
[53] '. . . cum consensu episcopi': see above, n. 49.
[54] In the case of the church of S. Romolo, permission of the vicar of the bishop of Florence had to be obtained prior to its destruction: see above, n. 35. [55] See above, n. 45.
[56] On 9, 11, and 13 Aug.: Lib. Fab., 42, fos. 98ᵛ, 99ᵛ, 101ʳ. Did the Signoria order the demolition without having obtained the assent of the Colleges, that is the XVI Gonfaloniers and the XII Buonuomini? This is possibly implied by the statement, in the consultative meeting of 10 Aug. (Cons. e Prat., 25, fo. 100ᵛ), of the spokesman for the Twelve: 'Et provideatur quod in futurum non possit aliquid destrui pro platea sine deliberatione dominorum et collegiorum.'

one should see to it that the councils obey the Signoria'.[57] On the same day, the council of the People passed the bill with a comfortable majority.[58] The two questions which were discussed in the debates preceding its passage concerned the damages to be paid to the owners of demolished properties,[59] and the extent to which the plots gained by these demolitions were to be used for the enlargement of the piazza. Having taken the advice of the Colleges, the Signoria decided that the piazza in its enlarged form should be 'squared and levelled', 'squadretur et adequetur'.[60] Most of the speakers in the council of the People wanted the decision to be left to the Signoria and the Colleges,[61] but there were differences of opinion on the precise location of the western edge.[62] When in 1349 it had been decided to demolish the church of S. Romolo and rebuild it elsewhere, the resulting enlargement of the piazza was to be carried out in such a way 'quod recta linea procedat et sit ista platea'.[63] The same procedure was now adopted on the west side. The shape of the piazza appears to have been further emphasized by its paving being divided into rectangular sections of bricks.[64]

The partial rebuilding on its northern and western sides, as a result of the demolition of the churches of S. Romolo and S. Cecilia and their properties, also provided an opportunity for unifying the façades of houses bordering on the piazza. In 1362, the Signoria decreed that the owners of houses on its north side that were to be 'pulled back' ('retrahantur retro') in the process were to rebuild the façades 'iuxta plateam' 'in a beautiful and becoming fashion' ('pulcrum et decentem'), to the height of twelve *braccia*:[65] and in 1388 that the wall on the west side, which was to be constructed after the demolition of S. Cecilia and adjacent property in order to hide the ruins of the demolished houses, was to be faced with rusticated stones, 'cum lapidibus et cantonibus bugnosis'.[66] In the following year, legislation on the widening of the Via

[57] Cons. e Prat., 25, fos. 101ᵛ–102ʳ (14 Aug.): 'provideatur imposterum ita quod consilia pareant dominis.'

[58] Lib. Fab., 42, fo. 102ʳ: with 178 votes to 60. The council of the Commune passed it two days later with 107 votes to 53: fo. 102ᵛ.

[59] The *provvisione* of 14–16 Aug. is described in the register of votes (ibid., fo. 98ᵛ) as 'in favorem illorum, quorum domus pro ampliando plateam dominorum fuerunt destructe'.

[60] In the meeting of 10 Aug., the XVI Gonfaloniers proposed that the 'platea squadretur a domo que est in beccattelis ex parte platee, et integra remaneat et adequetur usque in Vaccarecciam, et a facie sancti Romuli ultra usque ad rectum dicte domus fiat angulus', while the XII Buonuomini insisted that 'platea non extendatur ultra domum que est in beccattellis, et ibi quadretur versus Vaccarecciam et versus sanctum Romulum ex altera parte' (Cons. e Prat., 25, fo. 100ᵛ: see above, n. 56). Between 11 and 13 Aug., the spokesman for the *quartiere* of S. Giovanni declared 'quod quadrum platee placet eis a domo de beccattellis ... prout hodie fuit ordinatum per dominos et collegia' (see below, n. 61). The *provvisione* of 14 Aug., on the other hand, laid down that the Signoria and the Colleges were to take a decision in this matter by the end of August (Frey 1885, p. 226, no. 136): 'quod ex parte, in qua domus et hedifitia sunt de presenti destructa ... debeat ipsa platea quadrari et ad quadrum et in quadro honorabiliter actari ... prout ... per totum presentem mensem augusti deliberatum fuerit'. On the meaning of 'quadrare', see Elam 1978, p. 62 n. 46.

[61] Lib. Fab., 42, fo. 100ʳ–101ᵛ (*s.d.*, between 11 and 13 Aug. 1386), 'super provisionem platee'. Pierozzo di Piero Pieri, for the Captains of the Guelf Party: 'super quadro platee remaneat in dominis et

collegiis'. Cf. Cons. e Prat., 25, fo. 101ᵛ (14 Aug.): the XII Buonuomini propose 'quod in Dominis et Collegiis sit autoritas quadrandi plateam'; see above, n. 57.

[62] Lib. Fab., 42, fo. 101ᵛ (13 Aug.), 'super provisionem platee': Francesco di Federico Falconi for the *quartiere* of S. Spirito: 'quod quibusdam placet quadrum ... et alii dicunt quod remaneant beccatelli et alii dicunt quod quadretur a turri Panchesis et tollantur beccatelli et remaneat fundacum ad turrim d. Antonii et Andree Nerii, et postea fiat tectum a fundaco cum honorabili sede'. The 'tectum' is probably identical with the so-called Tetto dei Pisani. See below, n. 76.

[63] See above, p. 83.

[64] In 1330, it had been ordered that the paving of the piazza be executed 'partim de lapidibus partimque matonibus' (see above, n. 27), which must refer to the subdivision of the pavement into rectangular sections, as shown in the painting of the burning of Savonarola of *c.*1500 (Fig. 40). There is no evidence of the piazza having been repaved after the pavement was completed in the 1380s and before 1500.

[65] Frey 1885, pp. 216–17, no. 119 (23–4 Dec. 1362): by 10 May 1363. Three years earlier, a greater height, of sixteen *braccia*, was stipulated for a building which was to be erected 'iuxta plateam populi': Spilner 1987, p. 456 n. 127.

[66] Frey 1885, pp. 229–30, no. 139 (4 Feb. 1388): see Spilner 1987, pp. 430–1. This wall, as it existed in the 18th cent., can be seen in the engraving of the Piazza della Signoria by Andrea Scacciati (Fig. 54).

Calzaiuoli between Orsanmichele and the piazza included regulations on the appearance of its new buildings;[67] they were to be modelled on the palace of the Guelf Party.[68] In the same year, 1388, it was decreed that the houses on a section of the Via S. Reparata along the north and east sides of the Duomo should have their façades provided with a continuous rusticated and arcaded wall, and new buildings that were to be erected in the process were to have an identical elevation.[69]

The law which in 1356 ordered the rebuilding of the church of S. Romolo further back on the north side of the piazza[70] also ordered the construction of a 'beautiful and honourable loggia' on its south side.[71] The Loggia was to be built on the site of the Mint, and the Zecca was to be compensated by a new building, erected further back. The somewhat arbitrary manner in which this project was inserted into a law dealing with the rebuilding of S. Romolo may indicate that its acceptance was not considered by the Signoria a foregone conclusion. At the time, it was criticized on the grounds that loggias were typical of despots,[72] probably with reference to the Loggia degli Osii in the Broletto Nuovo at Milan, which had been reconstructed by Matteo Visconti in 1316 as part of his palace.[73] Preparatory work for the building did not begin in earnest until 1374, when it was decided to proceed with the project,[74] so that the Signoria would not have to hold its public ceremonies in the small church of S. Pier Scheraggio when it was raining.[75] The *ringhiera* in front of the palace afforded no protection from the elements, as did, for ordinary citizens, the awning along the wall on the west side of

Fig. 54 the piazza, the Tetto dei Pisani.[76] In view of the frequency of those ceremonies—the inauguration of the Signoria alone took place six times a year—a loggia, even if it was not situated adjoining the palace, possessed an obvious attraction for the Signoria and other magistrates, less so for the citizens at large.[77]

Fig. 55 When its construction was finally taken in hand in 1380 it was on a monumental scale. The spandrels of the arches were adorned with reliefs of the Seven Virtues executed by Jacopo di

[67] Frey 1885, pp. 243–4 (29–30 Mar. 1390): 'de ornamento et forma novorum hedifitiorum'; see Braunfels 1959, pp. 118–19; Spilner 1987, pp. 432–6.

[68] Frey loc. cit.: 'sint pulcra et ornata ad similitudinem hedificii partis Guelforum existentis iuxta viam predictam.' On the Parte Guelfa palace on the Via Calzaiuoli, see below, n. 89.

[69] Sinding-Larsen 1975, pp. 182–6.

[70] Frey 1885, pp. 212–14, no. 113 (21–2 Nov. 1356); see above, p. 83.

[71] Ibid.

[72] Matteo Villani, *Cronica*, vii. 41 (vi, p. 38): the Signori were 'biasimati dell'impresa, e che loggia si convenia a tiranno e non a popolo.'

[73] Biscaro 1904; *Storia di Milano*, iv, p. 518.

[74] Frey 1885, pp. 253–4, no. 5 (14–16 Jan. 1374).

[75] Stefani, *Cronaca*, p. 288: '. . . veduto che quando i Priori entravano, o si davano i gonfaloni, e piovesse, conveniva che si rinchiudessero li Signori e 'l popolo in S. Pier Scheraggio, piccola chiesa.' (The banners were given, every four months, to the new *gonfalonieri* of the city militia, see above, pp. 79–80.) According to Ammirato, *Istoria fiorentina*, ii, p. 689, the immediate cause of this decision was the inability of the Signoria which took up its office on 1 Jan. 1374 to hold its inauguration ceremony on the *ringhiera* owing to rain.

[76] According to Florentine tradition, the Tetto or Loggia dei Pisani had been built by Pisan prisoners after the Florentine victory over Pisa at Cascina in 1364: cf. Ammirato, op. cit. ii, p. 646: 'Furono poi rinchiusi nelle pubbliche prigioni, e condannati a far quel tetto nella piazza de' Priori, che infino a questi dì è chiamato la loggia de' Pisani . . .'. Spilner 1987, p. 430 n. 154, argues that this was a legend, the west side of the piazza having been rebuilt entirely, after the demolition of S. Cecilia, in the 1380s. In fact, it was probably on that occasion that the *tetto* was constructed: in 1393, it was described as new (*Diario di anonimo fiorentino (1382–1401)*, p. 162: 'Venono alla piaça tutte le vicherie, nella logia e sotto il tetto nuovo da Santa Cicilia . . .'), see also above, n. 62, and below, p. 90. According to Vespasiano da Bisticci, in the 1420s the Tetto dei Pisani was a meeting place for humanists (*Vite*, ii, p. 522: '. . . in piaza, dove dal tecto de' Pisani in quel tempo tutti gli uomini docti si rigunavano'. Cf. della Torre 1902, pp. 217–20). In 1506, the Operai del Duomo decided that Simone del Pollaiuolo, il Cronaca, their *capomaestro*, 'possit restaurare et aptare vel etiam de novo reficere in totum et in parte . . . Tectum de Pisanis de Platea . . .' (Archivio dell' Opera dei Duomo, Deliberazioni, 1498–1507, II–2–9, fo. 155ᵛ, 15 Oct. 1506. I owe this reference to Margaret Haines). The census of 1527 refers to the 'volta di Sancta Cecilia sotto el tetto de' Pisani' (under 'Piazza della Signoria'; see below, n. 92).

[77] See above, pp. 14–15, and below, n. 80.

Piero Guidi and others between 1383 and 1387.[78] The inauguration of the Loggia in 1382 coincided with the reassertion, after the crisis of the Ciompi revolt, of the supreme authority of the Signoria; but while the Loggia might be considered worthy of a magistracy whose authority was, in the words of a contemporary, 'grande senza misura', 'immensely great',[79] its construction was criticized at the time as typical of excessive public spending.[80] Conceived, by way of its ceremonial function, as an annexe of the palace, its magnificence contrasts with the austerity of the palace's façade, its splendid sculptural decoration with the modest attempts made in recent years to relieve that austerity. But the Loggia not only presents an aesthetic contrast to the palace: its openness to the piazza reflects the transformation of the political climate of the city since the turn of the century, when the palace was constructed as a civic fortress—a transformation which the failure of the Ciompi revolt helped to confirm.

The final enlargement of the piazza also completed the shift of emphasis from its original northern to its western section. In the course of the century, the new section of the piazza had gradually overtaken the former. The closing of the north door of the palace in 1380[81] and the completion, two years later, of the Loggia were landmarks in an evolution which transformed the western front of the palace into its principal façade, and the area before it into the main piazza. This transformation was accompanied by a distinction of functions. The smaller northern area came to be surrounded by, or close to, administrative buildings. The western section, with the Loggia, had become more properly the piazza of the Signoria, and of the people.

The widening of the piazza facilitated the concentration of office buildings close to the palace. Even before the construction of the palace, the Captain of the People resided temporarily in a house on the Via della Ninna facing the church of S. Pier Scheraggio.[82] Before 1342, the Executor of the Ordinances of Justice—a magistracy which was abolished in 1435—had a house on or next to the piazza;[83] three years later, a palace behind that of the Signoria, which had been the property of the sons of Bello Alberti, had been assigned to him.[84] An anonymous description of Florence of 1339 singles out the palaces of these two officials as minor in comparison with the 'duo magna palatia' of the 'governors of the city', 'presidentium civitatis', that is of the Podestà and the Signoria.[85] The magistracy in charge of mercenary troops, the Ufficiali della Condotta, occupied, from 1337, a house on the east side of the piazza;[86] after 1337, this house was joined up with the newly built palace of the association (*universitas*) of the five major merchant guilds, the Mercanzia, which acted as mercantile court. In that year, the

[78] Frey 1885, pp. 35–9; Lensi Orlandi, pp. 55–6; Pope-Hennessy 1985, p. 197.

[79] Dati, *Istoria di Firenze*, p. 137.

[80] Stefani, *Cronaca*, p. 423: 'La quale spesa fu molto meravigliosamente ragguardata . . . per la soperchia spesa.'

[81] See above, p. 17.

[82] Davidsohn, *Geschichte*, iv. 1, p. 314. Uccelli 1865, p. 93, states that at the beginning of the 14th cent. he had a permanent residence behind the palace on the Via dei Leoni.

[83] Villani, xii. 6 (iv, p. 16): the duke of Athens 'mise i Priori dove prima stava l'esecutore in sulla piazza'. According to Uccelli 1865, pp. 98–9, he stayed, early in the 14th cent., 'nelle case dei Manieri' in the Via della Ninna, and in 1320 in the house of the heirs of Bernardino de' Cerchi in the Via dei Cimatori. In 1323, the Captain

of the People moved into the palace where 'ad presens habitat dominus executor ordinamentorum iustitie' (Frey 1885, p. 202, no. 90 (26–7 Apr. 1323)).

[84] Provv., 33, fo. 77ᵛ (9–10 Dec. 1345): 100 florins are assigned 'pro construendo et construi faciendo portas palatii quod olim fuit filiorum Belli Alberti, in quo morari debet Executor Ordinamentorum Iustitie et sua familia': cf. Frey 1885, pp. 206–7, no. 100 (19 June 1343), and p. 90. Frey tentatively locates this house, on the Via Bellanda, on the corner of this street and the Via dei Gondi. When, in Sept. 1434, Cosimo de' Medici went to the palace of the Signoria, he entered it clandestinely through that of the Executor of Justice (cf. Fabroni 1789, ii, p. 103).

[85] Ed. Frey 1885, p. 120.

[86] See Del Badia 1907; Bombe 1910, p. 100.

councils invited the Mercanzia, which had previously used a private house on the west side,[87]
to build a beautiful new palace, 'unam domum pulcram et honorabilem', at the corner of the
Via de' Gondi and the piazza. Its façade was to take as its model that of the Condotta, and it was
to 'equal or surpass in beauty all the other houses on the piazza'; at the beginning of the next
Fig. 56 century, Dati called it 'a very large, ornate, and magnificent palace'.[88] Shortly before the Via
Calzaiuoli was widened in its stretch between the piazza and Orsanmichele, the Parte Guelfa
had begun, in 1386, to construct a new palace on the west side of that street, between Via
Calimaruzza and Via Porta Rossa. The transfer of its residence from its old palace in the Via
delle Terme, if it had been carried out, would have demonstrated the importance the Guelf
Party attached to proximity to the piazza and to the palace of the Signoria.[89]

The Parte's decision to build a palace in the section of the Via Calzaiuoli closest to the piazza
was characteristic of its evolution as the civic centre of the republic. The construction of the
palace of the Mercanzia next to that of the Condotta was not followed, on the north side of the
piazza, by that of other public buildings or by the adaptation of existing property for the use of
communal magistracies. In fact, the magistracies which were assigned houses near the palace
were concentrated at its rear, in the two streets leading into the piazza from the east, the Via de'
Gondi (Via delle Prestanze)[90] and the Via della Ninna (Via di S. Pier Scheraggio), where the
abolition of the office of the Executor of the Ordinances of Justice in 1435 and that of the
Captain of the People between 1477 and 1498 and permanently in 1502,[91] created vacant space.
The census of 1527, which constitutes the earliest complete survey of the urban fabric[92] around
the piazza, lists the following magistracies as having their office on this site. Starting from the
north side of the palace, the census records the customs house, the Dogana, and continues in
the Via de' Gondi[93] with the house of the Captain of the Piazza, or Bargello.[94] From there
the census proceeds to that of the controllers of the communal revenue and expenditure, the
Regolatori delle Entrate e delle Uscite,[95] to the residence of the magistracy in charge of the
forced loans, the Prestanze, which also housed the notary of the register of tax debtors,
the Specchio,[96] and to that of the magistracy responsible for the grain supply to the city, the
Ufficiali della Grascia.[97] Turning back in the direction of the piazza on the north side of the Via
de' Gondi, the census proceeds to the Mercanzia on the corner of the piazza and, next to it, to

[87] Davidsohn, *Geschichte*, iv. 1, pp. 290–1; *Forschungen*, iii, p. 145,
no. 730 (17 Mar. 1320): 'in domo Alberti et Neri del Judice'.

[88] Provv., 46, fos. 158ʳ–159ʳ; Spilner 1987, p. 435 n. 18 (6–7 June
1359); see pp. 420–2. Dati, *Istoria di Firenze*, p. 142.

[89] The palace, which remained unfinished, has recently been
identified by Diane Zervas, on the basis of the inventory of Parte
property of 1431, with the block of houses on the Via Calzaiuoli
between the Via Calimaruzza and the Via Porta Rossa: see Zervas
1987, pp. 173–83. In Sept. 1389, it was decreed that its rusticated
façade was to serve as a model for those of the houses that were to be
rebuilt as a result of the widening of the Via Calzaiuoli (ibid., p. 176;
cf. Frey 1885, pp. 243–44 (29–30 Mar. 1390)). See also Spilner 1987,
p. 435.

[90] See Tönnesmann 1983, pp. 12 ff.

[91] Martines 1968, pp. 137, 140.

[92] BNF, MS Nuovi acquisti, 987. For the date, see Nardi, *Istorie di
Firenze*, ii, p. 117: in view of the approach of the imperial army in

Apr. 1527, the Signoria had 'ottenuto che si desse l'arme al popolo,
distribuendo quelle come anticamente si soleva . . . E perciò la
signoria aveva fatto fare la descrizione degli uomini di tutta la città,
partendogli in sedici gonfaloni capitanati da' sedici gonfalonieri delle
compagnie . . .'. Nardi was one of the *gonfalonieri* at that time
(ibid., p. 119). I am grateful to John Henderson for helping me with
the dating of this document.

[93] Which is here called 'la via per l'adreto de' Magalotti'.

[94] That these two titles referred to the same office is borne out by
Sig., Delib., ord. aut., 95, fo. 135ʳ⁻ᵛ (31 Oct. 1483): 'concesserunt
capitaneo eorum platee alias barzello'. On the police functions of the
Bargello, see Guidi 1981, ii, p. 194.

[95] Ibid. ii, pp. 270–3. [96] Ibid. ii, pp. 259–60.

[97] At the end of the 15th cent., a house 'in che stavano' the Ufficiali
della Grascia, and which adjoined the palace of the Mercanzia, was
bought by Giuliano Gondi and incorporated in his palace:
Tönnesmann 1983, pp. 15, 125.

the Condotta, where at that time also the appeals judge had his office. No magistracies are listed on the north side of the piazza, nor on its west side. On its south side, a street next to the Loggia led to the Mint and to the residence of the Ufficiali del Contado, who supervised the financial administration of the subject territory;[98] while in the Via della Ninna we find, having passed the customs house, which had an entrance on that street, the offices in charge of the indirect taxes on salt and on contracts, the *gabella del sale* and the *gabella dei contratti*.[99]

The progressive enlargement of the piazza was bound to affect its role in Florentine politics. The much larger number of citizens it could now contain enhanced its significance as the principal assembly place of the city and enabled the Signoria, on particularly important or solemn occasions, to address assemblies that were large enough to be considered equivalent with the citizenry at large. This assumption had always been the basis of the legislative functions performed by the *parlamenti*; the regime which in 1382 replaced the guild regime of 1378 gave a new lease of life to the principle of consensus underlying the decisions of such assemblies.[100] The *parlamento* which was convened on 20 January was asked for its assent to the creation of a Balìa, whose task it was to lay the foundations of the new regime, on the grounds that its reforms would not be valid 'without the full, free, total, and absolute power and authority of the entire Florentine people, and unless the entire people was summoned . . . and its will sought'.[101] When in November 1384 the acquisition of Arezzo was announced by the Signoria from the *ringhiera*, 'the entire Florentine people' was held to have 'assembled on the piazza'.[102] Such solemn announcements by the Signoria from the *ringhiera* were, with the enlargement of the piazza, bound to reach a much wider audience than before. While not an innovation—in July 1378, the conclusion of peace with the Pope was announced in this way[103]—they may now have to be seen as yet another manifestation of the consensus policy of the new regime. In February 1386, the chancellor Coluccio Salutati read out letters from Charles of Durazzo informing the Signoria of his coronation as king of Hungary;[104] two years later, during the first war with Giangaleazzo Visconti, the news of Francesco da Carrara's recovery of the citadel of Padua was similarly announced from the *ringhiera*.[105] On all these occasions, the good news was celebrated with rejoicings and festivities and must have at least momentarily reinforced the sense of community between the citizens and their government.

But assemblies on the piazza were not always so peaceful. The large crowds which could now gather on it could also pose a threat to the palace, and hence to the Signoria. This became abundantly clear during the Ciompi revolt, when the piazza suddenly became the obvious battleground for popular upheavals. In July and August 1378, it was at the centre of revolutionary events. On 22 July, the occupation of the piazza by the *popolo minuto* was followed, after the Signoria had capitulated to its demands, by that of the palace; in August, it

[98] Molho 1971, p. 42; Guidi 1981, iii, pp. 175–7.

[99] Ibid. ii, pp. 297–8, 301–3. Cf. Adriani, *Istoria*, p. 232: during the flood of 1547, the water 'giunse alla porta della Dogana: entrò nella Gabella del Sale e in quella de' Contratti, che allora erano sotto il Palagio pubblico . . .'.

[100] See Najemy 1982, pp. 267–8, 303–7.

[101] Quoted ibid., p. 268 n. 10, from Balìe, 17, fo. 5.

[102] *Diario di anonimo fiorentino (1382–1401)*, p. 54: 'in sulla piaça vene tutto il popolo fiorentino'.

[103] Alamanno Acciaiuoli, *Cronaca*, in *Tumulto dei Ciompi*, p. 19.

[104] *Diario di anonimo fiorentino (1382–1401)*, p. 61.

[105] Ibid., p. 97.

was the turn of the Signoria to defeat the Ciompi with the help of the majority of the guilds.[106] At the outbreak of the revolt, the Signoria had been unable to make use of the opportunities for military support the piazza had provided: the soldiers who were to guard it turned out to be fewer than expected, and all but two of the Sixteen Gonfaloniers, who had been summoned to come with their companies to the defence of the Signoria, failed to do so.[107] This débâcle must have taught the government a lesson. A month later, the piazza was once more the scene of violence by the Ciompi, this time against the new popular regime which did not seem to them radical enough. On 31 August, the Signoria had 'all the bells of the palace ring the alarm', so that everyone armed himself, 'and the Gonfaloniers came, in great fear, with their banners to the protection of the piazza of the Signori'.[108] During the months following on the fall of the guild regime in January 1382, fears of insurrections by the defeated *popolo minuto* and its allies had repeatedly made the Signoria guard the piazza with John Hawkwood's men-at-arms and with Genoese crossbowmen, some of whom were stationed on the *ringhiera*.[109] Also later, the Signoria would, at critical moments, seek to forestall disorders on the piazza in this fashion.[110] Thus when in May 1387 the Alberti were disenfranchised, it was guarded 'by all the men-at-arms', with levies from the *contado* on the *ringhiera* and at the entrances of the piazza.[111] During the crisis of October 1393, which led to the convening of a *parlamento* for the creation of a Balìa and resulted in the definitive reinforcement of the regime established in 1382, the piazza was again heavily guarded by mercenary forces and by troops from the Florentine territory.[112] A few days later, a crowd invaded shouting 'Long live the people and the guilds', whereupon the soldiers immediately returned 'and took the entrances of the piazza, to prevent the *popolo minuto* from entering' it.[113] These events form the background to the decision of the Balìa, before its dissolution on 31 October, that 300 foot-soldiers and 200 Genoese crossbowmen were for one year to be stationed there:[114] nothing could show better the regime's concern over the security of the piazza, and hence of the palace. That concern was clearly borne out by the immediate reaction, at the beginning of November, to a minor disturbance caused by workers, the *gente minuta*. The piazza was occupied by *contado* troops, many of which had just been sent home, and by mercenary cavalry, the former being deployed in the new Loggia and on the west and east sides of the piazza, the latter on its north side; 'and with this', writes a contemporary diarist, 'the city came to rest on that day'.[115]

In the military provisions for the security of the piazza, the blocking of its entrances, the *bocche*, could be of the utmost importance,[116] the more so as this could also be adopted by

[106] See above, pp. 16–17 and the contemporary accounts of these events in *Tumulto dei Ciompi*, pp. 22–5, 83, and 141–3.

[107] Ibid., pp. 22–3.

[108] *Cronaca prima d'anonimo*, in *Tumulto dei Ciompi*, p. 83: 'fecero sonare tutte le campane, a martello, di palagio; sì ch'allora ciascuno s'armò ogni grasso e ogni artefice; e sì i confalonieri co' confaloni sì n'andaro, con gran paura, alla guardia della Piazza di Signori . . .'.

[109] *Diario di anonimo fiorentino (1382–1401)*, pp. 27, 30–2, 43: 'E tutta la gente de l'arme a chavalo i sulla piaça, e' balestrieri e la fanteria sulla ringhiera e nella logia e alle boche della piaça' (5 Dec. 1382). Cf. Stefani, *Cronaca*, p. 403: on 15 Feb. 1382, 'messer Giovanni Auguto capitano di guerra con più di 1500 cavalli e balestrieri genovesi, assai altri fanti si furono in piazza'; Buoninsegni, *Historia fiorentina*, pp. 661–2.

[110] *Diario di anonimo fiorentino (1382–1401)*, p. 48 (21 Aug. 1384).

[111] Ibid., p. 68. [112] Ibid., p. 150.

[113] Ibid., p. 159. Cf. Buoninsegni, *Historia fiorentina*, p. 726.

[114] Balìe, 17, fo. 117ʳ (29 Oct. 1393): 'qui . . . continue stare debeant in civitate Florentie iuxta plateam et in platea palatii dominorum'. Cf. *Cronica volgare di anonimo fiorentino*, p. 181: '. . . quelli della Balìa feciono che per lo Comune si soldasse trecento fanti e dugento balestrieri genovesi, i quali tutti continovamente istessono in su la piazza de' Signori, e quivi vicino abitassono'. See Brucker 1977, p. 94.

[115] *Diario di anonimo fiorentino (1382–1401)*, p. 162. Cf. Buoninsegni, *Historia fiorentina*, p. 730.

[116] See below, pp. 91, 94.

enemies of the government. On 24 October 1393, it was meant to prevent the *popolo minuto* from occupying the piazza; in December 1378, the Ciompi and their allies had used the same strategy to bring pressure to bear on the Signoria.[117] In July 1343, it had been used to force the duke of Athens to capitulate. During the rising against him, the leaders had the *bocche* of all the streets leading into the piazza blocked with barricades made of timber and metal, in order 'to speed up the deposition of the duke of Athens from the rule of the city'.[118] In 1393, the closing of the access to the piazza formed an essential part of the Signoria's policy of securing control of it. Before the *parlamento* of 19 October, they had its *bocche* closed before having them reopened to allow the citizens to enter in an orderly fashion;[119] before that of September 1434, the leading Medicean who was in charge of the city's mercenaries 'closed all the *bocche* of the piazza, like a good condottiere'.[120]

The *parlamento* of 28 September 1434 elected a Balìa which on the following day recalled Cosimo de' Medici from exile. His banishment which, a year earlier, in September 1433, had been decreed by the Signoria, had immediately been confirmed by a *parlamento* dominated by the Albizzi faction. In order to prevent their supporters from entering it, the piazza was now occupied by those of the Medici: according to a fifteenth-century account, no less than between 6,000 and 8,000 armed men assembled on it, in addition to about 700 mounted mercenaries of the republic.[121] Two days earlier, the supporters of the Albizzi had in their turn been urged to go to the piazza. They were told that the houses of the Condotta and of the Grascia had been occupied by their faction: this would enable them 'to hold the piazza'; and, writes Cavalcanti in a narrative which provides an admirably succinct comment on the strategic role of the Piazza della Signoria in Florentine politics, 'whoever holds the piazza, always achieves victory in the city.'[122]

The identical observation, which may have become proverbial by that time, occurs in an account of the repairs, carried out in 1478, of the fortified enclosure of the centre of Parma by the Sforza governor of that city: he knew that 'in all the insurrections which until then had taken place in Parma, the piazza had always been captured, and whoever had captured it, had remained the victor'. The *platea Communis* had been fortified by Luchino Visconti, after he had acquired Parma in 1346, with a ring of crenellated walls which enclosed not only the piazza, with the palaces of the Podestà and of the Captain of the People, but also sections of the streets leading to it.[123] To enclose the central piazza with a ring of permanent fortifications had thus

[117] *Cronaca prima d'anonimo*, in *Tumulto dei Ciompi*, p. 88.

[118] Gaye, i, p. 495 (27 Sept. 1343): 'Nerio Fioravanti . . . qui de mandato officii clausit cum lignaminibus et ferramentis omnes boccas viarum, que [*ed.* qui] respondent super platea palatii comunis florent. pro duce Athenarum de dominio civitatis florent. celerius deponendo'. The use of such *serragli* to block access to parts of the city had been common in Florentine street fighting at the turn of the century: see Compagni, *Cronica*, iii. 3, 8, 40 (pp. 172, 184, 263; see p. 172 n. 2). Before the *parlamento* of 16 Sept. 1512, the entrances to the piazza were closed with barriers (*sbarre*): see below, n. 143. The fact that the account of the contemporary diarist refers to *le sbarre* indicates that this was a customary device for closing the *bocche*.

[119] *Diario di anonimo fiorentino (1382–1401)*, p. 150: 'E poi fatte aprire le boche della piaçça, che tutte erano prese per le vicherie e per la gente de l'arme e per li cittadini ghuelfi . . .'.

[120] Cavalcanti, *Istorie fiorentine*, x. 13 (p. 311): Bartolomeo Orlandini, under whose command the city's men-at-arms were on the piazza, 'a guisa di buono conductitore, serrò tutte le bocche della piazza'.

[121] A contemporary *Priorista*, C. Strozz., 2a ser., 103, fo. 115r, records that: 'el martedì adì 28 a ore 18 sonò a parlamento e trase in piaza armati circha 6000 o forse 8000 milla [*sic*] citadini armati chon tanto ordine che fu una maraviglia, et in quest'ora entrò drentro in piaza circha 700 chavagli di gente d'arme e soldatti del Chomune . . .'. See Kent 1978, p. 337.

[122] *Istorie fiorentine*, x. 8 (p. 306): 'Venite, chè noi abbiamo presa la Condotta e la Grascia, le quali vi manterranno la piazza. Colui che tiene la piazza, sempre è vincente della città.'

[123] *Chronica gestorum in partibus Lombardiae*, p. 28: 'quod in tumultibus ortis hactenus in Parma semper platea ipsa capiebatur et

come to be seen as typical of despotic rule; in republican Florence, the openness of the piazza of the Signoria, enhanced by the end of the fourteenth century as a result of the widening of the Via Calzaiuoli,[124] reflected a fundamentally different relationship between government and people.

The *parlamento* of 1433 represented the climax in the division of the regime which had set in during the late 1420s, and which ended the long period of internal stability Florence had enjoyed after 1393.[125] During that period, *parlamenti* had not been needed to approve controversial government proposals or to grant extraordinary powers for short terms to specially elected councils, thus substituting plebiscitarian procedure for statutory legislation. After Cosimo's return from exile, Balie remained an integral part of the Medicean system of government during the first two decades of its existence, but were now elected, for increasingly long periods, by the councils of the People and the Commune.[126] It was not until August 1458 that the Signoria, which was facing the former council's tenacious opposition to a renewed introduction of institutional controls, resorted to the time-honoured device of summoning a *parlamento* in order to bypass normal legislative procedure.[127] Only once more during the fifteenth century did the Medici regime appeal to a popular assembly, in 1466, when its very existence was threatened by the republican opposition.[128] The next *parlamento*, which took place on 2 December 1494, a few weeks after the fall of that regime, confirmed the abolition of its institutions and thus the restoration of republican liberties;[129] but the vast size of the Great Council established three weeks later deprived the argument of popular consultation of whatever force it had retained.[130] In the following year, the summoning of *parlamenti* was prohibited under penalty of death, on the grounds that they were instruments used by tyrants to suppress liberty and subjugate the citizens.[131] Savonarola, who had inspired this law, had branded the Medici as tyrants, but there was a much earlier precedent in the seizure of despotic authority by the duke of Athens in 1342, when the populace which had assembled on the piazza for a *parlamento* proclaimed him Signore for life.[132]

With its policy to observe the traditional forms of constitutional legitimacy, the Medici regime had in fact been reluctant to resort to assemblies which substituted plebiscites for the ordinary process of legislation by the councils. In the debate which preceded the *parlamento* held in August 1458, it was moreover argued that to summon one was 'extremely dangerous', 'pericolosum valde',[133] evidently because it could turn the citizens against the Signoria and the ruling group, and result in possibly violent resistance to their proposals by sections of the assembly. In the circumstances, it was essential to provide for a military presence on the piazza in order to prevent disturbances and to bring pressure to bear on the assembled citizens to vote in favour of the law proposed by the Signoria. A contemporary diarist gives a vivid account of such a *parlamento*. On 10 August 1458, the Signoria summoned all adult citizens to come the

capiens victor remanebat, et ut officiales intra eam existentes et amici status in omni adventu forent securiores'. See Pellegri 1978, p. 134; Schulz 1982, p. 301. The walls still existed in the middle of the 16th cent., as emerges from a description of the piazza cited ibid., p. 305: it was 'surrounded by strong walls and iron doors on the streets . . . so that it can be closed and turned into a fortress'.

[124] See above, p. 88.

[125] See Brucker 1977, pp. 472 ff.; Kent 1978, pp. 212 ff.
[126] Rubinstein 1966, pp. 68 ff.
[127] Ibid., pp. 95 ff. [128] Ibid., pp. 163 ff.
[129] Guicciardini, *Storie fiorentine*, p. 106. See Rubinstein 1960, pp. 152 ff. [130] See above, p. 40.
[131] See Villari 1887–8, i, p. 309, and above, p. 73.
[132] Giovanni Villani, *Cronica*, xii. 3 (iv, pp. 9–10).
[133] See Rubinstein 1966, p. 101.

next day unarmed to the piazza, which they found heavily guarded, its entrances blocked by soldiers and armed citizens. The Signoria had the law creating a Balìa read from the *ringhiera* by a notary, after he had asked whether two-thirds of the citizens were present; but 'as only few understood what Ser Bartolomeo was saying . . . only a few citizens answered with yea . . . Then the Signoria returned to the palace and the citizens to their shops and the mercenaries to their billets' (the Podestà, on the other hand, reported that the people gave their assent as with one voice).[134] The same procedure had been used in 1433, when the Albizzi faction occupied the piazza before the assembly voted in favour of a Balìa.[135] In September 1466, the *parlamento* which was expected to overturn the republican reforms of the preceding months and to restore the Medicean system of government took place on the piazza which was lined by about 3,000 armed men sent by Piero de' Medici; not surprisingly, when asked to give their assent to the creation of a Balìa, the people shouted yea.[136]

Only two *parlamenti* were held between 1434 and the fall of the Medici regime in 1494, and no attempts were made during this period permanently to strengthen the defences of the piazza and thus to reduce its accessibility. However much the Medici regime in the course of the fifteenth century transformed the structure of Florentine politics, the openness of the piazza, like that of its Loggia, remained an urbanistic expression of civic consensus and of the continuity of republican traditions. As such, it conformed to the policy pursued by the Medici in maintaining and extending their political ascendancy in Florence, a policy which in its turn found similar architectural expression in the open loggia facing the street on the ground floor of Cosimo's new palace. The only attempt made during this period to modify the access to the piazza occurred in 1491, according to a contemporary diarist on the order of Lorenzo, when a platform of polished stone was constructed between the door of the palace and the Loggia.[137] This so-called *rialto* was, however, not designed to bar the access to the piazza from the Via della Ninna, but to render more comfortable the passage between those two buildings, whose physical separateness was an inherent disadvantage of the location of the Loggia. As a result, however, horses and carriages were prevented from entering from that street, while pedestrians had to negotiate the *rialto* by ascending and descending steps.[138] Although it was praised at the time for its 'great convenience and beauty',[139] it did not please everyone;[140] and a year after

[134] Francesco di Tommaso Giovanni, *Ricordanze*, C. Strozz., 2a ser., 16 *bis*, fo. 29ʳ: '. . . fu ordinato che ciascuno da 14 anni in su si ragunassi all'alba' at the house of the Gonfalonier and come with him to the piazza, 'e che nessuno portassi arme. E prima innanzi dì fu dato la ghuardia a tutte le boche di piaza a certi cittadini con molti compagni armati, e Bernardetto de' Medici e Giuliano di Nichol Ridolfi e Piero Torelli a cavallo ebbero la ghuardia generale del tutto . . . e gl'Otto stavano armati in su la porta del palagio, e su in palagio eran molti armati parenti e confidati de' Signori . . .'. See Rubinstein 1966, pp. 103–4, for his account of the *parlamento*.
[135] Cavalcanti, *Istorie fiorentine*, ix. 8 (p. 272).
[136] Rubinstein 1966, p. 164.
[137] Landucci, *Diario fiorentino*, pp. 61–2: 'E a dì primo di maggio 1491, si cominciò uno rialto tralla Loggia de' Signori e 'l Palagio, in tanto alto che s'andava al pari dalla porta del Palagio nella Loggia . . .' Parenti, *Storia fiorentina*, I, p. 291: 'Dinanzi alla porta del palagio per ordine di Lorenzo de' Medici fatto s'era con nuovo disegno . . . uno getto, il quale el piano innanzi a detta porta allargava, con commodità

e bellezza grande di chi usare lo avea: distendeasi etiam detto piano fino al principio, cioè testa, della loggia . . .'. Lorenzo was at that time one of the Operai del Palazzo: see above, p. 69. In December the Operai put their colleague Antonio di Bernardo Dini in charge of the paving of the section of the piazza between the *rialto* and the Tetto dei Pisani, and decided that the *rialto* was to be completed as will be determined ('quod planum rialti . . . debeat perfici ut declarabitur') by him and Bernardo Rucellai (Op. Pal., 4, fo. 13ᵛ, 1 Dec. 1491). The piazza was again repaved from 1507 onwards: Cambi, *Istorie*, xxi, p. 226: 'L'anno 1507 gli Operai di S. Maria del Fiore per ricordo de' nostri Magnifici Signori . . . cominciorono a ramattonare la piazza . . . e chominciorono da la porta del Palazzo di verso la loggia . . . e feciesene ognanno dua quadri . . .'.
[138] Landucci, *Diario fiorentino*, loc. cit.: '. . . non potevano passarvi più nè [*ed.* n'è] cavagli, nè altre bestie; e anche un poco incomodo agli uomini, avere a salire e scendere. A chi piace, a [*ed.* e] chi no: a me non piaceva troppo'.
[139] See above, n. 137.
[140] See above, n. 138.

the expulsion of the Medici, the Signoria decided, on the same day on which it decreed the effacement of the inscription PATER PATRIAE on the plaque above the tomb of Cosimo at S. Lorenzo, to demolish the *rialto*, so that 'the appearance of the palace may not be disfigured on its sides'.[141] According to Parenti, the decision was due to the Gonfalonier of Justice, Antonio Manetti, the biographer of Brunelleschi, and an 'amateur of architecture', who argued that the new platform was weakening the defence of the palace and in particular that of its entrance. Parenti adds that it was widely believed that Manetti was motivated by jealousy of the herald of the palace, Francesco Filarete, who was in his turn an 'expert in architecture' and who had supplied the design for the *rialto*.[142] While the decree of the Signoria ordering its destruction was clearly aimed at a project for which Lorenzo had been held responsible, it contained no hint whatsoever of that project's having had any other purpose than to provide a physical link between the Loggia and the palace of the Signoria, to which the Loggia had, ever since its construction over a century earlier, belonged by way of its ceremonial function as a magnificent complement of the *ringhiera*.

In 1494, a *parlamento* had sealed the abolition of the Medici regime; in 1512, another *parlamento* initiated its restoration. On 16 September, Giuliano de' Medici, who had returned to Florence after Piero Soderini had been deposed from the Gonfalonierate of Justice, seized the palace with the help of armed supporters; on the same evening, a *parlamento* was called to the piazza, all its entrances having been barred by soldiers.[143] Twice more before the establishment of the Medici principate was the piazza to be the stage of momentous events in the history of the palace of the Signoria: on 26 April 1527, during the attack on the palace after the abortive anti-Medicean rising which preceded the short-lived restoration of the republican regime of 1494;[144] and on 20 August 1530, after the siege by the imperial army and the surrender of the republic. Once again, the *bocche* of the piazza were blocked, this time by the troops of the Florentine captain-general Malatesta Baglioni, who had changed sides; and the assembly, called 'to restore the Medici to Florence',[145] gave full powers to a small Balìa, which carried out this task.

[141] Sig., Delib., ord. aut., 97, fo. 119ᵛ; Landucci, *Diario fiorentino*, p. 118, n. 1, Frey 1909, pp. 114–15, no. 11 (22 Nov. 1495): '. . . quod pavimentum saxis politis stratum ante portam dominorum paucis ante annis confectum, dictum el rialto, removeatur et remaneat ut prius erat ad maiorem palatii pulchritudinem, ne conspectus palatii a lateribus deformatus videatur', the stones to be used for the construction of the new hall of the Great Council. Cf. Landucci, *Diario fiorentino*, p. 118.

[142] Parenti, loc. cit. (n. 137): 'Piacque nondimeno al Gonfaloniere della Iustizia Antonio Manetti, homo in architectura dilettatosi, che detto getto si disfacessi e la via come prima era s'aprissi, assegnando ragione che di meno forte ne era il palagio e massime la entrata, stando come al presente stava. Da molti biasimato ne fu, giudicandosi che da invidia dello Araldo, di cui tale disegno suto era, mosso si fussi, più che da giusta cagione, perché l'uno et l'altro in architectura perito era, et come artefici aversarii e inimici si portavano

insieme . . .'. On Francesco Filarete, see Trexler 1978. In 1491, Manetti was described as 'civis et architectus': Vasari–Milanesi, iv, p. 305. He was Gonfalonier of Justice in Nov.–Dec. 1495.

[143] Landucci, *Diario fiorentino*, pp. 328–9; Bartolomeo Masi, *Ricordanze*, p. 107: 'avevano preso tutte le bocche della piazza, e postovi le sbarre.'

[144] See above, Ch. 1, n. 78, and C. Roth 1925, pp. 23–6.

[145] Cambi, *Istorie*, in *Delizie*, xxiii, pp. 71–2: 'feciono parlamento per rimettere e' Medici in Firenze.' One of the accusations against Alessandro presented in 1536 by the Florentine exiles to Charles V was that the *parlamento* of Aug. 1530 'fussi fatto violentemente . . . essendo stato occupato il Palazzo pubblico, presi i canti della piazza da' fanti forestieri . . . e ordinato da' seguaci de' Medici di non lasciare venire in piazza chi potessi ovviare a' disegni loro . . .' (ed. in Guicciardini, *Opere inedite*, ix, p. 344).

EPILOGUE

The Medici were expelled from Florence on 17 May 1527 after the imperial army had entered and sacked Rome and the Medici pope Clement VII had taken refuge in Castel S. Angelo. The republican constitution of 1494 which had been abolished in 1512 was restored on the following day and the Great Council resumed its meetings on the 21st, a month earlier than had originally been ordered.[1] During the preceding fifteen years, its hall had been used as barracks for the palace guard[2] and before the first meeting of the council had to be cleared of the partitions which had been installed for that purpose.[3] In January 1528, the Signoria allocated the large sum of 1,000 florins to the restoration of the hall.[4] Two major works of restoration must have concerned the tribune of the Signoria and the altar;[5] and in March 1529, the Signoria ordered Fra Bartolomeo's unfinished altarpiece to be transferred from S. Marco, where it was then kept, to the hall.[6]

The restoration of the hall of the Great Council produced the most important and conspicuous, but not the only, building project for the palace undertaken by the republican regime. Early in 1528, it was decided to construct new audience chambers for the Dieci di Balìa and for the Otto di Guardia.[7] The intention may have been to compensate these magistracies for the relative neglect their accommodation in the palace had suffered in the past, when priority was given at first to the renovation campaign on the first and second floors and then to Piero Soderini's requirements for his apartment,[8] and to adopt a more even-handed policy in allocating space in the palace.

The restoration of the republican regime brought with it the triumphant revival of the influence of the friar whose followers considered him its founder, and whose prophecies could appear to have been fulfilled by the sack of Rome.[9] After the creation of the Great Council on

[1] C. Roth 1925, pp. 45 ff. In keeping with the short-lived reform of 6 Sept. 1512, the term of office of the Gonfalonier of Justice was reduced to one year.

[2] Cerretani, *Ricordi*, p. 291 (Oct. 1512): 'Il palazzo . . . pe' fantti della ghuardia si ghuardava, e la sala del consiglio in un chanto era la taverna ne l'altro il fraschato ne l'altro la ghrichia ne l'altro il bordello, che era una miseria . . .'. See above, p. 71. In 1513, the hall was called the 'sala grande della guardia' (Frey 1909, p. 136, no. 136 (30 Apr. 1513)).

[3] See Nardi, *Istorie di Firenze*, ii, p. 132, on the labours of the Florentine youth in clearing the hall of 'quelle stanze e casette che erano state edificate . . . per alloggiamento della guardia de' soldati'. The partitions between the barrack-cells must have been solid walls: 'non fu quasi giovane alcuno, che . . . non si gloriasse di aver portato fuori colle barelle buona quantità di calcinacci.'

[4] Sig., Cond. e stanz., 27, fo. 270ʳ, 27 Jan. 1528 (I owe this reference to John Stephens): 'per la restauratione della sala grande del consiglio in muramenti, legnami, magisteri e altre cose necessarie per tale opera'. [5] See App. VIII.

[6] Sig., Delib., ord. aut., 131, fo. 58ʳ, 29 Mar. 1529. See C. Roth 1925, pp. 106–7 and n. 127.

[7] The new audience chamber of the Dieci was being constructed, in Apr. 1528, in (or next to) the customs house, 'principiata in dogana': Sig., Cond. e stanz., 27, fo. 274ᵛ, 30 Apr.; cf. ibid., fo. 285ᵛ, 9 Dec. 1528 (see above, n. 4). On the new audience chamber of the Otto di Guardia, for which 200 florins were allocated in Aug., see App. IX.

[8] See above, pp. 32–3 and 43–5, and App. I.

[9] See C. Roth 1925, p. 62, and in particular Polizzotto 1994, pp. 337–9.

23 December 1494, Savonarola had preached that the Florentines ought to take Christ as their king;[10] on 9 February 1528, the Gonfalonier Niccolò Capponi, having addressed the council 'with a long account of the mercy and justice of God which he illustrated with many examples taken from our city and from other nations', proposed that it elect Christ as king of Florence and the Virgin as her queen, and that the election be commemorated in gold letters above the door of the palace,[11] 'where the arms of the king of France had already been placed and later those of Pope Leo'.[12] Capponi also had inscriptions, which probably reproduced those Savonarola had composed for the hall of the council, engraved on two marble tablets and affixed in a prominent position;[13] and in January 1530, Christ was invoked in an inscription above the door which led from the Udienza to the chapel.[14]

The new republican regime also revived the pro-French policy of its predecessors and thus became involved in the struggle over preponderance in Italy between France and Spain. In June 1529, Charles V concluded an alliance with the pope Clement VII, in which he promised to restore the Medici to their former position in Florence, and four months later, the imperial army laid siege to the city. Florence capitulated on 12 August 1530. In November 1531, Baccio d'Agnolo was paid by the Signoria for two wooden coats of arms which he had furnished for its audience chamber, one of Pope Clement VII and the other of Duke Alessandro de' Medici.[15] Even when Medici power was at its height under Lorenzo the Magnificent, it would have been unthinkable to display the Medici arms in the palace of government of the republic. But in July 1531, Charles V's bull declaring Duke Alessandro hereditary head of government had been solemnly published in the old council hall;[16] a Medici was now, for the first time, the constitutional ruler of Florence. In the following April, the Signoria was abolished, and its audience chamber was taken over by the Duke and his four counsellors; the hall of the Great Council had already been reconverted into barracks for the palace guard.[17] A new chapter in the history of the palace had begun.

[10] *Prediche sopra Aggeo*, 28 Dec. 1494 (pp. 422–4). See Ridolfi 1964, pp. 94–5; Weinstein 1970, p. 294.

[11] Lib. Fab., 72, fo. 234ᵛ (9 Feb. 1528): '. . . post longam misericordie et iustitie dei enarrationem pluribus exemplis a nostra civitate sumptis aliisque populis in medium adductis'. See Nardi, *Istorie di Firenze*, ii, pp. 148–9; Varchi, *Storia fiorentina*, i, pp. 329–30. The law was passed, at its first reading, with 1,094 out of 1,102 votes.

[12] Cambi, *Istorie*, in *Delizie*, xxiii, p. 11: 'propose in Consiglio gienerale . . . che si mettessi in marmo a lettere d'oro chillo voleva per suo Re . . . e [si] mettessi tale memoria sopra la porta del Palazzo, dov'era stato già messa l'arme del Re di Francia, e dipoi quella di Papa Lione, che ora si mettessi quella del nostro Re Cristo'. There are different versions of this inscription, which was replaced in 1851 with the present one (see Lensi, p. 315 n. 47), REX REGUM ET / DOMINUS / DOMINANTIUM. According to Segni, *Storie fiorentine*, i, p. 69, the inscription read: JESUS CHRISTUS REX FLORENTINI / POPULI S.P. DECRETO ELECTUS, and this inscription was still above the door in 1851 (cf. Moisè 1851, p. 65). Varchi, *Storia fiorentina*, i, p. 330, records a longer text of the inscription, which may have constituted its first version. See Lensi, p. 110, and n. 109.

[13] Varchi, loc. cit.; Nerli, *Commentari*, ii, p. 61: 'Furono anche, forse per suo ordine e per soddisfazione de' Frateschi poste due tavole nella sala del consiglio ed in luogo molto apparente'. On Savonarola's inscriptions, cf. Landucci, *Diario fiorentino*, p. 126; see above, pp. 42, 73.

[14] Op. Pal., 15, fo. 14ᵛ; Frey 1909, p. 136, no. 254; A. Cecchi 1990b, p. 43 n. 24 (31 Jan. 1530 [Cecchi: 1529]): *l*.237 *s*.7 are paid 'a mettere el nome di Giesù sopra la porta va in cappella . . . per marmi, opere di scarpellini, oro per doratura dicto nome'. The inscription reads: SOL IUSTITIAE / CHRISTUS / DEUS NOSTER / REGNAT IN AETERNUM.

[15] Op. Pal., 15, fo. 24ʳ, 24 Nov. 1531; Lensi, p. 119 n. 1: 'A Baccio d'Agnolo ducati 35 lar. d'oro in oro, sono per factura et doratura di 2 arme de' Medici, cioè una di papa et una di ducha, di legname con loro ornamenti, fatte et appiccate nella audientia de' Signori et per comandamento di detti Signori'. The inventory of 1532 records the *cornicione* of the tribune of the Signoria in their audience chamber as having 'et di qua et di là l'arme de' Medici' (fo. 162ᵛ). On Leo's arms above the door of the palace, see above, n. 12.

[16] Varchi, *Storia fiorentina*, ii, pp. 569–74.

[17] Op. Pal., 15, fo. 22ʳ (24 Nov. 1531): the Operai order *l*.2,197 *d*.8 to be paid 'per la muraglia fatta nella sala grande per le stanze della guardia'. On the same day, they decided to pay Bartolomeo del Troscia, their bursar (*camerario et proveditore*), 30 florins 'per havere lui oltra al suo officio ordinario durato faticha et usata diligentia et masseritia nella muraglia fatta pe' soldati nella sala grande' (ibid., fo. 27ᵛ).

APPENDIX I

The Camere *of the Priors and of the Gonfalonier of Justice*

Vasari writes in his Life of Michelozzo that, as part of his internal reconstruction of the palace, Michelozzo created, 'spartendo in fila, dalla parte di verso San Piero Scheraggio, alcune camere per i Signori, che prima dormivano tutti insieme in una medesima stanza; le quali camere furono otto per i Signori, ed una maggiore per il gonfalonieri' (Vasari–Milanesi, ii, p. 436). In fact, there is a great deal of evidence for the existence of separate rooms of the Signoria from the late fourteenth century onwards (cf. Alamanno Acciaiuoli, *Cronaca*, in *Tumulto dei Ciompi*, p. 32, *ad* July 1378: two of the Priors, 'uscendo delle camere loro e venendo nella udienza [of the Signoria], non viddono niuno de' loro compagni'; Sacchetti, *Trecentonovelle*, see below; Dati, *Istoria di Firenze*, p. 136: 'Ciascuno [of the Signori] ha la sua camera nel Palagio fatta per ordine, e per Quartiere, e quella del Gonfaloniere è in capo di tutte'; *Statuta* 1415, V. i. 12; ii, p. 505: the Signori 'habeant . . . assides pro lectis ad cameras'; Cavalcanti, *Istorie fiorentine*, x. 8 (p. 306), *ad* 1434: 'i Signori andarono di sala in camera, l'uno in quella dell'altro').

That the Signori slept together in one large dormitory appears to apply only to the early history of the palace (see *Consigli*, i, p. 192, 9 March 1305: 'in presentia priorum et vexilliferi, in camera eorum'; p. 296, 9 December 1306: 'in camera priorum et vexilliferi'). It is not possible, on the basis of the available evidence, to ascertain when this dormitory was partitioned; a document of 1345 refers to the 'camera Priorum' (Capitoli, 18, 12 August 1345: 'pro faciendo destrui murum qui erat in camera Priorum'; the wall may have been constructed by the duke of Athens). The partitioning may have been carried out, as Spilner 1993, p. 460, suggests, after the councils had allocated, in 1371, funds for the *melioramentum* of the palace (see above, Ch. 1, n. 112), but an inventory of the palace of 1366–8 records 'i chandeliere ne le chamere de' priori' (BLF, MS Ashb. 1214, fo. 6ᵛ; Mazzi 1897, p. 362). From one of Sacchetti's *novelle* it emerges that the partitions between the rooms of the Priors, which had been installed by then, must have been so flimsy that the Priors were kept awake by one of them urinating in his *camera* (*Trecentonovelle*, lxxxiii, p. 267: 'tu ci desti ogni notte con questo tuo orinare'). At the same time, their rooms must have been large enough to make it possible for two persons to spend the night in them and, for a short period, to contain as many as nine persons. In 1456, Francesco Giovanni kept his brother hidden in his room during the night, and in 1441, he had hidden in it nine members of the *famiglia* of the Signoria, in preparation for the attack on Baldaccio d'Anghiari: see below. In 1463, the partitions appear to have been demolished and replaced with more solid walls (Rinuccini, *Ricordi*, p. xc: 'E più feciono i sopraddetti signori di Gennaio e Febbraio gittare in terra le camere dove abitavano, per rifarle e raconciarle, et questo feciono a dì 26 di Febbraio': see above, p. 30).

Francesco Giovanni's account of the arrest and execution of the Florentine *condottiere* Baldaccio d'Anghiari on 5 September 1441 is a major source for our knowledge of the arrangement of the sleeping quarters of the Signoria (*Ricordanze*, C. Strozz., 2a ser., 16, fo. 22ᵛ, quoted in Lensi Orlandi, p. 62. Cf. the shorter narrative in the contemporary *Priorista* of Piero Pietrobuoni, fo. 144ʳ). Francesco Giovanni's detailed account is discussed by Trachtenberg 1989, pp. 601–4, whose interpretation of it, which is based on his hypothesis of a balcony existing at that time in the courtyard along the second floor, differs substantially from mine. Francesco Giovanni, who was one of the Priors for September and October 1441, records that on the evening of 5 September the Priors consented to the Gonfalonier's request 'di fare qualunque cosa paressi' to him against the *condottiere*. On the following day, 'avendo ordinato el cavaliere e otto fanti del Capitano di Firenze, e rachiusili in camera mia, el Gonfaloniere mandò per detto Baldacio che era in piaza, e dopo circa una hora lui venne, e essendo ne l'andito fra le camere soli lui e il Gonfaloniere, facemo venire la famigla in Saletta, e io mi stavo a capo a l'andito fingendo di legere lettere; e quando il Gonfaloniere m'acennò e io acennai la famigla, e subito lo gittorno in terra per legarlo come gl'avevo imposto. Ma volendo Baldaccio con uno trafiere che avea difendersi e dare al Gonfaloniere e fedendo uno famiglo, per tanto gl'altri per difendersi fedirno lui e per detto del Gonfaloniere subito lo gittorno nella corte del Capitano. Dipoi se gli fe' tagliare il capo in sulla porta . . . V[in]cemo poi pe' Consigli che di detta facenda non si possi mai cognoscere per rispetto di quelli vi si trovorno.' Cf. Pietrobuoni, loc. cit.: 'fu ferito infra lle camere della Signoria, et così ferito fu gittato a terra delle finestre nel cortile del Capitano del Popolo e dov'è oggi la doghana . . .'. The Signoria had prepared the attack on Baldaccio by arranging to have eight *fanti* and a knight—not of the palace guard, as Trachtenberg loc. cit., but of the retinue of the 'Capitano di Firenze', that is the Captain of the People—hidden in Francesco's room. The distinction is not without importance. The action which was contemplated by the Signoria was strictly illegal. The condottiere, once arrested, should have been handed over to the Captain of the People, with orders (*bollettino*) from the Signoria or from the Otto di Guardia—a fact which is confirmed by the amnesty, which was subsequently obtained by the councils, exonerating the Signoria. By having one of the Captain's two knights and eight of his foot-soldiers present in the palace, the Signoria was evidently hoping to give its action a semblance of legality. Francesco Giovanni belonged to the *quartiere* of S. Spirito, and his room was consequently one of the first two of the row of *camere* of the Priors which were closest to that of the Gonfalonier of Justice (see below). Baldaccio was thus caught between two groups of armed men, those of the Captain and those of the *famiglia* of the Signoria hidden in the Saletta near the other end of the *andito*. The extant documentation leaves no doubt that by the 'andito fra le camere', Francesco Giovanni referred to the corridor, on the side of the courtyard, along the rooms of the Priors, and not, as Trachtenberg argues, to a—hypothetical—balcony along the façade of the courtyard (see App. II). Owing to its location, Francesco's room evidently lent itself as a hiding-place of the Captain's men; those of the *famiglia* of the Signoria would have been subsequently introduced into the Saletta without Baldaccio's noticing it, through its door facing the entrance to the Sala dei Gigli. Francesco, standing at the other end of the *andito* pretending to read a letter, would have been able to signal to them to seize Baldaccio.

The inventory of 1471 shows that the rooms of the Priors were arranged in pairs by *quartieri*; the two rooms of the Priors who belonged to that of S. Spirito are listed after the room of the Gonfalonier, and from there the inventory proceeds to those of S. Croce, S. Maria Novella, and S. Giovanni (Inventory 1471, fos. 8ᵛ–10ʳ); this was still the arrangement at the time of the abolition of the Priorate in 1532 (Inventory 1532, fos. 164ᵛ–165ᵛ).

The Gonfalonier of Justice as the most prestigious member of the Signoria occupied a separate room (see *Statuta* 1415, v. i. 43; ii, p. 549: 'cameram per se separatam ab aliis in palatio residentiae dominorum priorum . . . habeat'). It was large enough to accommodate the meetings of small consultative committees: in April 1477, for example, six leading citizens including Lorenzo de' Medici met 'in camera del Magnifico Gonfaloniere', to advise him on his reply to the Neapolitan ambassador (Lorenzo de' Medici, *Lettere*, ii, p. 345; cf. p. 372). The furnishings of this room included a large chest ('uno cassone grande') which contained a casket for imperial privileges and other important public documents, as well as eleven flags, among them the 'gonfalone della giustizia vecchio', the 'gonfalone vecchio con l'arme del Popolo che si pone alla finestra', and the new banner with the cross of the People, 'che si dà al Gonfaloniere della Giustizia la mattina che piglia l'uficio'; and, from 1442, two banners, one of Niccolò Piccinino and the other of Filippo Maria Visconti, which had been captured in the battle of Anghiari in 1440 (Carte di corredo, 65, fos. 26ʳ, 30 August 1439, 40ʳ, 20 September 1444: 'Una bandiera biancha dentrovi uno lio_pardo di Nicolò Picinino, una bandiera rossa con la divisa del duca di Melano, le quali li furono tolte quando fu rotto tra Anghiari e 'l Borgho a San Sepolcro.' These 'insigna sive stendarda' had been taken to the palace in 1442 from the cathedral, 'ubi steterant ultra annum': Poggi 1988, ii, p. 155, no. 2196, 14 February 1442).

Piero Soderini, having created an apartment for himself and his wife on the second floor and the mezzanine (see above, pp. 43–4), appears to have converted the old *camera* of the Gonfalonier of Justice into his audience chamber: in August 1504, payments were made for the decoration of the 'camera overo audientia' of the Gonfaloniere (Op. Pal., 10, fo. 66ᵛ; Frey 1909, p. 132, nos. 185, 86, 30 August: payment to Francesco di Piero dell' Orto [MS: Dito] *dipintore* for work in the *camera* of the Gonfalonier, and to the same on 31 October [p. 133, no. 197] 'per suo resto . . . per havere dipinto . . . l'udientia del Gonfaloniere'. Cf. also ibid., p. 133, no. 195; Op. Pal., 10, fo. 69ᵛ; 31 October 1504, payment 'a' frati degl' Ingesuati . . . per dua finestre di vetro' in the 'udientia del Gonfaloniere'; see above, pp. 45, 76–7). Of all the smaller rooms (*camere*) of the Signoria, only that at the corner of the Via della Ninna and the piazza had two windows. It also was the only one of these rooms which had a window on the piazza; and Segni records, writing in the 1540s the *Life* of Niccolò Capponi, that 'una colomba bianca entrata una volta per la finestra che si risponde in sulla piazza, nella camera del Gonfaloniere, fu cacciata via' (*Vita di Niccolò Capponi*, in *Storie fiorentine*, iii, pp. 289–90). This room must therefore have been the present Sala di Penelope.

The inventory of 1532 lists the 'camera del Gonfaloniere da basso' and, after his *udienza*, the 'camera ch'era del Gonfaloniere' (fos. 165ᵛ, 167ʳ). After Niccolò Capponi was deprived of the Gonfaloniership in April 1529, the Great Council decreed that henceforth it should no longer be possible to enter the apartment (*habitatione*) of the Gonfalonier except through 'la solita entrata tra le camere delli altri Signori' (see App. II), that is through the door of the corner

room on the second floor; 'et però si provede che l'uscita da basso si rimuri di muro grosso intra
la sala et la camera; et la camera et anticamera da basso chiusa come de s[opra] resti al servitio
di decto Gonfaloniere solamente' (Provv., 207, fos. 5ᵛ–6ᵛ, 18 April 1529; cf. Varchi, *Storia
fiorentina*, i, pp. 503–4. The wall was demolished after the fall of the republican regime: Balìe,
49, fo. 35ʳ, 28 September 1530; I owe this reference to Caroline Elam. Cf. also Nerli,
Commentari, ii, p. 75: after his arrest, Capponi was confined to the 'stanze da basso sotto la
camera del Gonfaloniere'.) The 'camera del Gonfaloniere giù da basso' of the 1532 inventory
must consequently be identical with his *camera* on the mezzanine, while 'la camera ch'era del
Gonfaloniere' probably refers to the room, next to his *camera* or *audientia* on the second floor,
which had belonged to the Signoria's notary and which Piero Soderini had annexed to his
apartment (see above, p. 44).

The inventory of 1532 probably gives a fairly accurate picture of the furnishings of the room
at the time, twenty years earlier, when Piero Soderini was deprived of his office. A prominent
piece of furniture must have been a desk made of walnut, 'un descho con armario di noce di
braccia 4', that is, with a cupboard capacious enough to store a large number of privileges and
other documents as well as seventeen books. This *armario* must have replaced the *cassone* which
is not recorded in the 1532 inventory. The desk was covered with a carpet of the same length
of four *braccia* and was complemented by a chair with balusters, also made of walnut. (On desks
with cupboards, see Thornton 1991, pp. 222–9, on chairs with balusters, ibid., p. 173.) The
desk may have resembled the 'desco . . . grande da scrivere, con un armario di noce . . .' which
at the beginning of the sixteenth century was in the villa of the younger branch of the Medici
in Fiesole (ibid., p. 229, Shearman 1975, p. 25).

APPENDIX II

Fra le camere

Vasari writes in his Life of Michelozzo that Michelozzo had partitioned on the second floor, 'in fila, dalla parte di verso San Piero Scheraggio [that is facing the Via della Ninna], alcune camere per i Signori . . . che tutte rispondevano in un andito che aveva le finestre sopra il cortile' (Vasari–Milanesi, ii, p. 436; cf. App. I). Vasari, who converted these rooms into an apartment for Cosimo I's wife, Eleonora of Toledo, is evidently describing the arrangement of the rooms as he found it when he began his work in the palace. Machiavelli, who, as a member of the chancery between 1498 and 1512, knew the palace inside out, calls that passage 'lo andito lungo le camere de' Signori' (*Istorie fiorentine*, vi. 7, in *Opere*, p. 769). In his account of the arrest, in 1441, of the condottiere Baldaccio d'Anghiari (see App. I), Francesco Giovanni writes that the Gonfalonier of Justice, having sent for Baldaccio, and Baldaccio, 'essendo ne l'andito fra le camere soli lui e il Gonfaloniere', was seized by men from the Signoria's household who had been hidden in the *saletta* and thrown into the courtyard of the Captain of the People. The *andito fra le camere*, which was briefly called *fra le camere* or *inter cameras*, must have been spacious enough to accommodate, occasionally, consultative meetings, as in March 1431 when a meeting held *inter cameras* was attended by fourteen persons (Pellegrini 1880–9, p. xlvi). The inventory of objects in the palace in 1471 lists *tralle camere* as containing, among other objects, 'una Vergine Maria in cholmo cornic[i]ata d'oro', two 'huomini di legnio', and a 'focholarato di ferro'—a painting of the Virgin in an arched gold frame, two wooden male statues, and an andiron (Inventory 1471, fo. 10ᵛ). In 1441, the Signoria had a marble sink installed *tra le camere* (Francesco Giovanni, *Ricordanze*, C. Strozz., 2a ser., 16, fo. 22ᵛ: 'facemo fare . . . l'acquaio del marmo tra le camere'). At the west end of this passage there was a doorway leading to the room of the Gonfalonier of Justice: a law of 1529 describes this doorway as 'la solita entrata tra le camere delli altri Signori' (see App. I).

Another passage connected the rooms of the Signoria with their audience chamber, which was called 'l'andito che va dall'Udientia alle camere' (Francesco Giovanni, loc. cit.). In 1481, a payment was made for whitewashing, among other rooms in the palace, 'andronem qui tendit ad cappellam, ad cameras Dominorum et cameram notarii Dominorum' (Op. Pal., 2, fo. 53ᵛ, 27 November 1481; the chapel was situated in the Udienza: see App. IV). As the word *androne* indicates, this passage was a spacious *andito*; it had a window to the courtyard above the main entrance to the palace. In 1478, a payment was made for a shutter of the *andito*, 'pro dipintura, manifattura et auro misso in gelosia fenestre anditi camerarum dominorum supra ianuam dicti palatii' (Op. Pal., 2, fo. 49ᵛ, 21 December 1478). In 1501, a small door (*porticciuola*) 'che va nell'andito delle camere de' . . . Signori' was made in the Udienza chapel (Frey 1909, p. 125, no. 121, 15 December 1501: see App. IV).

APPENDIX III

The Sala dei Gigli

According to Vasari (Vasari–Milanesi, iii, p. 341), the partition of the large hall on the second floor, which corresponded to the Camera dell'Arme and the council hall on the lower floors (cf. Paul 1969, pp. 19 ff., 43 ff., on the location of halls in public palaces in Northern Italy), into two rooms was due to Benedetto da Maiano, who thus created 'una sala ed una audienza' (see above, pp. 18, 33). Vasari's account has been accepted in all works on the history of the palace (cf. e.g. Lensi Orlandi, p. 77), but in fact the division of the north wing of the second floor into two rooms existed long before 1472. The hall was probably still undivided at the time of the electoral reform in 1328, when, according to Villani (*Cronica*, x. 108; iii, p. 104), the commission of 85 citizens which held the first 'scrutiny' for eligibility to office, met in the *sala de' priori*. But by the time the statutes of 1415 were compiled, there was a large room next to the Udienza of the Signoria, for the Sixteen Gonfalonieri and the Twelve Buonuomini, that is the Colleges of the Signoria, were required, on being summoned to the palace, to assemble 'super sala superiori' (*Statuta* 1415, V. i. 42; ii, p. 547). Cavalcanti describes this room, which was also called 'aula audientie dominorum' (cf. e.g. Op. Pal., 4, fo. 16ʳ, 18 February 1485, payment to Ghirlandaio 'pro parte picture . . . Sancti Zenobii aule audientie dominorum') as 'la maestra sala', from which one entered the Udienza (*Istorie fiorentine*, ix. 10 (p. 276): in September 1433, 'Niccola [di Vieri de' Medici] arrivò in su la maestra sala, che d'indi s'entra nella signorile udienza'). This *sala*, like the Udienza and the Saletta, was often used for meetings of advisory committees (cf. e.g. Cons. e Prat., 48, fo. 83ʳ, 24 August 1429: 'in sala prope audientiam'; Pellegrini 1880–9, p. xlviii, 1 April 1431: 'in sala pene audientiam'; Cons. e Prat., 53, fo. 85ʳ, 26 June 1454: 'in sala magna superiori'); it was described as *sala superior* or *sala magna superior* to distinguish it from the *sala magna*, the council hall, on the first floor, where also exceptionally large consultative meetings met on rare occasions (cf. e.g. ibid., fo. 153ʳ, 19 January 1455). A good example of the way in which different rooms, among them the *sala superior*, were used for such meetings is provided by the debates preceding the conclusion of the peace treaty with Venice in July 1454 (ibid., fos. 90ʳ ff.): after a 'consilium habitum in sala magna', the council hall, there were meetings in the Udienza, in the *sala superior*, and in the Saletta (on meetings in the council hall, see Vespasiano da Bisticci, *Vite*, ii, p. 326). The Sala dei Gigli was also called the *sala* or *aula* of the Signoria (e.g. Op. Pal., 4, fo. 26ᵛ, 24 September 1490: 'pro pictura tribus parietibus aule dominationis'). After money had been allocated in 1469 for work in the palace, it was decided that it should be used 'per l'opera della sala del consiglio et per la sala grande de sopra et per la audientia' (Fabriczy 1904, p. 109 n. 1, 20–1 April 1469; ibid., pp. 108–10, 17–21 August 1470; see above, Ch. 1, n. 228: 'considerando . . . quanto tempo è che s'ordinò che

la sala del consiglio et quella di sopra nel Palagio . . . si dovesse aconciare et ornare . . .'. See also above, Ch. 1, n. 229). Three years later it was decided that 'debea[n]t destrui sala magna et audientia . . . Dominorum' (C. Strozz., 2a ser., 53, fo. 174ᵛ; Gaye, i, p. 571: see above, Ch. 1, n. 232). It was in consequence of this decision that the existing partition between the *sala* and the Udienza of the Signoria was replaced by a new wall, and the doorway between them by Benedetto da Maiano's splendid marble doorway, and it is to this new wall that Vasari, who inspected and admired its technical construction, refers in his Life of Benedetto.

The Sala dei Gigli was also used by the Signoria as a dining-room. In the estimate of the cost of the three new ceilings in 1475, one of the ceilings is described as 'il palco della sala dove mangia la Signoria', the other two as 'il palco della sala del consiglio' and 'il palco dell' Udienza' (Op. Pal., 1, fos. 5ᵛ–6ʳ, 29 August 1475). Cambi writes that in 1436 the Signoria entertained Eugenius IV and all the ambassadors 'a dexinare colloro in Palazzo, insu la Sala grande loro' (*Istorie*, in *Delizie*, xx, p. 210).

The inventory of 1471 (fo. 11ʳ) shows the room to have been furnished with four benches, two of them with backs (*spalliere*), but not with a table; however, there were two tables in the adjoining Udienza, one of them a folding table ('uno descho che si ripiega da due lati') and the other a trestle table ('uno descho chon due trespolini confiti'), of the length of four and two *braccia* respectively, which could have been easily moved into the *sala*. By 1532, it contained a sideboard ('una credenza d'albero bianco') and three large trestle tables, which would have served for its function as a dining-room, as well as a round table for musicians ('desco tondo per li sonatori': Inventory 1532, fo. 163ᵛ). This furniture may well have been there at the time of Piero Soderini's Gonfaloniership, possibly acquired during that period. This was certainly the case of the famous clock ('oriuolo con le sue appartenentie', ibid.) of Lorenzo della Volpaia, which the Captains of the Guelf Party gave to the Signoria in 1509 (see Dorini 1909), and after which the room came to be named (cf. Rastrelli 1792, p. 193: 'Fuori della Sala, detta dell'Orivolo'). Albertini singles out, in his *Memoriale* published in the following year, the 'mirabile et artificioso horologio che mostra el corso del Sole et le palle della terra' as one of the principal sights of the palace (Sig. a iiii 3ʳ).

The Chapel and the Audience Chamber of the Signoria

Giovanni Cambi writes that before the construction in 1511 of the new chapel of the Signoria (see above, pp. 45–6), their chapel consisted of 'a simple altar in the audience chamber', 'un senpricie altare nella loro Udienza, allato alla porta de l'entrata de l'Udienza, ché solo una pancha divideva la chapella da l'Udienza' (*Istorie*, in *Delizie*, xxi, pp. 275–6. On the description of altars as chapels, see Lightbown 1980, i, p. 180). In fact, this chapel, whose roof (*copertura*) was decorated around 1385, must have been a substantial structure. It was dedicated to St Bernard (see above, p. 49), and contained, in 1357, besides the altar and the altarpiece (see above, Ch. 2, n. 22), a chest (*cassone, armario*), which served for the safe-keeping of particularly important documents (see Marzi 1910, pp. 462, 468). In 1471, this chest was covered with a carpet (*tappeto*); another such carpet was on the altar, and two others 'dove s'appoggia il ghonfaloniere e 'l proposto', that is the Prior who periodically chaired the meetings of the Signoria (Inventory 1471, fo. 7ᵛ). The chapel also contained seats, for in May 1501 Baccio d'Agnolo was commissioned to make 'quatuor sedes novas' and to restore fifteen 'sedes veteres . . . in audientia et cappella Dominorum . . . ad usum cori' (Op. Pal., 10, fos. 32ᵛ–33ʳ; Frey 1909, p. 124, no. 114, 22 May); he had been paid, a few months earlier, 'per parte del coro fa su nella cappella de' Signori' (ibid., p. 123, no. 104, Op. Pal., 10, fo. 9ᵛ, 30 December 1500), and was paid on 12 June 'per resto del coro fece in la chapella della audientia della Signoria' (Op. Pal., 10, fo. 16ᵛ; Frey 1909, p. 124, no. 117. On the meaning of *coro* in fourteenth-century Tuscany, cf. Rinaldeschi, *Esposizione de' Salmi*, p. 73, on the temple of Jerusalem: of its three parts, one was 'quella parte dove stanno i preti, che noi diciamo coro'). In the same year 1501 the chapel was provided with a small separate entrance to the passage between the Udienza and the *camere* of the Signoria (Op. Pal., 10, fo. 23ᵛ; Frey 1909, p. 125, no. 121, 15 December): a 'porticciuola del marmo bianco messa nella cappella de' . . . Signori, che va nell'andito delle camere de' . . . Signori'. A. Cecchi 1990*a*, p. 39, identifies this with the marble doorway leading from the Sala di Gualdrada to the new chapel, whose design he attributes to Baccio d'Agnolo; but the new chapel did not yet exist in 1501, and the size of that doorway would in any case hardly justify its description as a *porticciuola*.

In 1432, on the occasion of the cleaning of the altarpiece of the chapel (see above, Ch. 2, n. 22), the Signoria provided the altar with a 'bellissimo tabernacolo a oro fine di legname nuovo, fornito con stelle d'oro fine in campo di fine e azurro oltramarino, con una cortina di bocchaccino azurro . . . per conservatione et guardia del decto tabernacolo e tavola dipinta' (Carte di corredo, 65, fo. 8ʳ⁻ᵛ, 30 June 1432). The golden rose which Martin V had given Florence in 1419 was placed by the Signoria in a tabernacle in its audience chamber (see

Buoninsegni, *Storia di Firenze*, p. 13: '. . . et a perpetua memoria di questo dono la Signoria la fece deporre nell'audienzia de' Signori in un Tabernaculo molto honoratamente'); it is later recorded as being kept in 'uno tabernaculo nella cappella' (Carte di corredo, 66, fo. 8ᵛ, March–April 1458). In 1451, the Signoria decided that, since the rose 'retinetur clausa continuo' in their audience chamber, it should be placed on the altar of the chapel of St Bernard, 'super altari capelle Sancti Bernardi site in dicta audientia', on high feast days such as Christmas, Easter, and the feast of St Bernard (Sig., Delib., ord. aut., 71, fo. 41ʳ⁻ᵛ, 21 April 1451).

In 1420, the Opera del Duomo paid for work done in the palace on a tabernacle for the Pandects ('pro faciendo tabernaculam Pandittarum': Archivio dell'Opera del Duomo, II–1–74, fo. 65, 15 June 1420; I owe this reference to Margaret Haines. On the Florentine codices of the Pandects which had been taken from Pisa after its conquest by the Florentines in 1406: Cavalcanti, *Istorie fiorentine*, vii. 20 (p. 219); see also Branca 1983, pp. 188–92.) In this tabernacle, the two codices of the Pandects were kept in a case (*cassetta*) which also contained imperial privileges that had been granted to Pisa (Carte di corredo, 65, fo. 24ᵛ, 30 August 1439: 'Nel tabernacolo de l'audienza una chassetta, nella quale sono . . . due libri di legge antichi chiamansi le Pandette' as well as 'privilegi . . . conceduti a' Pisani' by Frederick I and other German emperors). After the Council of Florence in 1439, it was joined there by another *cassetta*, made of silver, enamelled and partly gilded, and one *braccio* long, with the arms of Eugenius IV and of its donor, Cardinal Cesarini, which contained copies of the decrees of union with the Greek Church (ibid., fos. 27ʳ⁻ᵛ, 28 February 1440, fos. 35ᵛ–36ᵛ, 17 May 1444. This case is now in the Biblioteca Laurenziana: see *San Lorenzo* 1984, pp. 277–9: ill., p. 278.) In 1454, the Signoria bought from a refugee from Constantinople for 400 florins an allegedly fourth-century manuscript of the Greek text of the Gospels (Pietrobuoni, *Priorista*, fo. 167ʳ⁻ᵛ: a 'gentile huomo di Ghostantinopoli', Marco Castianselmo, having arrived in Florence in July with 'certe gratiose e sante reliquie' and 'un libro grande iscritto in grecho, dove sono tutti e vangeli de' quattro vangelisti fatti fare al tempo di Ghostantino imperadore', which had been hidden at the time of the conquest of Constantinople, sold it to the Signoria; see Bandini 1787. The account in *Memorie istoriche sopra la città di Firenze*, BLF, MS Ashb. 802, fo. 237ʳ, cited by Poggi 1988, ii, p. 85, no. 1861, is clearly based on Pietrobuoni's *Priorista*.) On 3 July a meeting was held to advise the Signoria 'utrum reliquie quedam sancte et liber evangeliarum grece scriptus ac mirifice ornatus sint emende'. As for the relics, most speakers wanted them to be bought, provided 'ut vere sint', by the Arte della Lana for the Cathedral, but one of them (Domenico Martelli) wanted the Signoria to buy the relics 'pro capella palatii' (Cons. e Prat., 53, fos. 86ʳ–89ᵛ. The manuscript, BLF, Med. Pal. 243, was in fact copied in the eleventh century: see Bandini, *Catalogus codicum*, iii, suppl., p. 78*.) About a fortnight later, on 15 August, the Signoria commissioned Neri di Bicci to decorate a newly made wooden tabernacle *fatto all'antica*, 'il quale à stare d'atorno a uno armare dove istano le Pandette e uno altro libro, il quale vene di Ghostantinopoli e certe altre solenissime chose del Popolo di Firenze' (*Ricordanze*, p. 17; see above, Ch. 2, n. 111). In 1458 the tabernacle also contained, beside this 'evangelistario greco fornito tutto d'ariente e di perle', a 'libro delle Storie fiorentine' by Leonardo Bruni 'covertato di velluto' (Carte di corredo, 66, fo. 8ᵛ; Gori 1755, p. 220, March–April 1458. On the copies of Leonardo Bruni's work in the palace, see Santini, introduction to

the *Historiae Florentini populi*, pp. xviii–xxi. One of these, which is recorded in 1454, and which had been bought from Vespasiano da Bisticci, was 'coverto di velluto rosso': p. xx).

On the altarpiece of the chapel and on Verrocchio's candlestick, which was set up in it between 1468 and 1480, see above, pp. 58, 59 (in the inventory of 1471, fo. 11ʳ, the candlestick appears to be recorded in the audience chamber: 'l° chandeliere di bronzo ch' è 'l più alto').

Liturgical and other objects required in the chapel were kept in the *sagrestia*. In 1429, the Signoria decreed that henceforth each Signoria was to check the presence in the palace of these objects 'et di tutti gli arienti della loro mensa' (Carte di corredo, 65, fo. 2ᵛ, 30 October 1429); in 1458, a section of the inventory 'di tutte le cose dedicate alla cappella della loro audientia et degli arienti et beni per la mensa loro' is headed: 'Inventario di tutte le cose che si truovano nella sagrestia della cappella della Signoria' (Carte di corredo, 66, fos. 4ᵛ, 5ᵛ; Gori 1755, p. 215; the 'cose che si truovano nel tabernacolo della audienza de' detti M. Signori' are listed separately on fo. 8ᵛ, Gori 1755, p. 219). Where was the *sagrestia*? In the inventory of 1471 (fos. 13ʳ⁻ᵛ), it is listed after the council hall and the *camera* of the captain of the *fanti* (see App. IX) and before the Camera dell'Arme, whose lay brethren were also guardians of the silver objects and liturgical textiles of the chapel and of the seal of the Commune. The inventory of the palace of the Signoria of 1436 records that 'tucte le cose d'ariento et drappi esistenti per la capella' were kept by the religious who were guardians of the seal ('apresso a' frati guardiani del sugello': Carte di corredo, 65, fo. 13ᵛ, 30 December 1436; see App. VI). A hundred years later, the *frati* were still in charge of objects belonging to the chapel (Inventory 1532, fo. 162ᵛ: 'cose nelle mani de' Frati per conto della Cappella'). On the two Cistercian lay brethren of the Camera dell'Arme, see *Statuta* 1415, V. i. 19 and 20 (ii, pp. 523–5), and Trexler 1978, pp. 326–8; on the new chapel, see above, pp. 45–6, 78.

On the audience chamber, see also App. VII.

The Sala dei Grandi and the Chancery of the Riformagioni

A deliberation of the Signoria of 1454 shows that this *sala* was adjacent to the room of the Notary of Legislation: 'officiales electi per Dominos de mense ianuarii sive februarii . . . ad destruendum certa loca sive muramenta in parte inferiore palatii . . . possint et debeant . . . rumpi facere murum qui est in Sala de' Grandi pro fieri faciendo anditum in locum Reformationum' (C. Strozz., 2a ser., 53, fos. 159ᵛ–160ʳ, 9 May 1454, see above, p. 27; Marzi, p. 477 n. 4, misread this passage). The Sala dei Grandi, or Sala Magnatum, for which Giovanni da Gaiole was commissioned in 1466 to make benches of the total length of about 40 *braccia* (Sig., Del., ord. aut., 19, fo. 19ᵛ, 16 October 1466: 'ad faciendum . . . omnes panchas cum spalleriis intarsiatis et lavoratis cum cornici[bu]s nucis . . . que panche . . . sunt panche sale Magnatum . . .'), must have been located either on the first or on the mezzanine floor: Buoninsegni writes, on the Ciompi revolt, that one of the Ciompi who, on 31 August 1378, had entered the palace and had threatened the Gonfalonier of Justice, Michele di Lando, was chased by him from the second floor 'giù per la scala insino in su la sala de' grandi' (*Historia fiorentina*, p. 628; cf. Stefani, *Cronaca*, p. 333: the Gonfalonier 'giunsegli in capo della scala'; Bruni, *Historiae Florentini populi*, p. 225: the Ciompi 'fugientes insecutus per scalas aedium praecipites egit'). *Scala* in these passages must either refer to the entire length of the internal stairs from the first to the second floor, or only to the flight from the mezzanine to the second floor. In the inventory of 1471, which lists the objects preserved in the rooms of the palace by starting from the attic and ending with the ground floor, the room of the *Riformagioni* is listed before that of the electoral records, the *tratte*, which was situated on the mezzanine (Inventory 1471, fo. 11ʳ. On the location of the office of the *tratte*, see above, p. 37.) That the Notary of Legislation too had his office on that floor appears to emerge from Cerretani's description of the conversions that were carried out in the palace after the election in 1502 of Piero Soderini as Gonfalonier for life (see above, p. 44). The apartment which Soderini had created for himself and his wife included part of the mezzanine, and Cerretani reports that 'dalla finestra della croce andare alle riformag[i]one si fe' un rastrello di legname che si serrava' (*Storia fiorentina*, p. 315. Marzi, p. 478, followed by Lensi, p. 97, and Lensi Orlandi, p. 102, erroneously transcribed 'rastrello' as 'castello'; hence its description, by Lensi Orlandi, as a 'costruzione di legname addossata alla facciata del Palazzo'). The 'finestra della croce' must have been a window of the mezzanine, for Varchi describes the rooms of Soderini's wife, which he locates underneath those of the Signoria ('sotto le loro camere'), that is on the mezzanine, as having been situated on the 'piano della croce' (*Istoria fiorentina*, ii, p. 183). Cerretani comments that, according to hearsay, the gate (*rastrello*) had been installed for the Gonfalonier's safety, 'per sua

sichurttà'; it must therefore have been placed where it could protect the access to his own and his wife's apartment (see also above, Ch. 1, n. 334). This only makes sense if the gate was installed on the lower floor of that apartment, which was, in fact, less protected from intrusion than the floor of the Signoria above.

By May 1503, the chancery of the *Riformagioni* had a new office: Bernardino d'Antonio di Giannozzo *scarpellino* was paid for 'uno uscio al nuovo scriptoio delle riformagioni' (Op. Pal., 10, fos. 50ᵛ–51ʳ, 23 May 1503; ibid., fo. 51ᵛ: 'in cancelleria delle riformagioni').

It is not clear what purpose the Sala dei Grandi served. The Magnates (*grandi*, *magnati*) were excluded by the Ordinances of Justice of 1293 from the Signoria and all major offices of the republic, as well as from the council of the People. After 1355, they were, however, admitted, with a fixed quota, to that of the Commune, and had a fixed share in a large number of offices, some of them of considerable importance, including a number of major offices in the administration of the Florentine dominion (see Guidi 1981, ii, pp. 126–9, and for the 1355 legislation Brucker 1962, p. 151; cf. the lists of offices in *Statuta* of 1415, Ordinamenta Justitiae, 93–4; i, pp. 509–10). In order to be allowed to accept public office, they had to obtain a licence from the Signoria which was delivered to them by the Notary of Legislation, who also drew up their instruments of surety of lawful behaviour (see Marzi 1910, p. 74). I am grateful to Christiane Klapisch-Zuber for drawing my attention to these procedures, which could explain the proximity of the Sala dei Magnati to the chancery of the *Riformagioni*.

APPENDIX VI

The Secretum

In the council hall on the first floor there was a recess (*recessus*) which must have been separated from the rest of the hall by a partition. This room was used for the technical procedures of the electoral scrutinies as well as of the sortition for election to office, both of which required the utmost secrecy. The procedures of the scrutinies are minutely described in the Statutes of 1355 (Statuti del Capitano, ii. 5, Statuti del Comune di Firenze, 10, fos. 55ᵛ–59ᵛ, Italian version ed. Marzi 1910, pp. 557–65) and of 1415 (*Statuta* 1415, v. i. 4; ii, pp. 481–91). Sealed nomination papers were given to the Signoria, who handed them over to three notaries, including the Notary of the *Riformagioni* and the Notary of the *specchio*. These notaries were joined, 'in aliqua parte palatii . . . segregatim ab aliis', by three of the six foreign religious appointed for the scrutiny; the three remaining religious took the names of the nominees to the council hall, where they were put to the vote by the members of the scrutiny commission. The results of this vote were entered by the Notary of the *Riformagioni* in a register which was taken for safe-keeping to S. Croce, as were the purses with name slips (*polizze*) of the successful candidates. See Trexler 1978*b*, 323–4.

The location of the Secretum, the room in which these secret transactions took place, emerges from documents recording work for its furnishing. In December 1478, Domenico da Prato and Giuliano da Maiano reported on work by Benedetto di Luca *legnaiuolo* 'nel luogho che ssi dicie segreto, il quale è in sulla sala del consiglio', 'in secreto in aula consilii' (Op. Pal., 2, fos. 2ᵛ, 49ʳ, 4 and 30 December). The work involved the manufacture of 'panche a chasse colla spalliera et colla predella da piè'; the total measurement of the *spalliere* amounted to 50 square *braccia*, which would have been more than adequate for a small room. (*In su* is used here interchangeably with *in*; elsewhere the room is referred to as the 'segreto della sala vecchia': Op. Pal., 10, fo. 40ᵛ, 20 December 1502. For the use of *in su* for *in*, cf. e.g. ibid. 15, fo. 22ʳ, 24 November 1531: payments for 'la muraglia fatta in sulla sala grande [i.e. the Sala dei Cinquecento] per la stanza della guardia'.) The room must have been located on the east side of the Sala dei Dugento, since its south side was occupied by the tribune of the Signoria (see App. VII) and since the other two walls contained windows to the piazza. In 1480, the Secretum was provided with an opening (*foramen*) which may have allowed its occupants to watch the goings on in the council hall during the sessions of the scrutiny commissions and during the sortition (Op. Pal., 2, fo. 52ʳ; Poggi 1909*b*, p. 158, 8 December 1480: 'pro . . . fenestra videlicet foramine secreti in aula consilii'). On one such occasion, in September 1466, Francesco Neroni saw, as he writes in his confession, 'mentre si traevono e ghonfalonieri, Messer Angnolo [Acciaiuoli] solo e ritto da l'altare al segretto andare' (ed. Rubinstein 1968, p. 385), which must

therefore have been situated opposite the altar. The Secretum was, exceptionally, also used for other, specially important purposes. In 1483, the Dieci di Balìa ratified the peace treaty which had been concluded by the triple alliance with Sixtus IV 'in sala magna consiliariorum et in dicte sale recessu, quod secretum vocatur' (Cento, 2, fos. 81ʳ–82ᵛ, 11 January 1483).

The palace of the Guelf party had, according to an inventory of 1323, next to its 'grande e bella sala' a 'consilglatoio . . . o sagrestia', which was used by the Captains of the *Parte* when they wished to withdraw for secret consultations; an inventory of the palace of 1324 locates this room next to (*dal lato*) the great council hall (Zervas 1988, pp. 171–3, 376, 379). *Sagrestia* could, in fact, denote a secret room as well as a sacristy (see C. Devoto, *Dizionario della lingua italiana*). After the new hall of the Great Council began to be used for elections in 1496 (see above, p. 40), it required, like the old council hall on the first floor, a Secretum for electoral business. Since, under the constitution of December 1494, most elections were now carried out by the Great Council, that business was much increased; and a larger number of persons participated in its technicalities. Giannotti writes (*Discorso intorno alla forma della repubblica di Firenze*, in *Opere*, i, p. 20) that the nominators had to enter a 'stanza chiamata il segreto, dove erano altri segretarii, e due de' Signori, e [*ed.* o] due de' Collegi, ed altre persone che intervenivano a quella azione'; cf. 'Stratto di Piero Buonaccorsi coadiutore delle Tratte' (Tratte, 49, fo. 3ᵛ; see Marzi 1910, p. 330): 'Al secreto alla creatione de' Signori et Collegi stanno quattro de' principali chancellieri . . .'. This room was entered through a small door next to the tribune of the Signoria (Giannotti, loc. cit.: 'per una porta che era allato a quello [sc. il tribunale della Signoria], entrava in una stanza chiamata il segreto'). Vasari states that there was a door on either side of the tribune of the Signoria, one of which led to the Segreto, and the other to the Specchio (Vasari–Milanesi, iv, p. 450); but the office of the *specchio*, the register of tax debtors, was situated in the same house as that of the *prestanze*, the forced loans, at the rear of the palace in the present Via de' Gondi: see Appendix VIII, and above, p. 88. In 1498, a payment for the ceiling and for the furnishing of the new hall also included two small doors of the Secretum (Op. Pal., 8, fo. 8ᵛ; Frey 1909, p. 120, no. 59; 13 January 1498: 'Etiam ad ponendum illas duas porticciuolas secreti bene').

APPENDIX VII

The Tribunes of the Signoria

When in 1323 the councils granted money to constructing outside the façade of the palace 'unam nobilem, pulcram et decentem arengheriam' (Provv., 20, fo. 2ʳ⁻ᵛ; Davidsohn, *Forschungen*, iv, p. 501, 27–8 May 1323), they intended to provide the Signoria with a raised platform from which it could address (*arringare*) the people assembled on the piazza and perform public ceremonies. The *ringhiera* was rebuilt after the fortifications added by the duke of Athens to the doors of the palace had been dismantled (Frey 1885, p. 209, no. 105, 27–28 *Fig. 5* November 1349; see above, pp. 15, 16); and it must have been at that time that the rows of seats to accommodate the Signoria and other magistracies were constructed on the section of the *ringhiera* facing the principal area of the piazza. (The shorter, northern, section of the *ringhiera* *Fig. 57* was destroyed in 1565 to make place for Ammannati's fountain: see Lensi Orlandi, p. 169.) The architect Giuseppe Del Rosso, whom the Napoleonic administration of the city had put in charge of an extensive building campaign in the palace, demolished the medieval *ringhiera* and replaced it with the present platform. In his apologia for his work, Del Rosso describes the *ringhiera* before its demolition. Accessible from the level of the door to the palace by six steps and protected towards the piazza by a high balustrade, it had three rows of stone benches along the façade of the palace (Del Rosso 1815, pp. 19–20: 'era un ripiano alto di sei scalini sopra il livello della soglia del portone principale con alto parapetto, o sponda sul davanti, e tre gradi di pietra da sedere appoggiati lungo la muraglia della facciata . . .'). Fifteenth- and sixteenth-century paintings of the palace show the balustrade, whose height in Ghirlandaio's S. Trinita fresco exceeds a man's height by about one half, and the rows of seats on the *ringhiera*. The Statutes of 1415 describe the seating arrangements on the *ringhiera* during the inauguration *Figs. 4, 58* ceremony of the new Signoria (*Statuta* 1415, v. i. 10; ii, pp. 501–4). On the top row of seats the Priors and, *primo loco*, the Gonfalonier of Justice were seated, as well as the Podestà, the Captain of the People, and the Executor of Justice with their judges; on the next row, at the feet of the Signoria ('in gradu sequenti ad pedes prefatorum dominorum') their guarantors. An illuminated manuscript of Donato Acciaiuoli's translation of Leonardo Bruni's History of Florence, of 1480, contains what appears to be the earliest representation of this tribune with the Signoria seated on the top row of seats. (The miniatures in this manuscript are attributed *Fig. 59* by Garzelli 1985, i, p. 158, to the Master of the Hamilton Xenophon. The tenth figure may have represented the Podestà: the office of the Captain of the People had been abolished in 1477, that of the Executor of Justice in 1435.)

The official seating arrangements of the Signoria on their tribunes in the council hall and their audience chamber (they had to give audience three times a week: *Statuta* 1415, v. i. 17; ii,

Fig. 60 p. 518) corresponded to those on the *ringhiera*. One of these tribunes, probably that of the Udienza, is represented in the same manuscript as a wooden structure with a high back and with four rows of steps, which was wide enough to accommodate the nine members of the Signoria. Above the seat of the Gonfalonier of Justice in the Udienza was painted the red cross of the People (Carte di corredo, 65, fo. 19ᵛ, 8 July 1438: 'Al tempo de' detti Signori si fece inarientare el campo della crocie vermiglia et essa crocie rifiorire, la quale è nella audientia della Signoria sopra el capo del Gonfaloniere di giustitia quando si siede a collegio'); when the Signoria deliberated jointly with the Sixteen Gonfaloniers and the Twelve Buonuomini, the Colleges were seated 'a' loro piedi a consigliare' (Dati, *Istoria di Firenze*, p. 139). In 1501, the tribune of the Udienza was enriched by Baccio d'Agnolo with a cornice with architrave (a 'cornicione facto alla residentia de' decti Signori in decta Audientia'; see above, Ch. 2, p. 76 and n. 281). The inventory of 1471 lists two tables in the Udienza (see App. III); when the Signoria deliberated without the Colleges, they would be sitting round one of these: in 1502, Baccio d'Agnolo was paid *l*.190 'per la monta di braccia 16½' of benches 'coperte di nocie, cornici, balaustri, tarsie e predelle', made for the Udienza (Frey 1909, p. 127, no. 138, 11 August 1502). The table was covered with a carpet: Nardi describes how the incriminating letter from Rome whose discovery led to the downfall of the Gonfalonier Niccolò Capponi in April 1529 had remained hidden under the carpet ('cadde al prefato gonfaloniere disavvedutamente . . . e per caso rimase occultata sotto la lunghezza del tappeto del desco, sopra il quale il gonfaloniere l'aveva posata insieme con altre sue scritture': *Istorie fiorentine*, ii, p. 154).

The tribune of the Signoria in the Sala dei Dugento, the council hall, is represented in Vasari's painting, on the ceiling of the Sala dei Cinquecento, of Antonio Giacomini addressing a meeting; if, as is probable, this tribune was still in place when Cosimo I moved into the palace *Fig. 49* in 1540, Vasari's painting must have been fairly accurate (see above, p. 76). Nerli describes the tribune in his account of the reception by the Signoria of Duke Alessandro de' Medici on his visit to Florence in June 1531 (*Commentari*, ii, p. 192): 'Era ordinato nella sala da basso', that is in the old council hall, 'a raised tribune . . . which was very richly manufactured ['una rilevata residenza . . . molto riccamente parata'], on which was seated the Signoria . . . and at the feet of the tribune were seated the Colleges and the other magistrates.' The tribune was situated 'opposite the door' ('rincontro alla porta'), which must refer to the marble doorway leading to the Sala dei Cinquecento. Varchi, whose account of this event is partly derived from Nerli's *Commentari* (cf. Lupo Gentile 1905, pp. 93–4), adds the information that the tribune, which was 'in the middle of the said room', had 'a few steps at the bottom for the magistrates' ('alcuni gradi da piè per li magistrati': *Istoria fiorentina*, ii, p. 569).

When Baccio d'Agnolo was put in charge of constructing the tribune of the Signoria for the new hall of the Great Council, one obvious model must have been that of the old council hall, another the far larger and more magnificent loggia of the Venetian Signoria in the hall of the *Fig. 14* Maggior Consiglio (see App. VIII). But whatever model was chosen, the vastly superior size of the new hall would have called for a larger structure than that of the old council hall, the Sala dei Dugento. Wilde 1944, p. 73, argues that the entablature of the new tribune, which was 12 *braccia* long, 'is proof of the considerable height of the structure'. Landucci, when lamenting the demolition of the splendid and costly woodwork of the hall after the abolition of the Great

Council in 1512 (*Diario fiorentino*, p. 333; see above, p. 71), singled out the *residenza* of the Signoria as a particularly grievous loss. An elevated wooden platform surrounded the hall which, like the one outside the palace, was called *ringhiera* (Vasari–Milanesi, iv, p. 450; Vasari, *Vite*, iv, p. 242: 'feciono . . . una ringhiera di legname intorno intorno alle mura di quella, larga et alta tre braccia, con i suoi sederi a uso di teatro e con balaustri dinanzi'; cf. Frey 1909, p. 118, no. 34; Isermeyer 1964, p. 104). According to Vasari, this *ringhiera* was allocated to 'all the magistrates of the city' ('sopra la quale ringhiera avevano a stare tutti i magistrati della città'). In 1502, Baccio d'Agnolo was to be paid *l.*504 for 42 *braccia* of benches 'existentibus in sala magna predicta ante altare Verginis et residentia Dominorum, ubi resident doctores et X Balie' (Op. Pal., 9, fos. 62v–63v; Frey 1909, p. 125 n. 127, 10 June 1502; cf. Op. Pal., 10, fo. 29v).

The Location of the Tribune of the Signoria in the Sala dei Cinquecento

According to Vasari, in the Life of Cronaca (Vasari–Milanesi, iv, p. 450; Vasari, *Vite*, iv, p. 242), the tribune of the Signoria was situated 'nel mezzo della facciata che è volta a levante'; Wilde 1944, p. 73, relates this passage to the east wall by interpreting the words 'volta a levante' as referring to the viewpoint of the spectator to whom the wall facing him would appear to be turned away from him, that is to the east, because Vasari immediately afterwards refers to the opposite wall, 'la facciata che è dirimpetto a questa', as being on the west side, 'dal lato di ponente' (Vasari–Milanesi, iv, p. 430; Vasari, *Vite*, iv, p. 242). Wilde's interpretation has been generally accepted, but Vasari writes *facciata*, not *muro*, and the obvious reading of the first passage is that the (interior) façade at whose centre the tribune of the Signoria was located was turned towards east, and that the passage therefore referred to the west wall (cf. Antonio Manetti, *Vita di Filippo Brunelleschi*, cited above, Ch. 3, n. 38: the 'due faccie [of the palace] si veggono intere, quella che è volta verso ponente e quella che è volta verso tramontana'). This reading is supported by the results of the recent technical examination of the walls with the help of thermovision and ultrasonic equipment (see Newton and Spencer 1982, p. 47), which has produced important new evidence for the location of the windows of the hall. The altar would accordingly have been situated on the east wall, an orientation which one would anyway have expected to be adopted. Our reading appears, however, to be contradicted by Vasari's statement that the altar which was on the *facciata* opposite the *tribuna* was on the west side, 'dal lato di ponente', of the hall.

Whatever the correct reading of these passages, Vasari's description of the furnishings of the hall is not that of an eyewitness. The tribune of the Signoria was dismantled after the abolition of the Great Council in 1512, when its hall was converted into barracks for the palace guard, and was reconstructed, with other furnishings of the hall, after the restoration of the Great Council in 1527 (see App. VII). The tribune must again have been dismantled soon after the final abolition of the Great Council in 1530, and certainly by the time after 1542 when Baccio Bandinelli was constructing for Cosimo I the monumental *udienza* on the north side of the hall (see Allegri and Cecchi 1980, p. 32). In the first edition of the *Vite* of 1550, Vasari does not mention any of the furnishings of the hall; his detailed description of them in the second edition was probably based on hearsay. On the other hand, while the original furnishings of the hall must have disappeared long before, its windows must still have been in place, or could at least be located, when he took up his post as the architect of the palace.

Vasari states that Cronaca had made, apart from the windows on the north and south ends of the hall, two at the centre of its east wall and four on its west wall, 'dalla parte di levante due finestre nel mezzo della sala, e quattro dalla banda di ponente' (Vasari–Milanesi, iv, p. 450; Vasari, *Vite*, iv, p. 242). Wilde's reconstruction of the windows on the west wall has been substantially modified as the result of the discovery in 1969 of the remains of four windows on that wall (Newton and Spencer, p. 48; see above). The most important consequence of this for our purpose is the evidence of a gap of over twelve metres between the second and third of these windows which, unlike those in Wilde's reconstruction, would have provided ample space for the nine seats of the Signoria on the *tribuna*. As for the east wall, the recent investigations have not produced any trace of the two windows mentioned by Vasari, but a fragment of a window has been found on its northern end. This window must have risen from a level of only about 1.35 metres above the original floor of the hall, or 1.30 metres above Vasari's floor (ibid., pp. 48–9). If this was also the level of the two windows which Vasari locates at the centre of the wall, it would have prevented the siting there of the tribune.

The strongest argument in favour of the tribune's location on the west wall, however, derives from its procedural functions. It is unthinkable that, in order to reach their seats, the eight Priors and the Gonfalonier of Justice should have been forced to traverse the entire width of the hall through one of the passages that separated the rows of the benches of the council members from one another, for it was only the west wall which provided the Signoria with a direct access from their living quarters in the old block of the palace. (See also Newton and Spencer, pp. 50–1, who point to a similar location in the Palazzo Ducale in Venice. Cf. the anonymous engraving of the Sala del Maggior Consiglio before the fire of 1577.) According to Vasari, one of two small *Fig. 14* doors on either side of the *tribuna* led to the Secretum where the votes of the members of the council were counted and scrutinized (see App. VI), and the other to the Specchio; but there is no documentary evidence for the existence of such a room adjoining the council hall. In the fifteenth century, the Notary of the *specchio*, the register of tax debtors, was required to be present at the extraction of names from the electoral pouches, no doubt in the Secretum (App. VI, and *Statuta* 1415, v. i. 312 (ii, pp. 803–4)); and there is no reason to assume that this procedure was changed after the creation of the Great Council. According to the Statutes of 1415, the Notary of the *specchio* was to have his office in the house of the Ufficiali delle Prestanze, the administration of forced loans (*Statuta* 1415, v. i. 311 (ii, p. 803): 'in loco prestantiarum': see above, Ch. 1, n. 314), which was situated behind the palace, opposite the present Palazzo Gondi (see Tönnesmann 1983, pp. 18, 125: this palace was extended, at the end of the fifteenth century, 'dirinpetto ale Prestanze').

The Sala degli Otto

It is generally assumed that the audience room of the Otto di Guardia (after 1458, Otto di Guardia e Balìa, see Rubinstein 1966, p. 111) was identical with the present Sala degli Otto which is situated on the first floor between the fourteenth-century palace and the Sala dei Cinquecento (Ground plan I). According to this view, when the new ceilings were installed in the Sala dei Gigli, the Udienza, and the Sala dei Dugento in the 1470s, the Sala degli Otto also received a new ceiling (see Lensi, p. 67: 'con tutta probabilità', Lensi Orlandi, p. 78). But the register of the Operai del Palazzo, which in 1475 records the estimates of the expenses for the new ceilings (Op. Pal., 1, fos. 5ʳ–6ʳ, 29 August and 2 December 1475; see above, Ch. 1, n. 241, and App. III), refers to these three rooms only; there is no mention in it of a ceiling for a fourth room. As a result of Vasari's conversion of the palace, the Sala degli Otto was reduced in size in order to provide space for the new stairs and, as a result, its ceiling had to be reshaped (Lensi Orlandi, loc. cit.). In style and execution, it does not appear to be the work of the same masters who had been responsible for the ceilings of the council hall on the same floor and of the two

Fig. 61 halls above it.

The magistracy of the Otto di Guardia had been created in 1378 (Pampaloni 1953, p. 269); a few years later, when he belonged to it, Franco Sacchetti wrote a patriotic sonnet that was inscribed in its audience chamber ('ne la loro audienza descritto': see above, p. 51). The room is not included in the inventory of the palace of 1471, but figures in two accounts of the lightning which struck the palace in November 1511 (see above, Ch. 1, n. 267). Cambi writes (*Istoria*, in *Delizie*, xxi, pp. 274–5) that the lightning 'venne giuso nella chamera del Chapitano de' fanti, ch'è a lato a l'udienza degli Otto, e forò la volta', which points to the Camera dell'Arme. Piero Masi (*Ricordanze* fo. 152ʳ) locates their audience chamber in the vicinity of the rooms of the Ufficiali del Monte, which must have adjoined the ground floor of the palace (see above, Ch. 1, n. 267): 'dette ne le istanze degli uficiali del Montte . . . e più s'agirò per l'udienza degli Otto . . .'. In the inventory of 1471, the 'chamera del chapitano de' fanti' is listed immediately after the Sala del Consiglio, that is the Sala dei Dugento (fo. 12ᵛ). In 1496, the Medici agent Francesco Cegia went, on being summoned by the Signoria to the palace, first to the landing 'which led to the Otto', and then through a passage to their audience chamber (Pampaloni 1957, p. 229: 'quand'io fui al pianerottolo che ssi va agli Otto mi fu detto avevo a ire agli Otto e andai agli Otto e subito, chome fu' nel andito, mi feciono mettere nell'udienza . . .').

In 1528, the Signoria stated that the Otto 'were in great need of an audience chamber, since their customary one was very small and inadequate' (they had 'bisogno grande di una

audientia', since their 'usata et solita [audientia] è molto pichola et non capace di decto loro uficio': see below), a description that would hardly fit the spacious Sala degli Otto, which before Vasari's construction of the new stairs was even larger than it is today. In fact, the Signoria explained that the inadequacy of the customary audience chamber of the Otto, 'maxime a questi tempi della peste', and the inconvenience of 'el luogo nel quale al presente si ragunono', which 'non è congruo né conveniente al decto loro uficio', had led them to order the construction of a new large audience chamber and chancery, 'una grande et bella audientia et cancelleria'. The work could be carried out 'chon pichola spesa', and the Signoria accordingly allocated up to 200 florins to it (Sig., Cond. e stanz., 27, fos. 278v–279r, 7 August 1528; I owe this reference to John Stephens). This sum proved, however, too small: by 31 August, 424 florins had been allocated by the Signoria and the Colleges to the 'muraglia nuova facta per l'audientia nuova de' Signori Otto', and various payments amounting to *f*.20 *s*.164 *d*.10 'per resto della muraglia della audientia et cancelleria' of the Otto were authorized on 31 December (Otto di Guardia, Delib., 202, fos. 168r–169v, 31 August 1528; 203, fo. 147v, 31 December 1528: 'a diversi muratori et scarpellini et fornaciaio et legnaiuolo . . . sono per resto della muraglia della Audientia et Cancelleria de' Signori Octo . . . et costo di uno tapeto per desco di decti Signori Octo'. By this time, the construction of the new audience chamber of the Otto di Guardia had evidently been completed.) I suggest that this room is the present Sala degli Otto. Supported, partly, by the fourteenth-century pillars of the old Cortile del Capitano between the palace and the customs house, its construction must have been relatively easy. Commissioned by the Signoria during the last period of the Florentine republic, it may have retained the name of the magistracy for which it was built after Cosimo I had moved the Otto di Guardia to the Bargello when in 1540 he took over the palace as his residence (see Adriani, *Istoria*, p. 74).

APPENDIX X

The Operai del Palazzo

The law of 30 December 1298 which decreed the building of the new palace and ordered the Signoria to choose the site for it, did not mention the election of Operai to be in charge of building operations. That such officials were in fact elected, no doubt by the Signoria, is, however, shown by a document of 10 December 1299 which records the sale of property to the 'officialibus comunis Florentie deputatis super opere novi palatii dominorum priorum et vexilliferi iustitie' (Frey 1885, pp. 190–1, no. 41). The office probably continued in existence until the main work for the construction of the palace was completed; subsequently, Operai are recorded for building operations in connection with the widening of the piazza. In 1319, six officials (one from each *sestiere*) were appointed to supervise the widening of the piazza, 'super platea palatii populi . . . crescenda, elarganda et augmentanda seu amplianda' (Provv., 16, fo. 93^{r-v}, 19 July 1319; see above, Ch. 3, n. 16); in 1330, its paving was to be carried out as instructed by 'illis personis' whom the Signoria had elected for this purpose (Provv., 214, fo. 30v; see above, Ch. 3, n. 25); in 1335, again six officials were to be elected by the Signoria and the Twelve Buonuomini for the purchase of property on the east side of the palace (Frey 1885, pp. 203–4, no. 95); in 1351, four or more were to be responsible for preparing the removal of the church of S. Romolo from its site on the piazza (Frey 1885, pp. 210–11, no. 107; see above, Ch. III, n. 35). Officials 'circa translationem ecclesie sancti Romuli' still existed in 1356 (ibid., p. 212, no. 113: they were elected by the Signoria for six months); they were now also put in charge of the construction of the new Loggia (p. 213). In 1371, four officials, one from each *quartiere*, were elected 'ad ordinandum' the addition to the palace and its improvements for which the councils had allocated funds (see above, Ch. 1, n. 112. They were Jacopo di Lapo Gavacciani, Simone di Rinieri Peruzzi, Niccolò di Neroccio Cocchi, and Giorgio di Bencio Carucci.) But in 1362, the rebuilding of the houses on the north side of the piazza was organized by the Ufficiali della Torre, and in 1385, it was the Opera of the Cathedral which was put in charge of the paving of it (Frey 1885, pp. 216–17, 218 ff., nos. 119, 127 ff.; see also above, p. 84). Thus during the fourteenth century Operai appear, after the completion of the palace, to have been elected only for major building operations; the Signoria itself must have been looking after minor work.

This remained the situation throughout the first half of the following century. When, in 1419, major repairs were undertaken in the council hall, the Sala dei Dugento, for which fir trees were transported from the Apennines, we find 'uficiali deputati sopra l'achoncimo della sala del palagio de' Signori' in charge (see above, p. 25). When, in 1444, it was decided to renovate the palace and the council hall and to extend the palace at the rear, five Operai were

elected, and the same procedure was adopted in 1452 for the planned restoration of that hall (see above, pp. 24, 26). One and a half years later, three Operai, Andrea Minerbetti, Tommaso Davizi, and Piero de' Medici, were elected to take in hand the restoration of the colonnade of the courtyard; but while in 1444 and 1452 the failure to carry out the projected building operations made the office of the Operai redundant, in 1454 it was decided that they should retain it until the completion, 'usque ad perfectionem', of this work (see above, Ch. 1, nn. 194, 201). By January 1455, they had however been replaced by other Operai (Neri di Bicci, *Ricordanze*, p. 23: 'operai fatti per Signori di Firenze, c[i]oè l'uno Piero Borsi, Pandolfo Pandolfini, Reccho Capponi'). Unidentified Operai are recorded in the annual renewals of funds for that work until 1460 and, before 1469, in special allocations in 1461, 1463, and 1468 (see above, Ch. 1, n. 217).

Of the three Operai who were elected on 14 February 1454 (see above, Ch. 1, n. 201), one was again in office at the time of his death in 1467. For in February 1468, the councils decreed that since Tommaso Davizi, who had been one of the Operai 'diputati sopra l'opera dell'acconcime del palagio', had died in the previous October, and had not yet been replaced, and since much remained to be done for the projected restoration of the palace ('et per l'opera disegnata farsi per detto acconcime et per commodità et ornamento del detto palagio si restano a fare anchora molte cose'), the Signoria should nominate a Florentine citizen who was qualified for such a post ('uno cittadino fiorentino intendente et idoneo a tale opera') for election by the council of Cento (Provv., Prot., 33, fo. 315r, 23–6 February 1468). The council of Cento accordingly elected, on 26 February, Antonio di Niccolò Martelli, to serve for the rest of his predecessor's term (Tratte, 2, fo. 388^{r-v}).

Antonio Martelli was one of three Operai recorded in the first of the extant registers of the Operai, which covers the period from 15 September 1470 to 26 November 1477, in September 1470; the other two were Piero di Giovanni Minerbetti and Jacopo di Andrea de' Pazzi (Op. Pal., 1, fo. 3r, 15 September 1470): they had been elected by the council of Cento (Tratte, 915, fo. 10r). Antonio Martelli is again recorded as Operaio in February 1472 and in March 1473 (Monte Comune, 1521, fo. 480, 1523, fo. 705), and in November 1477 (Op. Pal., 1, fo. 9r) and Jacopo de' Pazzi in March 1476 (ibid., fo. 8v). There is hence a high probability that the three Operai who were in office in 1470, and who may have been elected in the preceding year when the new decoration campaign was projected, were intended, like the three Operai of 1454, to retain their office until the completion of that campaign.

The extent and protraction of the restoration campaign launched in 1469 must have placed considerable strain on the Operai and caused demands for a reform of their office. Matters came to a head in 1477, when gross mismanagements were revealed in the administration of the Opera. It had emerged, states the *provvisione* of 19–21 November (Provv., 168, fos. 146v–149v; N. Santini 1919, pp. 120–3), that 'degli assegnamenti dell'Opera del Palagio de' Signori et spese di quella non si tiene quello diligente conto che si conviene, et gli Operai di quello . . . ne sono ingannati et fraudati, di che in buona parte n'anno cagione i ministri loro . . . in tanto che, vero o no, il grido et la infamia è grandissimo de danno facto . . .'. As a result, a complete revision of the accounts of the Opera (of 'le ragioni di tutta l'Opera') is ordered, as well as stringent controls of future expenditure. The law of 1469 on the restoration campaign had

required the Operai to submit to the Signoria and the Colleges projects prior to their adoption (see above, Ch. 2, n. 119). This requirement was now sharply reinforced. Henceforth, no work involving expenditure of more than 10 florins could be commissioned by the Operai unless a design (*modello*) of it had been affixed for one month at the entrance to the Camera dell'Arme or nearby, and then approved by the Signoria and the Colleges.

Until the middle of the fifteenth century, the Operai were probably elected by the Signoria, as were the members of its household staff, the *famiglia*, including the lay brethren of the Camera dell'Arme, or by the Signoria and its Colleges (cf. *Statuta* 1415, V. i. 13, 19–20; ii, pp. 507–10, 523–5). Accordingly, in 1371 and 1444 the Operai were elected by the Signoria and the Colleges, in 1452 and 1454 by the Signoria. This changed after the creation in 1458 of the council of Cento. This council, introduced by the Medici regime after its victory over the opposition to its institutional controls, was put in charge of the elections to particularly sensitive offices such as the Ufficiali del Monte and the Otto di Guardia, which had previously been filled by sortition (see Rubinstein, 1966, p. 114). That the Operai in office in 1470 should have been elected by the Cento, possibly in 1469 when the renovation campaign was launched, shows the importance which was now attributed to their office. It probably also shows that, in contrast to their previously temporary character, the Operai were now regarded, like the Ufficiali del Monte and the Otto, as a permanent institution. This, at any rate, was implied in the reform of the office of 1477 which definitively settled the method by which they were elected (see above). Following the precedents of 1444 and 1452, the law of November 1477 fixed the number of the Operai at five, four of them belonging to the greater and one to the lesser guilds, and decreed that from November 1478, the Operai of the following year were to be elected each November by the Signoria, the Colleges, and the council of Cento. The first Operai to be elected in this way were Tommaso Ridolfi, Francesco Dini, Antonio de' Nobili, Lorenzo de' Medici, and Francesco Romoli (Tratte, 904, fo. 114ᵛ). This is also the first election which is recorded in the extant registers of the Operai (Op. Pal., 2, fo. 5ʳ); from that time onwards, their names are regularly listed in these registers, as well as in those of the internal offices of the Commune.

The annual election for one year remained in force until 1487, when the councils decided to extend the term of office of the next Operai to five years (Provv., 177, fo. 110ʳ⁻ᵛ, 10–13 February; see above, Ch. 2, n. 203). In support of this measure it was argued that the frequent changes of the personnel of the office was largely responsible for the long delays in completing the decoration of the palace; and much the same argument was used in 1492 when, in view of the fact that the term of office of the Operai who had been elected in 1487 was drawing to a close, it was decided to extend it for another five years; they had been 'a principio . . . deputati pro quinque annis ea praecipue ratione, ut sine interruptione opera quae inceperentur perficerentur' and it was known that 'per eos utiliter fuisse provisum multis ornamentis et parietum et laquearium sale superioris ob ipsorum solertem curam et diligentiam' (see above, pp. 68–9). The constitutional reforms of December 1494 put an end to their second term of office: when on 23 May 1495, the Great Council ordered the building of a new hall for its meetings, new Operai were elected for this work, and its successors continued to be elected by that council for one year at a time (see Rubinstein 1954, p. 175). The Medici restoration in 1512

was, in its turn, followed by a return to the system in force before the expulsion of the Medici in 1494. On 10 January 1513, the Medicean Balìa elected five Operai for one year, but in December extended their term of office by two years (Balìe, 43, fos. 109ᵛ–110ʳ, 184ʳ, 10 January and 30 December 1513). With a few changes—thus Lorenzo de' Medici the Younger, who took over the government of Florence from his uncle Giuliano, also succeeded him as one of the Operai, just as, in 1492, on Lorenzo the Magnificent's death, his son Piero had succeeded him (Provv., 183, fos. 1ʳ–2ᵛ, 13–16 April 1492)—they remained in office, having been periodically reconfirmed in it for one or two years, until the short-lived restoration of the republican regime, when they were 'privati isto offitio' on 9 January 1528 (Tratte, 906, fo. 80ʳ). After the fall of the last republic, new Operai were elected on 5 November 1530 for one year; they were still in office when the Signoria was abolished in April 1532 (their register, Op. Pal., 15, ends on 27 October 1532).

ABBREVIATIONS AND
ARCHIVAL SOURCES

ABBREVIATIONS

ASF	Florence, Archivio di Stato
BLF	Florence, Biblioteca Medicea Laurenziana
BNF	Florence, Biblioteca Nazionale Centrale
BRF	Florence, Biblioteca Riccardiana
Arch. Stor. Ital.	*Archivio Storico Italiano*
JWCI	*Journal of the Warburg and Courtauld Institutes*
Rer. Ital. Script.	Muratori, *Rerum Italicarum Scriptores*, new edition

ARCHIVAL SOURCES

(Unless otherwise indicated, all references are to the Archivio di Stato of Florence)

C. Strozz.	Carte Strozziane
Capitoli	Capitoli, Registri
Cento	Cento, Registri
Cons. e Prat.	Consulte e Pratiche
Dieci, Delib., cond. e stanz.	Dieci di Balìa, Deliberazioni, condotte e stanziamenti
Inventory 1471	Camera del Comune, Scritture diverse, Masserizie, no. 5, Inventario 12, fos. 1ʳ–18ᵛ
Inventory 1520	Camera del Comune, Scritture diverse, Masserizie, no. 6
Inventory 1532	BRF, MS Ricc. 1849, fos. 157ʳ–168ᵛ
Lib. Fab.	Libri Fabarum
Not. antecos.	Archivio Notarile antecosimiano
Op. Pal.	Operai del Palazzo
Otto di Guardia, Delib.	Otto di Guardia e Balìa, Deliberazioni, epoca della Repubblica
Otto di Pratica, Delib.	Otto di Pratica, Deliberazioni, partiti, condotte e stanziamenti
Provv.	Provvisioni, Registri
Provv., Dupl.	Provvisioni, Duplicati
Provv., Prot.	Provvisioni, Protocolli
Sig., Cond. e stanz.	Signori, Condotte e stanziamenti
Sig., Delib., ord. aut.	Signori e Collegi, Deliberazioni in forza di ordinaria autorità
Sig., Delib., sp. aut.	Signori e Collegi, Deliberazioni in forza di speciale autorità
Sig., Delib., Dupl.	Signori e Collegi, Deliberazioni, Duplicati

BIBLIOGRAPHY

PRIMARY SOURCES

Adriani, *Istoria*	Giovanni Battista Adriani, *Istoria de' suoi tempi* (Florence, 1583).
Albertini, *Memoriale*	Francesco Albertini, *Memoriale di molte statue et picture di Florentia* (Florence 1510); anastatic edn. in *Five Early Guides of Rome and Florence*, introd. by P. Murray (Farnborough, 1972).
Ammirato, *Istorie fiorentine*	Scipione Ammirato, *Istorie fiorentine* (Florence, 1647–51).
Anonimo Magliabechiano	*Anonimo Magliabechiano*, ed. A. Ficarra ([Naples], 1968).
Beltrami 1919	L. Beltrami (ed.), *Documenti e memorie riguardanti la vita e le opere di Leonardo da Vinci* (Milan, 1919).
Billi, *Il Libro*	C. von Fabriczy, 'Il libro di Antonio Billi e le sue copie nella Biblioteca Nazionale di Firenze', *Archivio Storico Lombardo*, ser. 5, 7 (1891), 299–368.
Biondo, *Historiarum . . . libri XXXI*	Flavio Biondo, *Historiarum ab inclinatione Romanorum libri XXXI* (Basle, 1559).
Boccaccio, *Amorosa Visione*	Giovanni Boccaccio, *Amorosa Visione*, ed. V. Branca (Florence, 1944).
Bruni, *Historiae Florentini populi*	Leonardo Bruni, *Historiae Florentini populi*, ed. E. Santini, *Rer. Ital. Script.* xix. 3 (Città di Castello, 1914–Bologna, 1926).
Bruni, *Historia fiorentina*	Leonardo Bruni, *Historia fiorentina* [*Historiae Florentini populi*, trans. Donato Acciaiuoli] (Venice, 1476); anastatic edn., introd. by E. Garin (Arezzo, 1984).
Bruni, *Humanistisch-philosophische Schriften*	Leonardo Bruni, *Humanistisch-philosophische Schriften*, ed. H. Baron (Leipzig, 1928).
Buoninsegni, *Historia fiorentina*	Domenico [*ed.* Piero] Buoninsegni, *Historia fiorentina* (Florence, 1580).
Buoninsegni, *Storia di Firenze*	Domenico Buoninsegni, *Storia della città di Firenze dall'anno 1410 al 1460* (Florence, 1637).
Cambi, *Istorie*	Giovanni Cambi, *Istorie*, in *Delizie degli eruditi toscani*, ed. I. di San Luigi, xx–xxiii (Florence, 1785–6)
Capponi, *Ricordi*	Gino di Neri Capponi, *Ricordi*, ed. G. Folena, '"Ricordi" politici e familiari di Gino di Neri Capponi', in *Miscellanea di studi offerti a A. Balduino e B. Bianchi* (Padua, 1962), 29–39.
Cavalcanti, *Istorie fiorentine*	Giovanni Cavalcanti, *Istorie fiorentine*, ed. G. Di Pino (Milan, 1944).
Cecchi, *Riforma sancta et pretiosa*	Domenico Cecchi, *Riforma sancta et pretiosa*, ed. U. Mazzone, '*El buon governo*': *Un progetto di riforma generale nella Firenze savonaroliana* (Florence, 1978).
Cerretani, *Storia fiorentina*	Bartolomeo Cerretani, *Storia fiorentina*, ed. G. Berti (Florence, 1994).
Cerretani, *Ricordi*	Bartolomeo Cerretani, *Ricordi*, ed. G. Berti (Florence, 1993).
Chronica gestorum in partibus Lombardie	*Chronica gestorum in partibus Lombardie . . .*, ed. G. Bonazzi, *Rer. Ital. Script.* xxii. 3 (Città di Castello, 1904–11).
Codice dantesco 1950	*Codice diplomatico dantesco*, ed. R. Piattoli, 2nd edn. (Florence, 1950).
Compagni, *Cronica*	Dino Compagni, *La Cronica*, ed. I. Del Lungo, *Rer. Ital. Script.* ix. 2 (Città di Castello, 1907–16).
Condivi, *Vita di Michelangelo*	Ascanio Condivi, *Vita di Michelangelo Buonarroti*, ed. E. Spina Barelli (Milan, 1964).
Consigli	*Consigli della Repubblica Fiorentina*, I, i and ii (no more published), ed. B. Barbadoro (Bologna, 1921–30).

Consulte	*Le Consulte della Repubblica Fiorentina dall'anno MCCLXXX al MXXXCVIII*, ed. A. Gherardi (Florence, 1896–8).
Consulte e Pratiche 1505–1512	*Consulte e Pratiche 1505–1512*, ed. D. Fachard (Geneva, 1988).
Cronica volgare di Anonimo Fiorentino	*Cronica volgare di Anonimo Fiorentino*, ed. E. Bellondi, *Rer. Ital Script.* xxvii. 2 (Città di Castello, 1915–Bologna, 1918).
Dati, *Istoria di Firenze*	Goro [Gregorio] Dati, *Istoria di Firenze*, ed. G. Manni (Florence, 1735).
Dei, *Memorie storiche*	Benedetto Dei, *Memorie storiche*, BRF, MS Ricc. 1853.
Delizie	*Delizie degli eruditi toscani*, ed. I. di San Luigi (Florence, 1770–89).
Diario d'anonimo fiorentino	*Diario d'anonimo fiorentino dall'anno 1358 al 1389*, ed. A. Gherardi, *Cronache dei secoli XIII e XIV* (Florence, 1876), 207–588.
Diario di anonimo fiorentino (1382–1401)	*'Alle bocche della piazza': Diario di anonimo fiorentino (1382–1401)*, ed. A. Molho and F. Sznura (Florence, 1986).
Fiamma, *Opusculum*	Galvano Fiamma, *Opusculum de rebus gestis ab Azone . . .*, ed. C. Castiglioni, *Rer. Ital. Script.* XII. 4 (Bologna, 1938).
Gaddi, *Priorista*	Agnolo and Francesco Gaddi, *Priorista*, ASF, Tratte, 62.
Gaye	G. Gaye, *Carteggio inedito d'artisti dei secoli XIV–XVI* (Florence, 1839–40).
Ghiberti, *Commentari*	Lorenzo Ghiberti, *I Commentari*, ed. O. Morisani (Naples, 1947).
Giannotti, *Opere*	Donato Giannotti, *Opere*, ed. F.-L. Polidori (Florence, 1850).
Giovanni, Francesco, *Ricordanze*	Francesco di Tommaso Giovanni, *Ricordanze*, C. Strozz., 2a ser., 16, 16 *bis*.
Giusto d'Anghiari, *Diario*	Giusto d'Anghiari, *Diario* (1437–87), BNF, MS II.II.127.
Guicciardini, *Carteggi*	Francesco Guicciardini, *Carteggi*, i, ed. R. Palmarocchi (Bologna, 1938).
Guicciardini, *Dialogo*	Francesco Guicciardini, *Dialogo del reggimento di Firenze*, in *Dialogo e discorsi del reggimento di Firenze*, ed. R. Palmarocchi (Bari, 1932).
Guicciardini, *Opere inedite*	Francesco Guicciardini, *Opere inedite*, ed. G. Canestrini (Florence, 1857–67).
Guicciardini, *Storie fiorentine*	Francesco Guicciardini, *Storie fiorentine dal 1378 al 1509*, ed. R. Palmarocchi (Bari, 1931).
Inventario di Lorenzo il Magnifico	*Libro d'inventario dei beni di Lorenzo il Magnifico*, ed. M. Spalanzani and G. Gaeta Bertelà (Florence, 1992).
Landino, *Scritti*	Cristoforo Landino, *Scritti critici e teorici*, ed. R. Cardini (Rome, 1974).
Landucci, *Diario fiorentino*	Luca Landucci, *Diario fiorentino dal 1450–1516*, ed. I. Del Badia (Florence, 1883).
Leonardo da Vinci, *Madrid Codices*	Leonardo da Vinci, *The Madrid Codices*, ed. L. Reti (New York, etc., 1974).
Lorenzo de' Medici, *Comento*	Lorenzo de' Medici, *Comento de' miei sonetti*, ed. T. Zanato (Florence, 1991).
Lorenzo de' Medici, *Lettere*	Lorenzo de' Medici, *Lettere*, ed. R. Fubini *et al.*, i–vi (Florence, 1977–90).
Lorenzo de' Medici, *Protocolli*	*Protocolli del carteggio di Lorenzo il Magnifico per gli anni 1473–74, 1477–92*, ed. M. Del Piazzo (Florence, 1956).
Machiavelli, *Opere*	Niccolò Machiavelli, *Tutte le opere*, ed. M. Martelli (Florence, 1971).
Manetti, *Vita di Filippo Brunelleschi*	Antonio Manetti, *Vita di Filippo Brunelleschi*, ed. D. De Robertis and G. Tanturli (Milan, 1976).
Masi, Bartolomeo, *Ricordanze*	Bartolomeo [di Bernardo] Masi, *Ricordanze*, ed. G. O. Corazzini (Florence, 1906).
Masi, Piero, *Ricordanze*	Piero di Bernardo Masi, *Ricordanze*, ASF, Manoscritti, 88.
Michelangelo, *Carteggio*	*Il Carteggio di Michelangelo*, ed. P. Barocchi and R. Ristori (Florence, 1965–83).
Naddo da Montecatini, *Memorie Storiche*	Naddo di Ser Nepo da Montecatini, *Memorie Storiche*, 1374–98, in *Delizie degli eruditi toscani*, xviii (Florence, 1784), 1–174.
Nardi, *Istorie di Firenze*	Jacopo Nardi, *Istorie della città di Firenze*, ed. L. Arbib (Florence, 1838–41).
Neri di Bicci, *Ricordanze*	Neri di Bicci, *Le Ricordanze (10 marzo 1435–24 aprile 1475)*, ed. B. Santi (Pisa and Leiden, 1977).

Nerli, *Commentari*　　　　Filippo de' Nerli, *Commentari occorsi dentro la città di Firenze dall' anno 1215 al 1537* (Trieste, 1859).

Palmieri, *Annales*　　　　Matteo Palmieri, *Annales*, in *Rer. Ital. Script.* xxvi. 1 (Città di Castello, 1906–15), 131–94.

Parenti, *Istoria fiorentina*　　　　Piero Parenti, *Istoria fiorentina*, BNF, MSS II.IV.169–71, II.II.129–34.

Parenti, *Storia fiorentina*　　　　Piero Parenti, *Storia fiorentina*, ed. A. Matucci, in progress (vol. I, Florence, 1994)

Pieri, *Cronica*　　　　Paolino Pieri, *Cronica*, ed. A. F. Adami (Rome, 1755).

Pietrobuoni, *Priorista*　　　　Paolo di Matteo Pietrobuoni, *Priorista*, BNF, MS Conv. soppr., C.4.895.

Poliziano, *Congiura* (1856)　　　　*Congiura de' Pazzi narrata in latino da Agnolo Poliziano . . .* , ed. A. Bonucci (Florence, 1856).

Poliziano, *Congiura* (1958)　　　　Angelo Poliziano, *Della congiura dei Pazzi*, ed. A. Perosa (Padua, 1958).

Poliziano, *Opera*　　　　Angelo Poliziano, *Opera* (Basle, 1553); anastatic edn., introd. by I. Maïer (Turin, 1971).

Prosatori latini del Quattrocento　　　　*Prosatori latini del Quattrocento*, ed. E. Garin (Milan, 1964).

Rimatori del Trecento　　　　*Rimatori del Trecento*, ed. G. Corsi (Turin, 1969).

Rinaldeschi, *Esposizione di Salmi*　　　　Rinieri de' Rinaldeschi da Prato, *Esposizione di Salmi* (Lucca, 1853).

Rinuccini, *Ricordi*　　　　Filippo di Cino Rinuccini, *Ricordi storici dal 1282 al 1460, con la continuazione di Alammano e Neri suoi figli fino al 1506*, ed. G. Aiazzi (Florence, 1840).

Sacchetti, *Opere*　　　　Franco Sacchetti, *Opere*, ed. A. Chiari (Bari, 1936–8).

Sacchetti, *Rime*　　　　Franco Sacchetti, *Il libro delle Rime*, ed. F. Brambilla Ageno (Florence and Perth, 1990).

Sacchetti, *Trecentonovelle*　　　　Franco Sacchetti, *Il Trecentonovelle*, in *Opere*, ed. V. Pernicone (Florence, 1946).

Salutati, *Epistolario*　　　　Coluccio Salutati, *Epistolario*, ed. F. Novati (Rome, 1891–1911).

Savonarola, *Prediche sopra Aggeo*　　　　Girolamo Savonarola, *Prediche sopra Aggeo*, ed. L. Firpo (Rome, 1965).

Savonarola, *Trattato circa el Reggimento . . . di Firenze*　　　　Girolamo Savonarola, *Trattato circa el Reggimento e Governo della città di Firenze*, ed. L. Firpo, in *Prediche sopra Aggeo* (Rome, 1965), 435–87.

Segni, *Storie fiorentine*　　　　Bernardo Segni, *Storie fiorentine* (Milan, 1805).

Simone della Tosa, *Annali*　　　　Simone della Tosa, *Annali*, ed. D. M. Manni, in *Cronichette antiche di vari scrittori del buon secolo della lingua toscana* (Florence, 1733), 125–71.

Spinelli, *Priorista*　　　　Ser Ricco Spinelli, *Priorista*, BNF, MS Magl. XXV, 64.

Statuta 1415　　　　*Statuta Populi et Communis Florentiae* ('Friburgi' [Florence], 1778–83).

Statuto del Capitano del Popolo　　　　*Statuto del Capitano del Popolo dagli anni 1322–25*, ed. R. Caggese (Florence, 1910).

Statuto del Podestà　　　　*Statuto del Podestà dell' anno 1325*, ed. R. Caggese (Florence, 1921).

Stefani, *Cronaca*　　　　Marchionne di Coppo Stefani, *Cronaca fiorentina*, ed. N. Rodolico, *Rer. Ital. Script.* xxx. 1 (Città di Castello, 1903–Bologna, 1955).

Tumulto dei Ciompi　　　　*Il Tumulto dei Ciompi: Cronache e Memorie*, ed. G. Scaramella, *Rer. Ital. Script.* xviii. 3 (Bologna, 1917–34).

Varchi, *Storia fiorentina*　　　　Benedetto Varchi, *Storia fiorentina*, ed. L. Arbib (Florence, 1838–41).

Vasari 1550　　　　Giorgio Vasari, *Le Vite de' più eccellenti architetti, pittori, et scultori italiani, da Cimabue insino a' tempi nostri*, 1550 edn., ed. L. Bellosi and A. Rossi (Turin, 1986).

Vasari–Frey　　　　K. Frey, *Der literarische Nachlass Giorgio Vasaris* (Munich, 1923–30).

Vasari–Milanesi　　　　Giorgio Vasari, *Le vite de' più eccellenti pittori scultori ed architettori*, ed. G. Milanesi (Florence, 1878–85; repr. Florence, 1973).

Vasari, *Vite*　　　　Giorgio Vasari, *Le vite de' più eccellenti pittori, scultori e architettori*, ed. R. Bettarini and P. Barocchi (Florence, 1966–87).

Vespasiano da Bisticci, *Vite*	Vespasiano da Bisticci, *Le Vite*, ed. A. Greco (Florence, 1970–6).
Villani, Filippo, *De origine*	Filippo Villani, *De origine civitatis Florentiae et eiusdem famosis civibus*, in *Philippi Villani Liber de civitatis Florentiae famosis civibus*, ed. G. C. Galletti (Florence, 1847).
Villani, Giovanni	*Nuova Cronica*, ed. G. Porta (Parma, 1990–1).
Villani, Giovanni, Matteo, Filippo, *Cronica*	Giovanni, Matteo, and Filippo Villani, *Croniche*, ed. I. Moutier and F. G. Dragomanni (Milan, 1848).

SECONDARY SOURCES

Acidini 1990	C. Acidini Luchinat, 'La Cappella medicea attraverso cinque secoli', in G. Cherubini and G. Fanelli (eds.), *Il Palazzo Medici Riccardi di Firenze* (Florence, 1990), 82–91.
Ackerman 1983	J. S. Ackerman, 'The Tuscan Rustic Order: A Study in the Metaphorical Language of Architecture', *Journal of the Society of Architectural Historians*, 42 (1983), 15–34.
Ademollo 1845	A. Ademollo, *Marietta de' Ricci, ovvero Firenze al tempo dell' assedio*, 2nd edn. by L. Passerini (Florence, 1845).
Adorno 1991	P. Adorno, *Il Verrocchio* (Florence, 1991).
Allegri and Cecchi 1980	E. Allegri and A. Cecchi, *Palazzo Vecchio e i Medici* (Florence, 1980).
Antonelli 1954	G. Antonelli, 'La magistratura degli Otto di Guardia a Firenze', *Arch. Stor. Ital.* 112 (1954), 3–39.
Aronow 1985	G. Schwarz Aronow, *A Documentary History of the Pavement Decoration in Siena Cathedral, 1362 through 1516*, Ph.D. Diss. (Columbia University, 1985; Ann Arbor, 1990).
Baldinucci 1845–7	F. Baldinucci, *Notizie dei professori del disegno . . .* , ed. F. Ranalli (Florence, 1845–7; repr. 1974).
Bandini, *Catalogus codicum*	A. M. Bandini, *Catalogus codicum manuscriptorum Bibliothecae Mediceae Laurentianae*, anastatic edn., ed. F. Kudlien (Leipzig, 1961).
Bandini 1787	A. M. Bandini, *Illustrazione di due evangelari greci del XI secolo* (Venice, 1787).
Barbadoro 1929	B. Barbadoro, *Le finanze della repubblica fiorentina* (Florence, 1929).
Barocchi 1962	P. Barocchi (ed.), *Giorgio Vasari: Vita di Michelangelo*, ii: *Commento* (Milan and Naples, 1962).
Barocchi 1984	P. Barocchi, *Studi vasariani* (Turin, 1984).
Baron 1955, 1966	H. Baron, *The Crisis of the Early Italian Renaissance* (Princeton, NJ, 1955; rev. edn., 1966).
Baron 1968	H. Baron, *From Petrarch to Leonardo Bruni: Studies in Humanistic and Political Literature* (Chicago and London, 1968).
Battaglia Ricci 1990	L. Battaglia Ricci, *Palazzo Vecchio e dintorni: Studio su Franco Sacchetti e le fabbriche di Firenze* (Rome, 1990).
Bayley 1961	C. C. Bayley, *War and Society in Renaissance Florence: The 'De Militia' of Leonardo Bruni* (Toronto, 1961).
Bergstein 1991	M. Bergstein, 'Marian Politics in Quattrocento Florence: The Renewed Dedication of Santa Maria del Fiore in 1412', *Renaissance Quarterly*, 44 (1991), 673–719.
Bernardo di Chiaravalle 1990	*Bernardo di Chiaravalle nell'arte italiana dal XIV al XVIII secolo*, ed. L. Dal Prà, Exhib. Cat., Florence, 1990 (Milan, 1990).
Bertelli 1971	S. Bertelli, 'Pier Soderini "Vexillifer Perpetuus Reipublicae Florentinae" 1502–1512', in A. Molho and J. A. Tedeschi (eds.), *Renaissance Studies in Honor of Hans Baron* (Florence, 1971), 335–59.

Biscaro 1904 G. Biscaro, 'La loggia degli Osi e la Curia Communis nel Broletto nuovo di Milano', *Archivio Storico Lombardo*, 31/1 (1904), 352–8.

Black 1985 R. Black, *Benedetto Accolti and the Florentine Renaissance* (Cambridge, 1985).

Bober and Rubinstein 1986 P. Pray Bober and R. Rubinstein, *Renaissance Artists and Antique Sculpture* (London, 1986).

Boffitto and Mori 1926 G. Boffitto and A. Mori, *Piante e vedute di Firenze* (Florence, 1926; repr. Rome, 1973).

Bombe 1910 W. Bombe, 'Florentiner Zunft- und Amtshäuser', *Zeitschrift für bildende Kunst*, NF 21 (1910), 93–102.

Borghini 1983 G. Borghini, 'La decorazione', in C. Brandi (ed.), *Palazzo Pubblico di Siena: Vicende costruttive e decorazione* (Siena, 1983), 147–349.

Borsook 1980 E. Borsook, *The Mural Painters of Tuscany from Cimabue to Andrea del Sarto*, 2nd edn. (Oxford, 1980).

Bowsky 1960 W. M. Bowsky, *Henry VII in Italy: The Conflict of Empire and City-State, 1310–1313* (Lincoln, Nebr., 1960).

Braghirolli 1879 W. Braghirolli, 'Zur Baugeschichte der Tribuna der S. Annunziata in Florenz', *Repertorium für Kunstwissenschaft*, 2 (1879), 259–79.

Branca 1983 V. Branca, *Poliziano e l'umanesimo della parola* (Turin, 1983).

Braune 1983 M. Braune, *Türme und Turmhäuser. Untersuchungen zu den Anfängen der monumentalen Wohn- und Wehrbauten in Toscana (1000 bis 1350)* (Cologne, 1983).

Braunfels 1953 W. Braunfels, *Mittelalterliche Stadtbaukunst in der Toskana* (Berlin, 1953).

Brown 1979 A. Brown, *Bartolomeo Scala, 1430–1497: The Humanist as Bureaucrat* (Princeton, NJ, 1979).

Brown 1992 A. Brown, 'Public and Private Interest: Lorenzo, the Monte and the Seventeen Reformers', in G. C. Garfagnini (ed.), *Lorenzo de' Medici: Studi* (Florence, 1992), pp. 103–65.

Brucker 1962 G. A. Brucker, *Florentine Politics and Society 1343–1378* (Princeton, NJ, 1962).

Brucker 1968 G. A. Brucker, 'The Ciompi Revolution', in N. Rubinstein (ed.), *Florentine Studies* (London, 1968), 314–56.

Brucker 1977 G. A. Brucker, *The Civic World of Early Renaissance Florence* (Princeton, NJ, 1977).

Brucker 1983 G. A. Brucker, 'Bureaucracy and Social Welfare in the Renaissance: A Florentine Case Study', *Journal of Modern History*, 55 (1983), 1–21.

Bucci 1971–3 M. Bucci, *Palazzi di Firenze* (Florence, 1971–3).

Butters 1985 H. C. Butters, *Governors and Government in Early Sixteenth-Century Florence, 1502–1519* (Oxford, 1985).

Caplow 1970 H. McNeal Caplow, *Michelozzo*, Ph.D. Diss. (Columbia University, 1970; London and New York, 1977).

Caplow 1972 H. McNeal Caplow, 'Michelozzo at Ragusa: New Documents and Revaluations', *Journal of the Society of Architectural Historians*, 31 (1972), 108–19.

Cardini 1973 R. Cardini, *La critica del Landino* (Florence, 1973).

Cardini 1990 R. Cardini, 'Landino e Dante', *Rinascimento*, 30 (1990), 175–90.

Carl 1983 D. Carl, 'Addenda zu Antonio Pollaiuolo und seiner Werkstatt', *Mitteilungen des Kunsthistorischen Institutes in Florenz*, 27 (1983), pp. 285–306.

Cassuto 1918 U. Cassuto, *Gli Ebrei a Firenze nell' età del Rinascimento* (Florence, 1918).

Cecchi, A., 1990a A. Cecchi, 'Percorso di Baccio d'Agnolo legnaiuolo e architetto fiorentino: Dagli esordi al Palazzo Borgherini. 1', *Antichità viva*, 29/1 (1990), 31–46.

Cecchi, A., 1990*b* A. Cecchi, 'Percorso di Baccio d'Agnolo legnaiuolo e architetto fiorentino: Dal ballatoio di Santa Maria del Fiore alle ultime opere. 2', *Antichità viva*, 29/2–3 (1990), 40–57.

Cecchi, A., 1994 A. Cecchi, 'Giuliano e Benedetto da Maiano ai servigi della Signoria fiorentina', in D. Lamberini *et al.* (eds.), *Giuliano e la bottega dei da Maiano: Atti del Convegno internazionale di studi, Fiesole 13–15 June 1991* (Florence, 1994).

Cederlöf 1959 O. Cederlöf, 'Leonardos "Kampen om standaret": En ikonografisk undersökning', *Konsthistorisk Tidskrift*, 28 (1959), 73–98.

Chastel 1982 A. Chastel, *L'Art et l'humanisme à Florence au temps de Laurent le Magnifique*, 3rd edn. (Paris, 1982).

Chittolini 1979 G. Chittolini, *La formazione dello stato regionale e le istituzioni del contado: Secoli XIV e XV* (Turin, 1979).

Ciardini 1907 M. Ciardini, *I banchieri ebrei in Firenze nel secolo XV* (Borgo S. Lorenzo, 1907).

Cipolla 1948 C. M. Cipolla, *Studi di storia della moneta*, i: *I movimenti dei cambi in Italia dal secolo XIII al XV* (Pavia, 1948).

Cohn 1958 W. Cohn, 'F. Sacchetti und das ikonographische Programm der Gewölbemalereien von Orsanmichele', *Mitteilungen des Kunsthistorischen Institutes in Florenz*, 8 (1958), 65–72.

Collareta 1986 M. Collareta, 'Il sigillo con l'Ercole del Museo degli Argenti', *Rivista d'Arte*, 38 (1986), 291–3.

Conti, C., 1875 C. Conti, *Ricerche storiche sull'arte degli arazzi in Firenze* (Florence, 1875).

Conti, C., 1893 C. Conti, *La prima reggia di Cosimo de' Medici nel Palazzo già della Signoria di Firenze* (Florence, 1893).

Conti, E., 1984 E. Conti, *L'imposta diretta a Firenze nel Quattrocento (1427–1494)* (Rome, 1984).

Cooper 1978 R. Pesman Cooper, 'Pier Soderini: Aspiring Prince or Civic Leader?', *Studies in Medieval and Renaissance History*, NS 1 (1978), 71–126.

Cordaro 1983 M. Cordaro, 'Le vicende costruttive', in C. Brandi (ed.), *Palazzo Pubblico di Siena: Vicende costruttive e decorazione* (Siena, 1983), 29–134.

Cox-Rearick 1984 J. Cox-Rearick, *Dynasty and Destiny in Medici Art* (Princeton, NJ, 1984).

Crum and Wilkins 1990 R. J. Crum and D. G. Wilkins, 'In Defence of Florentine Republicanism: Saint Anne and Florentine Art 1343–1575', in K. Ashley and P. Sheingorn (eds.), *Interpreting Cultural Symbols: Saint Anne in Medieval Society* (Athens, OH., 1990), 131–68.

Cust 1901 R. H. Cust, *The Pavement Masters of Siena (1369–1562)* (London, 1901).

d'Ancona 1905 P. d'Ancona, 'Gli affreschi del castello di Manta nel Saluzzese', *L'Arte*, 8 (1905), 94–106, 183–98.

Davidsohn, *Forschungen* R. Davidsohn, *Forschungen zur älteren Geschichte von Florenz* (Berlin, 1896–1908).

Davidsohn, *Geschichte* R. Davidsohn, *Geschichte von Florenz* (Berlin, 1896–1927).

Davies 1961 M. Davies, *The Earlier Italian Schools* (National Gallery Catalogues), 2nd edn. (London, 1961).

de Blasiis 1990 G. de Blasiis, 'Immagini di uomini famosi in una sala di Castelnuovo attribuite a Giotto', *Napoli Nobilissima*, 9 (1900), 65–7.

Degli Azzi 1908 G. Degli Azzi, 'La dimora di Carlo, figliuolo di Re Roberto, a Firenze (1326–'27)', *Arch. Stor. Ital.* ser. 5, 42 (1908), 45–83, 259–305.

Del Badia 1907 J. Del Badia, *Comizio Agrario di Firenze: La nuova sede nei palazzi della Condotta e della Mercanzia. Notizie Storiche* (Florence, 1907).

Delcorno 1989 C. Delcorno, *Exemplum e letteratura fra medioevo e Rinascimento* (Bologna, 1989).

della Torre 1902 A. della Torre, *Storia dell'Accademia Platonica di Firenze* (Florence, 1902).

Del Rosso 1815 G. Del Rosso, *Ragguaglio di alcune particolarità ritrovate nella costruzione dell'antico Palazzo della Signoria di Firenze detto in oggi il Palazzo Vecchio . . .* (Siena, 1815).

Diaz 1976 F. Diaz, *Il granducato di Toscana* (Turin, 1976).

Di Benedetto 1969 F. Di Benedetto, 'Leonzio, Omero e le "Pandette"', *Italia Medioevale e Umanistica*, 12 (1969), 53–112.

Dionisotti 1965 C. Dionisotti, 'Dante nel Quattrocento', in *Atti del Congresso internazionale di studi danteschi* (Florence, 1965), i. 333–78.

Dionisotti 1974 C. Dionisotti, 'Fortuna di Petrarca nel Quattrocento', *Italia Medioevale e Umanistica*, 17 (1974), 61–113.

Dobrick 1981 J. A. Dobrick, 'Ghirlandaio and Roman Coins', *Burlington Magazine*, 123 (1981), 356–9.

Donati 1904 F. Donati, 'Il Palazzo del Comune di Siena: Notizie storiche', *Bullettino Senese di storia patria*, 11 (1904), 311–54.

Donato 1985 M. M. Donato, 'Gli eroi romani tra storia ed "exemplum": I primi cicli umanistici di Uomini famosi', in S. Settis (ed.), *Memoria dell'antico nell'arte italiana*, ii (Turin, 1985), 93–152.

Donato 1987 M. M. Donato, 'Famosi Cives: Testi, frammenti e cicli perduti a Firenze fra Tre e Quattrocento', *Ricerche di Storia dell'Arte*, 30 (1987), 27–42.

Donato 1988 M. M. Donato, 'Un ciclo pittorico ad Asciano (Siena), palazzo pubblico e l'iconografia "politica" alla fine del medioevo', *Annali della Scuola Normale Superiore di Pisa*, Classe di lettere e filosofia, ser. 3, 18 (1988), 1105–272.

Donato 1991 M. M. Donato, 'Hercules and David in the Early Decoration of the Palazzo Vecchio: Manuscript Evidence', *JWCI*, 54 (1991), 83–98.

Dorini 1909 U. Dorini, 'L'orologio dei pianeti di Lorenzo della Volpaia donato dai capitani di Parte Guelfa alla Signoria di Firenze', *Rivista d'Arte*, 6 (1909), 137–44.

Edgerton 1985 S. Y. Edgerton, Jr., *Pictures and Punishment: Art and Criminal Prosecution during the Florentine Renaissance* (Ithaca, NY, 1985).

Elam 1978 C. Elam, 'Lorenzo de' Medici and the Urban Development of Renaissance Florence', *Art History*, 1 (1978), 43–68.

Elam and Gombrich 1988 C. Elam and E. Gombrich, 'Lorenzo de' Medici and a Frustrated Villa Project at Vallombrosa', in P. Denley and C. Elam (eds.), *Florence and Italy: Renaissance Studies in Honour of Nicolai Rubinstein* (London, 1988), 481–92.

Erffa 1970 H. M. von Erffa, 'Judith-Virtus Virtutum–Maria', *Mitteilungen des Kunsthistorischen Institutes in Florenz*, 14 (1970), 460–5.

Esch 1984 A. Esch, 'Mauern bei Mantegna', *Zeitschrift für Kunstgeschichte*, 47 (1984), 293–319.

Ettlinger 1972 L. Ettlinger, 'Hercules Florentinus', *Mitteilungen des Kunsthistorischen Institutes in Florenz*, 16 (1972), 119–42.

Fabriczy 1904 C. von Fabriczy, 'Michelozzo di Bartolomeo', *Jahrbuch der königlich preussischen Kunstsammlungen*, 25, Beiheft (1904), 34–110.

Fabroni 1784 A. Fabroni, *Laurentii Medicis Magnifici vita* (Pisa, 1784).

Fabroni 1789 A. Fabroni, *Magni Cosmi Medicei vita* (Pisa, 1789).

Field 1986 A. Field, 'Cristoforo Landino's First Lectures on Dante', *Renaissance Quarterly*, 39 (1986), 16–48.

Flamini 1891 F. Flamini, *La Lirica toscana del Rinascimento anteriore ai tempi del Magnifico* (Pisa, 1891).

Francovich 1926 G. de' Francovich, 'Benedetto Ghirlandaio', *Dedalo*, 6 (1925–6), 708–39.

Frey 1885 K. Frey, *The Loggia dei Lanzi zu Florenz* (Berlin, 1885).

Frey 1909 — K. Frey, 'Studien zu Michelagniolo Buonarroti und zur Kunst seiner Zeit, III', *Jahrbuch der königlich preussischen Kunstsammlungen*, 30, Beiheft (1909), 103–80.

Fubini 1982 — R. Fubini, 'Appunti sui rapporti diplomatici fra il dominio sforzesco e Firenze medicea', in *Gli Sforza a Milano e in Lombardia e i loro rapporti con gli Stati italiani ed europei (1450–1535)* (Milan, 1982), 291–334.

Gabelentz 1922 — H. von der Gabelentz, *Fra Bartolomeo und die Florentiner Renaissance* (Leipzig, 1922).

Garin 1954 — E. Garin, *Medioevo e Rinascimento: Studi e ricerche* (Bari, 1954).

Garin 1969 — E. Garin, 'Dante nel Rinascimento', *Rinascimento*, 7 (1967), 3–25; repr. in *L'età nuova: Ricerche di storia della cultura dal XII al XVI secolo* (Naples, 1969), 179–213.

Garzelli 1985 — A. Garzelli (ed.), *Miniatura fiorentina del Rinascimento 1440–1515: Un primo censimento* (Florence, 1985).

Giardino di San Marco 1992 — *Il giardino di San Marco: Maestri e compagni del giovane Michelangelo*, ed. P. Barocchi, Exhib. Cat. (Florence, 1992).

Göbel 1928 — H. Göbel, *Wandteppiche*, pt. 2, *Romanische Länder*, i (Leipzig, 1928).

Gombrich 1953 — E. H. Gombrich, review of A. Hauser, *The Social History of Art*, *Art Bulletin*, 35 (1953), 79–84.

Gori 1755 — A. F. Gori, *La Toscana illustrata nella sua storia* (Livorno, 1755).

Gotti 1889 — A. Gotti, *Storia del Palazzo Vecchio in Firenze* (Florence, 1889).

Gould 1954 — C. Gould, 'Leonardo's Great Battle-Piece: A Conjectural Reconstruction', *Art Bulletin*, 36 (1954), 117–29.

Grayson 1973 — C. Grayson, 'Poesie latine di Gentile Becchi in un codice Bodleiano', in B. Maracchi Biagiarelli and D. E. Rhodes (eds.), *Studi offerti a Roberto Ridolfi* (Florence, 1973), 284–303.

Grote [1960] — A. Grote, *Studien zur Geschichte der Opera di Santa Reparata zu Florenz im vierzehnten Jahrhundert* (Munich, [1960]).

Guerrini 1992 — R. Guerrini, 'Orbis moderamina: Echi di Claudiano negli epigrammi del Salutati per Palazzo Vecchio a Firenze', *Annali d. Facoltà di Lett. e Filosofia, Università di Siena*, 13 (1992), 319–29.

Guerrini 1993 — R. Guerrini, '*Effigies Procerum*: Modelli antichi (Virgilio, Floro, *De viris illustribus*) negli epigrammi del Salutati per Palazzo Vecchio a Firenze', *Athenaeum*, 81 (1993), 201–12.

Guidi 1981 — G. Guidi, *Il governo della città-repubblica di Firenze del primo Quattrocento* (Florence, 1981).

Günther 1988 — H. Günther, *Das Studium der antiken Architektur in den Zeichnungen der Hochrenaissance* (Tübingen, 1988).

Haines 1983 — M. Haines, *The 'Sacrestia delle Messe' of the Florentine Cathedral* (Florence, 1983).

Hankey 1959 — T. Hankey, 'Salutati's Epigrams for the Palazzo Vecchio at Florence', *JWCI* 22 (1959), 363–5.

Hartwig 1875–80 — O. Hartwig, *Quellen und Forschungen zur ältesten Geschichte der Stadt Florenz* (Marburg, 1875–Halle, 1880).

Hegarthy 1988 — M. C. Hegarthy, 'The Decorative Ensemble of the Sala dei Gigli in the Palazzo Vecchio', Ph.D. Diss. (University of Iowa, 1988).

Herzner 1978 — V. Herzner, 'David Florentinus. I', *Jahrbuch der Berliner Museen*, 20 (1978), 43–115.

Heydenreich 1960 — L. H. Heydenreich, 'Il bugnato rustico del Quattro e Cinquecento', *Bollettino del Centro internazionale di studi di architettura Andrea Palladio*, 2 (1960), 40–61.

Hirst 1988 · M. Hirst, *Michelangelo and his Drawings* (New Haven, Conn., and London, 1988).

Horne 1908 · H. P. Horne, *Alessandro Filipepi commonly called Sandro Botticelli* (London, 1908).

Horster 1980 · M. Horster, *Andrea del Castagno* (Oxford, 1980).

Hyman 1968 · I. Hyman, *Fifteenth Century Florentine Studies: The Palazzo Medici and a Ledger for the Church of San Lorenzo*, Ph.D. Diss. (New York University, 1968; New York and London, 1972).

Hyman 1975 · I. Hyman, 'Notes and Speculations on S. Lorenzo, Palazzo Medici, and an Urban Project by Brunelleschi', *Journal of the Society of Architectural Historians*, 34 (1975), 98–120.

Isermeyer 1964 · C. A. Isermeyer, 'Die Arbeiten Leonardos und Michelangelos für den grossen Ratssaal in Florenz', in W. Lotz and L. L. Möller (eds.), *Studien zur toskanischen Kunst: Festschrift für Ludwig Heinrich Heydenreich* (Munich, 1964), 83–130.

Janson 1954 · H. W. Janson, *The Sculpture of Donatello* (Princeton, NJ, 1954).

Kaftal 1952 · G. Kaftal, *Iconography of the Saints in Tuscan Painting* (Florence, 1952).

Kemp 1981 · M. Kemp, *Leonardo da Vinci: The Marvellous Works of Nature and Man* (London, 1981).

Kent 1978 · D. Kent, *The Rise of the Medici: Faction in Florence 1426–1434* (Oxford, 1978).

Kent 1979 · D. V. Kent and F. W. Kent, 'Two Comments of March 1445 on the Medici Palace', *Burlington Magazine*, 121 (1979), 795–6.

Kreytenberg 1991 · G. Kreytenberg, 'Bemerkungen zum Fresko der Vertreibung des Duca d'Atene aus Florenz', in R. G. Kecks (ed.), *Musagetes: Festschrift für Wolfram Prinz* (Berlin, 1991), 151–65.

La Sorsa 1902 · S. La Sorsa, *La Compagnia d'Or San Michele* (Trani, 1902).

Lein 1987 · E. Lein, *Benedetto da Maiano* (Frankfurt, 1987).

Lensi · A. Lensi, *Palazzo Vecchio* (Milan, 1929).

Lensi Orlandi · G. Lensi Orlandi, *Il Palazzo Vecchio di Firenze* (Florence, 1977).

Lesher 1979 · M. K. Lesher, *'The Vision of St Bernard' and the Chapel of the Priors: Private and Public Image of Bernard of Clairvaux in Renaissance Florence*, Ph.D. Diss. (Columbia University, 1979; Ann Arbor, 1984).

Levine 1974 · S. Levine, 'The Location of Michelangelo's *David*: The meeting of January 25th, 1504', *Art Bulletin*, 41 (1974), 31–49.

Lightbown 1978 · R. Lightbown, *Sandro Botticelli* (London, 1978).

Lightbown 1980 · R. W. Lightbown, *Donatello and Michelozzo* (London, 1980).

Li Gotti 1940 · E. Li Gotti, *Franco Sacchetti, uomo 'discolo e grosso'* (Florence, 1940).

Lopes Pegna 1962 · M. Lopes Pegna, *Firenze dalle origini al Medioevo* (Florence, 1962).

Lori 1980–1 · I. Lori Sanfilippo, 'La pace del cardinale Latino a Firenze nel 1280: La sentenza e gli atti complementari', *Bullettino Storico Italiano per il Medio Evo*, 89 (1980–1), 193–259.

Lupo Gentile 1905 · M. Lupo Gentile, *Studi sulla storiografia fiorentina alla corte di Cosimo I de' Medici* (Pisa, 1905).

MacCracken 1956 · J. MacCracken, 'The Dedication Inscription of the Palazzo del Podestà dating from the Period of the First Democracy (1250–1260) probably composed by Brunetto Latini', *Rivista d'Arte*, 30 (1956), 183–205.

MacManamon 1991 · J. M. MacManamon, 'Marketing a Medici Regime: the Funeral Oration of Marcello Virgilio Adriani for Giuliano de' Medici (1516)', *Renaissance Quarterly*, 44 (1991), 1–41.

Mallett 1959 · M. E. Mallett, 'The Sea Consuls of Florence in the Fifteenth Century', *Papers of the British School at Rome*, 27 (1959), 156–69.

Mallett 1967	M. E. Mallett, *The Florentine Galleys in the Fifteenth Century* (Oxford, 1967).
Mallett 1974	M. Mallett, *Mercenaries and their Masters* (London, 1974).
Mallett 1988	M. Mallett, 'The Florentine *Otto di Pratica* and the Beginnings of the War of Ferrara', in P. Denley and C. Elam (eds.), *Florence and Italy: Renaissance Studies in Honour of Nicolai Rubinstein* (London, 1988), 3–12.
Manetti 1951	A. Manetti, 'Roberto de' Rossi', *Rinascimento*, 2 (1951), 33–55.
Marchese 1878–9	V. Marchese, *Memorie dei più insigni pittori, scultori e architetti domenicani* (Bologna, 1878–9).
Marchini 1975	G. Marchini, *Filippo Lippi* (Milan, 1975).
Martindale 1986	A. Martindale, 'The Problem of Guidoriccio', *Burlington Magazine*, 128 (1986), 250–73.
Martindale 1988	A. Martindale, *Simone Martini* (Oxford, 1988).
Martines 1963	L. Martines, *The Social World of the Florentine Humanists 1390–1460* (London, 1963).
Martines 1968	L. Martines, *Lawyers and Statecraft in Renaissance Florence* (Princeton, NJ, 1968).
Marzi 1910	D. Marzi, *La Cancelleria della Repubblica Fiorentina* (Rocca S. Casciano, 1910).
Mazzi 1897	C. Mazzi, 'La Mensa dei Priori di Firenze nel secolo XIV', *Arch. Stor. Ital.* ser. 5, 20 (1897), 336–68.
Messini 1942	A. Messini, 'Documenti per la storia del Palazzo Trinci di Foligno', *Rivista d'Arte*, 24 (1942), 74–98.
Mignani 1982	D. Mignani Galli, 'Restauri e burocrazia: Palazzo Vecchio nel Settecento', *Labyrinthos*, 1/2 (1982), 165–202.
Milanesi 1872	G. Milanesi, 'Documenti inediti riguardanti Leonardo da Vinci', *Arch. Stor. Ital.* ser. 3, 16 (1872), 219–30.
Moisè 1843	F. Moisè, *Illustrazione storico-artistica del Palazzo de' Priori oggi Palazzo Vecchio e dei monumenti della Piazza* (Florence, 1843).
Molho 1971	A. Molho, *Florentine Public Finances in the Early Renaissance, 1400–1433* (Cambridge, Mass., 1971).
Molho 1977	A. Molho, 'Three Documents regarding Filippo Brunelleschi', *Burlington Magazine*, 119 (1977), 851–2.
Mommsen 1959	T. E. Mommsen, 'Petrarch and the Decoration of the *Sala Virorum Illustrium* in Padua', *Art Bulletin*, 34 (1952), 95–116; repr. in his collected essays, E. F. Rice, Jr. (ed.), *Medieval and Renaissance Studies* (Ithaca, NY, 1959), 130–74.
Monaci 1873	E. Monaci, *Rime e lettere di Ser Ventura Monaci* (Bologna, 1873).
Morpurgo 1933	S. Morpurgo, 'Bruto, "il buon giudice", nell'Udienza dell'Arte della Lana in Firenze', in *Miscellanea di storia dell'arte in onore di Igino Benvenuto Supino* (Florence, 1933), 141–63.
Moscato 1963	A. Moscato, *Il Palazzo Pazzi* (Rome, 1963).
Müntz 1888	E. Müntz, *Les collections des Médicis au XVe siècle. Le musée. La bibliothèque. Le mobilier* (Paris, 1888).
Najemy 1982	J. M. Najemy, *Corporatism and Consensus in Florentine Electoral Politics, 1280–1400* (Chapel Hill, NC, 1982).
Natali 1988	A. Natali, '*Exemplum salutis publicae*', in L. Dolcini (ed.), *Donatello e il restauro della Giuditta* (Florence, 1988).
Newton and Spencer 1982	H. T. Newton and J. R. Spencer, 'On the Location of Leonardo's *Battle of Anghiari*', *Art Bulletin*, 64 (1982), 45–52.
Oertel 1942	R. Oertel, *Fra Filippo Lippi* (Vienna, 1942).
Ortalli 1979	G. Ortalli, '*. . . Pingatur in Palatio . . .*': *La pittura infamante nei secoli 13–16* (Rome, 1979).

Ottokar 1926, 1962 N. Ottokar, *Il Comune di Firenze alla fine del Dugento* (Florence, 1926; 2nd edn., Turin, 1962).

Paatz 1931 W. Paatz, 'Zur Baugeschichte des Palazzo del Podestà (Bargello) in Florenz', in *Mitteilungen des Kunsthistorischen Institutes in Florenz*, 3 (1931), 287–321.

Palazzo Pubblico 1983 *Palazzo Pubblico di Siena: Vicende costruttive e decorazione*, ed. C. Brandi (Siena, 1983) (see pp. 413–36 for Documenti, ed. U. Morandi).

Palazzo Vecchio 1980 *Palazzo Vecchio: Committenza e collezionismo medicei*, Exhib. Cat. (Florence, 1980).

Pampaloni 1957 G. Pampaloni, 'I ricordi segreti del medicco Francesco di Agostino Cegia (1495–1497)', *Arch. Stor. Ital.*, 115 (1957), 188–234.

Pampaloni 1973 G. Pampaloni, *Firenze al tempo di Dante: Documenti sull'urbanistica fiorentina* (Rome, 1973).

Paoli 1862 C. Paoli, 'Della Signoria di Gualtieri Duca d'Atene in Firenze', *Giornale Storico degli Archivi Toscani*, 6 (1862), 81–121, 169–286.

Parks 1975 R. N. Parks, 'The Placement of Michelangelo's *David*: A Review of Documents', *Art Bulletin*, 17 (1975), 560–70.

Passavant 1969 G. Passavant, *Verrocchio: Sculptures, Paintings and Drawings*, trans. K. Watson (London, 1969).

Passerini 1869 L. Passerini, 'Il sigillo fiorentino con l'Ercole', *Periodico di Numismatica e Sfragistica*, 1 (1869), 276–88.

Paul 1963 J. Paul, *Die mittelalterlichen Kommunalpaläste in Italien*, Ph. D. Diss. (Cologne, 1963).

Paul 1969 J. Paul, *Der Palazzo Vecchio in Florenz* (Florence, 1969).

Pedretti 1968 C. Pedretti, *Leonardo da Vinci inedito* (Florence, 1968).

Pellegri 1978 M. Pellegri, 'Parma medievale dai Carolingi agli Sforza', in V. Banzola (ed.), *Parma: La città storica* (Parma, 1978), 83–148.

Pellegrini 1880–9 F. C. Pellegrini, *Sulla repubblica fiorentina a tempo di Cosimo il Vecchio* (Pisa, 1880–9).

Perosa 1981 A. Perosa, 'Lo Zibaldone di Giovanni Rucellai', in *Giovanni Rucellai ed il suo Zibaldone*, ii: *A Florentine Patrician and his Palace* (London, 1981), 99–152.

Piper 1912 O. Piper, *Burgenkunde*, 3rd edn. (Munich, 1912).

Poggi 1909a G. Poggi, 'Di un'opera di Andrea Sansovino per il Palazzo della Signoria', *Rivista d'Arte*, 6 (1909), 144–6.

Poggi 1909b G. Poggi, 'Le sculture di Benedetto da Maiano per la porta dell'Udienza in Palazzo Vecchio', *Rivista d'Arte*, 6 (1909), 156–9.

Poggi 1909c G. Poggi, 'Note su Filippino Lippi: La tavola per la Sala del Consiglio del Palazzo della Signoria', *Rivista d'Arte*, 6 (1909), 305–8.

Poggi 1988 G. Poggi, *Il Duomo di Firenze*, ed. M. Haines (Florence, 1988). 2 vols. (vol. I first published 1909).

Polizzotto L. Polizzotto, *The Elect Nation: The Savonarolan Movement in Florence 1494–1545* (Oxford, 1994).

Pope-Hennessy 1974 J. Pope-Hennessy, *Fra Angelico*, 2nd edn. (London, 1974).

Pope-Hennessy 1985 J. Pope-Hennessy, *Italian Gothic Sculpture*, 3rd edn. (London, 1985).

Preyer 1985 B. Preyer, 'Two Cerchi Palaces in Florence', in A. Morrogh, F. Superbi Gioffredi, P. Morselli, and E. Borsook (eds.), *Renaissance Studies in Honor of Craig Hugh Smyth* (Florence, 1985), ii. 613–25.

Preyer 1990 B. Preyer, 'L'architettura del palazzo mediceo', in G. Cherubini and G. Fanelli (eds.), *Il Palazzo Medici Riccardi di Firenze* (Florence, 1990), 58–75.

Rastrelli 1792 M. Rastrelli, *Illustrazione istorica del Palazzo della Signoria* (Florence, 1792).

Richa 1754–62	G. Richa, *Notizie istoriche delle chiese fiorentine* . . . (Florence, 1754–62).
Ridolfi 1974	R. Ridolfi, *Vita di Girolamo Savonarola*, 3rd edn. (Rome, 1974).
Rochon 1963	A. Rochon, *La Jeunesse de Laurent de Médicis (1449–1478)* (Paris, 1963).
Rodolico 1945	N. Rodolico, *I Ciompi: Una pagina di storia del proletariato operaio* (Florence, 1945).
Rodolico and Marchini 1962	N. Rodolico and G. Marchini, *I Palazzi del Popolo nei comuni toscani del medio evo* (Milan, 1962).
Roover 1970	R. de Roover, *Il banco Medici dalle origini al declino (1397–1494)* (Florence, 1970).
Roscoe 1796	W. Roscoe, *The Life of Lorenzo de' Medici the Magnificent*, 2nd edn. (London, 1796).
Roth, C., 1925	C. Roth, *The Last Florentine Republic* (London, 1925).
Roth, E., 1917	E. Roth, *Die Rustika in der italienischen Renaissance und ihre Vorgeschichte* (Vienna, 1917).
Rubinstein 1942	N. Rubinstein, 'The Beginnings of Political Thought in Florence: A Study in Medieval Historiography', *JWCI*, 5 (1942), 198–227.
Rubinstein 1954	N. Rubinstein, 'I primi anni del Consiglio Maggiore di Firenze (1494–99)', *Arch. Stor. Ital.* 112 (1954), 151–94, 321–47.
Rubinstein 1960	N. Rubinstein, 'Politics and Constitution in Florence at the End of the Fifteenth Century', in E. F. Jacob (ed.), *Italian Renaissance Studies: A Tribute to the Late Cecilia M. Ady* (London, 1960), 148–83.
Rubinstein 1966	N. Rubinstein, *The Government of Florence under the Medici (1434 to 1494)* (Oxford, 1966).
Rubinstein 1968	N. Rubinstein, 'La confessione di Francesco Neroni e la congiura antimedicea del 1466', *Arch. Stor. Ital.* 126 (1968), 373–87.
Rubinstein 1971	N. Rubinstein, 'Notes on the Word *Stato* in Florence before Machiavelli', in J. G. Rowse and W. H. Stockdale (eds.), *Florilegium Historiale: Essays Presented to Wallace K. Ferguson* (Toronto, 1971), 313–26.
Rubinstein 1972	N. Rubinstein, 'Machiavelli and Florentine Politics', in M. P. Gilmore (ed.), *Studies on Machiavelli* (Florence, 1972), 3–28.
Rubinstein 1978	N. Rubinstein, 'The Piazza della Signoria in Florence', in E. Hubala and G. Schweikhart (eds.), *Festschrift Herbert Siebenhüner* (Würzburg, 1978), 19–30.
Rubinstein 1981	N. Rubinstein, 'Il regime politico di Firenze dopo il tumulto dei Ciompi', in *Il Tumulto dei Ciompi* (Florence, 1981), 105–24.
Rubinstein 1987	N. Rubinstein, 'Classical Themes in the Decoration of the Palazzo Vecchio in Florence', *JWCI*, 50 (1987), 29–43.
Rubinstein 1991	N. Rubinstein, 'Machiavelli and the Decoration of the Hall of the Great Council in the Palazzo Vecchio', in R. G. Kecks (ed.), *Musagetes: Festschrift für Wolfram Prinz* (Berlin, 1991), 275–85.
Ruck 1989	G. Ruck, 'Brutus als Modell des guten Richters: Bild und Rhetorik in einem Florentiner Zunftgebäude', in H. Belting and D. Blume (eds.), *Malerei und Stadtkultur in der Dantezeit: Die Argumentation der Bilder* (Munich, 1989), 115–31.
Saalman 1965	H. Saalman, 'The Palazzo Comunale in Montepulciano', *Zeitschrift für Kunstgeschichte*, 28 (1965), 1–46.
Salmi 1919	M. Salmi, 'Gli affreschi del Palazzo Trinci a Foligno', *Bollettino d'Arte*, 13 (1919), 139–80.
Salvemini 1899, 1960	G. Salvemini, *Magnati e popolani in Firenze dal 1280 al 1295* (Florence, 1899; 2nd edn., Milan, 1960).

Salvini 1934 R. Salvini, 'Lo sviluppo stilistico di Giovanni dal Ponte', *Atti e memorie dell'Accademia Petrarca*, NS 16–17 (1934), 17–44.

San Lorenzo 1984 *San Lorenzo*, ed. U. Baldini and B. Nardini (Florence, 1984).

Santini, N., 1919 N. Santini, 'Gli Operai del Palazzo del Popolo', *Bullettino del Comune di Firenze*, 5 (1919), 17–19, 115–23.

Santini, P., 1895 P. Santini, *Documenti dell'antica costituzione del Comune di Firenze* (Florence, 1895).

Schlosser–Kurz 1964 J. Schlosser Magnino, *La letteratura artistica*, 3rd edn. by O. Kurz (Florence, 1964).

Schrader 1592 L. Schrader, *Monumentorum Italiae . . . libri quatuor* (Helmstedt, 1592).

Schroeder 1971 H. Schroeder, *Der Topos der Nine Worthies in Literatur und bildender Kunst* (Göttingen, 1971).

Schulz 1982 J. Schulz, 'The Communal Buildings of Parma', *Mitteilungen des Kunsthistorischen Institutes in Florenz*, 26 (1982), 279–323.

Seidel 1982 M. Seidel, '"Castrum pingatur in palatio" 1: Ricerche storiche e iconografiche sui castelli dipinti nel Palazzo Pubblico di Siena', *Prospettiva*, 28 (1982), 17–41.

Shearman 1975 J. Shearman, 'The Collections of the Younger Branch of the Medici', *Burlington Magazine*, 117 (1975), 12–27.

Sinding-Larsen 1975 S. Sinding-Larsen, 'A Tale of Two Cities: Florentine and Roman Visual Context for Fifteenth-Century Palaces', *Acta ad Archaeologiam et Artium Historiam Pertinentia*, 6 (1975), 163–212.

Southard 1978 E. Carter Southard, *The Frescoes in Siena's Palazzo Pubblico, 1289–1539*, Ph.D. Diss. (Indiana University, 1978; Ann Arbor, 1981).

Spencer 1991 J. R. Spencer, *Andrea del Castagno and his Patrons* (Durham, NC, and London, 1991).

Sperling 1992 Ch. M. Sperling, 'Donatello's Bronze "David" and the Demands of Medici Politics', *Burlington Magazine*, 134 (1992), 218–24.

Spilner 1987 P. L. Spilner, *'Ut civitas amplietur': Studies in Florentine Urban Development, 1282–1400*, Ph.D. Diss. (Columbia University, 1987; Ann Arbor, 1987).

Spilner 1993 P. Spilner, 'Giovanni di Lapo Ghini and a Magnificent New Addition to the Palazzo Vecchio', *Journal of the Society of Architectural Historians*, 52 (1993), 453–65.

Spufford 1986 P. Spufford, *Handbook of Medieval Exchange* (London, 1986).

Steinberg 1977 R. M. Steinberg, *Fra Girolamo Savonarola, Florentine Art, and Renaissance Historiography* (Athens, OH., 1977).

Stephens 1983 J. N. Stephens, *The Fall of the Florentine Republic 1512–1530* (Oxford, 1983).

Stoppelli 1977 P. Stoppelli, 'Malizia Barattone (Giovanni di Firenze) autore del Pecorone', *Filologia e Critica*, 2 (1977), 1–34.

Storia di Milano *Storia di Milano* (Milan, 1953–66).

Sznura 1975 F. Sznura, *L'espansione urbana di Firenze nel Dugento* (Florence, 1975).

Tanturli 1992 G. Tanturli, 'La Firenze laurenziana davanti alla propria storia letteraria', in G. C. Garfagnini (ed.), *Lorenzo il Magnifico e il suo tempo* (Florence, 1992), 1–38.

Thiem 1961 C. and G. Thiem, 'Andrea di Cosimo Feltrini und die Grotteskendekoration der Florentiner Hochrenaissance', *Zeitschrift für Kunstgeschichte*, 24 (1961), 1–39.

Thornton 1991 P. Thornton, *The Italian Renaissance Interior 1400–1600* (London, 1991).

Tönnesmann 1983 A. Tönnesmann, *Der Palazzo Gondi in Florence* (Worms, 1983).

Tönnesmann 1984 A. Tönnesmann, '"Palatium Nervae": Ein antikes Vorbild für Florentiner Rustikafassaden', *Römisches Jahrbuch für Kunstgeschichte*, 21 (1984), 61–9.

Trachtenberg 1988 M. Trachtenberg, 'What Brunelleschi saw: Monument and Site at the Palazzo

	Vecchio in Florence', *Journal of the Society of Architectural Historians*, 47 (1988), 14–44.
Trachtenberg 1989	M. Trachtenberg, 'Archaeology, Merriment, and Murder: The First Cortile of the Palazzo Vecchio and its Transformation in the Late Florentine Republic', *Art Bulletin*, 71 (1989), 565–609.
Trexler 1978*a*	R. C. Trexler, *The Libro Cerimoniale of the Florentine Republic* (Geneva, 1978).
Trexler 1978*b*	R. C. Trexler, 'Honor among Thieves: The Trust Function of the Urban Clergy in the Florentine Republic', in S. Bertelli and G. Ramakus (eds.), *Essays Presented to Myron P. Gilmore* (Florence, 1978), i. 317–34.
Uccelli 1865	G. B. Uccelli, *Il Palazzo del Potestà* (Florence, 1865).
Uffizi 1979	*Gli Uffizi: Catalogo generale* (Florence, 1979).
Ullman 1963	B. L. Ullman, *The Humanism of Coluccio Salutati* (Padua, 1963).
Valentiner 1950	W. R. Valentiner, *Studies in Italian Renaissance Sculpture* (London, 1950).
Venturi 1910	L. Venturi, 'Pietro, Lorenzo Luzzo e il Morto di Feltre', *L'Arte*, 13 (1910), 362–76.
Verde 1973–94	A. F. Verde, *Lo Studio fiorentino 1473–1503* (Pistoia, 1973–94).
Villari 1887–8	P. Villari, *La storia di Girolamo Savonarola e de' suoi tempi*, 2nd edn. (Florence, 1887–8).
Villari 1895–7	P. Villari, *Niccolò Machiavelli e i suoi tempi*, 2nd edn. (Milan, 1895–7).
Viti 1992	P. Viti, 'Cristoforo Landino: La riscoperta di Dante e il primato di Firenze', in *Consorterie politiche e mutamenti istituzionali in età laurenziana*, Exhib. Cat. (Florence, 1992), 115–17.
Wackernagel 1981	M. Wackernagel, *The World of the Florentine Artist*, trans. A. Luchs (Princeton, NJ, 1981).
Walser 1914	E. Walser, *Poggius Florentinus: Leben und Werke* (Leipzig and Berlin, 1914).
Weil-Garris 1983	K. Weil-Garris, 'On Pedestals: Michelangelo's *David*, Bandinelli's *Hercules and Cacus*, and the Sculpture of the Piazza della Signoria', *Römisches Jahrbuch für Kunstgeschichte*, 20 (1983), 377–415.
Weinstein 1970	D. Weinstein, *Savonarola and Florence: Prophecy and Patriotism in the Renaissance* (Princeton, NJ, 1970).
Wilde 1944	J. Wilde, 'The Hall of the Great Council of Florence', *JWCI*, 7 (1944), 65–81.
Wilde 1953	J. Wilde, 'Michelangelo and Leonardo', *Burlington Magazine*, 95 (1953), 65–72.
Witt 1976	R. C. Witt, *Coluccio Salutati and his Public Letters* (Geneva, 1976).
Witt 1983	R. C. Witt, *Hercules at the Crossroads: The Life, Works, and Thought of Coluccio Salutati* (Durham, NC, 1983).
Wolters 1983	W. Wolters, *Der Bilderschmuck des Dogenpalastes: Untersuchungen zur Selbstdarstellung der Republik Venedig im 16. Jahrhundert* (Wiesbaden, 1983).
Wright 1994	A. Wright, 'The Myth of Hercules', in G. C. Garfagnini (ed.), *Lorenzo il Magnifico e il suo mondo: Convegno Internazionale di Studi (Firenze, 9–13 giugno 1992)* (Florence, 1994), 323–39.
Wundram 1867–8	M. Wundram, 'Jacopo di Piero Guidi', *Mitteilungen des Kunsthistorischen Institutes in Florenz*, 13 (1967–8), 195–222.
Zervas 1987	D. Finiello Zervas, *The Parte Guelfa, Brunelleschi and Donatello* (Locust Valley, NY, 1987).
Zippel 1892	Review of F. Flamini, *La lirica toscana del rinascimento . . .*, *Arch. Stor. Ital.*, ser. 5, 9 (1892), 366–70.
Zorzi 1988	A. Zorzi, *L'amministrazione della giustizia nella repubblica fiorentina: Aspetti e problemi* (Florence, 1988).

INDEX

Bold type denotes the principal discussion of a topic. References to 'Palace' and 'Piazza' are to the Palazzo Vecchio (Palazzo della Signoria) and to the Piazza della Signoria, and paintings and sculptures are or were in the Palazzo Vecchio unless otherwise indicated. To facilitate identification personal names have in many places been completed by the addition of patronyms.

Acciaiuoli:
 Agnolo di Jacopo 109
 Agolanti, Alessandro di Giovanni 44 n.
 Donato di Neri 49, 111, figs. 59, 60
Accolti, Benedetto 23 n.
Accursius 54 n.
Adriani, Marcello Virgilio 64 n.
Alberti, Bello 15 n.
 houses 7, 15 n., 87
 sons 87
Alberti del Giudice family 53, 90
 Alberto and Neri, house 88 n.
Albertini, Francesco 103
Albizzi:
 Antonio di Tedice 25 n.
 Maso di Luca 53
 Rinaldo di Maso 54
Alexander the Great, represented in Palace 53
Alfonso of Aragon, king of Naples 26, 72 n.
Allori, Alessandro 64 n.
Amboise, Georges d' 74 n.
Ammannati, Bartolomeo 111
Anghiari, battle 74, 75, 99
 see also Leonardo da Vinci: Battle of Anghiari
antique sculpture 70
Antonio di Bernardo, see Dini: Antonio di Bernardo di Miniato
appeals judge, offices 89
Ardinghelli, Tommaso di Neri 25 n.
Arezzo 89
Arezzo, Six of, offices, see Palazzo Vecchio: XI. Rooms, Six of Arezzo, offices
arms:
 on or in Palace:
 Anjou (fleurs-de-lis): ballatoio 17–18; courtyard and second floor 30; Sala dei Gigli 55 n., 59, 62
 Duke Alessandro de' Medici 96
 Florence: banners 99; ceiling and friezes 59, 60; façade 17–18; Ghirlandaio, St Zenobius 63, fig. 33; tribune of the Signoria 112; west portal 17; see also arms: Guelf party and Popolo
 Francesco Sforza 57
 gonfaloni 18
 Guelf party 60
 king of France 96
 Pope Clement VII and Pope Leo X 96
 Popolo (People) 60, 99

quartieri 17–18
and palaces of foreign magistrates 48
Athens, duke of, see Walter of Brienne
Augustus, Emperor, represented in Palace 53 n.

Baccio (Bartolomeo) d'Agnolo:
 apartment of Soderini 45, 76
 new chapel, doorway 104
 Sala dei Cinquecento 71, 112, 113
 altar 70, 71, 77
 Sala dei Dugento, doorway 76
 Udienza and chapel 76, 96, 104, 112
Baglioni, Malatesta 94
Baldaccio d'Anghiari 16 n., 38, 97, 98, 101
Baldovini, Chello di Uberto 22 n.
Balìe 19, 21, 67, 92
 1382–1433 89, 90, 93
 1434–71 25, 26, 27 n., 54 n., 67, 91, 93
 1513–30 77, 94, 121
Bandinelli, Baccio 114
Bargello (chief police official) 88 n.
Bargello (building), see Florence: palaces, Bargello
Bartolomeo, Fra 70, 71–2, 95, fig. 42
Becchi, Gentile 72 n.
Benedetto di Bartolomeo da Rovezzano 76
Benedetto di Luca 109
Benedetto da Maiano:
 and confiscation at Pazzi properties 67 n.
 privy door 38 n.
 Sala dei Gigli:
 doorway 33, 37, 60–1, 63 n., 75, 76, 103, figs. 29, 30
 wall 33
Bernardino di Antonio di Giannozzo 108
Bertoldo 72
Billi, Antonio 28
Biondo, Flavio 74
Bisticci, Vespasiano da 106
Boccaccio, Giovanni:
 fame in Florence 60
 planned memorial in Cathedral 53–4
 represented:
 in Palace 53–4
 in villa of the Carducci 61
 and wheel of Fortune 50 n.
Bonaventura di Manuele da Volterra 31 n.
Borghini, Vincenzo 28 n.

Borsi, Piero di Lorenzo 119
Botticelli, Sandro:
 engravings after, for *Divine Comedy* 61 n.
 Madonna della Melagrana, Uffizi 66 n.
 Sala dei Gigli:
 and intarsia panels 60
 mural decoration, commission 62
 work in Florence and Rome 69 n.
Bracciolini, Poggio, represented in Palace 52
Brunelleschi, Filippo 24
Bruni, Leonardo 60
 Historiae Florentini populi, copies in Palace 105–6
 praises Palace 10
 represented in Palace 52
Brutus, L. Junius, represented:
 in Palace 53, 63, 64, fig. 35
 in palace of the wool guild 53
Buchi, Betto di Luca 44 n., 75 n.
Buonaccorsi, Piero di Domenico 110
Buoninsegni, Domenico 107
Buonuomini, Twelve, *see* Twelve Buonuomini
bursars (*camerarii*):
 Camera dell'Arme (Palace) 15 n., 16 n., 17 n.,
 19 n.
 Commune 9, 47 n.

Caesar, Julius:
 represented in Palace 53 n.
 supposed founder of Florence 64
Cambi, Giovanni 27, 36 n., 45, 103, 104, 116
camerarii, see bursars
Camillus, M. Furius:
 Cosimo de' Medici compared to 64
 represented in Palace 53 n., 63, 64, fig. 35
Campaldino, battle, painted in Palace 49
Capponi:
 Gino di Neri 22
 Neri di Gino:
 and Leonardo da Vinci, *Battle of Anghiari* 74
 Operaio 24
 Niccolò di Piero 37 n., 96, 99, 100, 112
 Recco di Uguccione 119
captain of the guard of the Signoria 16
 see also Palazzo Vecchio: XI. Rooms, captain of the guard
 of the Signoria
Captain of the People:
 abolition of office 88, **111**
 duties 7, 11 n., 16 n., 80, 98, 111
 early accommodation 11, **87**
 inauguration ceremonies 14, 79
 palace 11, 16, 24, 38
 restrictions on decoration 48
Captain of the Piazza, *see* Bargello (chief police official)
Captains of the Guelf Party, *see* Guelf party: Captains
Carducci, villa of 61
Carrara, Francesco Novello da 89
Carucci, Giorgio di Bencio 118
Cascina, battle 66 n., **74**, **75**, 86 n.

see also Michelangelo Buonarroti: *Battle of Cascina*
Castella, Ufficiali delle, *see* Ufficiali: delle Castella
Castianselmo, Marco 57–8, 105
Castracani, Castruccio 15
Castrocaro 31
Catiline 64
Cato Uticensis, represented in Palace 53
Cattaneo, Simonetta 60 n.
Cavalcanti, Giovanni 54, 91, 102
Cegia, Francesco di Agostino 116
Cerchi family, palaces 5 n., 6, 14
Cerretani, Bartolomeo 43, 44, 45, 73, 107–8
Cesarini, Cardinal Giuliano 105
chancery 22–3
 Chancellor of the Signoria 12, 22, 23
 see also Palazzo Vecchio: XI. Rooms, Chancellor of the
 Signoria
 members 23, 34 n., 36, 37, 41 n., 65
 1483 reform **23**, 34, 37
Charlemagne, represented in Palace 53, 54 & n.
Charles V, Emperor 94 n., 96
Charles VIII, king of France 39
Charles I of Anjou, king of Sicily, arms:
 Palace 18
 and palaces of foreign magistrates 48
Charles of Anjou, duke of Calabria 15, 20
 represented in Palace 47–8
Charles of Durazzo, king of Hungary 89
Christ:
 'king of Florence' 96
 see also Sansovino, Andrea, statue of Saviour
Cicero, represented in Palace 53, 63, 64, fig. 36
Ciompi revolt, *see under* Florence: government, politics, and
 constitution
Claudian, represented in Palace 53–4
Clement VII, Pope 95, 96
 arms 96
Cocchi Donati:
 Jacopo di Niccolò 54, 55
 Niccolò di Neroccio 118
 see also Donati
Colleges 3, 19, 20
 election of Operai 120
 and Piazza 84 n., 85
 use of Sala dei Gigli 37, 102
 see also Sixteen Gonfaloniers; Twelve Buonuomini
Compagni, Dino 6
Condotta, palace, *see under* Florence: palaces
Conservatori delle Leggi, offices **22** & n., 24, 26, 27
Constantine, Emperor, represented in Palace 53
consultative committees (*consulte* and *pratiche*) **19–20**, 43
 and council of Ottanta 43
 and council of Settanta 34
 meetings:
 andito fra le camere 38, 101
 camera of the Gonfalonier of Justice 99
 Sala dei Dugento 34 n., 102
 Sala dei Gigli and Saletta 37, 102

consultative committees (*cont.*)
Sala dei Settanta 43
Udienza 37 n., 102
Contado, Ufficiali del, *see* Ufficiali: del Contado
Cortona 22
Council of Florence 105
councils:
Captain of the People, later of the People 6 n., 20
debate on site and construction of Palace 5, 6 n., 7–8
exclusion of magnates 108
and extension of Piazza 84–5
meetings: Sala dei Dugento 12, 18, 20; S. Pier
Scheraggio 12, 14
Cento (One Hundred) (1280–):
debate on site of Palace 6
meetings: Sala dei Dugento 12, 20 n.; S. Pier
Scheraggio 12 n.
Cento (One Hundred) (1458–94):
abolition 40
creation and powers 23, 35, 67
election of Operai 119, 120
meetings 24, 36
terms of office 34
Commune and People:
and Balìe 92
election of Operai 27 n.
legislation 23, 25, 33–5 *passim*, 40, 66, 92
participation of magnates 108
terms of office 33–4
Great 40–2 *passim*, 70, 92
elections of Operai 120
1527 restoration 95
see also Palazzo Vecchio: XI. Rooms, Sala dei
Cinquecento
Ottanta (Eighty), creation and meetings 42–3
Podestà, later of the Commune:
and extension of Piazza 85 n.
meetings: Bargello 20; churches 12 n.; Sala dei
Dugento 12, 18, 20, 36, 40 n.
Settanta (Seventy):
abolition 40
creation and powers 23, 33–4, 35, 64–5, 66
see also Palazzo Vecchio: XI. Rooms, Sala dei Settanta
Cronaca (Simone del Pollaiuolo):
Sala dei Cinquecento 40
stairs 42, 76 n.
windows 115
Sala dei Dugento, doorway 76 n.
Tetto dei Pisani 86 n.

Daddi, Bernardo 49, 57, 59, 104, 106
Dante:
fame in Florence 60–1
and Hercules and David 55 n.
planned monument in Cathedral 53–4
represented:

in Palace 52 n., 53–4, 60–1, 62, fig. 32
in villa of the Carducci 61
Dati, Gregorio (Goro) 54, 88
on Palace 8, 13, 14
David:
compared to Hercules 55 n.
see also Donatello: bronze *and* marble *David*;
Michelangelo Buonarroti: *David*; Verrocchio: *David*
Davizi, Tommaso di Francesco 27 n., 119
Decius Mus, P.:
Lorenzo de' Medici compared to 64
represented in Palace 63, 64, fig. 36
Dei, Benedetto 22 n., 27
Del Massaio, Pietro 26 n., fig. 2
Del Nero, Bernardo di Nero 69 n.
Del Rosso, Giuseppe 111
Della Bella, Giano 6
Della Robbia, Luca 57
Della Seta, Lombardo 52 n.
Dell'Antella, Giovanni di Guido 82 n.
Dentatus, M. Curius, represented in Palace 53 n.
Dieci di Balìa 22, 23, 34, 35, 43, 110
seating in Sala dei Cinquecento 113
see also Palazzo Vecchio: XI. Rooms, Dieci di Balìa
Dini:
Antonio di Bernardo di Miniato 65 n., 69, 93 n.
Francesco di Piero 120
Dogana, *see* Florence: buildings, customs house
Domenico di Domenico 45, 77
Donatello:
bronze *David* 24 n., 56, 70, fig. 38
inscriptions 72 n.
marble *David* 55, 56, 62 n., fig. 22
inscriptions 56, 65, 72
Judith and Holofernes 70, fig. 39
inscriptions 72
Marzocco and inscription 17 n.
Donati:
Corso di Simone 12
Manno di Arpardo 75
see also Cocchi Donati
Donato, Francesco di Piero di 76

Eighty, council, *see* councils: Ottanta
electoral procedure 20, 23, 36, 102, 109–10, 115, 120
see also Notary: of the Tratte
Eleonora of Toledo, apartment 101
emperors, represented in Palace 53, 63
Empoli 65
Eugenius IV, Pope 103, 105
Evangelists, represented in Palace 58, 78
Executor of the Ordinances of Justice 10, 79 n., 80 n., 111
abolition of office 87, 88, 111
house and palace 87, 88
restrictions on decoration 48

Fabius Maximus, Q., represented in Palace 53 n.
Fabricius Luscinus, G., represented in Palace 53 n.

Facciano 31
Falconi, Francesco di Federico 85 n.
famiglia of the Signoria, *see* Palazzo Vecchio: VII.
 Household of the Signoria
Famous Men cycles:
 in Italy 52, 53, 55
 in Palace 33, 45 n., **52-4**, 55, 56 n., **61-5**, 66 n., 68, 102,
 figs. 33, 35, 36
 in villa of the Carducci 61
Ferdinand I (Ferrante) of Aragon, king of Naples 39, 64
Ficino, Marsilio 60-1, 61 n.
Filarete, Francesco 43 n., 94
Filippo di Giuliano 65 n.
Fioravanti, Neri 20 n., 91 n.
fleurs-de-lis, see arms: Anjou
Florence:
 arms on and in Palace, *see* arms: Florence
 buildings:
 customs house (Dogana) 22 n., **25-6**, 27 n., 38, 45,
 88, 89, 95 n.
 hospital of S. Giovanni Evangelista 8, 80 n.
 Mercato Vecchio 8, 79
 Mint (Zecca) 86, 89
 see also Ufficiali *and names of magistracies*
 census 86 n., 88
 churches:
 Baptistery 8; meetings of councils of the Podestà
 12 n.
 Carmine 29 n.
 Cathedral 1, 57; annual mass celebrating expulsion of
 Medici 71 n.; image of Pope John XXII 15 n.;
 inauguration ceremonies 14, 79; intarsia in Sacrestia
 delle Messe **62**, 64, fig. 34; Operai 32, 55, 74 n.,
 84 n., 86 n., 105, and Piazza della Signoria 84,
 93 n., 118; *parlamenti* 14, 80; planned monuments
 to famous Florentines 53-4; relics 63, 105;
 represented in Palace 63
 S. Cecilia 82-5 *passim*
 S. Croce 1, 38 n.; funds diverted to Palace 29 n.; and
 scrutiny 109
 S. Lorenzo: chapel of Ottaviano de' Medici 72 n.;
 tomb of Cosimo de' Medici 94
 S. Marco 95
 S. Maria Novella 1, 17 n., 73 n.
 S. Michele in Orto 7
 S. Pier Scheraggio: council meetings 12 & n.; and
 duke of Athens 82, 83; inauguration ceremonies 14,
 79 & n., 86; *parlamenti* 79
 S. Procolo 6
 S. Romolo: demolition 82, **83**, 85, 118; new church
 83, 86
 S. Spirito, funds diverted to Palace 29 n.
 S. Stefano 10
 SS. Annunziata, represented in Palace 78
 compared to Rome 2, 7, 53, 76
 description 87
 emblems 54
 feast days 71-2

foundation 64, 76
government, politics, and constitution:
 1282 establishment of popular regime 1, 7, 56
 1325-8 rule of Charles of Anjou, duke of Calabria **15**,
 20
 1342-3 rule of the duke of Athens **15-16**, 18 n., 50,
 71, 91, 92, fig. 5
 1378 Ciompi revolt **16-17**, 39, 87, **89-90**, 91, 107
 1458-83 Medicean reforms 23-4, **33-5**, 64-8 *passim*,
 92-3
 see also Medici: Lorenzo di Piero di Cosimo, political
 position
 1494: expulsion of Medici **39**, 70; republican reforms
 40-3 *passim*, 70, 92
 1512 restoration of Medici regime 36 n., 42, 46, 94
 1527 restoration of republican regime 94, **95-6**
 1530-2 restoration of Medici regime and abolition of
 the Signoria 2, 96
 see also consultative committees; councils; electoral
 procedure
maps 26 n., figs. 2, 52
palaces:
 Bargello (palace of the Podestà) fig. 1; attacks on 6,
 12 n., 80; construction 7, 12, 13, 79 n.; decoration,
 and restrictions on 48; destruction, partial 20;
 inscription on façade 7; internal disposition 18,
 armoury 12, council hall 12, 20; juridical bench
 36 n.; offices 66 n., 117; and Palazzo Vecchio 9, 10,
 13; praise for 87; residence of Charles of Anjou,
 duke of Calabria 15; square, lack of 79, 80
 Condotta 17 n., 88, 89, 91
 Mercanzia 31 n., 45 n., **87-8**, fig. 56
 see also Captain of the People; Cerchi; Executor of the
 Ordinances of Justice; Gondi; Guelf party; Medici;
 Palazzo Vecchio; Pazzi; Pitti; wool guild
patron saints 57, 60, 62, 71
 see also Christ; Mary, Virgin; St Anne; St John the
 Baptist; St Victor; St Zenobius
piazzas 8, 80
 S. Apollinare 79
 S. Giovanni 80 n.
 S. Maria Novella 80
 see also Piazza della Signoria
population, growth of 1
rivalry with Siena 11
Roman forum 8
seal 54-5, 106, fig. 21
streets:
 Via dell'Agnolo 80 n.
 Via Bellanda 9, 87 n.
 Via Calzaiuoli 83, 85-6, 88, 92
 Via dei Cerchi 14
 Via dei Cimatori 14, 87
 Via Condotta 82 n.
 Via delle Farine 82 n.
 Via del Garbo, *see* Via Condotta
 Via dei Gondi 41 n., **88-9**, 110
 Via dei Leoni 87 n.

streets (*cont.*)
Via della Ninna 87 n., 88, 89
Via Pandolfini 80
Via delle Prestanze, *see* Via dei Gondi
Via di S. Pier Scheraggio, *see* Via della Ninna
Via S. Procolo, *see* Via Pandolfini
Via S. Reparata 86
walls 1, 8, 13 n., 15, 80
restrictions on decoration 48
Foligno, Nine Worthies cycle 55
Foraboschi:
family properties 9, 10 & n.
Leone di Ormanno 9 n.
Fortune, wheel of, represented in Palace **50–1**, 55 n., 61
Fourteen, magistracy 5
Fra Bartolomeo, *see* Bartolomeo, Fra
France, king of, arms:
Palace 96
and palaces of foreign magistrates 48
Francesco di Agnolo, called La Cecca 59 n.
Francesco di Bernardo 77 n.
Francesco di Domenico, called Monciatto, *see* Monciatto
Francesco di Giovanni, called Francione, *see* Francione
Francesco di Niccolò di Tommaso 71 n.
Francesco di Piero di Donato 45, 77 n.
Francesco di Piero dell'Orto 99
Francione (Francesco di Giovanni):
ceilings and friezes **32–3**, 60 n.
Sala dei Gigli:
intarsia for door 33, **60**, 60 n., 61, 63
wall 33 n.
Frederick II, Emperor 13

gabella dei contratti and *del sale*, offices 89
Gabella delle Porte, Maestri della 25 n.
offices 22 n.
Gaddi, Angelo 49 n.
Gavacciani, Jacopo di Lapo 118
Ghiberti, Vittorio di Lorenzo 58
Ghirlandaio:
Benedetto, and *St Zenobius and Famous Romans* 62
Davide:
and *St Zenobius and Famous Romans* 62
tondo of Sts Peter and Paul **45**, 76–7, fig. 50
Domenico:
altarpiece, commission 59, 68
Confirmation of Franciscan Rule, S. Trinita 111, fig. 4
and Medici villa at Spedaletto 69 n.
St Zenobius and Famous Romans 33, 45 n., 56 n., **61–5**, 66 n., 68, 102, figs. 33, 35, 36
Ridolfo, decoration of new chapel 77–8, fig. 51
Giannotti, Donato 41, 42, 110
Giellisz, Lieven 58
Giotto:
Famous Men cycle in Naples 55 n.
portrait of Charles of Anjou before Virgin 47–8
Giovanni, Francesco di Tommaso 97, **98**, 101
Giovanni di Chimenti 65 n.

Giovanni di Domenico da Gaiole:
benches 107
ceilings and friezes 30 n., **32–3**, 59 n., 60 n.
Giovanni di Firenze 55 n.
Giovanni di Guccio 55 n.
Giovanni da Maiano 67 n.
Girolamo di Giovanni 66 n.
Giuliano da Maiano:
ceilings and friezes **32–3**, 60 n., 67 n.
intarsia in Cathedral 62, fig. 34
and Pazzi properties 67
report on work in Secretum 109
Sala dei Gigli:
intarsia for door 33, **60**, 61, 63
wall 33 n.
Giuncarico, painting of *castello*, Palazzo Pubblico, Siena 48
Giuntini, Giovanni 84 n.
Gondi:
Giuliano di Leonardo 88 n.
palace 88 n.
gonfaloni, arms 18
Gonfalonier of Justice:
creation **5**, 12 n.
duties 12, 80, 104
inauguration ceremonies 99
office-holders 6, 17, 27, 58 n., 70 n., 94, 96, 99, 101, 107
and Palace restoration 67
terms of office 3, 43, 46, 95 n.
see also Palazzo Vecchio: XI. Rooms, Gonfalonier of Justice; Signoria; Soderini, Piero di Tommaso
Gonfaloniers of Companies, *see* Sixteen Gonfaloniers
Gonzaga, Ludovico, marquis of Mantua 30 n., 59 n.
Grascia, offices 88, 91
Great Council, *see* councils: Great
Grifo di Tancredi 48 n.
guard of the Signoria, *see under* Palazzo Vecchio: VII. Household of the Signoria
Guariento 73–4
Guelf party:
arms in Palace 60
Captains 31 n., 85 n., 103, 110
division 6
palaces:
new 86, 88, 110
Trecento 88
Guicciardini, Francesco 42
Guidi:
Bartolomeo di Guido 93
Guido Novello, Count 7 n.
Jacopo di Piero:
reliefs on Loggia dei Lanzi 50 n., **86–7**, fig. 55
sculpture 50
Guidoriccio da Fogliano 47

Hawkwood, Sir John 75, 90
Henry VII, Emperor 13

Hercules:
 Antonio Pollaiuolo, *Labours of Hercules* 55, 70, **75**
 in Florentine imagery 54–5
 great seal of Florence 54–5, fig. 21
 image in Palace 54–5
household of the Signoria, *see* Palazzo Vecchio: VII.
 Household of the Signoria

inscriptions:
 Bargello façade 7
 Siena, Palazzo Pubblico 51, 60
 tomb of Cosimo de' Medici 94
 tradition of 72–3
 see also Palazzo Vecchio: I. General, inscriptions
inventories, *see* Palazzo Vecchio: IX. Inventories,
 Furnishings, and Objects
Isach (Isaac) di Giuseppe da Bologna 31 n.

Jacopo di Antonio 57 n.
Jewish bankers 25, 29 n., 31, 32 n., 33 n.
Joanna of Austria 28 n.
John XXII, Pope 15 n.
justice:
 allegory in Palazzo Pubblico, Siena 60
 and St Thomas the Apostle 51–2
 Udienza:
 invoked in inscriptions 51–2, 96 n.
 represented 60, fig. 31

Ladislas of Anjou, king of Naples 56
Landino, Cristoforo 54 n., 61
 and Palace 61, 65
Landucci, Luca 71, 112–13
Latino, Cardinal Malabranca 5, 80
legislation:
 façades of buildings 86
 Palace:
 ban on unauthorized alterations 27
 compulsory purchase of property 80
 construction 118
 household of the Signoria 37 n.
 Operai 58, **68–9**, 119–20
 Piazza 79, 80
 towers 10
 see also Ordinances of Justice; Statutes concerning Palace
Legnaia, villa of the Carducci at 61
Leo X, Pope, arms 96
Leonardo da Vinci:
 altarpiece, commission **59**, 68
 Battle of Anghiari: The Fight for the Standard 4, **73–5**,
 fig. 43
 see also Anghiari, battle
liberty:
 and Great Council 42
 invoked in inscriptions:
 Donatello statues 72
 Famous Men cycle 53, 64,
 Marzocco 17 n.

lilies, heraldic, *see* arms: Anjou *and* Florence
lions, heraldic, see *Marzocchi*
Lippi, Filippino:
 altarpiece, commission 70
 and Medici villa at Spedaletto 69 n.
 Sala dei Gigli:
 and intarsia panels 60
 mural decoration, commission 62
 Virgin and Saints 59, **66**, 75, fig. 37
Lippi, Filippo:
 Annunciation 57
 and Famous Men cycle 52
 Virgin adoring the Child 70, fig. 41
 Vision of St Bernard 57, fig. 24
Loggia dei Lanzi figs. 55, 58
 construction 16, 83, **86–7**, 118
 deployment of troops 90
 inauguration ceremonies 87
 reliefs 50 n., **86–7**
 symbolism 93
 see also *rialto*
loggias, in Italy, typical of despots 86
Loguyon, Jacques de 55
Lorenzetti, Ambrogio 47, 51
Lorenzo, Fra 47 n.
Lorenzo di Michelangelo 76 n.

Machiavelli, Niccolò 75
 and Palace 75 n., 101
Maestri della Gabella delle Porte, *see* Gabella delle Porte,
 Maestri della
magistracies:
 increase in number 2, **21–2**
 offices around Piazza 87–9
 see also individual names and under Palazzo Vecchio: XI.
 Rooms
Magnates:
 disenfranchisement 1, 6, **108**
 role in administration 21, **108**
 violence 5, **6**, 15
 see also Palazzo Vecchio: XI. Rooms, Sala dei Grandi
Maiano, Benedetto, Giovanni, and Giuliano da, *see*
 Benedetto da Maiano; Giovanni da Maiano;
 Giuliano da Maiano
Malaspina, Argentina, apartment 43, 44, 73, 107
Malatesta, Galeotto 75
Mancini family, houses 15 n.
Manetti, Antonio di Tuccio 24, 70 n., 94
Manieri family, houses 15 n., 87 n.
Manta, Nine Worthies cycle 55
Manuele di Bonaventura da Volterra 31 n.
Marcellus, M. Claudius, represented in Palace 53 n.
Mariano da Pescia 78, fig. 17
Marsuppini, Carlo 52 n.
Martelli:
 Antonio di Niccolò 32 n., 68 n., 119
 Domenico di Niccolò 105
Martin V, Pope 104

Martini, Simone 47, 48
Mary, Virgin:
 patron saint of Florence 57
 'queen of Florence' 96
 represented in Palace 101
 see also Bartolomeo, Fra; Ghirlandaio, Domenico;
 Ghirlandaio, Ridolfo; Giotto; Lippi, Filippino;
 Lippi, Filippo; Mariano da Pescia; Pesellino,
 Francesco; Ponte, Giovanni del
 represented in Venice, Doge's Palace 73–4
Marzocchi:
 façade and *ringhiera* 17
 friezes 60
 Ghirlandaio, *St Zenobius* 63, fig. 33
 newel post on stairs 19 n., 76 n., fig. 18
Masi, Piero di Bernardo 36 n., 116
Massai della Camera, offices 66 n.
Massimi, Carlo di Giulio 64 n.
Mazzei, Mazzeo di Giovanni 62 n.
Medici:
 arms in Palace 96 n.
 banks 32 n., 68, 69 n.
 members of family:
 Alessandro, Duke 94 n., 112; arms 96
 Bernardetto di Antonio 93 n.
 Carlo di Nicola di Vieri 58 n.
 Cosimo di Giovanni: building activity 67; compared
 to Furius Camillus 64; expulsion and return 87 n.,
 91, 92, 93; imprisonment in Palace 39; and Medici
 palace 30; Operaio 3, **24**, 67; opposition to 27 n.;
 political position 23, 92–3; tomb 94
 Cosimo I, Grand-Duke: move to Palace 112; and Pitti
 palace 1; *see also* Palazzo Vecchio: III. Building
 History, 1540–
 Ferdinand I, Grand-Duke 41
 Ferdinand III, Grand-Duke 17 n.
 Francesco, Grand-Duke 28 n.
 Giovanni di Cosimo 27, 67
 Giuliano di Lorenzo di Piero 64 n., 94; Operaio **77**,
 121
 Giuliano di Piero di Cosimo 64; and Verrocchio,
 David 56
 Lorenzo di Piero di Cosimo: criticism 65, 92; friends
 and clients 54, 61, 65, 69; and Palace: allusions to
 in Ghirlandaio, *Famous Romans* 64–5, 68, influence
 on building and decoration 3, **67–9**, **93–4**, Operaio
 3, **67**, 68, 69 n., 120, 121; political position 3, 23,
 33–5, 64–5, 67–8, 99; and Simonetta Cattaneo 60 n.;
 and Verrocchio, *David* 56; villa at Spedaletto 69
 Lorenzo di Piero di Lorenzo 77; Operaio 121
 Nicola di Vieri 58 n., 102
 Ottaviano di Lorenzo di Bernardetto 72 n.
 Piero di Cosimo: Operaio 3, 26 n., **27**, 67, 119;
 political position 92, 93
 Piero di Lorenzo: expulsion **39**, 70, 71–2; Operaio
 69 n., 121
 palace 30 n.
 chapel 42 n., 70

loggia 93
property confiscated from: Antonio Pollaiuolo, *Labours
 of Hercules* 55, 70, **75**; columns 42 n.; Donatello:
 bronze *David* 24 n., 56, 70, 72 n., *Judith and
 Holofernes* 70, 72; Filippo Lippi, *Virgin adoring the
 Child* 70
 windows 30, **31**, 67
 see also Clement VII, Pope; Leo X, Pope
Mercanzia, palace, *see* Florence: palaces, Mercanzia
Mercanzia, Sei di, offices 26
mercenaries 26, 74, 75, 90, 91, 93
 see also Hawkwood, Sir John; Piccinino, Niccolò;
 Ufficiali: della Condotta
Michelangelo Buonarroti:
 Battle of Cascina: The Bathers 4, **73–5**, fig. 44
 see also Cascina, battle
 David 56, **70**, 77 n.
Michele di Lando 17, 107
Michelozzi:
 Bartolomeo di Giovanni 24 n., 27 n.
 Michelozzo di Bartolomeo 27
 camere of the Signoria **30–1**, 97, 101
 courtyard **27–30**, 31, 58, 67
 Medici palace 30 n., 67
 mezzanine 18 n., 30
 new chapel 30–1
 porta della Catena 37 n.
 Niccolò di Michelozzo 36 n.
Milan:
 ducal palace 55 n.
 Loggia degli Osii 86
militia:
 civic **5–6**, 10, 80
 contado 80, 90
 reform 75
Minerbetti:
 Andrea di Tommaso 27 n., 119
 Piero di Giovanni 119
Monachi, Ventura 50, 51
Monciatto (Francesco di Domenico):
 benches 29 n.
 ceilings 32–3
 Sala dei Cinquecento 40
 Sala dei Dugento 60 n.
Montaccianico, painting of *castello*, Bargello 48
Montaperti, battle 7
Monte Officials, *see* Ufficiali: del Monte
Morelli, Matteo di Morello 27
Morto da Feltre 44 n., 77
Moses, represented in Palace 58

Naples, Castelnuovo 55 n.
Nardi, Jacopo 88 n., 112
Neri di Bicci:
 tabernacle **58**, 105
 tapestry 58
Neri di Fioravante, *see* Fioravanti, Neri
Nerli, Filippo 112

Neroni, Francesco Dietisalvi 109
Nine Worthies cycles 55, 56
 see also Famous Men cycles
Ninus, Emperor 53
Nobili, Antonio di Leonardo 120
Notaio delle Riformagioni, see Notary: of Legislation
Notaio delle Tratte, see Notary: of the Tratte
Notary:
 of Legislation 22–3, 109
 assistant (*coadiutor*) 23
 see also Palazzo Vecchio: XI. Rooms, Notary of
 Legislation
 of the Signoria 6, 12, **22**, 24
 see also Palazzo Vecchio: XI. Rooms, Notary of the
 Signoria
 of the Specchio (register of tax debtors) 88, 109, **115**
 offices 41 n., 88, 110, **115**
 of the Tratte 23
 assistant (*coadiutor*) 110
 see also Palazzo Vecchio: XI. Rooms, Notary of the
 Tratte

One Hundred, councils, *see* councils: Cento
Operai:
 Cathedral, *see* Florence: churches, Cathedral, Operai
 Palace, *see* Palazzo Vecchio: X. Operai del Palazzo
Ordinances of Justice 1, 6, 21, 80, 108
 see also legislation; Statutes, concerning Palace
Orlandini, Bartolomeo di Giovanni 91 n.
Orsanmichele, Company 83
Otto di Guardia **22**, 23, 32, 51, 93 n., 98, 116–7, 120
 see also Palazzo Vecchio: XI. Rooms, Otto di Guardia
Otto di Pratica:
 abolition 40
 creation and powers 23, 24, **34–5**
 restoration and final abolition 36 n., 66 n.
 see also Palazzo Vecchio: XI. Rooms, Otto di Pratica

Padua:
 Carrara palace 52, 53
 Palazzo della Ragione 13
palace of the Podestà, *see* Florence: palaces, Bargello
palaces:
 civic 8, 13
 conversion to princely residences 36
 decoration 47, 51 n.
 defensive features 13
 halls 12, 18, 102
 porticoes 13
 Siena, *see* Siena: Palazzo Pubblico
 symbolism 7, 14
 Venice, *see* Venice, Doge's Palace
 see also Florence: palaces

PALAZZO VECCHIO:

I. GENERAL

attacks on 12, 13, 37 n., 89–90, 94, 107

building materials:
 stone 45, 94 n.
 timber 25, 118
capomaestro (*maestro della muraglia*) 27, 45, 76 n., 77
inscriptions 49, 96
 see also under Donatello; Palazzo Vecchio: XI. Rooms,
 chapels of the Signoria, new, Otto di Guardia, Sala
 dei Cinquecento, Sala dei Dugento, Sala dei Gigli,
 Saletta, Udienza
name 1
patron saints, *see* Mary, Virgin; St Bernard of Clairvaux
sources for 2–3, 9, 35–6

II. ARCHITECTURAL ELEMENTS

balconies 18
ballatoio (gallery) **10**, 17–18, 43, fig. 12
 defensive and recreational use 13, 39
belfry **10**, 13, 30
 see also Palazzo Vecchio: VII. Household of the Signoria,
 members, bell-ringers
ceilings **47**, fig. 20
 arms 30
 and Operai 68
 see also under Palazzo Vecchio: XI. Rooms, Sala dei
 Cinquecento, Sala dei Dugento, Sala dei Gigli, Sala
 degli Otto, Sala dei Settanta, Udienza
columns:
 Cortile del Capitano 24 n., fig. 7
 passage to Sala dei Cinquecento **41–2**, 75
 principal courtyard 16 n., 26–30 *passim*, fig. 8
 Sala dei Dugento, doorways 76 & n.
courtyards:
 Cortile del Capitano (*or* Cortile della Dogana) **16**, 38, 98,
 101, fig. 7
 offices in **24**, 41, 116
 and Palace extensions 25, 41–2, 45, 117
 stairs **42**, 45 & n., 76 n.; door 45 n.
 well (*puteum Doane*) 69 n.
 principal fig. 8
 arms 30
 benches 29 n.
 columns 16 n., 26–30 *passim*, fig. 8
 decoration, *see also* Donatello: bronze *David* 30
 offices in **24**, 26–7
 proposed reconstruction 18, 98
 restoration: 1356 16 n.; by 1454 24, 26–7; 1454-
 26–30, 35, 58, 67; 1565 28 n., 30 n.
 stairs 19, 24 n., 30, **36**; door 30
 walls 30
 well 62 n.
doorways:
 between Sala di Gualdrada and new chapel 104
 decoration:
 Virgin *soprapporta* 66 n.
 see also Fortune, wheel of; Lippi, Filippo: *Vision of St
 Bernard*; Palazzo Vecchio: XI. Rooms, Udienza,
 decoration, *Incredulity of St Thomas*; Vanni, Antonio
 porta della Catena 30, **37**, 39

Palazzo Vecchio (*cont.*)

see also Pollaiuolo: Antonio, image of St John the
 Baptist; Verrocchio: *David*
see also under Palazzo Vecchio: XI. Rooms
façades:
 decoration and arms 17–18, 83, 96
 rustication **13–14**, 16 n., 45, figs. 3, 15, 16, 17
 north **9**, 81, 83, figs. 3, 16
 south 16 n., fig. 15
 west 83, **87**
gallery, *see* Palazzo Vecchio: II. Architectural Elements,
 ballatoio
passages (*anditi*):
 mezzanine:
 from offices of Notary of Legislation: to 'finestra della
 croce' **44**, 107–8; to Sala dei Grandi **27**, 107
 first floor:
 to Sala dei Cinquecento **41–2**, 45, 75
 second floor:
 fra le camere (along *camere* of the Signoria) 38, 46 n.,
 98, **101**; objects in 101; windows 38, **101**
 from *camere* of the Signoria to Udienza 37–8, **101**,
 104; painting in 49 n., 57; windows 38, 101
portals:
 north **9**, 13, 16 n., 81, fig. 3
 bulwarks **15**, 16, 111
 decoration 16 n., **17**, 83
 walled up (1380) **17**, 87
 west **13**, 81, 83
 bulwarks **15**, 16, 111
 lightning damage 24 n.
 sculpture, arms, and inscription **17**, 96
 steps 16 n., 19 n.
portcullises (*saracinesche*) 37 n.
rastrelli (wooden gates):
 mezzanine 44, **107–8**
 porta della Catena 37 n.
stairs 36 n.
 ballatoio to belfry **39**
 in Camera dell'Arme 36 n.
 Cortile del Capitano to Sala dei Cinquecento **42**, 45, 76 n.
 principal:
 courtyard to first floor 19, 24 n., 30, **36**
 first to second floor 19, 30, 37, 76 n., 107; newel post
 on mezzanine, *Marzocco* **19 n.**, 76 n.; *see also*
 Palazzo Vecchio: II. Architectural Elements,
 doorways, *porta della Catena* and *rastrelli*
 second floor to attic 38
 reconstruction by Vasari 19 n., **116**
 spiral:
 apartment of Soderini 44
 south wall **16** n., 19 n.
 west wall 19 n., fig. 19
tower 1, **10**, **13**, 30, 39
windows:
 construction 10 n.
 'finestra della croce' 44 n., 76 n., **107**
 ground floor 13

 mezzanine 18 n.
and Michelozzo 29, **30**, 31, 67
see also under Palazzo Vecchio: XI. Rooms

III. BUILDING HISTORY

1295–1302 construction 1–2, **5–14** *passim*, 79–80, 118
1342–3:
 enclosure walls **15–16**, 19 n., 24 n., 40–1, 45
 fortifications on portals and windows 15–16, 19 n., 111
 stairs 19 n.
1371 projected addition 16
*c.*1385 restoration 50, 52
1419 restoration **25**, 118
1444 projected addition and restoration **24–5**, 27 n.
1452 projected restoration 26, 67
before 1454 conversion of porticoes in courtyards for
 offices **24**, 26–7
1454– restoration 26–30
1463 restoration 30, 38, **97**, 101
1469–82 restoration 30, **31–5**, **58–65**, 67–8, 102–3
1495–6 construction of Sala dei Cinquecento **40–1**, 70,
 94 n., 120
1502– , *see* Palazzo Vecchio: XI. Rooms, Soderini, Piero,
 apartment
*c.*1507–*c.*1511 construction between medieval block and
 Sala dei Cinquecento 45–6, figs. 3, 15, 16
*c.*1511 construction of new chapel **45–6**, 77
1528 construction of new audience chambers 95, 116–17
1540– conversion into ducal residence 2, 19 n., 28, 30, **35**,
 36, 38 n., 41, 44 n., 46, 47 n., 66 n., 77 n., 101, 114,
 116, 117
1565–89 28 n., 63 n., 111
18th cent. 17 n., 18 n.
1865– 2, 35, 47 n., 76 n.
1908–29 19 n., 36 n., 47 n., 66 n.
see also under Palazzo Vecchio. XI. Rooms

IV. DECORATION

antique sources 60, 63 n., 76
civic and religious significance 50–78 *passim*
iconographic advisers:
 difficulties of identifying **3–4**, 67
 see also Medici: Lorenzo di Piero di Cosimo, and Palace;
 Soderini, Piero
see also under Palazzo Vecchio: XI. Rooms

V. FINANCES

bursars (*camerarii*) 15 n., 16 n., 17 n., 19 n.
funds allocated:
 1298–1349 5, 9, 10, 11, 15, 16 n., 17 n., 19 n., 47 n., 111
 1352–1445 16 & n., 18 n., 25, 50, 97
 1452–82 26 & n., 29, 31 & n., 32, 33 n., 58, 59, 61–2, 67,
 102
 1513–28 77 n., 95, 117
 from:
 church income 29 n.
 mercenary salaries 26, 29
 Otto di Guardia fines 32

Palazzo Vecchio (*cont.*)

taxes: on foreigners 32, 77 n.; *gabella* and Mercanzia 31 n.; on Jewish bankers and Christians using them 25, 29 n., 31 & n., 32 n., 33 n., 44 n.; judicial 77 n.

Ufficiali dei Ribelli funds 29 n.

payments:

1318–1429 24, 47, 49–50, 55 n.

1447–68 52, 57–8

1469–82 33 n., 37 n., 38 n., 56 n., 58 n., 59 n., 60 n., 61, 62 n., 65, 68 n., 101, 116

1483–1501 62 & n., 65, 66 & n., 69, 75 n., 76 & n., 102, 104, 110

1502–15 36 n., 41 n., 42 n., 43 n., 44 n., 45, 73, 76, 77 & n., 99, 104, 108, 112, 113

1530–2 37 n., 96 & n., 109

VI. FUNCTIONS

administrative 2, 11–12, **21–4**, **35–7**

council meetings, *see* Palazzo Vecchio: XI. Rooms, Sala dei Cinquecento and Sala dei Dugento

military 1, 10, 12, **13–17**, 18, 87

see also Palazzo Vecchio: I. General, attacks on

residence of the Signoria, *see* Signoria, and Palace

VII. HOUSEHOLD OF THE SIGNORIA 12, 21, 38–9

and arrest of Baldaccio d'Anghiari 38, 97, 98, 101

election 120

members:

barber 38–9

bell-ringers (*campanai*) 12, 21, 38

clock attendant 21

cook 12 n., 38

guard of the Signoria 1, **12**, 21

accommodation 12, 21, **42**, 95, 96

see also captain of the guard of the Signoria; Palazzo Vecchio: XI. Rooms, Camera dell'Arme

herald of the palace 21, 43 n., 94

messengers 12, 21

musicians 21, 103

paymaster (*spenditore*) 38

religious of the Camera dell'Arme 12, 21, 36, 47 n., **49**, 106, 120

bursars (*camerarii*) 15 n., 16 n., 17 n., 19 n.

servants (*donzelli, servitores*) 12 n., 21, 38

and Pazzi conspiracy 21, 39

regulations 21, 37 n.

see also Palazzo Vecchio: VIII. Internal Disposition, attic floor

VIII. INTERNAL DISPOSITION **18–24**, 36 n., 116

ground floor 18, 19, **36**, Ground plan I

first floor 18, 19, 27, **36**, Ground plan II

see also Palazzo Vecchio: XI. Rooms, Soderini, Piero, apartment, 'sala di sotto'

mezzanine floor 18, 34–5, **37**, Ground plan III

see also Malaspina, Argentina, apartment; Palazzo Vecchio: XI. Rooms, Soderini, Piero, apartment,

annexation of rooms, Dieci di Balìa, *and* Notary of the Tratte

second floor 18, 19, **37–8**, Ground plan IV

see also Palazzo Vecchio: XI. Rooms, Soderini, Piero, apartment, annexation of rooms, Notary of the Signoria

attic floor 18, 30, **38–9**, 47 n.

IX. INVENTORIES, FURNISHINGS, AND OBJECTS

inventories 2, 35

1366–8 97

1432 49 n.

1436, 1458 106

1471 35, 36 n., 38 n., 99, 101, 103, 104, 106, 107, 112, 116

1520 48 n.

1532 37 n., 49 n., 96, 99, 100, 106

andiron 101

banners 49, 63, 75, 99

bells 10 & n.

benches, bench-backs (*spalliere*) 29 n., 31 n., 34 n., 44 n., 59 n., 71, 76, 77, 103, 104, 109 n., 112

books 100

Greek Gospels 105

Leonardo Bruni, *Historiae Florentini populi* 105–6

Pandects 58, **105**

candlestick 97

see also Verrocchio: candlestick

carpets (*tappeti*) 100, 104, 112, 117

case (*cassetta*), casket 99, 105

chair 100

clock 103

cupboards and chests (*cassoni, armarii*) 45, 58, 99, 100, 101, 104

desk (*desco*) 100

golden rose 104–5

imperial privileges and documents **99**, 100, 104, 105

decrees of union with Greek Church 105

liturgical objects 106

relics (intended for) 105

seal, great, of Florence 106, fig. 21

shutters 44 n., 101

sideboards (*credenze*) 45, 103

silverware (*argenteria*) of the Mensa of the Signoria 31 n., 106

sink (*acquaio*) 101

tabernacles 58, **104–5**

tables 37, 103, 112

tapestries 66 n.

for *ringhiera* 58

tribunes of the Signoria 111–15

see also Palazzo Vecchio: XI. Rooms, Sala dei Cinquecento, Sala dei Dugento, and Udienza

X. OPERAI DEL PALAZZO 118–21

bursar (*camerario*) 31 n., 96 n.

criticism 68–9, **119–20**

depositaries 32 n., 68, 69 n.

election and terms of office 3, 27 n., **68–9**, 77–8, **120–1**

Palazzo Vecchio (*cont.*)
meetings 36 n.
members:
 1371 16 n., 118, 120
 1419 25
 1444 3, 24, 67, 118–19, 120
 1452–69 26, 27, 67, 119, 120
 1470–9 32 n., 67, 68 & n., 119, 120
 1479–95 3, 33, 62, 65 n., 67, 69, 93 n., 120
 1495 40, 120
 1513–32 77, 121
registers 2, **119–21** *passim*
requirement to display projects **58**, 59 n., 119–20

XI. ROOMS

antechamber of Sala dei Gigli 37
 see also Palazzo Vecchio: II. Architectural Elements,
 doorways, *porta della Catena*
 use by Notary of the Signoria 37 n., **38** n.
audience chambers:
 Piero Soderini, *see* Palazzo Vecchio: XI. Rooms,
 Soderini, Piero, apartment, annexation of rooms,
 Notary of the Signoria
 Signoria, *see* Palazzo Vecchio: XI. Rooms, Udienza
 see also under Palazzo Vecchio: XI. Rooms, Camera
 dell'Arme, Dieci di Balìa, Otto di Guardia, *and* Otto
 di Pratica
barber, room (*barberia*) 38–9
bell-ringers (*campanai*), room 38
Camera dell'Arme figs. 6, 11
 subdivision 36
 use:
 arsenal 12, 18
 audience chambers 34 n., 36
 offices of magistracies 27
camere (bedrooms):
 household 38
 Signoria, *see* Palazzo Vecchio: XI. Rooms: Gonfalonier of
 Justice, *camera and* Priors, *camere*
captain of the guard of the Signoria, room 36, 106, **116**
Chancellor of the Signoria:
 new room 45–6
 room 18, **38**, 46 n.
 door 38 n., 39
 see also Lippi, Filippo: *Vision of St Bernard*
chapels of the Signoria:
 in Udienza 37, 46, 78, **104–6**
 decoration **50** n., 104
 doorway 101, **104**
 furnishings and objects 57–8, 76, **104–6**
 see also Bartolomeo, Fra; Daddi, Bernardo; Ghirlandaio:
 Domenico, altarpiece, commission; Leonardo da
 Vinci: altarpiece, commission; Lippi, Filippo: *Virgin*
 adoring the Child
 new (1511) figs. 17, 51
 banner in 49
 construction **45–6**, 77
 decoration 30–1, 46, **77–8**

door 96
furnishings 77
inscriptions 78
see also Palazzo Vecchio: XI. Rooms, sacristy *and* Sala dei
 Cinquecento, altar *and* Sala dei Dugento, altar
Conservatori delle Leggi, offices 22 & n., 24, **26–7**
cook, room 38
depositeria 47 n.
Dieci di Balìa 22 & n., 37, 44 & n.
 audience chamber 24, **34**, 37, 43 n.
 new (1528–) 95
 sala 34 n.
 consultative committees 43
 see also under Palazzo Vecchio: XI. Rooms, Soderini,
 Piero, apartment
'diluvio' 36 n.
dining-rooms:
 household 38
 Signoria, *see* Palazzo vecchio: XI. Rooms, Sala dei Gigli
fra le camere, see Palazzo Vecchio: II. Architectural
 Elements, passages, second floor, *fra le camere*
Gabella delle Porte, Maestri della, offices 22 n.
Gonfalonier of Justice *camera* (bedroom) 18, **38**, 43, **97**, 98
 consultative committees in 99
 door 99–100, 101
 furnishings and objects 49 n., 75, **99**
 windows 38, 43, **99**
 see also Palazzo Vecchio: XI. Rooms, Priors, *camere, and*
 Soderini, Piero, apartment, *camera*
Great Council, hall of, *see* Palazzo Vecchio: XI. Rooms,
 Sala dei Cinquecento
hall:
 of Great Council, *see* Palazzo Vecchio: XI. Rooms, Sala
 dei Cinquecento
 of household 18
 second-floor undivided 102
kitchen 18, 38
Malaspina, Argentina, apartment 43, 44, 73, 107
 see also Palazzo Vecchio: XI. Rooms, Soderini, Piero,
 apartment
Notary of Legislation, offices 27, 37, **107–8**
Notary of the Signoria:
 camera (bedroom) 18, **38**, 46 n.
 see also under Palazzo Vecchio: XI. Rooms, Soderini,
 Piero, apartment
 office 37 n., **38** n.
Notary of the Tratte, offices 34 n., 37, 107
 see also under Palazzo Vecchio: XI. Rooms, Soderini,
 Piero, apartment
Otto di Guardia, audience chamber 22 & n., 36, **116–17**
 inscription 49, **51**, 116
 see also Palazzo Vecchio: XI. Rooms, Sala degli Otto
Otto di Pratica, audience chambers:
 in Camera dell'Arme 36
 see also Palazzo Vecchio: XI. Rooms, Dieci di Balìa,
 audience chamber
paymaster (*spenditore*), room 38
Priors, *camere* (bedrooms) 18, **38**, 43, **97–9**, 101

Palazzo Vecchio (*cont.*)
 original dormitory 21, **97**
 reconstruction 30–1, 38, **97**, 101
 see also Palazzo Vecchio: XI. Rooms, Gonfalonier of
 Justice, *camera*
prison (*alberghettino*) 39
privy (*necessarii*) 38, 46 n.
Regolatori delle Entrate e delle Uscite, offices 27
religious, rooms of 38
sacristy (*sagrestia*) 36, **106**
Sala delle Carte Geografiche 63 n.
Sala dei Cinquecento fig. 13
 altar:
 decoration 70; location 41 n., **114**; *see also* Bartolomeo,
 Fra; Lippi, Filippo: *Virgin adoring the Child*
 ceiling 40
 see also Vasari, Giorgio: *Antonio Giacomini addressing a
 Meeting*
 construction **40–1**, 94 n., 120
 conversions 42, **71**, 76 n., **95–6**, 109, 114
 decoration 70
 see also Leonardo da Vinci: *Battle of Anghiari*;
 Michelangelo Buonarroti: *Battle of Cascina*;
 Sansovino, Andrea
 doors 41–2
 to Secretum 110
 to Specchio 41 n., **115**
 inauguration ceremonies 40 n., **42**
 inscriptions 42, **73**, 96
 ringhiera (platform) for magistrates 71, 113
 scrutiny and sortition **40**, 110
 tribune of the Signoria **71**, 73, 110, **112–13**
 destruction and restoration 71, **114**
 location 41, **114–5**
 seat of Gonfalonier of Justice 71
 windows 114–15
Sala dei Dugento fig. 9
 altar, *see* Lippi, Filippino: *Virgin and Saints*
 arms 60
 ceiling, architrave, and frieze 30 n., **32**, 33 n., 59, **60**, 66,
 67 n., 68 & n., 69, 103
 conversions:
 1540– 35, 66 n.
 1865– 76 n.
 decoration:
 image of Hercules 54–5
 see also Lippi, Filippino: *Virgin and Saints*; Pollaiuolo:
 Antonio, *Labours of Hercules*; Vanni: Antonio di
 Francesco
 doorways **75–6**, figs. 45, 46, 47, 48
 inscriptions 54–5, 76
 restoration:
 1419 **25**, 118
 1444, 1452 (planned) **25–6**, 67, 118–9
 1469–78 31, 67; *see also* ceiling, architrave, and frieze
 above
 Secretum 36, **109–10**
 tapestries 66 n.
 tribune of the Signoria 41, 109, **111–12**, fig. 49

use:
 consultative committees 34 n., 102
 councils: Cento 24, 36; and Great Council, and
 Settanta 33–4, 40; Ottanta 42–3; People and
 Commune 18, **20**, 36
 scrutiny **20**, 36
 Six of Arezzo, room 42
 windows 15–16, 109
Sala dei Gigli 102–3
 antechamber, *see* Palazzo Vecchio: XI. Rooms,
 antechamber of Sala dei Gigli
 arms 55 n., 57 n., 59, 60, 62, 63
 ceiling, architrave and frieze 33, **59–60**, **65–6**, 69, 103,
 fig. 27
 construction 102
 doorways 63 n.
 see also Benedetto da Maiano: doorway; Giuliano da
 Maiano: intarsia
 decoration:
 mural: Botticelli, Filippino Lippi, Perugino, Piero
 Pollaiuolo, Domenico Ghirlandaio, commission **62**,
 69; Famous Men, *see* Ghirlandaio: Domenico, *St
 Zenobius and Famous Romans*; *fleurs-de-lis*: *c.*1416
 55 n., Bernardo Rosselli 1490 62, **69**; wheel of
 Fortune **50–1**, 55 n., 61
 see also Donatello: marble *David*
 furnishings and objects 103
 inscriptions 50–1, **64**, **65**, 68
 restoration:
 1469–89 31–3 *passim*, **58–66**; wall to Udienza 32, **60**,
 61, 103
 16th-cent. 35, 63 n.
 use:
 consultative committees 20, 37, **102**
 dining-room of the Signoria 37, 38, **103**
 waiting-room for Udienza 37, 102
 window 45 n.
Sala dei Grandi 21, 27, **107**, 108
Sala di Gualdrada 104
Sala degli Otto 95, **116–7**, fig. 61
Sala di Penelope, *see* Palazzo Vecchio: XI. Rooms,
 Gonfalonier of Justice, *camera*
Sala dei Settanta 24, **33–4**, 37, fig. 10
 benches 34 n., 59 n.
 ceiling 59, 66
 windows 59 n.
Saletta:
 and arrest of Baldaccio d'Anghiari 38, **98**, 101
 Famous Men cycle **52–4**, 55, 63
 inscriptions **52–4**, 64
 meetings 102
 consultative committees 20, **37**, 102
 portraits 52
Sea Consuls, offices 22, 27
second-floor undivided hall 102
Secretum, *see under* Palazzo Vecchio: XI. Rooms, Sala dei
 Cinquecento, doors *and* Sala dei Dugento
Sei di Mercanzia, offices 26
Signoria, *see* Signoria, and Palace

Palazzo Vecchio (*cont.*)
Six of Arezzo, offices 27, 42
Soderini, Piero, apartment **43–5**, 76, 77, 99, 100, 107–8
 annexation of rooms:
 Dieci di Balìa 43, 44
 Notary: of the Signoria 44, 45, 76, 100, decoration
 45, **76**; of the Tratte 44 & n.
 camera (bedroom) of the Gonfalonier of Justice 44, 76–7,
 99–100
 door 99–100, 101
 furnishings and objects **100**
 windows 38, 43, **99**
 criticism 44
 decoration 44 n., 45, **76–7**, 99
 furnishings 45, 100, 103
 paintings, *see* Domenico di Domenico; Ghirlandaio:
 Davide, tondo
 'sala di sotto' **44**, 77
 see also Malaspina, Argentina, apartment
Udienza (audience chamber of the Signoria):
 arms 57, 59, 60, 96, 112
 ceiling, architrave, and frieze 32–3, **59–60**, 103, fig. 28
 chapel, *see under* Palazzo Vecchio: XI. Rooms, chapels of
 the Signoria
 construction 102
 conversion 1540– 35
 decoration **50**, 52
 Incredulity of St Thomas 50, 51
 Jacopo di Piero Guidi, sculpture 50
 doorways 96
 see also under Benedetto da Maiano
 furnishings 37, 76, **103**, **112**
 inscriptions 50, 51–2, 60, 77, **96**
 objects 58, **104–6** *passim*
 restoration:
 1469–94, *see* ceiling, architrave, and frieze *above*; wall
 to Sala dei Gigli 32, **60**, 61, 103
 tribune of the Signoria 96 n., **111–12**
 use:
 consultative committees 37 n., 43 n., **102**
 by Duke Cosimo I 96
 sortition 20
Ufficiali:
 delle Castella, offices 22
 del Monte, offices 22 & n., **24**, 41, 116
 dei Pupilli, offices 24, **26–7**

Palmierini, Papio 69 n.
Pandects 58, **105**
Pandolfini, Pandolfo di Giannozzo 119
papacy, arms 48
 see also St Peter, keys of **89–94**
Parenti, Piero di Marco 43–4
parlamenti 15, 79, 80
 prohibited 73, 92
Parma 91
patriotism, republican, and Palace decoration 51, 56, 63–4,
 65, 67

patron saints:
 Florence, *see* Christ; Mary, Virgin; St Anne; St John the
 Baptist; St Victor; St Zenobius
 Palace, *see* Mary, Virgin; St Bernard
Pazzi conspiracy 21, 37, 38 n., **39**, 64, 67 n., 68, 72
 war 33, 61, 62, 64, 65
Pazzi family:
 Jacopo di Andrea 39, 67, 68, 119
 palace and villa 67
People, arms, *see* arms: Florence *and* Popolo
Perugino:
 Medici villa at Spedaletto 69 n.
 Sala dei Gigli mural decoration, commission 62
 Sistine Chapel 69 n.
Peruzzi, Simone di Rinieri 118
Pesellino, Francesco 57
Petrarch:
 fame in Florence 60, 61 n.
 and Famous Men cycle 52–3
 planned monument in Cathedral 53–4
 represented:
 in Palace 53–4, 60, 62, 63, fig. 32
 in villa of the Carducci 61
Piazza della Signoria figs. 40, 52, 53, 54
 alignment of houses 83, **85**, 118
 capomaestro 84
 entrances (*bocche*) **90–1**, 94
 extensions:
 1304–20 **81–2**, 118
 1342–3 planned 15, **82**
 1356 demolition of S. Romolo **82–3**, 85, 118
 1386 demolition of S. Cecilia 83–5
 function:
 aesthetic 79, 80, 81, 83, 85
 defensive **80**, 82, **90**, 92–3
 inauguration and public ceremonies **79–80**, 86 & n.,
 111
 parlamenti 80, **89**, 92–3, 111
 magistracies around 87–9
 northern section (*platea Ubertorum*) 8–9, **79–81**
 Operai 81 n., 118
 paving 81, 83, 84, 85 n., 93 n., 118
 and popular risings 17, **89–90**
 purchase and demolition of properties 80–6 *passim*, 118
 rialto 93–4
 western section, creation 80–1
 see also Loggia dei Lanzi; *ringhiera*; Tetto dei Pisani
piazza of the Uberti, *see* Piazza della Signoria: northern
 section
piazzas, in northern Italy 8, 79, 91
 see also Florence: piazzas
Piccinino, Niccolò 74
 banner 75, **99**
Pieri, Pierozzo di Piero 85 n.
Piero di Grifo 23 n.
Pisa:
 acquisition 22, 58, 105
 war 74–5

Pisano, Andrea 16 n.
Pitti palace 1
Podestà 6–7, 11, 80 n., 93, 111
 inauguration 14, 79
 original accommodation 7
 palace, *see* Florence: palaces, Bargello
Podestà, palaces in northern Italy 7
Poggio a Caiano, Medici villa at 64 n.
Pollaiuolo:
 Antonio:
 image of St John the Baptist 37 n., **57**
 Labours of Hercules 55, 70, **75**
 Piero:
 altarpiece, commission 59 n.
 Sala dei Gigli mural decoration, commission 62
 Simone, *see* Cronaca
Ponte, Giovanni del **57**, 66 n., fig. 25
Popolo, arms, *see* arms: Popolo
pratiche, *see* consultative committees
Prestanze, *see* Ufficiali: delle Prestanze
Priors:
 creation and number 1, 21
 original accommodation 5 n., 12 n.
 see also Signoria
Pulicciano, painting of battle, Bargello 48
Pupilli, Ufficiali dei, *see* Ufficiali: dei Pupilli

quartieri:
 arms 17–18
 and *camere* of the Priors 99
 division of city into 20–1
 see also *sestieri*

Regolatori delle Entrate e delle Uscite, offices 27, 88
religious of the Camera dell'Arme, *see under* Palazzo
 Vecchio: VII. Household of the Signoria
rialto 93–4
Ribelli, Ufficiali dei 29 n.
Ridolfi:
 Giuliano di Niccolò 93 n.
 Ridolfo di Pagnozzo 62 n.
 Tommaso di Luigi 120
Riformagioni, chancery, *see* Notary: of Legislation
ringhiera 15, 16, 111, figs. 4, 5, 57, 58, 59
 announcements, inauguration ceremonies, and *parlamenti*
 14–15, 58, 79–80, 86, 89, 93
 reconstruction **16**, 17, 111
 sculpture 17, 56, **70**
 tapestry 58
Robert of Anjou, king of Naples 55 n.
 arms 18
Romans, represented in Palace 53, 63–5
Rome:
 compared to Florence 2, 7, 53, 76
 Forum of Augustus 14 n.
 S. Sabina 76 n.
 see also Vatican
Romoli, Francesco di Andrea 120

Rosselli, Bernardo di Stefano:
 ceilings 65–6
 Sala dei Gigli mural decoration 62, 69
Rossi, Roberto di Francesco 54–5
Rucellai, Bernardo di Giovanni 3, 69, 93 n.
Ruspoli:
 Francesco 44 n.
 Lorenzo 44 n.
rustication:
 Cerchi palace 14
 Guelf party palace 88 n.
 Via S. Reparata buildings 86
 wall on west side of Piazza 85
 see also Palazzo Vecchio: II. Architectural Elements,
 façades

Sabato da Pistoia 31 n.
Sacchetti:
 Franco 97
 inscriptions: audience chamber of Otto di Guardia
 49, **51**, 116; *Marzocco* 17 n.; Udienza 50, **51–2**,
 77
 Niccolò di Franco 25 n.
St Anne:
 patron saint of Florence 71–2
 represented in Fra Bartolomeo, *Virgin and Saints* 71–2
St Bernard of Clairvaux:
 banner 49
 dedication of chapel of the Signoria 49, 104
 feast day 105
 patron saint of Palace **49**, 57
 represented:
 in Badia a Settimo 49 n.
 in Palace 78 & n.; *see also* Daddi, Bernardo; Lippi,
 Filippino: *Virgin and Saints*; Lippi, Filippo: *Virgin
 adoring the Child*
St Christopher, represented:
 on landing of stairs 49
 Palazzo Pubblico, Siena 50 n., 57 n.
 passage between Udienza and *camere* of the Signoria
 49 n., **57**
St Crescentius:
 relics 63
 represented:
 Ghirlandaio fresco 62–3, fig. 33
 intarsia in Cathedral 62, fig. 34
St Elizabeth, represented in Mariano da Pescia altarpiece
 78, fig. 17
St Eugenius:
 relics 63
 represented:
 Ghirlandaio fresco 62–3, fig. 33
 intarsia in Cathedral 62, fig. 34
St John the Baptist, represented:
 Filippino Lippi, *Virgin and Saints* 66, fig. 37
 Filippo Lippi, *Virgin adoring the Child* 70, fig. 41
 Mariano da Pescia, altarpiece 78, fig. 17
 Ridolfo Ghirlandaio, fresco 78, fig. 51

St John the Baptist, represented (*cont.*)
 Sala dei Gigli, doorway **60**, 62, fig. 29
 Udienza, tabernacle 58
St Mary Virgin, *see* Mary, Virgin
St Paul, represented in Davide Ghirlandaio, painting **45**,
 77, fig. 50
St Peter:
 keys of, represented 60
 see also papacy, arms
 represented in Davide Ghirlandaio, painting **45**, 77, fig. 50
St Thomas the Apostle, represented:
 civic palaces in Tuscany 51 n.
 Domenico di Domenico, painting **45**, 77
 Incredulity of St Thomas 50, **51–2**, 77
 Palazzo Pubblico, Siena 50 n.
St Thomas Aquinas, represented in Domenico di
 Domenico, painting 45, **77**
St Victor:
 patron saint of Florence 66 n., 74
 represented in Filippino Lippi, *Virgin and Saints* 66
St Zenobius:
 patron saint of Florence 62
 relics 63
 represented:
 Filippino Lippi, *Virgin and Saints* 66, fig. 37
 Ghirlandaio, *St Zenobius* 61–3, fig. 33
 Giuliano da Maiano, intarsia, Cathedral 62, 64
Salutati, Coluccio 22 n., 23 n., 89
 De laboribus Herculis 54 n.
 epigrams for Famous Men cycle **52–4**, 60, 64
 represented in Palace 52
Salviati, Francesco, Archbishop of Pisa 38 n., 39
Sandro dei Vetri, *see* Agolanti, Alessandro di Giovanni
Sangallo:
 Antonio da:
 Sala dei Cinquecento 40; chapel **70**, 71
 Giuliano da 76
Sansovino, Andrea, statue of Saviour, commission 71–2
Saviour, the:
 expulsion of Piero de' Medici on feast day 71–2
 see also Sansovino, Andrea
Savonarola, Girolamo:
 criticism of decoration 70
 criticism of *parlamenti* **73**, 92
 execution 42, fig. 40
 and Great Council 40, 42
 posthumous influence 95–6
 sermon in Sala dei Cinquecento 42
Scaevola, P. Mucius, represented in Palace 63, fig. 35
Scala, Bartolomeo 23, 34 n.
 and Famous Men cycle in Sala dei Gigli 65
Scipio Africanus:
 Lorenzo de' Medici compared to 64
 represented in Palace 53 n., 63, fig. 36
scrutiny, *see* electoral procedure
Sea Consuls, offices 22, 27
Sei di Mercanzia, offices 26
Serristori, Giovanni di Antonio 69 n.

sestieri:
 abolition 20–1
 division of city into 19
 and location of Palace 8 n.
 and Operai 118
 see also quartieri
Settimo, abbey 12 n., 49 & n.
Seventy, council, *see* councils: Settanta
Sforza, Francesco 26
 arms in Palace 57
Siena:
 Campo 79
 Cathedral, wheel of Fortune 50 n.
 Palazzo Pubblico:
 construction 11
 decoration 47, **48**, 50 n., 51, 57 n., 60
 rivalry with Florence 11
Signoria (Gonfalonier of Justice and Priors):
 abolition 2, 96, 121
 election 20
 inauguration ceremonies **14–15**, 17 n., 58, 79, 86, 111
 original accommodation **6**
 and Palace:
 choice of site 5, **8–9**
 dining-room 37, 38, **103**
 election of Operai 120
 inventories 106
 prohibition on leaving Palace 14
 residence 5, **14**, 19, 39
 tribunes 111–15, figs. 49, 59, 60; *see also* Palazzo
 Vecchio: XI. Rooms, Sala dei Cinquecento, Sala dei
 Dugento, *and* Udienza
 and Piazza 81, 84
 powers 3, 11–12, **19–20**, 34, 40
 see also chancery, Chancellor of the Signoria; Gonfalonier
 of Justice; Notary of the Signoria; Palazzo Vecchio:
 VII. Household of the Signoria, guard of the
 Signoria *and* religious of the Signoria; Palazzo
 Vecchio: XI. Rooms, Sala dei Gigli *and* Udienza;
 Priors
Six of Arezzo, offices 27, 42
Sixteen Gonfaloniers **19**, 20, 90
 and decoration of north portal 17
 inauguration ceremonies 79–80, 86 n.
 and Piazza 83 n.
 seating in Sala dei Cinquecento 73 n.
 see also Colleges; Twelve Buonuomini
Sixtus IV, Pope 110
Soderini, Piero di Tommaso, Gonfalonier of Justice for
 life 43–6
 and Palace decoration 73
 see also Palazzo Vecchio: XI. Rooms, Soderini, Piero,
 apartment
sortition (*tratta*), *see* electoral procedure
Specchio, *see* Notary: of the Specchio
Spedaletto, Medici villa at 69
Spinelli, Ricco di Domenico 24
Statutes, concerning Palace 10, 20 n., 21, 102, 109, 111

Statutes, concerning Palace (*cont.*)
 see also legislation; Ordinances of Justice

Taddeo di Bartolo 50 n., 57 n.
Tasso, Battista del 28
Tetto dei Pisani 85 n., **86**, 93 n., fig. 54
Torelli, Piero di Guido 93 n.
Torre, Ufficiali della, *see* Ufficiali: della Torre
towers, family 14
 ballatoi 13
 Foraboschi 10
 Neri 85 n.
 restrictions on height **10**, 13
 Uberti 13
tratta, see electoral procedure
Tratte, chancery, *see* Notary: of the Tratte
Troscia, Bartolomeo del 96 n.
Twelve Buonuomini 19, 20, 84–5
 seating in Sala dei Cinquecento 73
 see also Colleges; Sixteen Gonfaloniers

Uberti family, houses 8, 9 n., 81
Ufficiali:
 delle Castella, offices 22
 della Condotta, *see* Florence: palaces, Condotta
 del Contado, offices 89
 della Grascia, offices **88**, 91
 del Monte 23, 120
 offices **22** & n., **24**, 41, 116
 delle Prestanze, house 41 n., 88, 110, **115**
 dei Pupilli, offices 24, **26–7**
 dei Ribelli, offices 29 n.
 della Torre, and extension of Piazza 118
uomini famosi, see Famous Men cycles
Uzzano, Niccolò di Giovanni da 25 n.

Vanni:
 Antonio di Francesco 49–50
 Lippo 48
Varchi, Benedetto 112
Vasari, Giorgio:
 Antonio Giacomini addressing a Meeting 41 n., 76, 112,
 fig. 49
 and Medici palace 30 n.
 on Palace:
 apartment of Soderini 77
 depositeria 47 n.
 Michelozzo as architect of Palace **27–31**; *camere* of the
 Priors 30, **97**, 101; courtyard **28–31**, 67; mezzanine
 18 n.; *porta della Catena* and stairs 37 n.
 Sala dei Cinquecento 41 n., 73, 110, 113; tribune of
 the Signoria 41, **114–15**
 stairs **16** n., 19 n., 37 n.
 see also Palazzo Vecchio: III. Building History,
 conversion into ducal residence
Vatican, Sistine Chapel 69 n.
Venice, Doge's Palace, hall of the Maggior Consiglio 41,
 fig. 14
 Guariento, *Coronation of the Virgin* 73–4
 tribune of the Signoria **41**, 71, 112, 115

Verrocchio, Andrea del:
 and Antonio Pollaiuolo, *Labours of Hercules* 75 n.
 candlestick **58**, 106, fig. 26
 David 37 & n., **56**, 59, 70, fig. 23
Vespasiano da Bisticci 106
Villani:
 Filippo 50
 Palace: Famous Men cycle 52, 53; Michelangelo
 Buonarroti, *Battle of Cascina* 75
 Giovanni:
 duke of Athens and Palace 16, 82
 Florence 1, 2
 Foraboschi tower 10
 original accommodation for the Signoria 6
 scrutiny 102
 Matteo 18, 50
Virgin, *see* Mary, Virgin
virtues, representations of:
 on Loggia dei Lanzi 50 n., 86–7, fig. 55
 in palace of the wool guild 53 n.
 in Sala dei Gigli 60, fig. 30
 see also justice
Visconti:
 Azzone 55 n.
 Filippo Maria 72 n., 75, 99
 Giangaleazzo 53, 54, 56, 72 n., 89
 Luchino 91
 Matteo 86
Vitale di Dattilo da Montalcino 31 n.
Volterra 33 n.
Volpaia, Lorenzo di Benvenuto della 103

walls, city:
 Castrocaro 31
 Empoli 65
 Facciano 31
 Parma 91
 see also Florence: walls
Walter of Brienne, duke of Athens:
 expulsion **16**, 71–2, 91
 Expulsion of the Duke of Athens from Florence 18 n., fig. 5
 rule **15–16**, 50, 87 n., 92
 see also Palazzo Vecchio: III. Building History, 1342–3;
 Piazza della Signoria, extensions, 1342–3
war, affecting Palace construction or decoration:
 of the Pazzi conspiracy 61, 62, 64, 65
 with Pisa 74, 75
 with Pope Gregory XI 17 n.
 with Siena 7
 with Venice 26, 65
 with Visconti:
 Filippo Maria 72 n.
 Giangaleazzo 53, 54, 56
wheel of Fortune, *see* Fortune, wheel of
wool guild, palace 53 n.
women, presence in Palace 43, 44

Zanobi da Strada:
 planned monument in Cathedral 53–4
 represented in Palace 53–4

PLATES

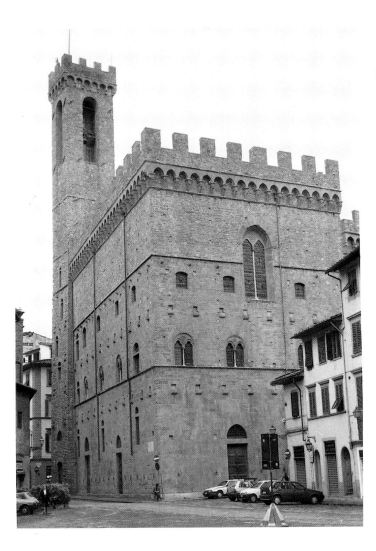

1. Florence, Bargello

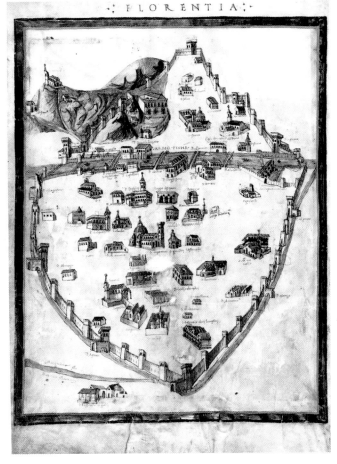

2. Pietro del Massaio, Plan of Florence (1469). Ptolemy, *Cosmographia*, Biblioteca Apostolica Vaticana, Cod. Vat. lat. 5699, fo. 126ᵛ

3. North façade

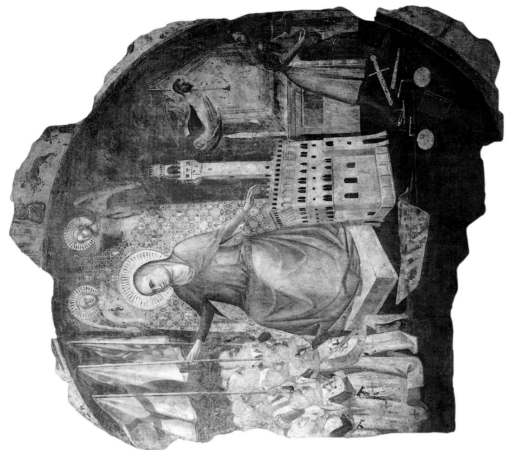

5. Orcagna, attr., *Expulsion of the Duke of Athens from Florence* (detached fresco now in the Saletta)

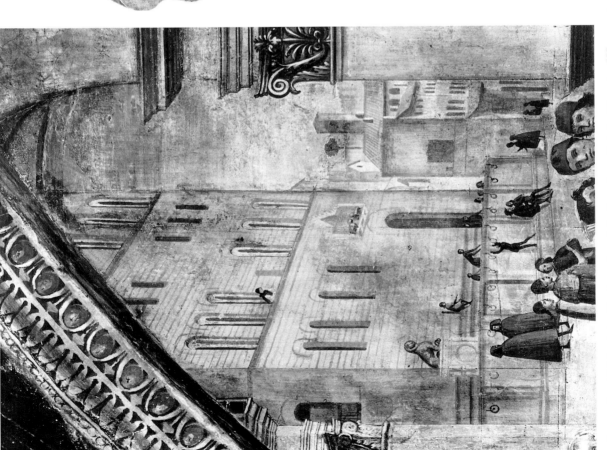

4. Domenico Ghirlandaio, *Confirmation of the Franciscan Rule by Honorius III.* Florence, S. Trinita. Detail.

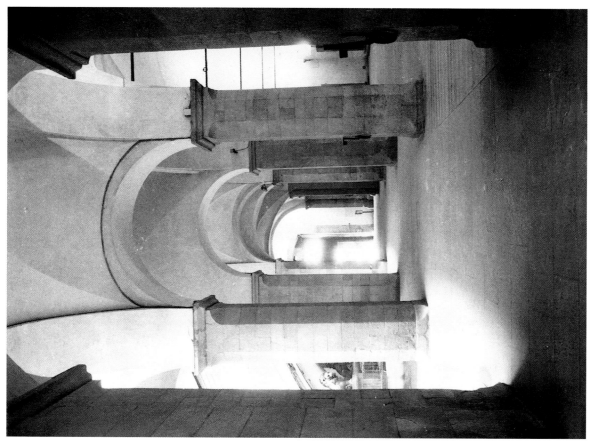

7. Cortile della Dogana

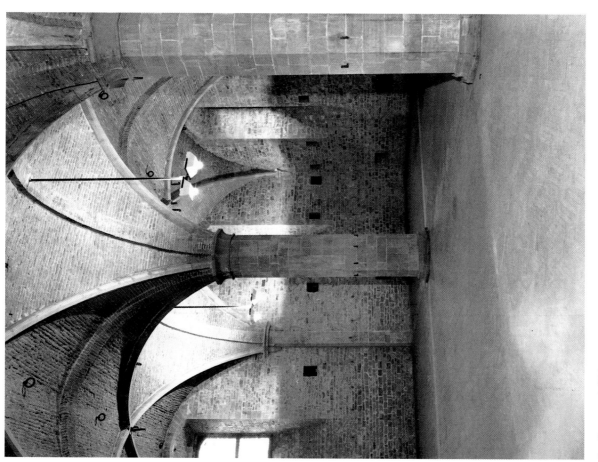

6. Camera dell'Arme

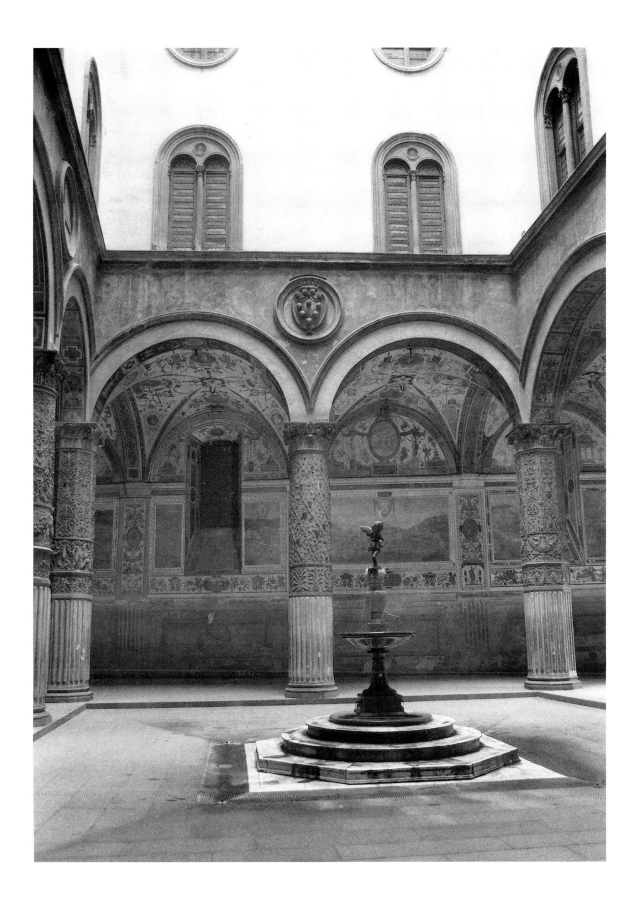

8. Courtyard

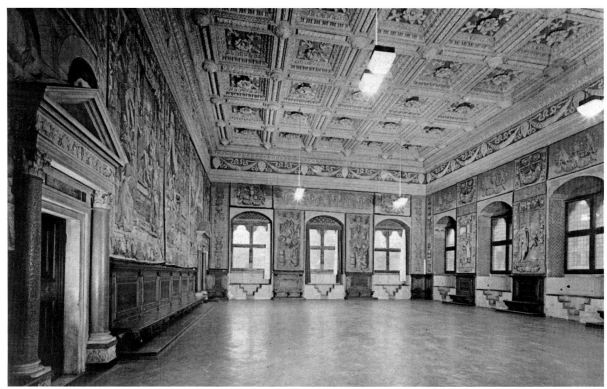

9. Sala dei Dugento. By courtesy
 of Scala

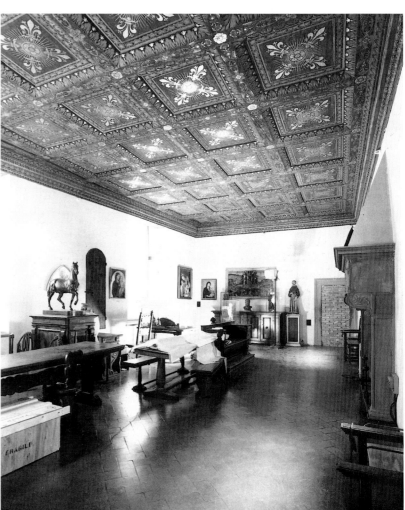

10. Room on the mezzanine

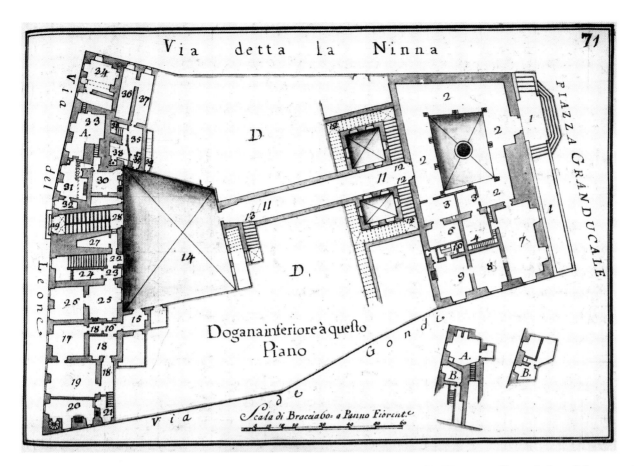

11. Ground plan of the ground floor (*c*.1775). Prague, State Archives, Family Archive of the Habsburgs in Tuscany

12. Ballatoio

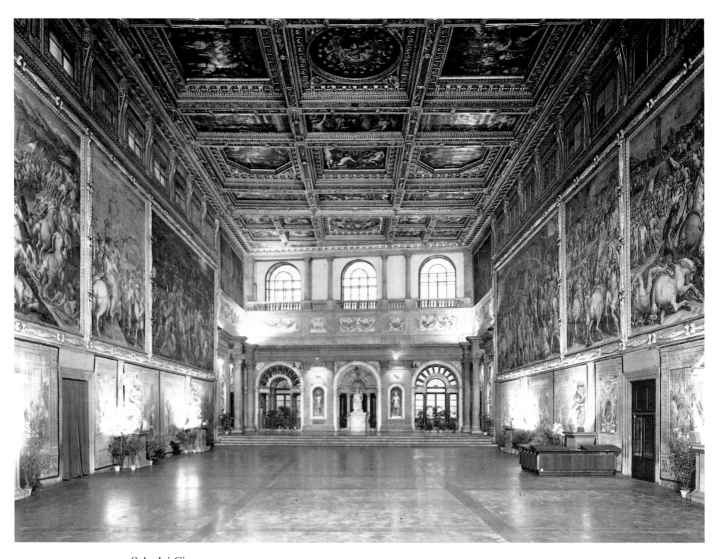

13. Sala dei Cinquecento

14. (*right*). Anon., *Sala del Maggior Consiglio*, Venice, Doge's Palace, sixteenth-century engraving.
By permission of the British Library

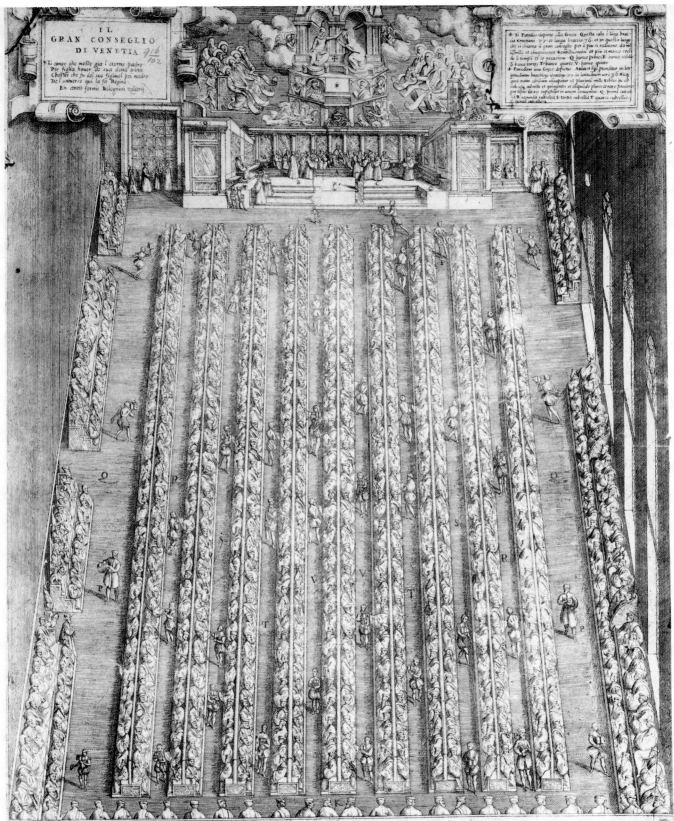

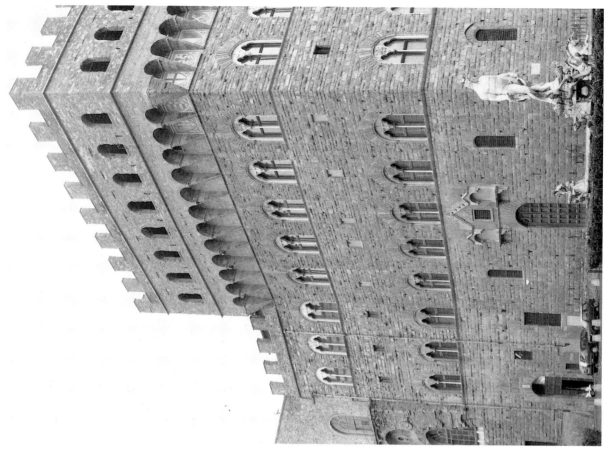

16. North façade

15. South façade, detail

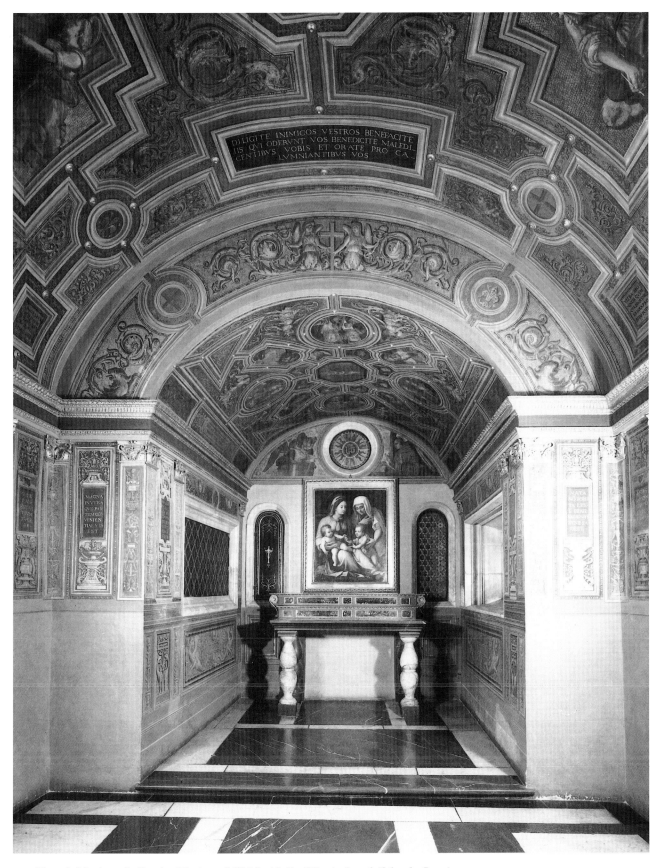

17. Chapel, Mariano da Pescia, *Virgin and Child with Sts Elizabeth and John the Baptist*

18. Newel post on the mezzanine (photo of 1931)

19. Spiral stairs in west wall

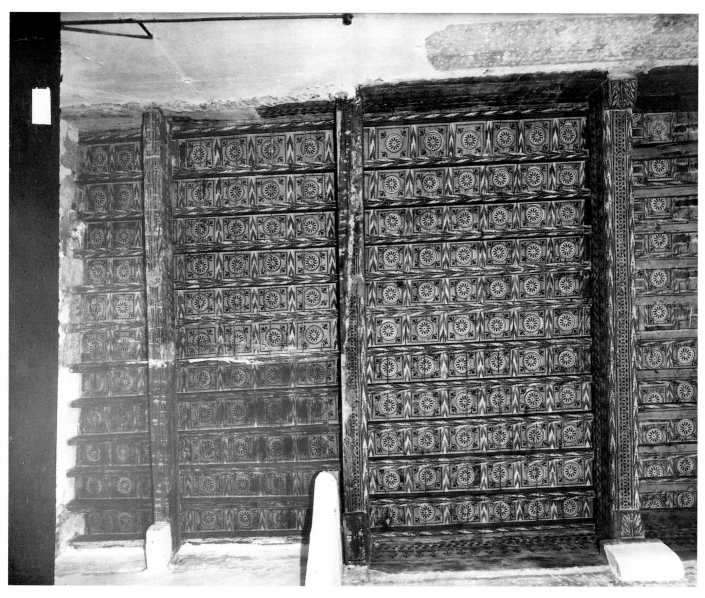

20. Mezzanine, fourteenth-century ceiling

21. Hercules seal of Florence, cut by
Domenico di Polo, 1532. Florence,
Palazzo Pitti, Museo degli Argenti

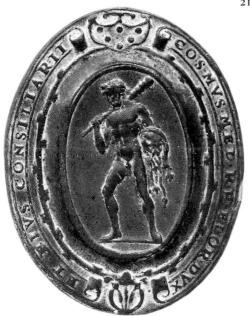

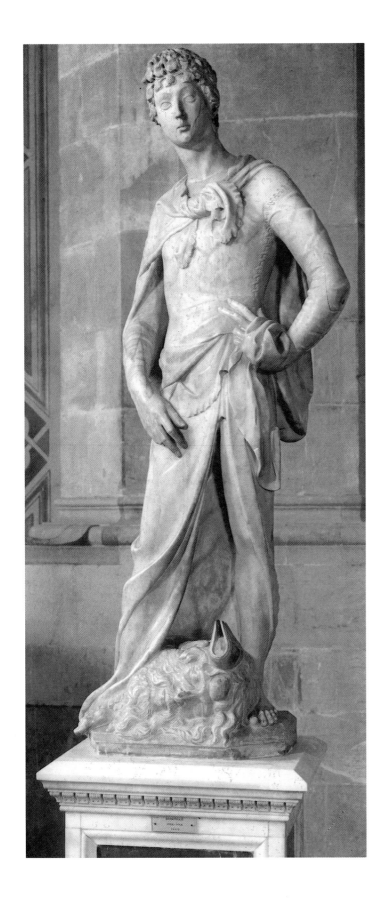

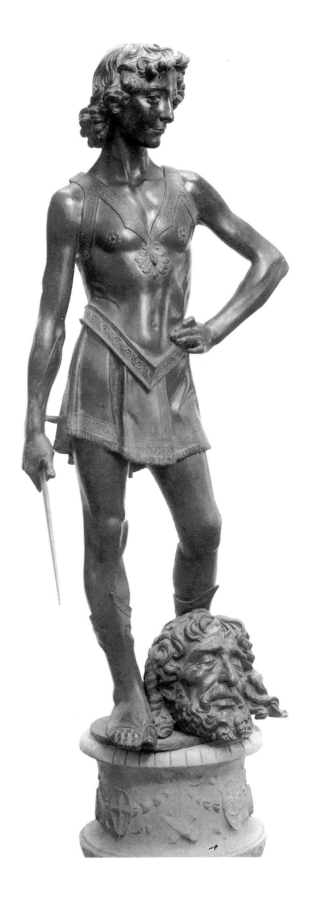

22. Donatello, marble *David*. Florence, Museo del Bargello

23. Verrocchio, *David*. Florence, Museo del Bargello

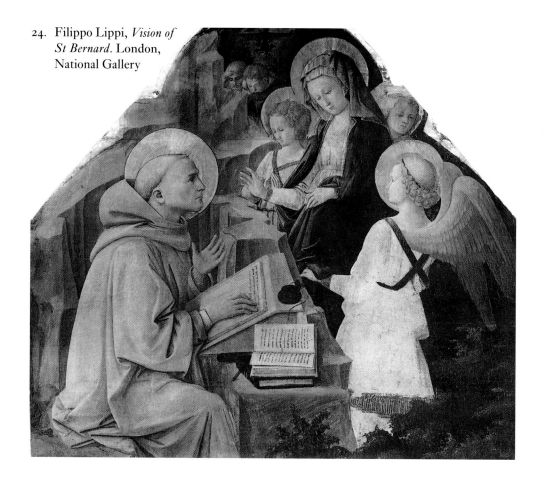

24. Filippo Lippi, *Vision of St Bernard*. London, National Gallery

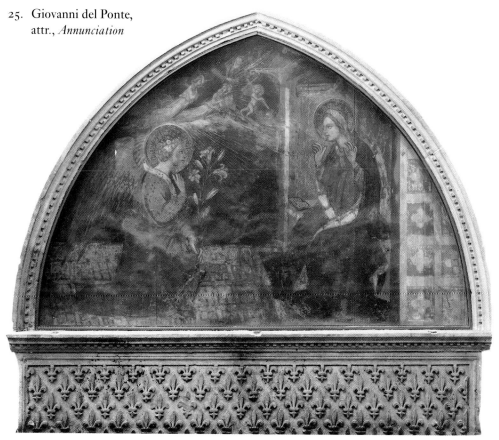

25. Giovanni del Ponte, attr., *Annunciation*

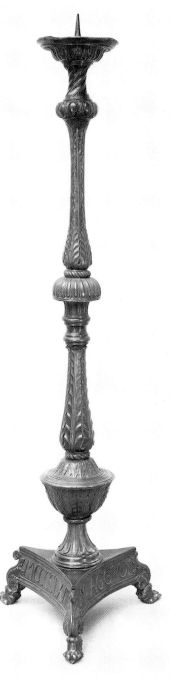

26. Verrocchio, Candlestick. Amsterdam, Rijksmuseum

28. Udienza, ceiling, detail. By courtesy of Scala

27. Sala dei Gigli, ceiling, detail. By courtesy of Scala

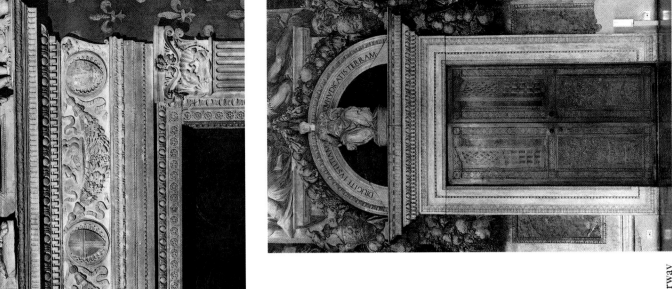

30. Sala dei Gigli, marble doorway,
 detail

31. Udienza, marble doorway

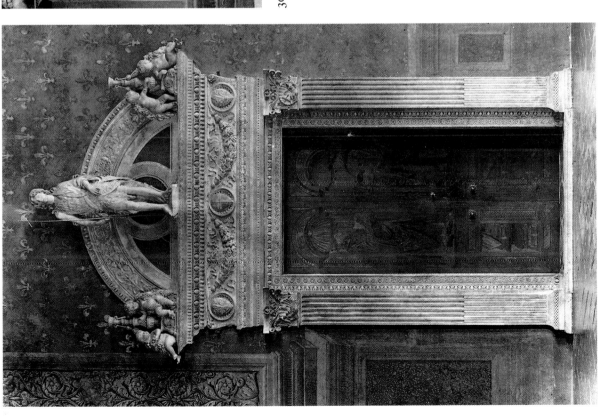

29. Sala dei Gigli, marble doorway

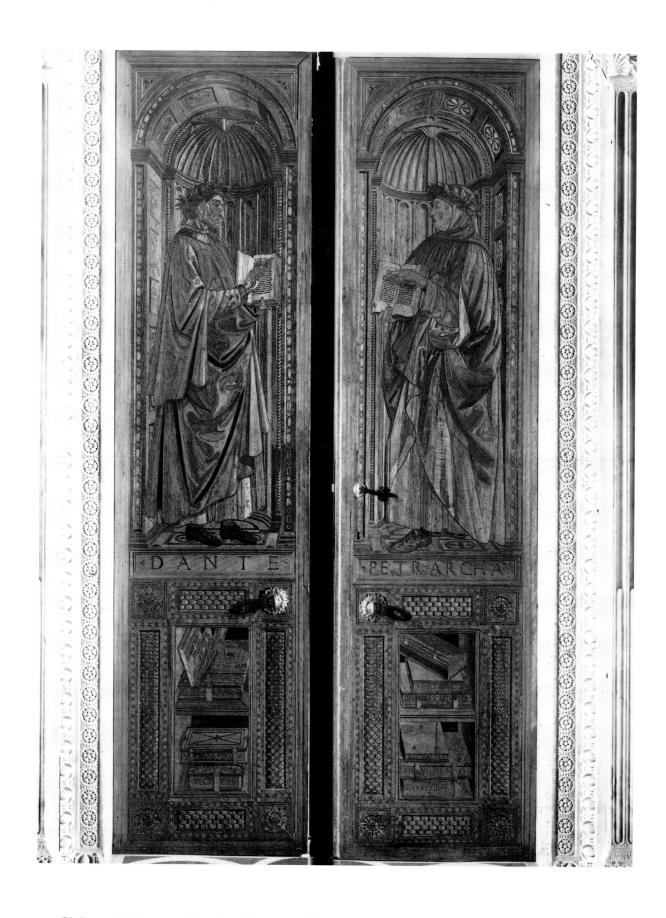

32. Giuliano da Maiano and Francione [Francesco di Giovanni], *Dante* and *Petrarch*, inlaid panels.
Sala dei Gigli, marble doorway

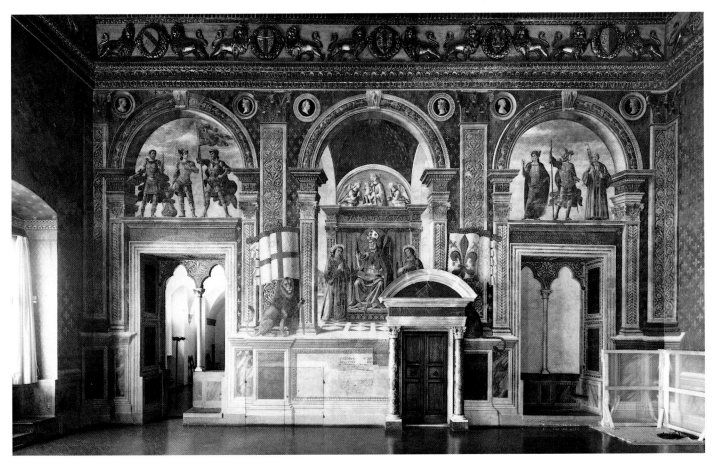

33. Domenico Ghirlandaio, *St Zenobius and Famous Romans*. Sala dei Gigli

34. Giuliano da Maiano, *St Zenobius with Sts Eugenius and Crescentius*, inlaid panel. Duomo, Sacrestia delle Messe

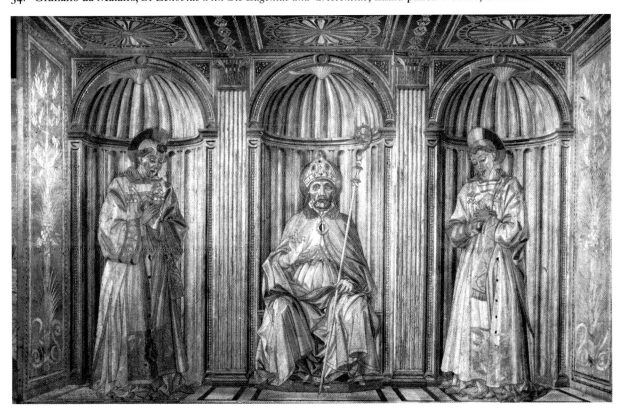

35. Domenico Ghirlandaio, *Famous Romans*, left side

36. Domenico Ghirlandaio, *Famous Romans*, right side

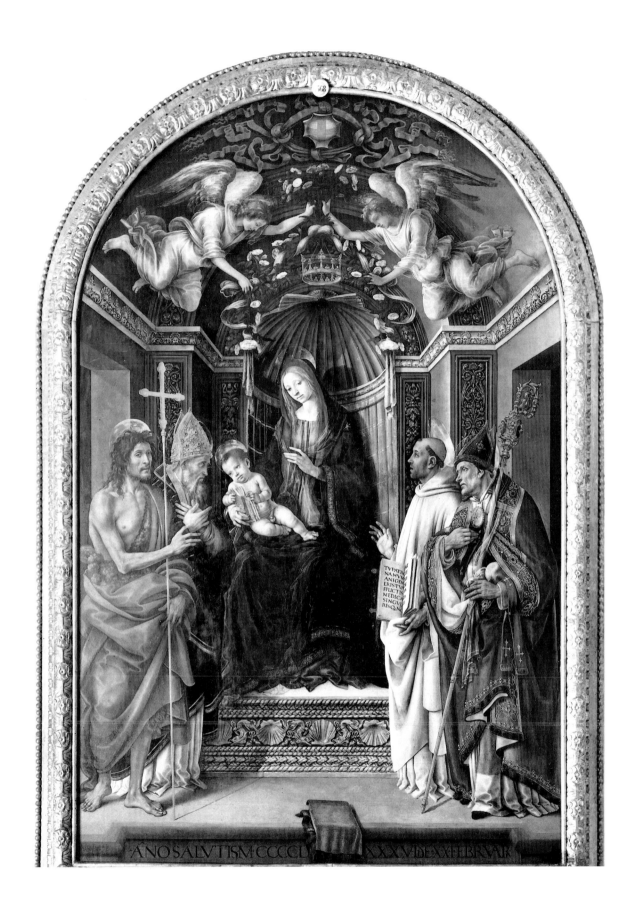

37. Filippino Lippi, *Virgin and Saints*. Florence, Galleria degli Uffizi

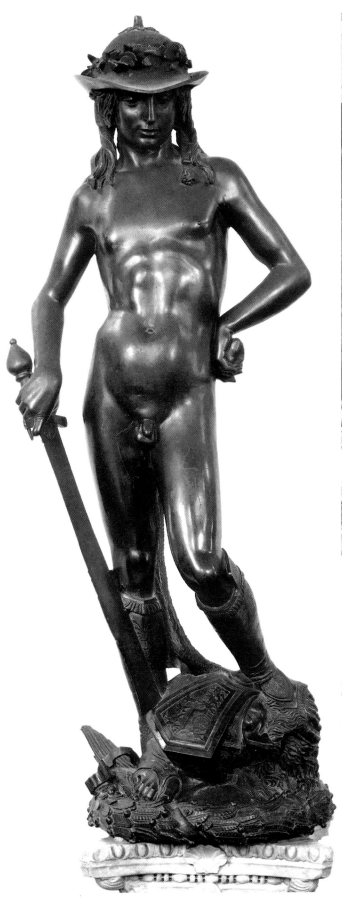

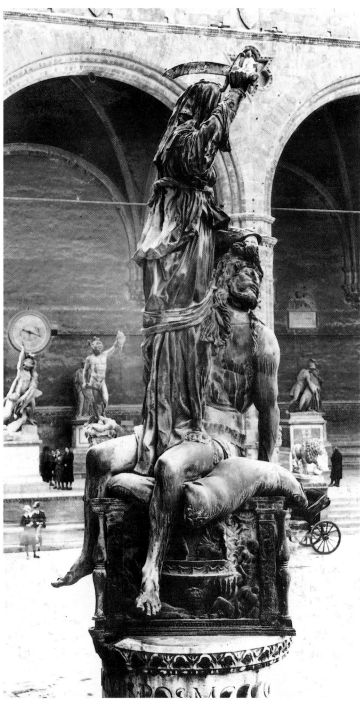

39. Donatello, *Judith and Holofernes*. Piazza della Signoria (now in the Sala dei Gigli)

38. Donatello, bronze *David*. Florence, Museo del Bargello

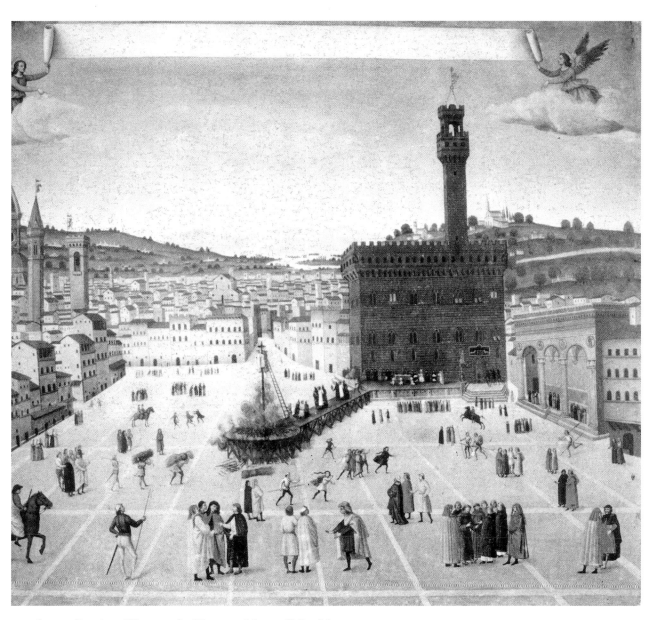

40. Anon., *Burning of Savonarola*. Florence, Museo di San Marco

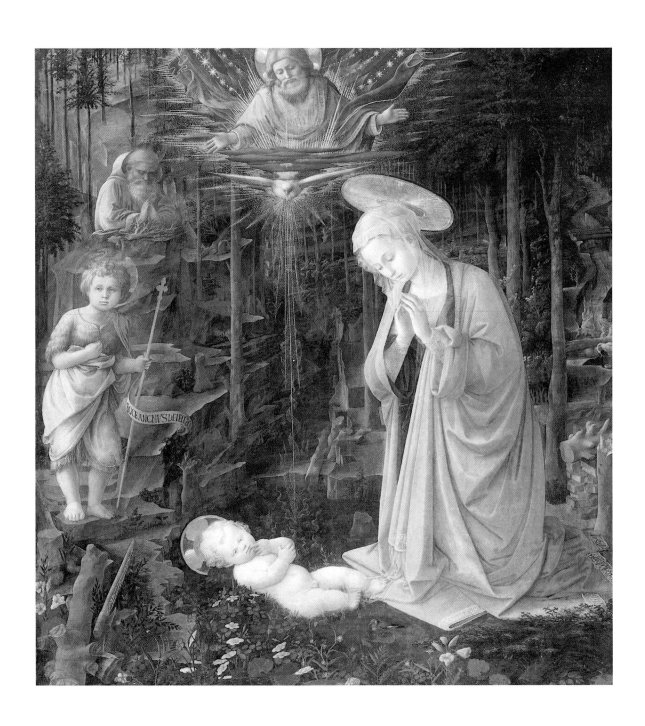

41. Filippo Lippi, *Virgin Adoring the Child*, Berlin, Staatliche Museen,
Preussischer Kulturbesitz, Gemäldegalerie

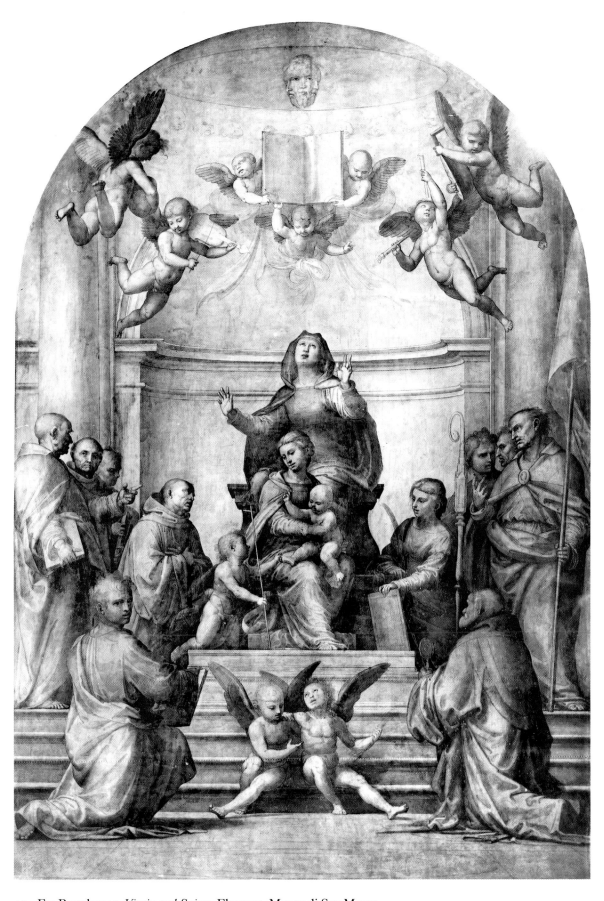

42. Fra Bartolomeo, *Virgin and Saints*. Florence, Museo di San Marco

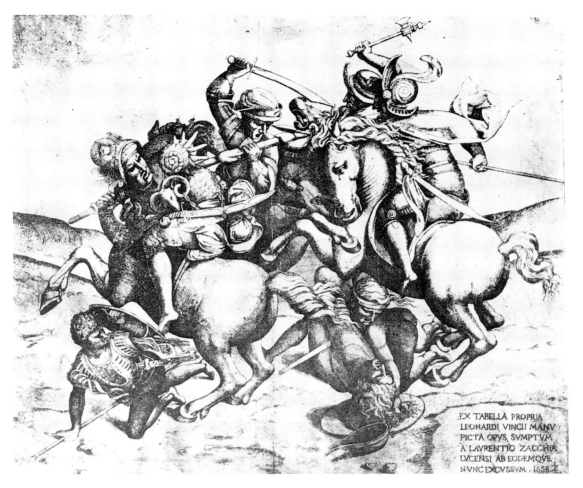

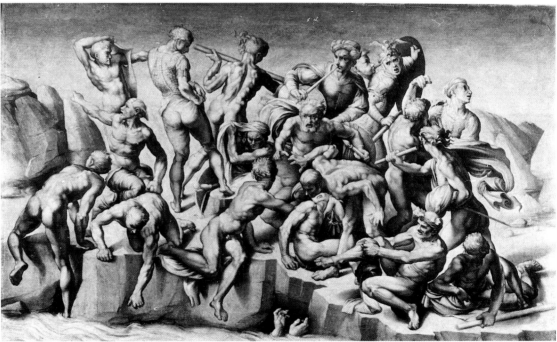

43. (*above*). Leonardo da Vinci, *Battle of Anghiari: The Fight for the Standard*, engraving by Lorenzo Zacchia after Leonardo. Vienna, Albertina

44. (*below*). Michelangelo Buonarroti, *Battle of Cascina: The Bathers*, grisaille by Bastiano da Sangallo, attr., after Michelangelo. Holkham Hall. By kind permission of Viscount Coke and the trustees of the Holkham estate

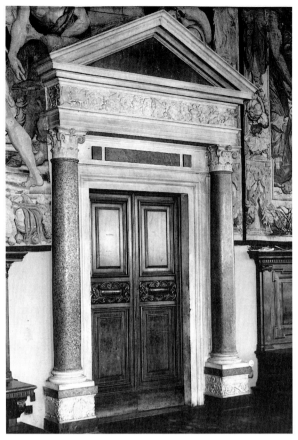

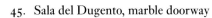
45. Sala del Dugento, marble doorway

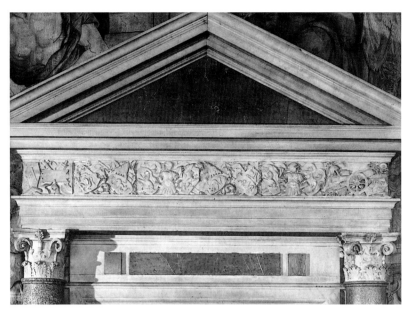

46. Sala del Dugento, marble doorway, frieze

47. (*left*). Sala del Dugento, marble doorway, base, detail of 45

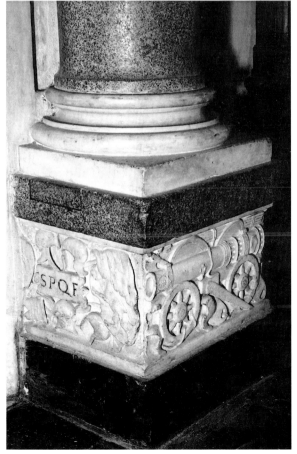

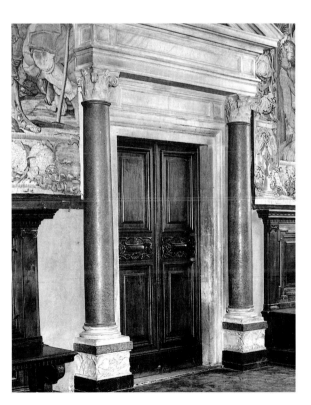

48. Sala del Dugento, second marble doorway

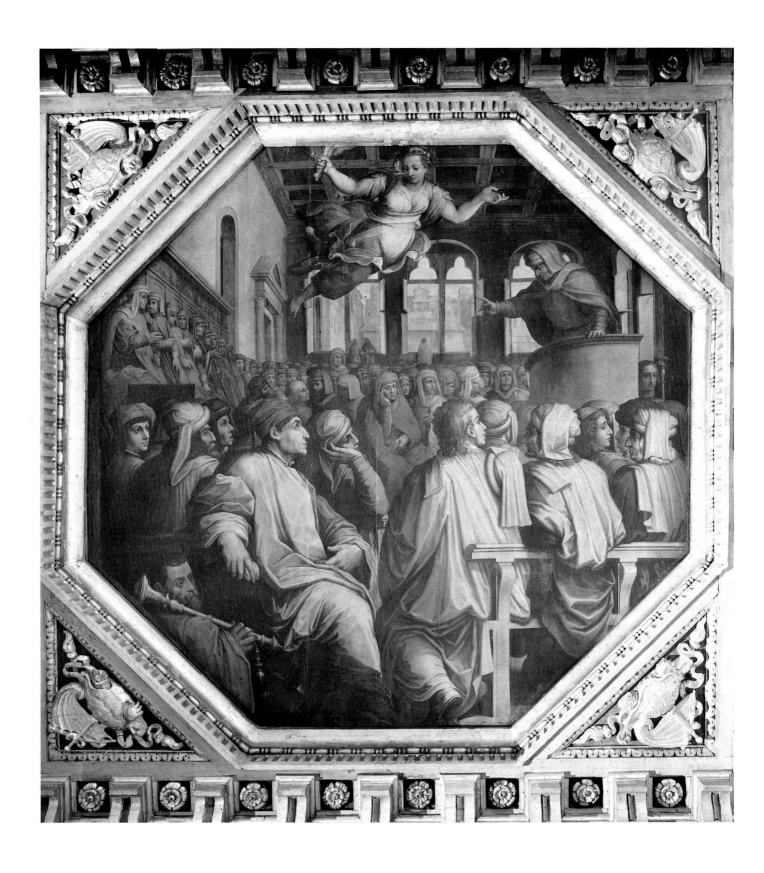

49. Giorgio Vasari, *Antonio Giacomini Addressing a Council Meeting*. Sala dei Cinquecento

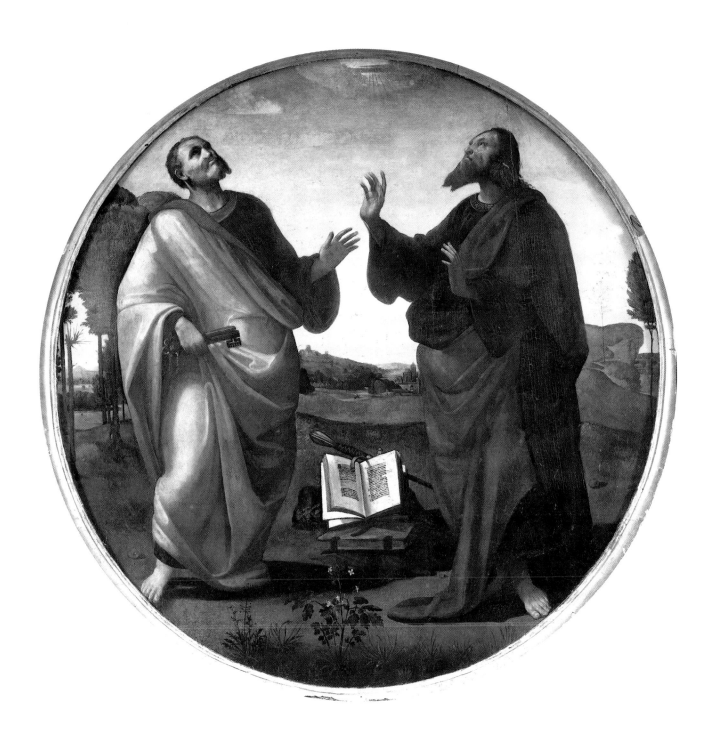

50. Davide Ghirlandaio, *Sts Peter and Paul*. Florence, Palazzo Pitti, Galleria Palatina

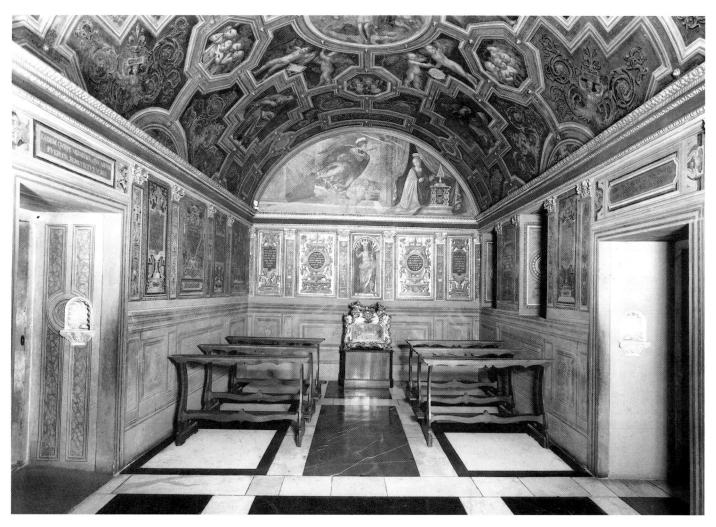

51. Chapel, Ridolfo Ghirlandaio, *Annunciation*

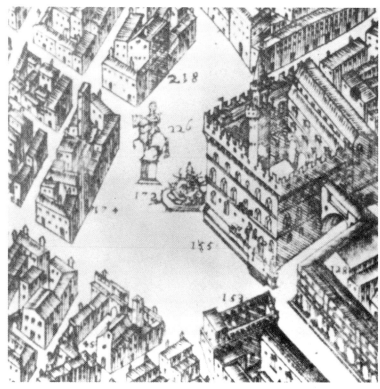

52. Stefano Bonsignori, Map of Florence (1584), detail

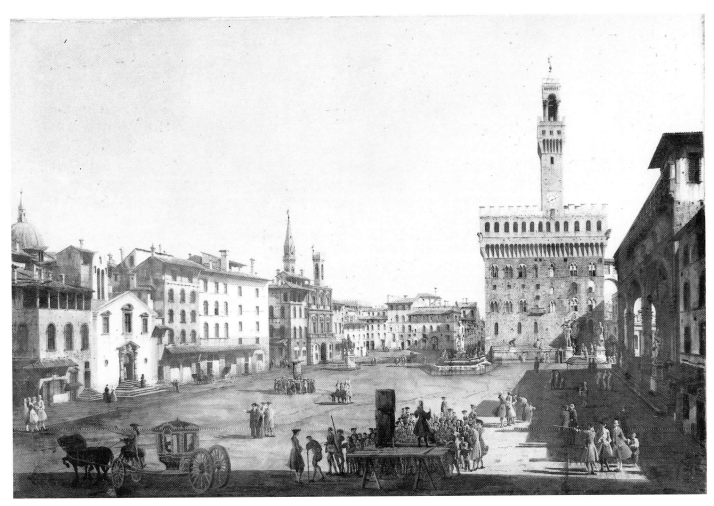

53. Bernardo Bellotto, *Piazza della Signoria*. Budapest, Museum of Fine Arts

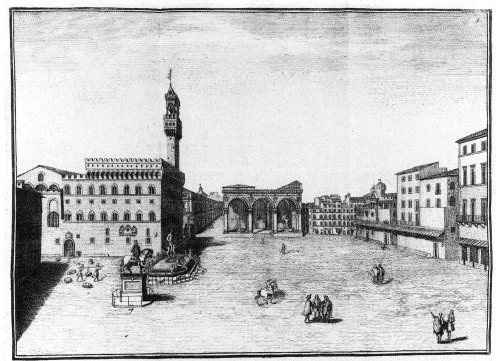

Veduta del Palazzo vecchio dol G:D:

1.*Palazzo Vecchio.* 2. *Vfizi.* 3.*Loggia de Lanzi.* 4. *S. Cecilia.* 5.*la Dogana.* 6. *la Fonte col Nettuno.* 7. *Cosimo I.*
8.*Loggia de Pisani*

54. Andrea Scacciati, *Piazza della Signoria*, engraving

55. Florence, Loggia dei Lanzi

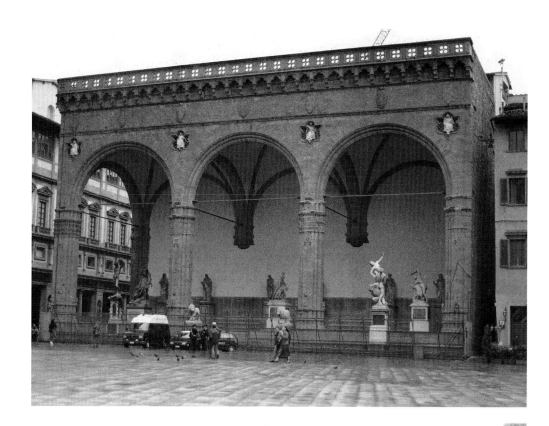

56. Florence, Mercanzia

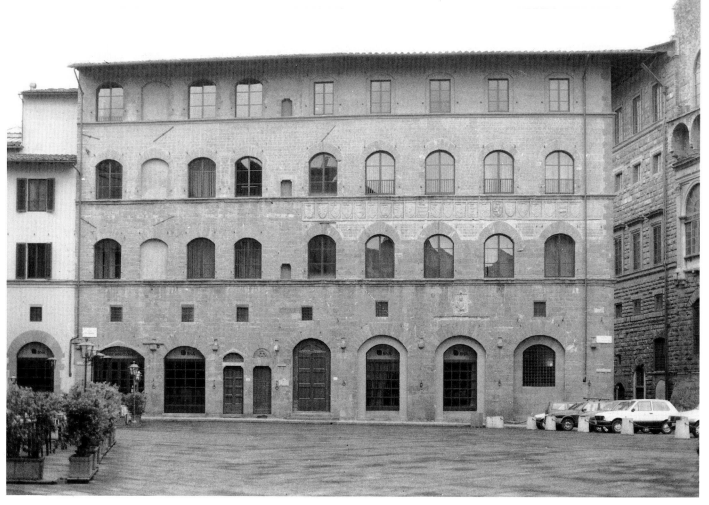

57. Giovanni Stradano, *Gifts from Leo X Presented to the Signoria*. Sala di Leone X

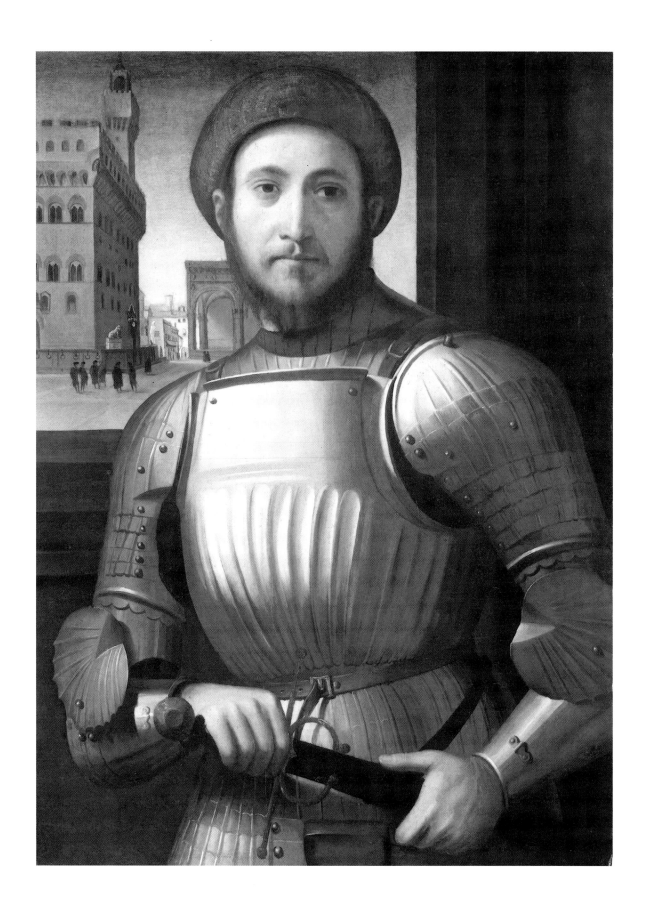

58. Francesco Granacci, attr., *Portrait of Man in Armour*. London, National Gallery

59. Master of the Hamilton Xenophon, attr., *Tribune of the Signoria on the Ringhiera*. Leonardo Bruni, *Historia fiorentina*, trans. Donato Acciaiuoli. BNF, MS Banco rari, 53 (1480), fo. 1ʳ

60. Master of the Hamilton Xenophon, attr., *Tribune of the Signoria in the Palace*. Leonardo Bruni, *Historia fiorentina*, trans. Donato Acciaiuoli. BNF, MS Banco rari 53 (1480), fo. 1ʳ

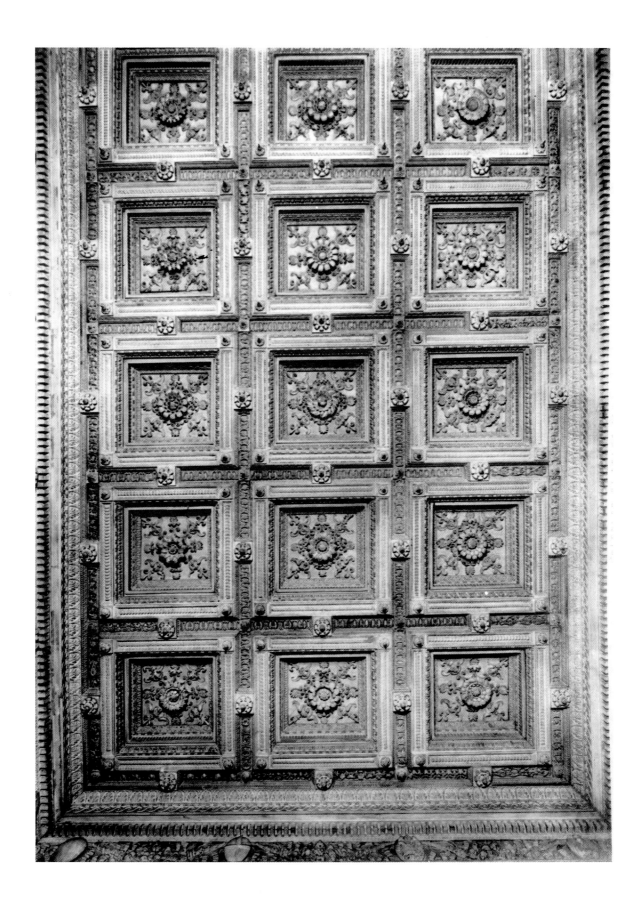

61. Sala degli Otto, ceiling